Who Will
Pay Reparations
on My Soul?

Who Will
Pay Reparations
on My Soul?

⊶ E S S A Y S ⊷

Jesse McCarthy

LIVERIGHT PUBLISHING CORPORATION

A division of W. W. Norton & Company

Independent Publishers Since 1923

For information about permission to reproduce selections from this book,
write to Permissions, Liveright Publishing Corporation, a division of
W. W. Norton & Company, Inc.,
500 Fifth Avenue, New York, NY 10110

For information about special discounts for bulk purchases, please contact
W. W. Norton Special Sales at specialsales@wwnorton.com or 800-233-4830

Manufacturing by Lake Book Manufacturing
Production manager: Julia Druskin

Library of Congress Cataloging-in-Publication Data

Names: McCarthy, Jesse, author.
Title: Who will pay reparations on my soul? : essays / Jesse McCarthy.
Description: First edition. | New York, NY : Liveright Publishing Corporation, [2021] |
 Includes bibliographical references and index.
Identifiers: LCCN 2020051560 | ISBN 9781631496486 (hardcover) |
 ISBN 9781631496493 (epub)
Subjects: LCGFT: Essays.
Classification: LCC PS3613.C345763 W48 2021 | DDC 814/.6—dc23
LC record available at https://lccn.loc.gov/2020051560

Liveright Publishing Corporation, 500 Fifth Avenue, New York, N.Y. 10110
www.wwnorton.com

W. W. Norton & Company Ltd., 15 Carlisle Street, London W1D 3BS

1 2 3 4 5 6 7 8 9 0

They gave us

Pieces of silver and pieces of gold

Tell me,

Who'll pay reparations on my soul?

—GIL SCOTT-HERON

This book is dedicated with deepest love to Raymond Lewis

To all my family & dear friends

Contents

III

IV

A Note on Style and Usage

Pride in culture and rooted history have always been important to our struggles. Historically, W. E. B. Du Bois and others fought to have the word "Negro" capitalized for this very reason. In that case, "the Negro" became a demonym specifically denoting US racial blackness. The word "Negro," and the campaign to raise its profile, reflects and will always be associated with the history of black Americans under the racial regime of Jim Crow. The landmark achievements of the civil rights movement spearheaded by the student movements (SNCC, CORE, et al.) and the leadership of the Southern Christian Leadership Conference under Martin Luther King Jr. defeated the legal standing of Jim Crow with the Civil Rights Act of 1964 and the Voting Rights Act of 1965. A new era, it was felt, demanded a new vocabulary and initiated debates over whether "African American," "Afro-American," or simply "black" should be the preferred term going forward. The impact of the Black Power and Black Arts Movements on these debates was considerable and consensus moved in the direction of adopting "black," sometimes capitalized and sometimes not, though it is worth noting that even Kwame Ture and Charles Hamilton in *Black Power* (1967), one of the seminal articulations of the politics of that moment, still have "black" in lowercase. Capitalizing "Black" belongs to a specific cultural moment—mostly concentrated in the late seventies and early eighties. Angela Davis uses "Black" in *Women, Race, and Class* (1981), as does Audre Lorde in *Sister Outsider* (1984). Mainstream usage of the capitalized form did not endure for very long. Angela

Davis, for example, no longer uses it in *Blues Legacies and Black Feminism* (1998). The reasons for preferring a lowercase usage are various. Writers and scholars have differed over what the most pressing problems with a capitalized "Black" are, while nevertheless reaching a broad (though by no means unanimous) consensus that the costs outweigh the benefits. The complexity and breadth of the global African diaspora constitutes a major hurdle, and many debates over this usage have centered on a multitude of serious conceptual inconsistencies that arise when one attempts to claim a unified transhistorical ethnoculture under the rubric of "Black." For those interested in a comprehensive and robust account of these problematics I recommend Tommie Shelby's *We Who Are Dark: The Philosophical Foundations of Black Solidarity*. While I encourage all who wish to capitalize to do so, you will find lowercase "black" throughout this text, except in cases where citation is a factor or if there is a locally pertinent exemption that makes capitalization necessary. While a robust historical consciousness of this issue seems to me essential, my own reasons for adopting a lowercase usage rest ultimately upon principles of tradecraft and precedent. I don't believe anyone has thought harder, taken more time, or weighed this question more carefully than Toni Morrison. She could have used a capitalized "Black" in her fiction, but she didn't. With the exception of the essay "Rootedness: The Ancestor as Foundation," which belongs to the period discussed above, she also refused to use a capitalized "Black" in her essays. The fact that Morrison tentatively considered the usage, and then abandoned it, strongly supports rather than erodes the case against capitalization. Hortense Spillers and Nell Irvin Painter consistently use the lowercase, as does Tommie Shelby in the book cited above. I tend to agree philosophically with Fred Moten that what is most important about blackness is its dispersive and de-essentializing qualities, its resistance to the assumptive logics of possessive individualism and state power, a function that I would argue is better captured aesthetically by the lower case. Style guidelines are split at the moment as to whether to use a capitalized "Black," and whether "White," "Brown," and perhaps other color demonyms should follow. The reasoning these norm-setting institutions have provided so far has not been clarifying or convincing. Despite all this, at the time of this writing, the style guidelines of the Associated Press and the *New York Times*

have switched to recommending a capitalization of the word "Black" in the place of "black" whenever it is used as a racial ascription. Some feel that lowercasing "black" diminishes dignity. I would respectfully disagree. I believe the spirit of the people resides in the word—majuscule or not—as long as it is used wisely, considerately, and with care. If my reader fails to recognize themselves or to comprehend my usage in what follows, it will mean I have failed at some deeper level than any orthographic alteration could resolve.

—JM

Introduction

Art is not a matter of pointing up alternatives but rather of resisting, solely through artistic form, the course of the world, which continues to hold a pistol to the head of human beings.

—THEODOR ADORNO

WHAT DO PEOPLE OWE each other when debts accrued can never be repaid? What role does culture play in a society governed in such a way that its historical inequalities are continually reproduced and widened, and its moral insolvency perpetually renewed? What do those owed nevertheless owe to each other? What possible role can art or literature play under these conditions?

These were some of the questions that I was trying to answer for myself when I first started writing the essays collected here in 2014. That year saw Ferguson, Missouri, and then the entire country convulsed by a protest against the murder and brutalization of black citizens at the hands of police officers sworn to uphold the law and protect them. It was a time of revolt and an interrogation of the ongoing failure of the United States to live up to its stated beliefs and declared values when it came to applying those beliefs and values to the black people it has historically constructed itself over and against. Protests swelled under the banner of the Black Lives Matter movement. Ta-Nehisi Coates wrote his famous essay, "The Case for Reparations."

Reports were issued, reforms recommended, and new technologies of surveillance suggested as solutions.

Today, as I write these words, the nation is once again aflame. The cause is the murder and brutalization of black citizens at the hands of police officers. The revolt is more general than the last time; the virulence and sadism of its repression by the state more vicious. The essays in this book were all written in the interval between these uprisings, a strange time when everything and nothing seemed to change in America. When every hope and aspiration seemed for many tantalizingly for the first time within reach, and yet every disaster loomed larger than ever and more sinister. We took refuge in achievements. Our culture was making money like never before. Barack Obama was elected as the first black president of the United States. But all these breakthroughs came against the background of ecological disaster, the social disaster of incarceration and policing, the political disaster of our squabbling dysfunctional elites, the economic disaster of the derivative economy and its offshore looting of the real economy. America as the aspirational nation in progress that Obama tried to restore faith in seemed less and less tangible. In its place, America as a system, predatory upon its own citizens and upon the rest of the world's resources, became increasingly obvious, its thuggish attitude embodied in Obama's successor.

Meanwhile, something was happening in the world of culture: a surging and unprecedented visibility at every level of black art making. It is not unreasonable to speculate that we may have even been living through what future generations will look back on as something like a second "Renaissance." At the very least there seems to be a pattern of intensification and consolidation, a fresh surplus of style, a great *flexing*. Creativity and opportunity were greater than ever, but the language of cultural criticism was changing too. It moved away from the centralized arbiters of taste and toward the open-source model of the social media platforms, driving sharply divisive debates that repeatedly flared up about the relations of power within sites of cultural production, the role of identity in cultural consumption, and the limits of understanding across human differences.

Directly or indirectly, in these essays I have sought to grapple with the implications of these manifold and sometimes contradictory changes as

reflected through the prism of the arts and intellectual culture. This is not a book of political essays about race and the moral crisis facing our country. I do not have a central guiding argument to make about where we are headed or what we should do about it. Nor are these personal essays as the genre is usually conceived. Instead, this is a book animated by lingering questions that I think are important for us to continue reflecting on in this moment, and that I think are best addressed in an open-ended way through criticism. They are very much essays in the French etymological sense of *essais*, attempts. In truth, I would go a bit further and describe them as experiments, eccentric but serious attempts to synthesize and connect different bodies of knowledge and their relationship to race or black culture.

As Cheryl Wall observed in her unrivaled study of the history of the African American essay, *On Freedom and the Will to Adorn*, "starting with Victoria Matthew's 'The Value of Race Literature' in 1895 and continuing through the Harlem Renaissance and beyond, the essay became the medium in which debates over aesthetics were waged." In our tradition the essay has indeed held a special place, as a space not only for argument but for experimental writings that mix and chop the old ways into new ones. This collection of essays follows, and is indebted to, a long history of "beautiful experiments," to borrow an expression from Saidiya Hartman. They would not have been possible if I had never read books like Paul Gilroy's *Small Acts*, Michele Wallace's *Invisibility Blues*, or Greg Tate's *Flyboy in the Buttermilk*, essay collections that addressed aspects of black popular culture seriously, treating them the way someone else might read a book on metaphysics or a piece of art criticism. I have sought to apply that kind of writing to subjects that combine my own intellectual interests with the debates, art, music, literature, and politics that have animated the culture in recent years. I wanted to know: What are the underlying historical and cultural dimensions of trap music? How should I think about the paintings of Velázquez after looking at the paintings of his slave Juan de Pareja? How does Kara Walker's art function? What is the history of black poetry? In every instance, my approach to finding an answer has been first and foremost to expand the frame. To keep the lens at a wide angle and pull radically different intellectual and creative strands closer together.

The title of this book comes from a chanted poem by Gil Scott-Heron that

appeared on his 1970 album, *Small Talk at 125th and Lenox*. By pointing to the question he poses and the medium he poses it in, I mean to evoke the role that art, political thinking, and moral interrogation play in black culture. Scott-Heron's question is not meant, as I conceive it, to prompt a single answer. On the contrary, I like it precisely because it is the kind of *critical* question that generates new and even better questions the more one ponders it. I am convinced that this aspect of the black experience is every bit as important as the necessary activism we must likewise engage in. The long and distinguished tradition of black criticism, black thought, and since 1968, of Black studies, is an oxygen that must continue to supply the black struggle—which, in turn, has kept the American experiment in democracy open against all those who have sought to constrict its vital force.

We know that violence always threatens to hold our creativity hostage, but it is no less incumbent, for ourselves as much as for anyone else, not to allow the "oasis," as Du Bois called black culture, to dry up, or, worse, turn into a mirage. I am convinced the urgency of this role has become more acute, not less, as the crisis of black life in this country persists. One reason for this is that the United States has increasingly become a technocratic oligarchy, the very image of "a dusty desert of dollars and smartness" that Du Bois warned against more than a century ago. This "way of life" has produced plutocratic fortunes unimaginable even a few decades ago; services, goods, and conveniences circulate with remarkable ease and efficiency. Yet the costs are plain to see: staggering levels of social anomie, political decay, and a frightening tolerance for inequality, injustice, and spectacular cruelty. As the poet Tongo Eisen-Martin drily observes, no matter what chaos is currently gripping the land,

somewhere in america
the prison bus is running on time

These essays are for anyone who wishes to read them, but they are addressed in particular, and very expressly, to the younger generations struggling right now to find their footing in a deeply troubled world. If there is one thing I would wish for them to take from these essays it is the basic premise that noth-

ing is outside of our purview, that there are no limits to the ideas, realms of knowledge, creative traditions, or political histories that we can lay claim to and incorporate. And that the knowledge of the accumulated genius of our literary, intellectual, political, and religious traditions is crucial to determining a course not only through the present crisis but through those still to come.

We know this is true because black resistance has from the very beginning channeled itself through cultural and aesthetic forms and practices. Because these practices are always alive in us, we sometimes forget that a deep knowledge of the past and critical resistance in the present go hand in hand. One of the themes that runs through these essays is the need to look backward in order to move forward. I want to close out, therefore, by turning back momentarily to leave you with some thoughts on a record that meant a great deal to me when I was young.

There are several tracks on Nas's album *It Was Written* that can change you if you listen to them. One is "I Gave You Power." The conceit is simple: Nas raps from the point of view of a gun. The result is a timeline of violence, consequences told from the perspective of the barrel. The gun becomes a center of consciousness, while the people caught in its path are treated like fungible objects. The harsh and unsparing beat reinforces the oppressive darkness. It is a demanding song, and what it demands of the listener is that you *think*: about violence, about masculinity, about the power of analogy itself. It is one of many testaments to "getting it how you live" in the crack era. A requiem for an entire generation of black youth that we lost, whose pain lives on in the families and friends who love and remember them. This is why, a quarter century on, and despite zero commercial airplay, hip-hop heads everywhere still talk about it in tones of reverence and respect.

But there was a successful single from that album, a big hit that year: "If I Ruled the World (Imagine That)" featuring Lauryn Hill. Yes, that's Fugees-era Lauryn Hill in her prime, dazzling in hoop earrings and a sunhat, her choral harmonies floating over the tinkling homage to Kurtis Blow and Whodini, the old-school foundation under the mental elevation of Nasir's Africana utopia (*imagine that*), itself a bricolage of raw street knowledge and confected "street dreams," colored by the Hollywood stardust of the eighties. Nas's charismatic flow, flashy Gambino suit, and fresh waves suggesting,

among other things, the terrible gulf between the real and the tantalizingly conceivable. Nas soaks up every inch of the beat with his trademark elasticity and range of reference, the punchy yet unstoppable flow relenting only at the open windowsill of Lauryn's soaring voice. Her hypothetical refrain repeatedly points back to the verses, gazing at them with gentle wonder, as if Nas had placed each of his dreams in an iridescent soap bubble sent in her direction. Yet her own vision is not the same as his fleeting ones. She takes up an independent orientation when she sings the bridge. There, at the threshold, or perhaps on the threshing floor, she invokes something still intangible but older and more enduring: the ancestral myth circulated among the American slaves that their people could fly. That some of them did, in fact, rise up out of the fields and return across the ocean to Africa:

And then we'll walk right up to the sun
Hand in hand
We'll walk right up to the sun
We won't land

Taken together, the seamless weave of ancestral past, social life in the present, and imagined future of an enlarged and inclusionary community at peace ("The way to be, paradise like relaxin', Black, Latino and Anglo-Saxon") represents a democratic vista that, however distant a horizon, is richer in some important ways than Whitman's and more ethically impressive when one thinks about the conditions, described in "I Gave You Power," that produced it. Lauryn's promise is also Milkman's in the closing lines of *Song of Solomon*, a novel that likewise suggests that lost young men full of dreams have to connect with the glide path of the past before they can fly on their own wings. There are many other good reasons to contemplate the significance of what is signified in these two songs and their presence on *It Was Written*; I don't pretend to exhaust them or to have the final word. Nor is this about properly appreciating these artists, who are already critical and commercial successes. Rather, as with the essays in this book, I'm trying to seize the occasion of listening to do more thinking—to take up this material on its own terms and incorporate it in writing that doesn't leave anything out and,

hopefully, gets at something new that we couldn't see before. This, at any rate, is the kind of thing I have tried to do. It is my conception of the direction our criticism should take.

What black critics and artists have in common is a self-defined understanding of responsibility to what the poet Robert Hayden, in his short ode "Frederick Douglass," calls "this beautiful and terrible thing, needful to man as air." That thing is freedom. I am convinced that whenever one pushes the possibilities of form, something perhaps smaller than freedom, but like it in kind, becomes available to others. Every time one finds a new way to share culture, to value it for reasons beyond fleeting attention or narcissistic glow, new configurations of understanding and expression of underlying unity emerge. *Free your mind and the rest will follow*, as the women of En Vogue sing. The refrain is more than just a good hook. It is through acts of remembrance and flights of imagination that tradition conjures the future.

Cambridge, June 3, 2020

Who Will
Pay Reparations
on My Soul?

I

The outstanding fact of late twentieth-century European culture is its ongoing reconciliation with black culture. The mystery may be that it took so long to discern the elements of black culture already there in latent form, and to realize that the separation between the cultures was perhaps all along not one of nature, but one of force.

—James A. Snead

The Master's Tools

The master's tools will never dismantle the master's house.

—AUDRE LORDE

B OUND TOGETHER, two visions of mastery face each other down in the Brooklyn Museum. Jacques-Louis David's *Bonaparte Crossing the Alps* (1800–1801) and Kehinde Wiley's *Napoleon Leading the Army over the Alps* (2005) stare at each other over a sea of smartphones and across two revolutionary centuries. David's mounted Emperor points ahead, his index finger showing the way through the Saint Bernard Pass to his victory over the Austrians at Marengo. Wiley's anonymous subject is a black man who wears Timberlands (corporate logo to boot), baggy camo getup, and a bandana tied Tupac-style in the place of Napoleon's iconic bicorne.* He might well pass for a member of the Boot Camp Clik circa 1997 when they released the East Coast classic hip-hop album *For the People* ("All my peoples are you *reddee . . .*").

* The names *Williams* and *Bonaparte* appear as inscriptions on the stone at the foot of the stallion, possibly naming its rider. So does the name *Hannibal*, which reminds us of Carthage's most famous general and his own crossing of the Alps on mounted elephants. Or it could simply be this man's first name, *Hannibal* having some frequency in the African American population (viz. Hannibal Buress) in part on account of its having been a popular name to assign to slaves. *Hannibal* was also, incidentally, the name of a British slave ship captained by Thomas Phillips in the service of England's Royal Africa Company, which set off for the Guinea Coast in 1693 to purchase, as Phillips noted in his journal, "elephant's teeth, gold, and negro slaves."

The electric face-off is a brilliant coup for the museum: a visual duel of Old World and New, black and white, neoclassicism and postmodernism, French imperialism and Black Nationalism, nostalgia for greatness past and fantasies of future greatness. Whether a prophecy of doom or emancipation, the clash seems the cultural moment writ large, one in which a sitting US president wonders aloud excitedly at the possibility of another civil war, and a rap star from the Marcy Projects in Brooklyn regularly moves about the city decked out in diamonds that would have made Empress Joséphine's head spin. In an uncanny foreshadowing of history, in the fall of 2019 Wiley installed a massive sculpture of a black man atop a bucking war-horse in Times Square, an image that would come to life six months later amidst the chaotic protests against the killing of George Floyd, when a protestor commandeered a police equine unit and pranced it through downtown Chicago to the chants of "Black Lives Matter." Wiley called his sculpture *Rumors of War.*

Jacques-Louis David, whose commemorations of French grandeur are more comfortable in the Louvre than in Brooklyn, is, of course, a certified Old-World master. But Wiley is by now as close as one can get to being an established contemporary master in his own right. His paintings are especially prized (and purchased) by a black creative class that has accumulated unprecedented wealth and cultural prominence since the Reagan years. It's easy to see why his work appeals to them. Wiley is famous for his lush portraits of black friends, strangers, celebrities, and America's first black president. Irrespective of the sitter's background, his compositions are emotionally anchored by an afterglow of the irruptive "soul style" aesthetic Tanisha Ford describes in her scholarship on the politics of fashion during the "Black is Beautiful" 1970s. Wiley is deeply attuned to that era's Afrocentric tonality captured so well by photographers like Kwame Brathwaite, but trades in their penchant for matte surfaces and stiff, angular refinement for a populist cornucopia where a surfeit of adornment stands in for qualities that exceed the representational capacities of the body. This garishness also works like a lure because as one attempts to take in the floral spray, Wiley's subjects seem to catch us, to anticipate our cruising curiosity, as if waiting for us to notice that we too are being watched, perhaps even seen *through*. This, I think, is why his interest in the body often seems far less real, and less important, than his

ability to gather the details of his surface and concentrate them in his subject's gaze: cool, overpowering, concentrated, coming at you like Serena's backhand.

These extroverted qualities are indebted to the culture of voguing, as many critics like Bruce Hainley and Susan Ross have noticed. The optics are further complicated by having black subjects adopt poses that quote from canonical works in the history of European painting. This is embedded in Wiley's working method in which people he has encountered in the street are invited into the studio and given art history books to peruse so that they can choose and identify a painting they feel speaks to them. The resulting portraits throw the blackness of his sitters into relief by creating a kind of interference pattern where familiar and unfamiliar codes overlap. The black appropriation of Old Master swag necessarily changes the meaning of a symbol or a gesture, even if the difference may at first seem small. In a painting called *Decoration of the Sacrament in the Chapel of Udine, Resurrection* (2003), the art historian Sarah Lewis observes, "[Wiley] has taken away the flag featured in the original Tiepolo painting but kept the pole, adding a bulb at the bottom to convert it into a staff. Wiley alters the pole's orientation and design to signify a cultural shift: slung over the black model's back, the staff becomes a potential weapon."

But what kind of weapon? The twist, as many critics have noticed about Wiley's work, is that there is a quiet but persistent insinuation that both white and black performances of mastery are strikingly similar in their reliance on repressed sensibilities most eloquently cultivated by those who possess, or at least can momentarily embody, a queer sexuality. Black Jacobins or Napoleons in the drag of military attire are not simply plastic soldiers in a new color. When they show off an epaulette or a riding boot, they show us how power might be used otherwise. They coordinate previously inconceivable positions for anyone raised in a culture strictly attached to rigid and moralized sexual categories. Yes, they are paintings that white museumgoers might well experience as simultaneously ravishing and disquieting. But most poignantly, and in my view more importantly, straight black men might well find in them spaces to confront anxiety-ridden tropes of sexual and gender normativity; our inability, far too often, to make room for the possibilities of someone else's

desire to "come out," but also what Essex Hemphill called the ceremonies of "coming home"—his insistence that we listen and believe him when he said he was coming home *regardless* because "there is no place else to go that will be worth so much effort and love."

At their best, these works can show up the limitations of our sexual insecurity and creolize the pageantry associated with white aristocratic power. They can also teach us to see and think differently by scrambling our aesthetic genealogies. For example, Wiley's signature use of densely patterned background motifs bears an unmistakable resemblance to Gustav Klimt's opulent artificial planes, which he uses to endow his subjects with an ambivalently decadent Byzantine halo. But these same patterns are just as indebted to the lively portraits of the Malian photographer Seydou Keïta, who opened his Bamako studio in the 1950s and invited his clients to flaunt their midcentury cool against the vibrant backdrop of popular fabrics. Does this ambiguity of influence portend unforeseen or unspoken implications? For instance, the possibility that fin de siècle Austrians and black millennials might share a curiously similar attachment to decadence and kitsch, a gold-plated liaison between Kanye and Klimt? Perhaps future art historians will one day describe a synthesis of African, European, and African American attitudes toward power, hagiographic portraiture, and the excesses of laissez-faire capitalism as the twenty-first century's fascination with a Rococo *noire*.

But these are just the opening moves in a dance off that is vertiginous in its possibilities. Do David's and Wiley's masculine fantasies of conquest converge or diverge, and if so at what point? Does the question of imitation raise the stakes or diminish them? Does Wiley elevate the authority of blackness or merely relativize it? Does he perhaps cut both David and Napoleon down to size, reducing the former to a slick state propagandist, the latter to a common gangster? Will viewers of his painting be alert to the ironies of history? It is a remarkable fact that the troops in Napoleon's Army of the Alps were led by the black general Thomas-Alexandre Dumas, born to a French nobleman and an enslaved mother in Saint-Domingue, known to his enemies as *der schwarze Teufel*, "the black devil," and eventual father to one of the greatest French authors of the nineteenth century. Dumas's exceptional service to the glory of France was enough to get his name etched on the Arc de Triomphe

in Paris. His exceptional melanin, however, proved inauspicious. When he came around to collect his military pension, it was not forthcoming, and he died, leaving his wife and son, the future author of *The Count of Monte Cristo* and *The Three Musketeers*, in dire poverty. Dumas had served his master honorably, but all the tools at his disposal were not enough to secure him against the default devaluation of his blackness. I can't help but wonder, though, if they are now looking down from above at Wiley's wily homage and smiling at this proud black riposte to David's exercise in imperial hero worship.

A riposte has martial connotations from fencing, but its origins are more humbly in the Italian for "a response." Properly, it means a *spirited* response, that is, one which rises to meet the challenge by giving as good as it gets. Anyone paying attention to the signs of the times can see that we are living through something like an all-encompassing civilizational riposte, a crisis of cultural authority and the traditional means of its transmission. A raft of repressed histories is resurfacing with volcanic force. It's in the air, in the sound, in the imagery all around us. Two of the most powerful entertainment figures on the planet, The Carters, can be seen in the music video for their hit 2018 single "Apes**t" taking over the Louvre. Their dancers pick afros in front of Mona Lisa, put the Venus de Milo's curves under pressure, gyrate in front of Géricault's Medusa. Beyoncé, who has French-Creole ancestry on her mother's side, channels her preternatural Cleopatra. In the video she appears with a phalanx of her dancers in front of Jacques-Louis David's *The Coronation of Napoleon*—a painting whose subject also happens to be regime change. While singing about her "expensive fabrics" she erupts into dance moves traceable on one level to Houston, or maybe further back, to the shores of Senegal at Saint-Louis, capital of what was once French West Africa, a colonial empire three times the size of France itself. The message seems clear: We, who were once symbolically remanded to the racial Salon des Refusés and exhibited as animals at the colonial fairs, have stormed the palace of the Occident and crowned ourselves victorious in that gilded place.

Or maybe it's not so simple. As Doreen St. Félix points out, Jay-Z and Beyoncé are clearly more interested in "playing with tableaux" in their video than setting up barricades. Their choreography primarily communicates a desire to repurpose and finesse the enormous (some would say priceless)

exchange value of iconic artwork. They certainly aren't iconoclasts or vandals like Marinetti's Italian Futurists who threatened to burn libraries and raze the British Museum. Their blackness, like that of Wiley's subjects, shows up in the master's house and the master's portrait gallery intent on carrying out a *creative revolution*. Harnessing the instruments of power to a distinctly insurgent posture is not *only* done to protest discrimination; it also signals the intervention of a new intelligence, a spirit in the process of discovering the true extent of its untapped potential.

What new perspectives, what new forms of knowledge emerge when the tools of the master are taken up by the slave? In the 1980s, the critic and scholar of African American literature Houston Baker Jr. came up with a pithy chiastic phrase to describe how black artworks and writings negotiated this tension: "the mastery of form and the deformation of mastery." The art and literature produced in the wake of captivity has always been freighted with precisely this paradox. We should not be surprised to find echoes of this dynamic throughout history and to see it even intensifying in the present and near future as black artists gain increasing visibility in the canon and in the cultural consciousness. In 2016 the painter Kerry James Marshall enjoyed the first major retrospective of his work at the Museum of Contemporary Art of Chicago. When asked by an interviewer about the title he chose for his show, Marshall responded: "I had to recognize that in that pantheon of old masters—there are no black old masters." He called his show "Mastry."

THE LIFE AND WORK of the Spanish master Diego Velázquez and another, lesser-known painter tell an intriguing version of this recurring fable. Michel Foucault famously opens his book *The Order of Things* with a tour de force reading of Velázquez's iconic painting *Las Meninas*. Foucault's rhetorical strategy is to mirror the bravura of the painting in his own prose, a brinksmanship that sets up a rivalry across time and space between two Europeans (Old and New Masters), each deeply invested in exposing the reach of sovereignty through the power of representation. Their displays of mastery articulate how power can command fealty using tools that, at first blush, appear to be simply elegant, humanistic expressions of high culture.

For Foucault, *Las Meninas* is much more than a simple representation of the infantas and court attendants of Velázquez's royal patron, the king of Spain, Philip IV. It expresses the rise of European Man as a sovereign subject at the height of imperial and colonial power. Its famous trompe l'oeil presents Europe's monarchical and aesthetic regimes simultaneously. Politics and art become overlapping and interchangeable expressions of absolute power. In this conception, *Las Meninas* isn't merely an impressive painting of a powerful subject by a masterful painter; it is also symptomatic evidence of a historical process then unfolding. And that process was the arms race among Europe's royal houses in their bid to plunder the Americas, initially via campaigns of extermination and the enslavement of indigenous peoples, and subsequently through the enslavement and deportation of Africans to the New World. Velázquez took a selfie of the entire idea of European mastery as it clicked into place. In his masterpiece, we see the rulers discovering how to make their own project legible to themselves. This is the nature of my power, the painting says, I am the natural subject of history, the center and master of the universe.

The Order of Things is concerned with showing how this European Man begins to organize bodies of knowledge with increasing systematicity and abstraction, so that what defines him is not only what he knows about the world, but *how* he knows it. This process, inadvertently, has the byproduct of producing what Foucault calls distinct *epistemes*, paradigm shifts in the organization of knowledge, information, and power (which he argues are always intricately bound together). Foucault contends that these *epistemes* evolve over time, reordering our beliefs about the present and conditioning our understanding of the past.

There is a common misconception that Foucauldian critique is a reductive reading of a work of art to show how it is merely a product of its time. It's just the opposite: the idea is to show how time itself, historical epochs, or *epistemes*, are produced and organized by (and through) the language of art, science, and culture. *Las Meninas* is not simply a representation of sovereignty—it is a moment in the construction of the sovereign, of the entire Spanish empire. Consider this: a billionaire stamping his name on the outside wall of a museum doesn't merely represent a philanthropic donation but expresses and justifies

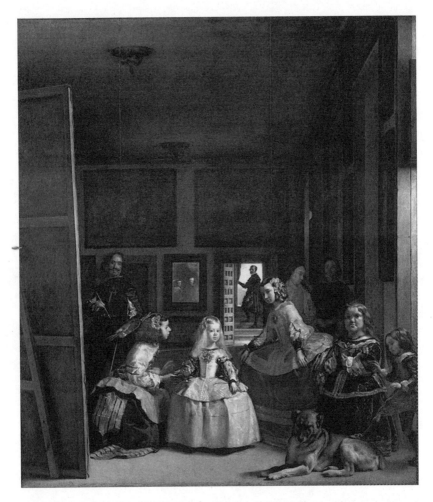

Diego Velázquez, *Las Meninas* (1656). Museo Nacional del Prado. © MADRID, MUSEO
NACIONAL DEL PRADO.

(one might even say launders) the sovereignty of the unregulated accumulation of private wealth. The contemporary art museum, with its wings and
rotundas named for robber barons, is itself a keystone in our own aesthetic
regime, one that mandates, reproduces, and further consolidates the nature
of sovereignty, the order of things in *our* society.

In *Las Meninas*, Foucault sees the faces of the people who set about laying the
foundations of that modern world, one that for him is defined by the dominance

of European values, aesthetics and political, sexual, and social hierarchies. But Velázquez's career was shadowed by another face—one that Foucault did not see. That face represents the people set in symbolic opposition to this European Man, his antithesis and antagonist. It was the face of a man Velázquez owned, an African slave born in Andalusia, who went by the name of Juan de Pareja.

This extraordinary coupling of master and slave has always been hiding in plain sight and was not insignificant to Velázquez's career. Having ascended to the position of court painter upon the death of his predecessor Rodrigo de Villandrando in 1622, Velázquez began taking on increasingly ambitious work with the aim of securing the permanent favor of King Philip. Then, as ever, one's reputation and the envy of others mattered, and nowhere more so than in Italy, where Velázquez traveled for important commissions. It so happens that the painting that launched this European master internationally, that made him known in high circles, was in fact a portrait of Juan de Pareja, his enslaved African assistant.*

This beautiful three-quarter profile hangs today in the Metropolitan Museum of Art in New York City. Velázquez's first biographer, Antonio Palomino, informs us that when the painting was first displayed, it "received such universal acclaim that in the opinion of all the painters of different nations everything else seemed like painting but this alone like truth." What was the truth of Velázquez's painting of Juan de Pareja that so definitively allowed it to transcend the nature of painting itself?

The portrait proved a watershed in more than one way. The praise it received both confirmed the greatness of its maker and conferred a cele-

* According to Carmen Fracchia, among the images he could have used as models for this portrait, "Velázquez would also have had in his mind one of the now lost half-bust portraits of the first Afro-Hispanic writer, the freedman humanist and Latinist Juan Latino (1518?–c.1594), recorded in 1636 at the Alcázar in Madrid: 'portrait from the chest up of a black man, who is Juan Latino, with a label that says he was ninety years old.'" The man at The Met is obviously much younger, but even if only the glimmer in the eyes owes something to Juan Latino, it would form a haunting constellation. In any case, the color on the canvas matters. As Fracchia says, "the distinctive non-white colour of Pareja's skin would have been seen as the inherent attribute that defined him as a slave in early modern Spain and Europe. Even if Velázquez had decided to depict Pareja as a Spanish gentleman devoid of any signifiers that might mark his legal and social functions, this is nevertheless the portrait of an Afro-Hispanic enslaved subject. *Juan de Pareja* is thus an exceptional work in being the only surviving depiction of an enslaved, mixed-race man (*mestizo*) in Hapsburg Spain."

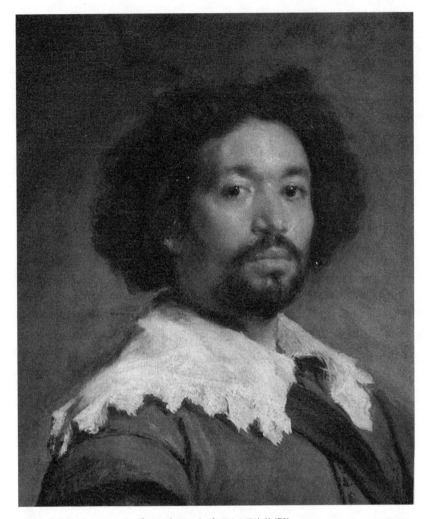

Diego Velázquez, *Portrait of Juan de Pareja (1606-1670)* (1650). METROPOLITAN MUSEUM OF ART.

bratory dignity upon its subject. In time, the work of aesthetics secured the personal liberty of Juan de Pareja, who became a free man when Velázquez agreed to sign a contract of manumission for him four years later, allowing Pareja to pursue his dreams of being a painter himself. Here is art historian Jennifer Montagu on how Palomino characterized the relationship between master and slave:

Palomino has no doubts about Pareja's status, and his short biography of Pareja himself is almost entirely concerned with his position as a slave: because of it, Velázquez would not allow him to paint, for the master respected his art too highly to allow a slave to practice it, and Palomino includes a reminder that the ancients had reserved such liberal arts for free men; however, he tells us, Pareja did paint without his master's knowledge, and he devised a stratagem whereby Philip IV, when visiting Velázquez's studio, saw one of Pareja's pictures, and thereupon insisted that the talented slave be given his freedom.

Art historian and Hispanist Carmen Fracchia notes that Palomino actually goes out of his way "to differentiate the 'slave' Pareja's occupation from that of the other assistants in Velázquez's workshop by listing his manual tasks, typical of those of a slave: '[Pareja would] grind his [Velázquez's] Colours and prepare the Canvas, and [perform] other servile Offices belonging to the Art and about the House.'" The contradictions of Pareja's position were not merely issues of labor relations but a matter of essence—of where he belonged and whom he belonged to. He wasn't just an assistant to the person of Velázquez; Palomino is saying Pareja was a slave to Velázquez's Art. If Pareja could paint at all, he says, it was despite "the disgrace of his nature" (*"no obstante la desgracia de su naturaleza"*). In the logic of the day, an African like Pareja was *naturally* unfit for access to the liberal arts, regardless of his abilities and talents, which Palomino implicitly recognizes. The rule is that the slave must never be given the master's tools.

Despite these prejudices and against the odds, Pareja acquired his canvas, brushes, and oils and got to work. He is quite likely the earliest black painter whose works still survive.* As of the year 2000, there are believed to be some thirty works attributed to Pareja, mostly portraits and biblical scenes. A majority of these have never been located, however, raising the prospect of discoveries still to come. His earliest known work, *The Flight into Egypt* from

* His contemporary Sebastián Gómez served in an almost identical capacity as a slave to the painter Bartolomé Esteban Murillo and was known as "El Mulato Murillo." Very few of Gómez's works survive, and those that do have been dated slighter later than Pareja's to the 1680s and 1690s.

1658, is in the John and Mable Ringling Museum of Art in Sarasota, Florida. But The Prado holds his most important work, *La vocación de San Mateo* or *The Calling of Saint Matthew*, from 1661.

If Foucault is right that Velázquez's *Las Meninas* is an image of sovereignty then Juan de Pareja's Saint Matthew is—what? It is not enough to claim the obverse—that his painting is structurally an image of subjection, that is, of slavery. On the face of it, the image is conventional in style; it appears, at least at a casual glance, to follow the rules of a game learned from the master. Paradoxically, its legibility seems a bit deflating. Being too easy to read, the painting, like a chameleon, sneaks back into this particular European period-style and disappears. Does the painter's race and enslaved status then make no difference at all? If it does, how could we tell? Would the difference have to be sought out within the marks on the canvas or in everything that lies beyond the frame? Do apparently incidental details, such as the fact that Pareja makes this painting in the year *after* Velázquez's death, have unsuspected additional meaning? And what does race mean to the interpreter, to the critic who thinks the world hasn't paid enough attention to this black assistant of one of the world's most famous European painters? Can this work of art produced by the slave sustain the kind of tour de force treatment Foucault accorded his master?

I'm not simply interested in reminding the world of Pareja's existence, or in complicating our reception of Velázquez, although those might be excellent ancillary benefits. Nor am I suggesting that Pareja's painting is necessarily a neglected masterwork that secretly rivals the image of the Old Master. My question is this: Even if we wanted to, do we know how to read a slave's "masterpiece"? I'm not asking whether a slave is *capable* of producing one, but rather what kinds of rhetorical and aesthetic claims such a work can make. What does it mean to apply the word "masterpiece," originally referring to the culmination of a journeyman's apprenticeship and acceptance into a commercial guild, to a black journeyman who knew the guild he was seeking admittance to existed in the first place by profiting from the fungibility of his own humanity, from the enslavement of his people? What did Juan de Pareja imagine he was doing when he painstakingly contributed his own entry to the history of European oil painting? Can we make sense of him in that moment? And further down the corridor of time, what can he tell us about our own?

The first step, of course, is to see him at all. If Foucault is right to locate in *Las Meninas* the coordinates of a newly sovereign Man, whose mastery of the tools of representation entitles him to the glory of rule, then surely a painting produced by his slave might bear some interrelated and plausibly commensurate importance in the world historical picture—indeed, an importance all the greater for the slave's invisibility. For Pareja is invisible not only to Velázquez and the discourse of "Art History" that has neglected him while simultaneously consolidating an aura of supremacy around his master, but also to Foucault. Despite excavating this archive precisely in the hopes of finding and naming its epistemic authority, this most remarkable theorist of power was unable to see the enslaved assistant or the racial logics that set him in servitude.

Perhaps we can write this off as a mere oversight. Except that the construction of racial blackness, the transatlantic slave trade, and the mercantilist colonization of the Americas are among the most fundamental inventions of the modernity that Foucault aimed to delineate in *The Order of Things*. This blind spot ironically suits an ongoing governing logic in Foucault's analysis that forgets to ask where Philip IV got the gold with which to pay Velázquez for *Las Meninas*, payment denied to his enslaved assistant, whose labor Velázquez valued but whose talents he mistrusted and whose ambitions he interdicted.

Suppose I were to read Juan de Pareja's *Saint Matthew* as carefully as Foucault does Velázquez's *Las Meninas*. What can I say? Where will my discourse fit, or fail to fit? Foucault recognizes that a tour de force requires its analogue in writing, and dutifully obliges. What would be my mirroring gesture given the failed reception of my subject? Certainly, I'm not able to emulate an art historical discourse of hagiographic adulation. Such a move would already be understood as belated and therefore derivative. Moreover, it would be slotted neatly into a contemporary notion of redress or reparation. It would risk the whiff of appealing to white liberal guilt. Such readers would concede to my claims as a matter of tacit etiquette, a small price to pay for a relieved conscience. To put it another way, even if I were able to muster the rhetorical force of a T. S. Eliot rescuing a John Donne whose talent he believed had been unfairly discarded by his tradition, my claims would be suspect. Donne was never a slave, except to

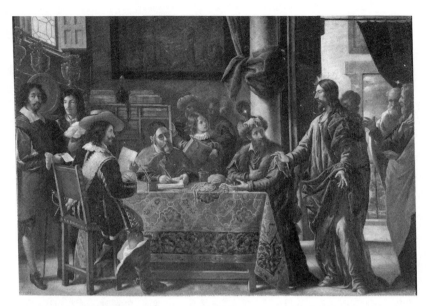

Juan de Pareja, *The Calling of Saint Matthew* (1661). Museo Nacional del Prado. © MADRID,
MUSEO NACIONAL DEL PRADO.

his appetites. The negligence Eliot had to overcome was essentially evaluative;
it presented no fundamental epistemological or ontological difficulty. Pareja,
by contrast, spent the greater portion of his life an African slave in Spain,
owned by an ambitious artist who in life and in death overshadows him. Pareja
presents complications before his brush even touches the canvas.

Even Pareja's most sympathetic viewer, perhaps one like myself, will see
first and foremost in his work things to criticize, places where we wish he had
done better, elements that seem in some way or another lacking. Like all the
black literary and cultural critics before us, we are ever and always, almost by
definition—if not exactly by design—disappointed in the masterpiece of the
slave. It can, in a nontrivial sense, *never be good enough*. Even when it presents
extraordinary excellence, we will wish of it that it did yet more, that it fulfilled
more of our hopes, that it reached a summit of indisputable affirmation and
universal praise that is essentially asymptotic.

It does not matter that Pareja's relatively generic painting might well have
been executed with more talent than, say, 80 percent of the Italian Renais-

sance frescoes that lesser-known studio painters and assistants composed for the churches and Palladian villas of the great European bourgeoisies, those gated communities that flourished as the merchant capitalists shifted their field of operations out of the Mediterranean Basin and into the wildly lucrative and expansive returns generated by what Paul Gilroy named "the Black Atlantic." We will still be disappointed that Pareja is not Michelangelo, that he doesn't draft as well as Raphael, that he lacks the sprezzatura and dramatic flair of Caravaggio, that he doesn't more skillfully employ the humanizing softness of Da Vinci's sfumato. Pareja's painting, we instantly notice, is frustratingly rearguard in its flatness. Details that might well have constituted his most prized achievements bore us as so many conventional and academic notes. We see all its neoclassical deference and Flemish nods and borrowings, suggestive of the understudy's performance. The apprentice's eager earnestness verges perilously on pastiche. Where is its radical confrontation, we ask—where is its *blackness*?

Only when we have raked the image over in this way can we allow ourselves to focus on the most obvious feature, one of undeniable interest: the presence of the slave in his own work. For Juan de Pareja (in a move from the master's repertoire familiar in figures as distant as Giotto and as recent as Hitchcock) inserts a self-portrait in his work. We know this is an image of Pareja because of its obvious resemblance to the portrait of him that Velázquez originally produced in 1650, the one that now resides at The Met. On one level, in *Saint Matthew*, Pareja records for posterity his own impression of his likeness in the otherwise imagined biblical scene, a practice Renaissance painters indulged in typically on behalf of wealthy patrons who were duly inserted into the works they had commissioned the way stadiums and sporting events are "brought to you by" such and such corporate conglomerate.

But how many biblical scenes feature the insert of a black ex-slave who also happens to be the artist? Moreover, look at the way Pareja has done so. There is something uncanny, almost eerie, about the painting's effort to reproduce (you might even say to quote) Velázquez in very specific ways. It's there in the face, everything down to the almost identical unsmiling three-quarter stance, the detailing of the white collar; it all suggests something more elaborate afoot. Is this a parody of the master's portrait of his slave? Of the

authorial gesture of *Las Meninas*? Is there tucked away discreetly inside this painting an inside joke, a form of colonial mimicry as Homi Bhabha describes it, an ambivalent response drawing the power of the master (or the colonizer) into a bind, a game of mirrors that disrupts and undermines his authority?

As one looks closer, more signs of potential subversion come into view. The titular subject of the painting is Saint Matthew, figured in the iconic scene of his calling, that is, his summoning and conversion by Jesus. The calling of Matthew is also known as his "vocation," a word that reminds us here of the original etymological significance of a sacred interpellation, literally a calling from the divine. Matthew had been a tax collector in the province of Galilee, an unpopular servant of empire and capital whose job would have resembled that of a minor functionary in a colonial outpost. His calling illustrates Jesus' ability to reach the most sinful and least spiritual of men, those that have a vested interest in protecting the status quo. You could say that Matthew occupies what is sometimes referred to in leftist circles as the "PMC" or professional managerial class: folks with a niche in the order of things and little taste for anything other than the comforts of material well-being and a modicum of worldly power.

By forsaking this cushy position and following Jesus, Matthew embodies a notion of vocation that persists to this day: the familiar trade-off between the job security that comes with going along with the system and the costs of standing athwart and in opposition to it by risking safety for the sake of a higher cause. Matthew is often depicted at the scene of his calling when Jesus finds him among his fellow tax collectors, but also, in an extension of this figuration, as a saint receiving the inspiration from the angels or the holy spirit that allows him to compose his gospel. In other words, Matthew's vocation is not only ethical, a choice to follow the path of truth, but practical, in the Marxist sense of praxis: he pursues truth by becoming a scribe, a divinely inspired creator, one might even say an artist.

One of the most spectacular depictions of Matthew's calling is the Caravaggio triptych (painted between 1599 and 1602) that hangs in the Contarelli Chapel in Rome. Juan de Pareja most likely saw it in Velázquez's company during their trip to the Eternal City in 1650—that fateful trip that triggered Pareja's eventual manumission some four years later. Caravaggio's version is

a masterpiece of dramatic comedy. His famous chiaroscuro captures a Matthew who looks less like a tax collector than a gambler, a man one might imagine in the company of cardsharps. For Caravaggio, as for so many of the Renaissance and late Renaissance masters, the interest of the biblical scene was not easily separated from their own vested interest in flaunting the mastery of an imposing style, using the subject material as an occasion to contest one another's supremacy in the fine arts. As a visual icon, Caravaggio's *The Calling of Saint Matthew* is outstanding—memorable, radiant, and polished in ways that Pareja's cannot aspire to, let alone rival. But Caravaggio was working on commission, the choice of his subject dictated by the commissioner who had selected a story to honor his namesake, an aesthetic act, ironically enough, of considerable worldly vanity.

Pareja's choice to paint Matthew seems likely to have been the result of very different motives, though the possibility that he was inspired by Caravaggio's glory cannot be discounted. In Pareja's version, however, it is above all the lucre of the tax collectors that is emphasized. An open purse oozes out gold doubloons; a string of pearls dangles alongside heaps of jewelry. This is an image not merely of collecting, or as in Caravaggio's sly imputation, of swindling. It is an image of plunder, of pirated bounty, of financial and political corruption of the highest order.

Everyone in the painting has their attention focused on the central subject of the scene, which, of course, is Jesus, who has entered (following convention) from the right-hand side of the canvas. Well, almost everyone. Curiously, implausibly, the two figures at far left seem unaware or uninterested in the scene. One is Juan de Pareja himself, the figure at the furthest edge of the canvas, who stares not directly out into the viewing plane, but slightly to our left, at something we cannot see. The other is a notably paler young man with a mustache, who appears either to be staring at Pareja himself, or at the same source of interest that has caught Pareja's eye. This odd conjunction sets them compositionally apart from the rest of the painting. They do not seem entirely involved in it. The pale man holds a hand to his heart, as if struck by some serene vision of grace, though oddly not the one he should be attracted to. Instead he seems to be looking at Pareja himself, with a mixture of astonishment, bemusement, and tenderness, as if seeing him truly for the

first time. Pareja's gaze is more ambiguous, even wary, directed out into the plane of the viewer but not engaging us directly. There is a certain amount of torque in his stance, his attention going one way, the arm going the other, as if he has just been caught doing something illicit. He is tendering forth a document, somewhat like a waiter presenting a bill, to the wealthy gentleman in the large white brimmed hat and almost comically lavish boots who is presumably getting his taxes done. The bill is inscribed with pride, "*Jo.°de Pareja F*[ecit].*1661*." Pareja is positioned as a man who is immersed in the world of commercial affairs, but also not quite of it—not because he is a slave since at this point he is very much a free man, but because he disdains material things. He is a man who has found freedom through his vocation. And yet the presence of the doubloons and the property tax documents invariably reasserts the troubling specter of commercial transaction, the emerging markets of the Mediterranean and the New World, which Pareja cannot fail to recall represent the auctioning site of his body, his talent, and personhood to the greatest Spanish painter of the age. Is this irrepressible but oblique knowledge what occasions the look of melancholy tenderness in the mustachioed pale gentleman? Could Pareja's more complicated gaze reflect the mind of a man mulling over something like Toni Morrison's apothegm that "the function of freedom is to free someone else"?

The realization that this painting is the product of a mind and hand that, unlike Caravaggio's, has experienced the transition from slavery to freedom, leads one to think about all the other possible epistemologies embedded in the work. What did Juan de Pareja know about the Americas? What stories or gossip about the results of Spain's foreign ventures could he have overheard in his intimate proximity to the court at a time when the Iberian Empire was at the height of its power and at the center of a vast network of transatlantic slavery? In the United States we rarely talk much about the Iberian traffic, but it represented 90 percent of the trade in humans shipped to the New World. Scholars estimate the Afro-Hispanic population on the Iberian Peninsula may have peaked at two million. It turns out, as Carmen Fracchia's fascinating studies of blackness in Siglo de Oro Spain show, that Saint Matthew the Apostle of Ethiopia was merely one focal point in an entire iconography of black saints and symbols that thriving communities of Afro-Hispanic

peoples used to celebrate their African heritage. Indeed, all around Juan de Pareja there was a rich black social and cultural life nurtured by Christian confraternities that produced their own poetry and black carols, many only recently discovered, centered on the veneration of an Africanized Christianity exemplified by figures like Benedict of Palermo, the first black European saint. Once one fills in the picture of Pareja's lifeworld, it becomes clear that not only is his painting subversive of the vertical authority of the master but its intricate web of allusions stretches horizontally as well—into the syncretic branches of the African diaspora. The painting is a lesson from and to the old master. But its message, woven deep into the fabric, is not for him but for them—*for the people.*

THE TOOLS BELONGING TO what Audre Lorde called "the white fathers" are master frameworks that continue to shape the world we live in. But those same tools are always being picked up by others, by people who have stories to tell that their masters never suspected and audiences the masters don't know how to reach. Lorde may be right that those tools will never be sufficient to accomplish a total revolution or completely dismantle the order of things. But the hand of the slave who wields the master's tools inevitably transforms them. New keys can unlock new doors that open onto unsuspected basements. Something always *changes* even if it's not always obvious at first sight. Juan de Pareja's painting of Saint Matthew of Ethiopia may not be a masterpiece in the way that *Las Meninas* is. But these two artists thought about mastery in different ways, learned different lessons, sought out different conceptions of the truth in painting. Pareja, I am convinced, was attuned to some very subtle questions about the relationship between freedom, art, and the divine. He was driving at questions that Velázquez never even contemplated. Brilliant though he was, Velázquez was nonetheless limited by his position as master. There were some things very near to him, things in fact essential to his own success, and indeed to that of his royal patron, that he could not see. Velázquez had the tools of a master. He didn't have the vision of the slave.

—2020

The Origin of Others

I N Virginia Woolf's last novel, *Between the Acts*, the word "nigger" appears exactly once, in a sentence that describes a queer artist feverishly at work. Miss Latrobe is in charge of putting on a pageant representing the procession of English history for an assembly of local villagers on a beautiful summer's day. With a phonograph at her disposal as well as a grab bag of costumes and a troupe of amateur actors, she runs around behind the stage trying to get everything in order, a depressingly familiar image of a woman laboring to restore the dignity and history of her community—and being rewarded, for the most part, with little to no recognition. Indeed, this is why the word is used: "Miss Latrobe had vanished," Woolf writes. Where did she go? "Down among the bushes she worked like a nigger."

Woolf's usage reflects a disturbing if common colloquialism of its time. With the brutal shadow of slavery still darkening the horizon, the equation of blackness with unremunerated labor was as much an ordinary piece of mental furniture in the cultivated coterie of Bloomsbury as it was in the rest of the Western world. But Woolf's description represented something else as well: Miss Latrobe may not be a black woman, but by using the word Woolf nonetheless forces her readers to confront the figure of the racialized outcast, a figure still prevalent in a society benefiting from the resources and exploited labor of millions of colonized peoples around the world.

Woolf always used the novel as a means for acute social criticism—to dilate those moments of moral complicity and complacency found in the daily

lives of middle-class Westerners. Her celebrated style brought ordinary syntax into ever-closer contact with the layers of consciousness that operate just below our cultivated personalities, turbulent areas of inner life where the stability of human character and morality breaks down and creates, as Zadie Smith put it recently, "grave doubts about the nature of the self." Woolf's faith in this moral power of fiction allowed her to wager that the lived quality of a black person's experience, however dimly apprehended, was not ultimately divorceable from the deepest self-understandings of white people. Woolf, in other words, dared to insist that there are "other" persons in our midst; all around us (and indeed within us) are hidden facets of humanity. Virtually everything in our society encourages us to deny, repress, disavow, distort, or irreparably damage that truth, which is, of course, one of the main goals of racism. Part of this invisibility is the result of a social system beyond any one individual's making. But Woolf's point is that the perpetuation of this invisibility is also our collective responsibility: To make us safe from the abjection of living in a society built on the foundations of violence and stratification, we assure ourselves that such a status belongs only to a well-defined stranger. The power of great fiction to challenge that common sense lies only partially in reflecting our lives back to us like a mirror; a great deal more resides in its capacity to dispossess us of our preferred assumptions, plunging us into knowledge like photographic paper into its chemical bath, revealing, even against our will, all the gray areas we find inconvenient, unpleasant, even impossible to acknowledge.

Today, we almost take for granted the idea that a powerful eruption of racial blackness in a novel should be obviously worthy of comment. But, of course, that hasn't always been the case. Our reading practices and habits are shaped among other things by our education, and the systematic examination of race in literary texts was still a relatively new concept well into the 1990s. At one time I, too, might have casually glossed over the page on which it appears. But by the time I started reading Woolf, Toni Morrison had already made her powerful argument in *Playing in the Dark: Whiteness and the Literary Imagination* for us to pause and consider precisely how racial eruptions like this occur throughout modern literature.

Since its publication in 1992, *Playing in the Dark* has become a seminal

reference work for literary studies in the academy and a regular presence on syllabi. The book has also helped transform the way many general readers consume the West's so-called canon, offering searing dissections of Ernest Hemingway and William Faulkner and teaching a generation of literary scholars how to read for the "Africanist presence" in texts that otherwise pretend not to be concerned with race.

Indeed, with *Playing in the Dark*, Morrison changed the rules of the game, effectively recasting what we see when we look back to figures like Woolf but also to writers of the present and future like Colson Whitehead, Jesmyn Ward, and Angela Flournoy. "All of us are bereft," she writes, "when criticism remains too polite or too fearful to notice a disrupting darkness before its eyes." Although we focus, for good reason, on Morrison's novels, which will endure far into the future as great works of art, her essays opened up new worlds as well. As is seen from the range and depth of moral insight collected in her last book, *The Source of Self-Regard*, her essays also bequeathed to us a mandate to see and speak clearly, in particular about the ways in which otherness persists in almost every facet of life—a responsibility we need to acknowledge more than ever in the present.

Taking the full measure of Morrison's recent passing, comprehending all that she has done to change what we read, how we read, and who we read, will be the work of subsequent generations. Arguably no single writer has done more to shape the direction of American fiction in the past fifty years, and no writer has set the bar for achievement in the form of the novel higher than where she left it in 1987 with her masterpiece, *Beloved*. Much like Pilate, the fierce outsider and moral conscience who guides the plot of *Song of Solomon*, it never occurred to Morrison to ask for the proverbial seat at the table. Instead, she pulled the entire table over to her side of the room.

Born in Lorain, Ohio, in 1931, Morrison began her revolution in American literature from within the gates of the lettered city. A graduate of Howard University, class of 1953, she went on to Cornell, where she studied modernism and wrote a thesis on Faulkner (already a major figure in American letters) and Woolf. It was a pioneering choice for a thesis in the 1950s, when Woolf had not yet been canonized and many of her books were out of print.

With her degree in hand, Morrison embarked on a teaching career, first at Texas Southern University in Houston and then at Howard, where she remained for seven years and met her husband, Harold Morrison. That marriage ended in 1964, and Morrison was forced to leave academe to support her two children with a job editing textbooks for Random House. Her confidence and formidable talents as an editor got her noticed, and once an opening appeared in the company's trade division in New York City in 1967, she became the first black woman to occupy a senior editorial position in the publishing industry.

Morrison's time at Random House was productive. She used her position to irrigate the literary and cultural landscape with new voices from the Black Arts Movement and with the icons and political champions of Black Power and Black Feminism, publishing Gayl Jones and Toni Cade Bambara, the still underrecognized Henry Dumas, and the autobiographies of Angela Davis and Muhammad Ali.

Morrison's most daring and experimental project at Random House was *The Black Book*, which gathered stories of black life across history and created a remarkable and mesmerizing commonplace book from it—something in between W. E. B. Du Bois's cherished dream of an Encyclopedia Africana and Stéphane Mallarmé's vision of "the Book" as a repository in which all that has ever been attains its preordained legibility.

In these years, Morrison also began to write, publishing *The Bluest Eye* in 1970, *Sula* in 1973, and *Song of Solomon* in 1977—works of uncompromising vision, assured in their purpose and crackling with passionate urgency. Each was groundbreaking in its own way, combining the power of black oral tradition with the authority of folklore, communal memory, and a feminist consciousness. Morrison did all of this fearlessly, no matter the costs that came with forcing American culture to come to her and her people. She composed her novels, edited her books, and published her literary criticism knowing that she could also write circles around her critics—and often did. No one has gone to bat for William Styron's *The Confessions of Nat Turner* since. The genuflecting esteem and towering fame accorded to writers like, say, John Updike and Norman Mailer have never recovered. Others played a role in

this too, but Morrison's critiques were hard to look past, and the due respect accorded to female novelists white, black, and of every shade owes something to her epochal impact on the "literary field," as Pierre Bourdieu would put it.

That Morrison will always be read first and foremost as a novelist is, of course, as it should be. But the tremendous impact of her fiction and her very public career as a novelist have tended to eclipse her contributions as a moral and political essayist, which the pieces gathered in *The Source of Self-Regard* help correct. Taken together with *What Moves at the Margin*, her first volume of nonfiction, as well as *Playing in the Dark* and *The Origin of Others*, her 2017 collection of lectures, this final book brings Morrison the moral and social critic into view.

In her essays, lectures, and reviews, we discover a writer working in a register that many readers may not readily associate with her. Rather than the deft orchestrator of ritual and fable, chronicler of the material and spiritual experience of black selfhood, and master artificer of the vernacular constitution of black communal life, here we encounter Morrison as a dispassionate social theorist and moral anthropologist, someone who offers acute and even scathing readings of America's contemporary malaise and civic and moral decline in an age defined by the mindless boosterism of laissez-faire capitalism.

In essays like "The Foreigner's Home," one almost hears echoes of Jean Baudrillard's theories of simulated life under late capitalism and Guy Debord's *The Society of the Spectacle* as she examines the disorienting loss of distinction between private and public space and its effect on our interior lives. The politicization of the "migrant" and the "illegal alien," Morrison argues, is not merely a circling of the wagons in the face of "the transglobal tread of peoples." It is also an act of bad faith, a warped projection of our own fears of homelessness and "our own rapidly disintegrating sense of belonging," which reflects back to us the anxieties produced by the privatization of public goods and commons and the erosion of face-to-face association. Our lives, Morrison tells us, have now become refracted through a "looking-glass" that has compressed our public and private lives "into a ubiquitous blur" and created a pressure that "can make us deny the foreigner in ourselves."

In other essays, one finds Morrison venturing into the tense intersections

of race, gender, class, and radical politics. The essay "Women, Race, and Memory," written in 1989, offers a retrospective attempt to make sense of the fractures within the 1960s and '70s left, to understand why a set of interlocking liberation struggles ended up splitting along racial, gender, and class lines. One can't help feeling a wincing recognition when Morrison writes of "the internecine conflicts, cul-de-sacs, and mini-causes that have shredded the [women's] movement." On top of racial divides, she asserts, class fissures broke apart a movement just as it was coming together, exacerbating "the differences between black and white women, poor and rich women, old and young women, single welfare mothers and single employed mothers." Class and race, Morrison laments, ended up pitting "women against each other in male-invented differences of opinion—differences that determine who shall work, who shall be well educated, who controls the womb and/or the vagina; who goes to jail; who lives where." Achieving solidarity may be daunting, but the alternative is "a slow and subtle form of sororicide. There is no one to save us from that," Morrison cautions—"no one except ourselves."

Yet even as her essays ranged widely, from dissections of feminist politics to the rise of African literature, from extolling the achievements of black women ("you are what fashion tries to be—original and endlessly refreshing") to the parallels between modern and medieval conceptions of violence and conflict in *Beowulf*, they also came together around a set of core concerns about the degradation and coarsening of our politics as we "other" one another and how this process often manifests itself through language.

This is particularly true of the essays included in *The Source of Self-Regard*, which give their readers little doubt about the power of her insights when she trains her eye on the dismal state of contemporary politics and asks how the rhetoric and experiences of otherness came to be transformed by the rise of new media and global free-market fundamentalism into a potent source of reactionary friction. Indeed, despite the fact that some of these essays are now several decades old, Morrison's insights are still relevant today. For example, her gimlet-eyed description of the cant of our political class in the essay "Wartalk," that "empurpled comic-book language in which they express themselves." Or her warning against "being bullied" by those in power "into understanding the human project as a manliness contest where women and

children are the most dispensable collateral." Or her chiding of the "commer-
cial media," in the run-up to the Iraq War, for echoing the uninterrogated
lines of Tony Blair and George W. Bush. Journalists, she insisted, must take
up the cause of fighting "against cultivated ignorance, enforced silence, and
metastasizing lies." They are not supposed to contribute to it.

The sheer quantity of her speeches and essays testifies to Morrison's power
as a moral and social critic. But this does not mean she left literature entirely
behind in her essays. In fact, the greater part of *The Source of Self-Regard* is
dedicated to her applying her moral and political insights also in the arena of
art. Fiction writers are not always the best readers of their own work or that of
others. (It's only natural that they have their blind spots.) Yet Morrison proves
to be a literary critic of the highest order, besotted with the intricacies and
pleasures of textual interpretation and with their political and moral import,
and enviably providing such close readings of her own work that we are some-
times left wondering whether there is anything else for us to really say.

In her 1988 lecture "Unspeakable Things Unspoken," she provides a
carefully argued account of black literature in relation to the Western canon
(while, in passing, also wonderfully provincializing Milan Kundera's Euro-
philia in *The Art of the Novel*) before peeling back the layers of her own cre-
ative process and guiding us through her decisions, omissions, and qualified
judgments as a novelist, from the opening sentences of her novels to their con-
cluding lines. "There is something about numerals," she explains in a passage
on the famous opening of *Beloved* ("124 was spiteful. Full of a baby's venom"),

> that makes them spoken, heard, in this context, because one expects
> words to read in a book, not numbers to say, or hear. And the sound
> of the novel, sometimes cacophonous, sometimes harmonious, must
> be an inner-ear sound or a sound just beyond hearing, infusing the
> text with a musical emphasis that words can do sometimes even bet-
> ter than music can. Thus the second sentence is not one: it is a phrase
> that properly, grammatically, belongs as a dependent clause with the
> first. . . . The reader is snatched, yanked, thrown into an environment
> completely foreign . . . snatched just as the slaves were from one place

to another, from any place to another, without preparation and without defense.

Reading her on literature one immediately recognizes that, for Morrison, literary criticism was also an art; the essay another vehicle for conveying her moral and political insights. Her skills as writer of nonfiction are in fact one and the same as her powers as a writer of fiction. For her, both the essay and the novel can undo the work of individuation foisted upon us by modern society; they can bring "others" into contact and remind us of our common humanity.

Sometimes this larger project of humanization can show itself in the choice of a single word, like the solemn weight and subtle inflections of the adjective "educated" as it describes Paul D's hands in *Beloved*, as he and Sethe fumble toward the beginnings of a new life eked out within the living memory of enslavement. Other times it expresses itself in a lyrical outburst that captures a fleeting moment of self-fashioned freedom, a world of possibility momentarily gleaned from an otherwise desperate circumstance, as in this passage from *Jazz*:

> Oh, the room—the music—the people leaning in doorways. This is the place where things pop. This is the market where gesture is all: a tongue's lightning lick; a thumbnail grazing the split cheeks of a purple plum.

Finding those places where things pop is the central task of her humanism, which she calls, in the titular essay of the new collection, the act of "self-regard." Self-regard, Morrison insists, is the process in which we recover our selves—in which we once again become human. It means experiencing black culture "from a viewpoint that precedes its appropriation"; it means seeing humanity after the veil of otherness has fallen. Above all, it enjoins us to be the arbiters of our own significance, to remember that every plank in the vast ark of black culture is as valid and precious as that of any other human vessel; and that the echoes ringing in that hull speak in tones we must never allow ourselves, or anyone else, to tune out.

Humanism is not much in vogue these days. The urgency of our moment has impressed upon us other more specific political programs. Yet the quiddity of Morrison's writing ultimately is just that. Her humanism is not restricted, as it is still often taken to be, to a tradition solely refracted through a small circle of men whose taste for classical learning, preference for moderation and reform, and disposition to kindliness and optimism helped them weather late medieval Europe's brutal religious and tribal warfare. For Morrison, humanism is a tradition of self-regard, confident and open to all that is worth knowing, but one that draws its special strength from the historical experience, community, and values possessed and refashioned by those Africans driven into the holds and shipped across the Atlantic while Erasmus and Thomas More exchanged their letters on the duties of conscience and friendship.

Morrison's humanism, therefore, is something made of far loamier and more challenging conditions of dispossession and natal alienation that only make the project of humanization all the more pressing. "It was there I learned how I was not a person from my country, nor from my families. I was negrita," as the mother in her novel *A Mercy*, known to the reader only in her Portuguese form of address, *a minha mãe*, puts it, and it is in these conditions that humanity is also recovered, where "language, dress, gods, dance, habits, decoration, song" take on new meaning.

MORRISON HAS ALWAYS WRITTEN out of this black humanist tradition. The battle over the meaning of black humanity has always been central to both her fiction and essays—and not just for the sake of black people but to further what we hope all of humanity can become. This is a humanism informed by Anna Julia Cooper, who insisted on the education of black women and the affirmation of their "undisputed dignity" as vital to any meaningful realization of social justice. It is the determination of Mary McLeod Bethune, who told a doctor who advised her in 1941 to slow down her relentless administrative and philanthropic activism, "I am my mother's daughter, and the drums of Africa still beat in my heart. They will not let me rest while there is a single Negro boy or girl without a chance to prove his worth." And, indeed, of Sojourner Truth, who, when advised that the meetinghouse in Angola, Indiana, where she was to speak was going to be burned down, replied, "Then I shall speak upon the ashes."

Although her work has been neglected, one of the contemporary thinkers who most resembles Morrison in this respect is the philosopher Sylvia Wynter, who has also, as it happens, called for a "re-enchantment of humanism" that would complete the work of Erasmus and his circle by breaking out of the paradigm that understood his intellectual and ethical virtues to be the special property of bourgeois European men over all the other inhabitants of the globe. While humanist, it also seeks to effect a revolution in ethics and perspective that is sensitive to the natural world around us. Such a humanism knows that the people who endured slavery are some of the best persons to consult on questions of social and political freedom.

This humanistic bent is especially evident in one of Morrison's most important essays included in the collection: "The Future of Time: Literature and Diminished Expectations." Its ostensible subject is the apocalyptic way we regard the future of human life—a future that is unquestionably at risk of being foreshortened—but its real targets lie elsewhere. What Morrison takes issue with is the pronoun at the center of the appeal for action:

> Political discourse enunciates the future it references as something we can leave to or assure "our" children or—in a giant leap of faith— "our" grandchildren. It is the pronoun, I suggest, that ought to trouble us. We are not being asked to rally for the children, but for ours. "Our children" stretches our concern for two or five generations. "The children" gestures toward time to come of greater, broader, brighter possibilities—precisely what politics veils from view.

Morrison wants us to think in more general terms: for humanity itself. Our inability to do so—to envision, plan, or imagine a deep future for the human race—is evidence, she worries, of a larger bankruptcy in our present culture, which cannot summon a sense of what we would do even if we could safely guarantee that kind of longevity. To have such an attitude toward the future we would need a common mission, some cultural pattern of vitality with which to fill the empty stretches of time to come—in short, we would need a humanism. "It will require," she concludes, "thinking about the quality of human life, not just its length. The quality of intelligent life, not just its

strategizing abilities. The obligations of moral life, not just its ad hoc capacity for pity."

THERE IS A SPEECH only partially included in *The Source of Self-Regard* that should have been entirely included: Morrison's 1995 convocation address to the students of Howard University on the 128th anniversary of its founding. In it, she apologizes for not dwelling on "the sweetness and the beauty and the conviviality" of the old days and instead traces Howard's long history of perseverance in the face of a nation openly hostile or skeptical (often both) to the notion of educating black people in the liberal arts.

TURNING TO THE PRESENT, Morrison warns her listeners that this struggle is far from over. There is, she insists, a creeping fascism in the midst of American culture that relies on the construction of "an interior enemy" for "both focus and diversion." Do not, she commends her audience, trust any one political party to combat this drift toward creating "others" out of neighbors. It will make no difference who is in power, if in the end we are only interested in building a bunkered future, a siloed desert without social intercourse and mutual conversation, a world with quantified convenience but no qualitative conviction that can help us transcend the otherness imposed on all of us.

Making a homeland worth keeping, for Morrison, is centrally about this: It requires a deep mutuality—a solidarity that can't be achieved by cutting any group or individual out but that looks past difference to find a shared sameness. As Morrison told another gathering of students, this time in 2013, "We owe others our language, our history, our art, our survival, our neighborhood, our relationships with family and colleagues, our ability to defy social conventions as well as support these conventions. All of this we learned from others. None of us is alone; each of us is dependent on others—some of us depend on others for life itself."

To read Morrison today is to remember all over again how badly we need the rogue sanity found in her essays and speeches as well as her novels. Sometimes this sanity consists of bright new ideas, but many other times it is very simple things, old ideas that we already know and should already understand but that magnify under Morrison's glass. As Morrison put it in her penultimate

collection of lectures, *The Origin of Others*, "The resources available to us for benign access to each other, for vaulting the mere blue air that separates us, are few but powerful: language, image, and experience."

OUR COUNTRY IS NOT now and never has been as noble as Morrison's work insisted we could be. In this sense, she wrote for the future—for the young readers who are only now taking their first steps into the classroom and the public library, gazing at the shelves searching for answers to as yet unknown questions. This generation will pull down those books and feel with enviable freshness that inordinate beauty and vitality we hold dear. They may find themselves, as we so often have, echoing Morrison herself, who said in praise of James Baldwin at his funeral, "In your hands language was handsome again. In your hands we saw how it was meant to be: neither bloodless nor bloody, and yet alive."

—2019

Venus and the Angel of History

*There are times . . . when normal responses of grief, horror, and
so on do not make sense because they bear no real relation to the
depth of the emotion one feels. It was impossible for me to cry
when I saw the field full of weeds where Zora is.*

—Alice Walker, "Looking for Zora"

History is something we learn. History is also a current that much of
our daily life is designed to insulate us from. Even though it surges all
around us, we only occasionally, and often accidentally, encounter its elec-
tric shock. When we do, as Walker suggests in her reflection on discovering
Zora Neale Hurston's burial ground, it often strikes our sensibility by over-
loading it to a point that can become dissociative, even anesthetic. We can-
not register it in the same way that we would a personal emotion. The poet
Nathaniel Mackey likens the experience to that of discovering "a phantom
limb," a numbness that points to a missing bodily member that refuses to be
lost. Momentarily, in a kind of trance, we inhabit the experience of another's
pain and internalize it as our own. Mackey also evocatively describes this
process as a "couvade," a term for sympathetic pregnancy in men, which
sometimes entails a set of rituals that allow a father to accompany the birth
of a child, as though he were going through labor himself. These attempts to
grasp the feeling of history suggest that it is the embodied learning of a vast

and impersonal grief or pain of past peoples. We channel loss for persons and situations and aspirations that we have never known, an unnerving intimacy with a disremembered and dismembered past. The grain of the unknowing produces a residual irritation, the gnawing tremors of a lack that can be hard to place, one we may even loathe acknowledging. Yet it refuses to go away. An instinctual desire for kinship, a gift for collective personal belonging, tells us that the things that happened to them also happen to us—they are our inalienable birthright, are *about* us in an important way. Sooner or later, we discover it is our time, our turn to go in search of our mothers' gardens. To discover what grew there that cleared the way for us.

Looking down through the generations, we see the crests of epochal moments, inflection points whose visceral impact lingers in our nervous system. Think of the news of Emancipation carried across battle lines like sparks from a winter campfire in the winter of 1863. Think of Juneteenth and the cries raising up like a summer storm in the Texan heat. Think, just over a century later, about the news bulletins reaching folks in their homes, in their kitchens, on street corners across the land with the news that Martin Luther King Jr. had been shot dead by a white gunman in Memphis. In our generation, we think of election night, November 4, 2008. The stinging of tears on the brink, or already falling; the outbursts but also the vigilant silence of old folks, who explained later in faltering voices that they had to concentrate because they were not only witnessing for themselves but also for the ancestors watching the moment through them. I remember for the second time in my life feeling that strange telescoping feeling, realizing people would be talking about and studying this very moment for hundreds of years to come. I happened to have been born in time to see the World Trade Towers fall and the first black president rise and take his elected office. Here was another chapter in what Du Bois called "the travail of souls whose burden is almost beyond the measure of their strength, but who bear it in the name of an historic race." In the roar of the crowds and in the flowing tears you could feel it: The awesome shudder of history when it is being made—when it suddenly reaches out and shoves you in the chest, daring you not to react, daring you not to make yourself humble before it.

At such moments we know we are part of an epic, that time is not empty,

but pregnant with narrative orientation and disorientation. What are we to make of this epic memory, its haunting and terrorizing eruptions? Who can hold in their mind all at once the seemingly endless disasters, losses, defeats and almost unspeakable degradations catalogued therein? The fondness of black parents for Old Testament names is surely one way of inscribing and transmitting a response of prophetic hope across time. The tradition's spiraling return to black Zionism, to utopian imaginations of black statehood and black arks of deliverance, the fundamentally theological bent of African American politics, is surely another.

But hope and deliverance are only one side of the coin. The other is a fatalistic and bewildering attempt to make sense of the fear of the irredeemable, of wasted life, of brutality without compensation, of denigration and dissolution beyond account, without analogue, incapable of repair. Black intellectual history has always been in part an effort to come to terms with a terrifying sense of wholesale abjection. Black life in this country has always been predicated upon and inextricably bound up with negligence, casual violence, and dishonorable death. There it is, in the very first sentence of the Preamble to David Walker's 1829 *Appeal to the Coloured Citizens of the World*:

> Having travelled over a considerable portion of these United States, and having, in the course of my travels, taken the most accurate observations of things as they exist—the result of my observations has warranted the full and unshaken conviction, that we, (coloured people of these United States,) are the most degraded, wretched, and abject set of beings that ever lived since the world began; and I pray God that none like us ever may live again until time shall be no more.

The signs change but a pall of negativity connects this appraisal of abjection in David Walker, to sorrow in W. E. B. Du Bois, bleakness in Richard Wright, and one could add today subjection in Saidiya Hartman and in Afropessimism, which has flourished, ironically enough, in the shadow of the Obama presidency. Stephen Best has lately diagnosed what he views as the "malady" of the "omnipresence of history in our politics": a *via negativa* committed to "the thesis that black identity is uniquely grounded in slavery and middle pas-

sage" and that "what makes black people black is their continued navigation of an 'afterlife of slavery,' recursions of slavery and Jim Crow for which no one appears able to find the exit."

Best raises a valid question: Does the past—however traumatic, however generative, however needful—ultimately determine the horizon of our belonging? Can it tell us who we are now at this moment and orient us toward the future? Does the shadow of disaster ever finally recede, cease to have the pull on us that perhaps it once had? If these questions seem unanswered or unanswerable, we might nevertheless ask: What accounts for the renewed intensity and urgency of these questions here and now in the first decades of the twenty-first century? Why, at a time when reasonable arguments can be made that things are looking better than ever—a pragmatic and empirically defensible position eloquently articulated by Coleman Hughes, for example—does there seem to be a renewed desire to look back instead of forward? Why this enormous reluctance to relinquish the past? Why indeed the countervailing force in recent decades of a desperate and furious need to prevent the memory of slavery and subjection from slipping away?

No thinker has addressed the contradictions of history—its shock and numbness, its pregnancies of meaning and miscarriages of justice, its hold over us and its ever-receding wake—as incisively and creatively as Saidiya Hartman. In her three major works thus far, *Scenes of Subjection*, *Lose Your Mother*, and *Wayward Lives, Beautiful Experiments*, the most vulnerable human being of all, the young black girl, appears everywhere as the plaything of history's imagination. As Hartman puts it in her celebrated essay "Venus in Two Acts": "Variously named Harriot, Phibba, Sara, Joanna, Rachel, Linda, and Sally, she is found everywhere in the Atlantic world. The barracoon, the hollow of the slave ship, the pest-house, the brothel, the cage, the surgeon's laboratory, the prison, the cane-field, the kitchen, the master's bedroom— turn out to be exactly the same place and in all of them she is called Venus." She is also, infamously, Sarah Baartman, the Khoikhoi woman who was paraded through Europe as the "Venus Hottentot," her anatomy "studied" by their leading scientific minds. Robin Coste Lewis catalogues her many variants in her poem "Voyage of the Sable Venus."

In this way, the real life of "Venus" is stolen, twice over. This is what Hartman calls "the scandal of the archive," its Janus-faced role in granting while simultaneously denying us the recovery of the few traces of the past that we have. "The archive is, in this case," Hartman says, "a death sentence, a tomb, a display of the violated body, an inventory of property, a medical treatise on gonorrhea, a few lines about a whore's life, an asterisk in the grand narrative of history."

Yet, the four opening words of *Beautiful Experiments*, her most recent and most exciting work, plunge us back into a paradoxical hope: "You can find her . . ." Who is *she*? The answer is both singular and plural, soloist and chorus. *She* is the countless individual lives of young black women, many of them only retrievable through the case files compiled by New York's Bedford Hills Correctional Facility where they so often were interned. She is, for instance, fifteen-year-old Mattie Nelson, who came north in the years of the first Great Migration between 1890 and 1935 in search of work and ways of life she would have to imagine, since no possibility of them for her had ever previously existed. Hartman's subject is "not the story of one girl, but a serial biography of a generation, a portrait of the chorus, a moving picture of the wayward."

That generation's search for new freedom collided with the most regressive and terrifying combination of science, technology, and racist ideology ever openly concocted, a period the historian Rayford Logan describes as "the nadir" of race relations in US history. Forced sterilizations of black women and girls as young as twelve, as Shatema Threadcraft has shown, were common enough in the South to be referred to as a "Mississippi appendectomy" and would be carried on until at least 1973 when the case of Minnie Lee and her sister Mary Alice Relf eventually brought landmark legal action against sterilization abuse in 1977. It has been all too easy for some Americans to forget places in the North with names like the "Laboratory for Social Hygiene," which operated at Bedford Hills; or the Eugenics Record Office at Cold Spring Harbor, where charming fellows like Harry Laughlin and Charles Davenport developed a racial eugenics program with policy recommendations so repulsive that the German Nazi state borrowed it as a template for the war against their own "undesirables": the disabled, the "feeble-minded," the Jews. Race "science," social hygiene, and especially the dubious science

of "criminology" were used to tar black migrant populations fleeing terror, expropriation, and debt peonage in the South. These same tactics were then used to distinguish them from the European immigrant populations flooding into the country at the same time, an insidious statistical legerdemain that Khalil Muhammad has scrutinized in *The Condemnation of Blackness*.

For black women in the North, the lack of recourse to the law to protect oneself meant a constant fear of the predations of all kinds of men. The great sculptor Augusta Savage, who came up from Florida to Harlem, was hounded for most of her time there by a white upper-class eccentric by the name of John Gould. Mr. Gould appears to have felt that by virtue of his genealogy (what was then called "old stock" Yankee), his "genius," and his Harvard connections, he was entitled to be boorish, maniacal, and generally disgusting to everyone, but particularly to Savage whom he glommed onto out of a perverse racial fetishization. The story of his stalking of Savage only came to light recently, when the historian Jill Lepore uncovered it while researching Gould and the alleged "masterpiece" that he never wrote, *The Oral History of Our Time*. Augusta Savage's artistic prowess, social grace, and warmth, which were legendary in her own day, have left only a faint mark on our cultural memory, a fate even more pronounced for those marginal women Hartman's methodology seeks to recover. Hartman digs deep in the case files, fleshing them with her imagined reconstruction of women's inner lives. We see them eking out satisfactions, pleasures, and communions in the teeth of a harassment that could bite down at any time at the whim of supposedly civilized men and officers of the law.

Hartman's hesitant first-person presence within her narrative is intensely reminiscent of W. G. Sebald: that unnerving alloy of fiction and nonfiction, the melancholic mannerisms of someone sifting through debris, speculating in an ex post facto rumination upon the meaning of photographs, objects, and the personal details of "minor" lives, reconstructing not the scene, but everything in the wings, of a historical crime. We have not always wanted to look at these lives—or known how to see them. This is true of the wayward who came North in pursuit of happiness, who have been so anonymous and treated so indifferently by historians past. But it is also true of famous figures, especially some of the more famous men of this era whom we discover in an

entirely new light. Men like W. E. B. Du Bois, whom Hartman, availing herself of the novelist's free indirect discourse, makes into a character that she can then follow as he carries out his pioneering (albeit moralizing) study, *The Philadelphia Negro*. Following his footsteps, she registers and holds up for our consideration the panic he betrays—especially with regard to the sexual mores displayed by his subjects—a panic that Hartman suggests may be connected to the traumatic memory of the loss of his own virginity to an older woman who he said in his autobiography "literally raped" him. No biography I know of has ever dwelled on this period or connected it in this impressionistic but persuasive way to this period in his life.

Other unusual angles are lifted into the light. How many of us knew that Hubert Harrison, the fiery orator and one of the most important black social-ist thinkers and writers of that era, "never tried to cloak his love of drag balls, which he attended regularly"? The "great men" of the canon are humanized in Hartman's renderings, cut down to size in a way, but also made more inter-esting, more promiscuously embedded with the social texture of that time and place, which was so unique, so terrible and yet exciting. Now we see them in the company of all the others, all the queer women of the stage and theater world, like the legendary Jackie "Moms" Mabley, who "wore trousers in the street, traipsed through Harlem with their women on their arms, and dared anyone to say a damn thing." Perhaps we have been too embarrassed to want to talk about the race men and their sex lives; but we shouldn't be. The systems of surveillance and punishment of that era shamed wayward women and tried to confine and hide them in the prison's case file histories. We should open and reclaim them, Hartman suggests, not to enlist them in some battalion of overlooked freedom fighters, but to take them as they are, or were, and cel-ebrate their desires and dreams, not least because we can recognize so many of them as our own.

Hartman undoes the erasure of these lives by allowing them to interan-imate each other, to reach out to each other across the gaps. They form lists on the page which are also chorus lines. "Muses, drudges, washerwomen, whores, house workers, factory girls, waitresses, and aspiring never-to-be stars." They embrace, and in turn, Hartman embraces them. In her book they are people again, they can be themselves instead of the "data" that someone

else's file needed them to be. Hartman is clear about the disillusionment and hurdles these women faced, but she also sees how their collective action and reckless aspiration point "toward what awaits us, what has yet to come into view, what they anticipate—the time and place better than here."

We should not forget that it is the very openness to futurity and incompleteness of history that makes Hartman's acts of redress possible. The cultural historian Carolyn Steedman captures this subtle point well in *Dust*, her brilliant study of the many uses of the archive. The writing of history, Steedman points out, "actually moves forward through the implicit understanding that *things are not over*, that the story isn't finished, can't ever be completed, for some new item of information may alter the account as it has been given." This leads to the rather startling, if retrospectively obvious, conclusion that "all historians, even the most purblind empiricists, recognize this in their writing: *they are telling the only story that has no end*." The only story that has no end. This means that history has no conclusion that includes the writer of that history in it. But this also means that the writer of history is actively shaping the nature of this past which has unfinished business with us, if only in its perpetual demand that we improve the quality of its transmission. Hartman has changed how we will henceforth think about the lives of black women during a historical period we thought we knew fairly well. She has changed the past precisely because that past is not over for her, or for us.

OUR CONTEMPORARY SENSE of the past as a site in need of a rescue mission can be traced to Walter Benjamin. Why did his theory emerge when it did and as it did? The apocalyptic terror of the 1930s is no longer, to use a term he liked, quite "knowable" to us. For thinkers in the wealthiest nations, today it is exceedingly rare for work to be produced under threat of imminent political assassination or incarceration. Indeed, the jailing and killing of poets and philosophers from Lorca to Dennis Brutus, such a hallmark of the twentieth century, has declined remarkably since the end of the Cold War. Benjamin's "Über den Begriff der Geschichte" or "Theses on the Concept of History," however, was forged in despair, a series of fragments written shortly before his death by suicide at the Spanish border as he was attempting to escape Nazi-occupied France.

One of the last things Benjamin did before fleeing was to give a Paul Klee painting he owned called *Angelus Novus* to the writer Georges Bataille to pass on for safekeeping to his dear friend and intellectual comrade, Gershom Scholem, who kept the painting in Jerusalem. In the "Theses," Benjamin famously describes the painting in mystical terms:

> This is how one pictures the angel of history. His face is turned toward the past. Where we perceive a chain of events, he sees one single catastrophe which keeps piling wreckage upon wreckage and hurls it in front of his feet. The angel would like to stay, awaken the dead, and make whole what has been smashed. But a storm is blowing from Paradise; it has got caught in his wings with such violence that the angel can no longer close them. The storm irresistibly propels him into the future to which his back is turned, while the pile of debris before him grows skyward. This storm is what we call progress.

For Benjamin, the horror of our historical trajectory lies in the Angel's inability to close his wings. What prevents that closure is the insistent storm of "progress," the stubborn belief of liberals, fascists, and communists alike that technology and rational control are positive forces that merely have to be harnessed to their respective utopian projects. The political ideology of the modern world—the storm pushing to reach the "Paradise" of modernity's impossible utopias—is in fact violent, Benjamin thinks, precisely because it cannot or will not make that which is truly valuable in the past whole and tangible to the present. The powerful may monumentalize historical icons in order to glorify the state in the present, but this is merely in order to further cement the belief that they are legitimately carrying us all forward into a better future. What they will not permit is any chance for the wretched, for those suffering at the base of the social pyramid, to come to know the past that is really relevant *to them*.

The artist, writer, and revolutionary anarchist's task is therefore to find a way to make the Angel's wings beat again. To grant it the hummingbird's momentum, to still the storm by making something unthinkable happen. This requires the walloping force of a memory's abrupt return, like the whiplash

of remembering something crucial at the last minute, an event or a revelation that will jolt the entire system off its foundations and allow the stage of history to reset with open parameters, a terrifying and also ecstatically joyful moment when everything is suddenly possible and the entire social order is thrown into the void of a new beginning. In other words, a revolution.

In Benjamin's messianic vision, the only way to save the future is by rescuing the past from the overlords of the present, by fighting against those forces around us that refuse to let the buried rise, to let the ghostly voices be heard. Despite his bespectacled aloof image, Benjamin's rage was immense, Blakean in spiritual intensity, and committed to active resistance: "no one may ever make peace with poverty when it falls like a gigantic shadow upon his countrymen and his house," he says in *One-Way Street*. "Then he must be alert to every humiliation done to him, and so discipline himself that his suffering becomes no longer the downhill road of grief but the rising path of revolt." Benjamin was no reformist. He was adamant that the bourgeoisie has to be completely abolished and that time is running out: "Before the spark reaches the dynamite the lighted fuse must be cut," he warned.

Benjamin's usefulness for the writing of "critiques" in the contemporary academy has muted, even eclipsed, the theo-political intensity of this revolutionary anarchism. He has become a kind of Che Guevara for a portion of the intelligentsia that feels it must talk the talk but cannot begin to imagine how to walk the walk. Some are embarrassed by his ardency, by his conviction that Art and Politics and History are One, and that getting them right is about saving the world by ending the one we know. Some grumble that his work is too cryptic. But the truth is that his writing is not hard to understand; it is hard to look at directly. His aphoristic fragments singe like solar flares: "The only way of knowing a person is to love that person without hope." Who can survive that test? Who today would dare to read Baudelaire's *Les Fleurs du mal* or Blanqui's prison writings on astronomy as serious reports on the state of damnation of the modern world? Who is prepared to say that social media, AI, and robotic automation are not just the products of neoliberalism, "the society of control," and lack of oversight—but visions of Hell? I'm not saying that Benjamin doesn't see any redemptive opportunities in culture and technology or that our own speculations on such are not worthwhile—he does

and they are. But it is undeniable that the intellectual culture of the present has come to relish that part of Benjamin's work without committing to, or taking seriously, his anarchist and messianic call for a revolutionary politics. To continue in Benjamin's terms, if the intellectual classes can stroll up to the precipice, look over, and decide it's not yet time to leap, then they will not be the ones to bring the light of redemption to the people.

It will be contested, but I think it's fair to say that black intellectuals, even those I respectfully disagree with, have been more willing than most to steer our way to the ledge, to hold our gaze over its edge. This makes sense since the people whose redemption we seek have the least to lose. We may be in disarray and disagreement about what to do about it, but at least Black studies takes as a premise that our society is in a terminal emergency. Yet, of all the cultural forces in the social fabric, black intellectuals also tend to have the shortest reach: we're hard to read, hard to like, hard to look at directly— sometimes hard to find at all. Black artists, however—and there is a case to be made that art is the realm of Benjamin's true legacy—are getting bolder and more far-reaching with every decade, more willing to force us to look.

Consider that extraordinary appearance in 2014 of *A Subtlety, or the Marvelous Sugar Baby*, that modern-day sphinx that Kara Walker raised inside the cavernous belly of the Domino Sugar Factory in Brooklyn. The art critic Roberta Smith singled out this installation as easily the most significant work of art produced in the last decade, a period which stood out to her as a new moment of "arrival" for black artists and black art. The road to this historic commission began back in the early 1990s when Kara Walker, then a student at the Rhode Island School of Design, began to rethink her relationship to race and representation in her artwork. Walker grew up in Stone Mountain, Georgia, and her father, a painter, taught at Georgia State University. Her first years as a young art student were spent at the Atlanta College of Art, where Walker initially conceived of becoming a painter like her father. Against the trends in the art world, she was interested in figural painting and devoted herself to studying the techniques of the Old Masters of European art.

But by the end of her MFA at Rhode Island School of Design, Walker made a radical swerve. In her first major show in 1994 she demonstrated an approach she would rework throughout the rest of the decade based on the

silhouette effect of cutouts using black and white paper. Jettisoning the frame of the individual painting, she became in effect a muralist, transforming the default white space of gallery walls from a neutral institutional background into a surface of psychic and phantasmagorical projection, like the cycloramas of the late nineteenth century. These works implicitly returned gallery viewers to the position of the leisured spectators of the age of minstrelsy, that antebellum brew of racial masquerade and humiliation, which formed the original grease that has lubricated America's culture industry, from Walt Disney to ABC's *Black-ish*, ever since.

The figures in Walker's cutouts are a Rabelaisian parade of stock characters from the American racial commedia: darkies, mammies, coons, pickaninnies, sambos, tar babies, jigaboos. Like the witty horror in Jordan Peele's 2017 film *Get Out*, or the trashy fantasies of Bubbles Brazil, the white heroine of Darius James's 1992 novel, *Negrophobia,* their force is due largely to the legibility that *we* the viewers supply to an otherwise surreal script before us. What's so disturbing in the vignettes is precisely that we *recognize* them—that the source of those racial scripts is not Walker's polarized abstractions, but our own heads. It is sufficiently baked into our miscegenated American DNA that younger viewers can recognize the characters even without having seen *Gone with the Wind*, read *Uncle Tom's Cabin*, or listened to *Amos 'n' Andy*.

In talks and interviews, Walker explains her turn to the cutouts as a way to deliberately deny herself some of the stylistic presence of her own hand, a rejection of the personal expressivity that she previously thought necessary to painting. But there is an underlying mannerism to her repertory. One never wonders if a cutout piece is by Kara Walker. The sexual and scatological scenarios, like the infernal landscapes of Hieronymus Bosch, are unmistakable at a glance. Walker figured out how to make the cutout congeal into chirography, a signature effect that seizes us, and to which we cannot be indifferent. The searing willfulness of this provocation was not greeted without controversy. She had to weather fierce attacks by black critics who accused her of reproducing the worst stereotypes ever used to demean black people. How dare Walker call herself "a Negress," as she often does in the titles or paratexts to her work, in the Age of Oprah?

In a powerful essay on Walker entitled "What Do We Want History

Kara Walker, *A Subtlety, or the Marvelous Sugar Baby*. Sugar, polystyrene, plastic, molasses, approx. 35.5 x 26 x 75.5 feet, New York City (2014). ARTWORK © KARA WALKER, COURTESY OF SIKKEMA JENKINS & CO., NEW YORK. PHOTOGRAPH COURTESY OF OSMAN CAN YEREBAKAN.

to Do to Us?" Zadie Smith focuses on this iconoclastic quality in Walker's work, holding it up as a beacon "for black freedom of expression itself." For Smith, Walker lays down a fierce example of what can be achieved when an artist refuses to reduce herself to what others demand, the role they believe you ought to play instead of the one you feel to be true. "I hope Walker is never ashamed to be the wrong kind of artist/woman/black person, or ever exhausted by our endless projections upon her." Smith is right to insist on the refusal of those twinned impulses so acutely characteristic of our public discourse: shame and outrage. "One gift an artist might give to other artists," Smith observes, "is a demonstration of how to make work without shame."

This is very true. Another gift, or perhaps the other side of this gift, is to help those of us experiencing art to learn the virtues of a more delicate reaction, one no less necessary or valuable: the capacity for embarrassment. I'm

surprised at how little this word comes up in relation to Walker's work. Can I be the only person who feels embarrassed in its presence? Regardless of the racial composition of a group, even in the event (however less likely) that one is solely in the presence of black visitors, encountering a piece by Kara Walker seems to me inherently embarrassing. There is no way to not be discomfited by its presence; any commentary on the work is immediately fraught; the evasion of such commentary with small talk is even more so. What we ought to do is laugh. As Glenda Carpio has noted, laughter and humor are essential to Walker's work, though just how much and exactly at what one is laughing are the rub.

Is the joke on us? On only some of us? Is the antebellum "Negress," who speaks so archly in the mischievous title cards to her works, a merry trickster? Tavia Nyong'o makes a persuasive case that there is a kind of artworld trolling at play in Walker's work that may not always evade the complicities she involves herself in through its commercialization. Her *Sugar Baby*, he points out, was erected in a portion of rapidly gentrifying Brooklyn and ended up effectively doing public relations work for the corporations and real estate companies behind that gentrification. Even if Walker were fully of aware that, and slyly giving them something they might not have found quite to taste, the ultimate outcome is still arguably a big check for her and a checklist item ticked off for the Vornado real-estate magnates seeking to woo the creative class into their glass condo towers.

I don't deny that there are important and possibly irresolvable questions about complicity between art and capital. But that does not necessarily negate or immediately annul the potential effects of the work upon those who saw it, or those who will at least know that it was possible to make such a work and raise it in that time and place. Walker has made it clear that she is interested in how people interact with her work. Fortunately, there is a record of the public's reaction to the installation. She had her team videotape the reactions of visitors as they walked through the ruins of the Domino Factory. Walker said that she was especially interested in the reaction of black visitors, those alone, those in couples, entire families that made the pilgrimage. What is responsible for the tremor, the shimmering strangeness and discomposure in the searching gazes they cast upon the Subtlety? All those bashful deflections,

those halting gestures of private response to a public exposure of intimate knowledge? Is art really, at bottom, a vehicle for communing around our embarrassments?

What, for instance, is the appropriate response to turning the corner at the rear of the factory and having the Sugar Baby's vulva come into view? I see a wink back to Walker's early art school days: a memory of Courbet's scandalous *L'Origine du monde*, a painting that gazes frontally into the sex of a white woman and names her "original." In addition to correcting Courbet from an anthropological point of view, Walker restores a historical and material sense to the "world." Her installation is very purposively made of the most profitable of the slave crops of the Americas, harvested on an industrial scale at exorbitant cost of African blood, and amassing great fortunes whose capital flowed through the commercial veins of the city at the mouth of the Hudson where the Domino Factory once churned out its highly lucrative and addictive product.

What is supremely profitable today is contemporary art. How profitable? In 2019, a work called *Rabbit* by the artist Jeff Koons sold at auction for $91 million, setting a new record for a living artist. Walker's work fetches hefty sums too. Yet aesthetically, and more importantly, ethically, I think they are radically and diametrically opposed. Still, they are worth pondering together, Walker's *Subtlety* and Koon's *Rabbit*. Because they stand before us like signs at a fork in the road, indicating the options ahead. Both are signatures of contemporary Americana. Neither could have been produced anywhere other than in the USA. Both express in remarkably accurate terms an ugliness unique to our culture. Walker's art tells us more than we want to hear about the ugliness of our past. Koons's silver bunny shows us the ugliness of our present, and—if we do nothing to alter its course—the ugly emptiness of our future. By polishing away any possible connection to the past, and glibly seeking succor in false innocence and false universality, Koons has produced perhaps the whitest art, ideologically not ethnically, ever created. Even the white bourgeoisie no longer find its shock value palatable. In a scathing review some years ago, Jed Perl called a Koons retrospective "a multimillion-dollar mausoleum in which everything that was ever lively and challenging about avant-gardism and Dada and Duchamp has gone to die." There is no

real laughter, no genuine embarrassment to be had in the presence of a Koons. Irritation, indifference, transient fascination, titillation? Maybe—but never embarrassment. How could you be embarrassed? Koons, not unlike Donald Trump, is a pure pure troll: one who sees that in a society obsessed with shaming the ultimate sign of freedom, superiority, and success is shamelessness *tout court*, and it sells itself. It is the triumph of pure appearance—the art and politics of a deathless, lifeless, narrative-free future.

Whether it is capital's concentration and colonization of our private lives, or some other force at work, there is mounting evidence that as a society we are increasingly and collectively fetishizing shame, while losing our responsive capacity as individuals for embarrassment. But the ability to acknowledge embarrassment is a precious resource and one deeply related to creativity, to the creative act, whether artistic or political. When cultivated in a poet like Keats, as Christopher Ricks famously argued, embarrassment can lay the foundation for that essential quality of "negative capability," moments of hesitation that extend the pursuit of thought beyond the accepted frame of our cetainties. We think of such qualities as important for poetic thinking but they can be no less necessary to political and social problems, and may be more so.

Whatever one thinks of the Sugar Baby, she is undeniably subtle in ways that Koons's Rabbit is not. She makes us uncomfortable and arouses emotions that his work cannot access or perhaps even remember once existed. The Sugar Baby signifies effortlessly, not in spite of her faults, but because of them, including her awkward entanglements in the art commodity market. She is full, even inflated with embarrassing memories that stir in us as we come into her space. There is pastness and something very present that radiates from her surreal presence. She is, at the very least, one way of envisioning the Angel of History.

The Angel is not only Benjamin's or Paul Klee's. We have to be on the lookout for her. We have to take notice and speak up when she passes by. She may come in all shapes, sizes, and forms. She often will not, and probably should not, seek to present herself in ways that will necessarily make us comfortable. But in the last instance, isn't it our mothers that make us feel the most important kind of embarrassment of all: the one that makes us want

to do better and be better? Not out of shame, but because we know in their sight that we really *are* better? If this is true, then letting ourselves dwell in embarrassment before our own history, to laugh productively at ourselves and with each other, is not a sign of hopelessness. It is a mark of vitality, a living current that only awaits our full acknowledgement and our willingness to be uncomfortable together a little longer than we usually allow. When I say that the Sugar Baby is the Angel of History, this doesn't require that the artwork itself be resistant or that the artist who made her be the agent of our progress and our salvation. The Angel or the Sugar Baby is no better than the rest of us, helplessly being pushed by the forces of progress and its accumulated disasters into the future. What makes her different is that she emerges as a towering work that looms for us to see, to look up from our daily routines and interrupt them if only for the space of a visit. If we can do that, we might begin to notice features in her worthy of our attention.

Like the way Walker's sphinx speaks to Langston Hughes's lines about those rivers, "ancient as the world and older than the flow of human blood in human veins." Or Zora Neale Hurston's line about how "de nigger woman is de mule uh de world." And what Saidiya Hartman tells us about mothers: "the slave ship is a womb/abyss. The plantation is the belly of the world." This is the world that the Sugar Baby looks back upon. The world made by the black woman. The one that tells the truth of our past, even when we'd rather not hear it like that. She is also the one who makes possible the work still to be done. "Without my mother's legacy," Jesmyn Ward writes in her searing memoir *Men We Reaped*, "I would never have been able to look at this history of loss, this future where I will surely lose more, and write the narrative that remembers."

What riddles does the sphinx tell? Does her behind, which might embarrass us upon first discovering it, upon further reflection, inform us that, it too, deserves greater respect than we have generally accorded it? Or is what matters most of all the direction she's looking in: backward, into the past that made her what she is?

—2020

The Low End Theory

I N 2013, a manifesto entitled *The Undercommons: Fugitive Planning & Black Study* began making the rounds among the growing pool of nervous graduate students, harried adjuncts, untenured professors, and postdocs whirling through the nation's faculty lounges. *The Undercommons* was published by the small anarchist press Autonomedia and made freely available for download; in practice, however, it circulated by word of mouth, copies of the PDF forwarded like samizdat literature for those in the know. On the surface, the text is an analysis of alienated academic labor at the contemporary American university. But it's also more radical than that: It is a manual for free thinking, a defiant call to dissent within educational institutions that betray their credos, filling their coffers even as they prepare students, armed with liberal arts degrees and "critical thinking" skills, to helm a social and economic order in which "to work . . . is to be asked, more and more, to do without thinking, to feel without emotion, to move without friction, to adapt without question, to translate without pause, to desire without purpose, to connect without interruption."

For those with little or no knowledge of Black studies, the text's deployment of terms like "fugitivity" and "undercommons" may seem baffling. To those in the circle, however, this lexicon of Continental philosophy, remixed with a poetic and prophetic fire resembling Amiri Baraka's, bears the signature of one of the most brilliant practitioners of Black studies working today: the scholar and poet Fred Moten.

Black studies, or African American studies, emerged out of the revolutionary fervor of the late 1960s, as students and faculty members demanded that universities recognize the need for departments engaged in scholarship on race, slavery, and the diasporic history and culture of peoples of African descent. Since its institutionalization, these departments have grown many branches of inquiry that maintain a rich interdisciplinary dialogue. One is a school of thought known as Jazz studies, which investigates the intersections of music, literary and aesthetic theory, and politics. Moten is arguably its leading theoretician, translating Jazz studies into a vocabulary of insurgent thought that seeks to preserve Black studies as a space for radical politics and dissent. In his work he has consistently argued that any theory of politics, ethics, or aesthetics must begin by reckoning with the creative expressions of the oppressed. Having absorbed the wave of "high theory"—of deconstruction and poststructuralism—he, more than anyone else, has refashioned it as a tool for thinking "from below."

Moten is best known for his book *In the Break: The Aesthetics of the Black Radical Tradition.* "The history of blackness is testament to the fact that objects can and do resist," is the book's arresting opening sentence, announcing his major aim: to rethink the way bodies are shaped by aesthetic experience. In particular, he explores how the improvisation that recurs in black art—whether in the music of Duke Ellington and Billie Holiday, the poetry of Amiri Baraka and Nathaniel Mackey, or the conceptual art of Adrian Piper—confounds the distinctions between objects and subjects, individual bodies and collectively experienced expressions of resistance, desire, or agony. Since 2000, Moten has also published eight chapbooks of poetry, and one, *The Feel Trio,* was a finalist for the National Book Award in 2014. He is that rare literary figure who commands wide and deep respect in and out of the academy, and who blurs the line between poetics as a scholarly pursuit, and poetry as an act of rebellious creation, an inherently subversive activity.

This past fall, Moten took up a new position in the Department of Performance Studies at New York University's Tisch School of the Arts, arriving from Los Angeles and a teaching appointment at the University of California at Riverside. In early September, his office was still a bare room with a single high window looking out over Broadway. He hadn't had a chance to unpack

his library, but already a small stack of books on jazz theory, performance, and quantum mechanics rested in a pile near his desk. It soon became clear, however, that he is the kind of thinker who keeps all his favorite books in his head anyway. His Paul Laurence Dunbar is always at his fingertips, and he weaves passages from Karl Marx, Immanuel Kant, and Hortense Spillers into his conversation with equal facility.

In someone else this learnedness could come off as intimidating, but in Moten it's just the opposite. Something about his composure, his relaxed attentiveness, the way he shakes his head with knowing laughter as he pauses over the direction he's about to take with a question, instantly erases any stuffiness: One can imagine the exact same conversation taking place on the sidelines of a cookout. And then there's his voice: warm, low, and propelled by a mellow cadence that breaks complex clauses into neat segments, their hushed, conspiratorial air approaching aphorism. At one point, Moten asked about my dissertation, which I confessed, sheepishly, was kind of a mess. His eyes lit up. He leaned back with a wide grin, his hands spreading out in front of him. "You know what a *mess* is?" he said. "In Arkansas, a mess is a unit of measure. Like of vegetables. Where my people come from folks might say: 'You want a bushel?' And you'll say, 'Nah, I want a mess.' You know, like that great James Brown line: 'Nobody can tell me how to use my mess.' It's a good thing to have. A mess is enough for a meal."

When he's speaking before an audience, no matter the size, he never raises his voice; a hush comes over the room and remains in ambient tension, like a low flame. On the occasion of John Ashbery's ninetieth birthday last July (just months before his passing), Moten collaborated in a celebratory recording of Ashbery's long poem *Flow Chart*. Ashbery was always a great reader of his own work, but it was thrilling to hear the sly affection with which Moten took the verse uptown, bending its notes with his Lenox Lounge delivery. The same qualities come out when he reads from his own poetry, always brimful of quotations from the songbook of black America. His poem "I got something that makes me want to shout," for example, consists of riffs that build off quotations from a celebrated funk record, each quote set off just enough and in just such a way—"I got something that tells me what it's all about"— that when he lands on the last line of the poem—"I got soul, and I'm super

bad"—he's fully sublimated a James Brown groove. The line between poetry and song quivers, the "high" lyric gets down with the low, and the Godfather of Soul's declamation of Soul Power boomerangs back to us as poetry, which is what it always was.

To UNDERSTAND HOW all the pieces that "make" Fred Moten come together, one has to step back and see where he's coming from. The autobiographical reference is a constant presence in his poetry, in which the names of beloved friends, colleagues, musicians, kinfolk, neighbors, literary figures all intermingle and rub up against each other like revelers at a cosmic rent party. "I grew up in a bass community in las vegas," opens one poem from *The Feel Trio*: "everything was on the bottom and everything was / everything and everybody's. we played silos. Our propulsion / was flowers."

Moten was born in Las Vegas in 1962. His parents were part of the Great Migration of blacks out of the Deep South who moved north and westward to big cities like St. Louis and Los Angeles. By the 1940s and 1950s they were also being drawn to Las Vegas and the opportunities offered by the booming casinos and military bases established during World War II. "A lot of people don't realize it, but Vegas was one of the last great union towns," Moten says. Jobs within the gaming industry were protected by the Culinary Union, and with a union check, even casino porters and maids could save up to buy a house—"at least on the West Side," the city's largely segregated black community where he was raised.

Moten's father, originally from Louisiana, found work at the Las Vegas Convention Center and then eventually for Pan American, a large subcontractor for the Nevada Test Site where the military was still trying out its new atomic weapons. His mother worked as a schoolteacher. (She appears often in his poetry as B. Jenkins, also the title of one of his finest collections.) Her path to that job was a steep climb. Her family members were from Kingsland, Arkansas, and had committed themselves against all odds to obtaining education. Her own mother had managed to finish high school, says Moten, who remembers his grandmother as a woman with thwarted ambitions and a great love of literature. She'd wake him up in the mornings by reciting poems by

Dunbar and Keats she'd learned in high school. "And she was the one who was really determined for my mother to go to college," he says. "She cleaned people's houses until the day she retired, and in the summer and spring she would pick cotton." Kingsland is the birthplace of Johnny Cash, and Moten's family picked cotton on the property of Cash's cousin Dave, a big landowner, to get the money together to send his mother to college.

Jenkins attended the segregated University of Arkansas at Fayetteville, which housed her in the dormitory basement; she eventually transferred to, and graduated from, the Arkansas Agricultural Mechanical and Normal College, at Pine Bluff. She was keen on doing more than just learning; she wanted to pursue knowledge for its own sake, and for how it might serve to explain the world around her. "My mother totally believed in the value of education," Moten says, "but she was scholarly in a certain way. She was invested in learning in a way that was disconnected from the material bene-fits it was supposed to get her, and I must have picked up on that." She was especially interested in sociology, and he grew up hearing her talk about figures like Horace Mann Bond, Hortense Powdermaker, Gunnar Myrdal, and John Dollard, towering figures of the liberal school of American social science who were engaged in solving what was then commonly referred to as "The Negro Problem."

Degree in hand, she went to Chicago to teach in the public schools, but "someone basically told her she was too dark to get a teaching job in Chicago." She hoped to have better luck in Vegas, but the schools were segregated there, too, and no one would hire her. "They used to call Nevada the Mississippi of the West," Moten recalls. Jenkins took up domestic work, and it was only by chance that she found herself cleaning the house of a woman who was on the local school board, who helped her get a job at Madison Elementary School on the West Side, where she met Moten's father.

The West Side was a tightly knit community. Moten likens it to the village in the Toni Morrison essay "City Limits, Village Values," where Morrison contrasts white fiction writers' "Gopher prairie despair" with the affection black writers typically express for the intimate, communal life built around "village values"—even if that black village, like Harlem, say, is part of a

larger city. "It seemed like everybody was from one of these tiny little towns in Arkansas. My mom's best friends—their grandparents were friends." Nevada was a small enough state, he says, that the West Side could swing tight elections, and much of Las Vegas politics in the early 1960s was concerned with national politicians' positions on civil rights legislation. "So a few precincts in Las Vegas might make the difference between the election of a senator, Paul Laxalt, who probably wouldn't vote for the Civil Rights Act, or the election of a Howard Cannon, who would, and my mom was deeply involved in all that." Through her, politics and music became intertwined in everyday life.

Though the flashpoint of national politics at the time was school desegregation, locally it was also about desegregating the Vegas Strip. "You know, you see all that Rat Pack shit in the movies," Moten says, "but the truth of it was that Sammy Davis Jr., Duke Ellington, Count Basie—they could perform on the strip, but they damn sure couldn't stay there. So when they came to town they would come to the West Side and stay in rooming houses, and there was this amazing nightlife on Jackson Street where you could hear everybody." Everyone, from headliners to pit-band musicians, came to stay on the West Side. Moten's mother knew a number of musicians, dancers, and singers; when jazz singer Sarah Vaughan came to town they would gather at a friend's house to cook greens, listen to music, and gossip. "For me that was like school," he says. His childhood summers, meanwhile, seemed to revolve around listening to Vin Scully and Jerry Doggett doing the Dodgers broadcast: "My family were all rabid Jackie Robinson–era Dodgers fans."

Moten also has strong memories of listening to KVOV, "The Kool Voice of Vegas." "It was one of those sundown stations, you know, that shuts down for the night, and they had a disc jockey named Gino B. Soon as the sun started getting low, he would put on a bass line and start rapping to himself . . . *bim bam, slapped-y sam, and remember everybody life is love and love is life* . . . that kind of thing, and everybody in town would tune in just to hear what he was going to say, and I loved that." He also vividly recalls encountering certain LPs in the 1970s, like Bob Marley's *Rastaman Vibration* and Stevie Wonder's *Innervisions*—"those double-gated record albums that had

the lyrics printed on the inside, so you could sit and read while the music played overhead." Aside from his grandmother's love of it, he says, his first experience of poetry was music.

FOR A KID FROM a midsize Western city, the shock of going east to college at Harvard might have been overwhelming. Moten felt he was ready for the challenge. He was lucky to have folks looking out for him, he insists—like David L. Evans, an admissions officer who was "like a hero to us": "Any black student from the late '60s onward, you can believe he had to fight like Mayweather, Ali, Frazier, and Joe Louis to get us in." Moten's first surprise at Harvard was encountering a certain kind of black elite. "My growing up was a lot more like *Good Times* than it was like the Huxtables, and now I was in a school with a lot of Huxtables." The even bigger shock was campus politics. "When I went to Harvard in 1980 I thought I was being trained for the Revolution. The Black Panther party in Vegas—they met in my mom's basement. So I was ready to go, and I had foolishly assumed everyone there would be thinking like me."

Moten originally planned to concentrate in economics, taking Social Analysis 10 and a class on development economics that he vaguely imagined might lead to agricultural development work in Africa. Freshman football helped him through his first semester by providing a loose structure without too strenuous a commitment—but by the second, things were getting messy. He was very influenced by Professor Martin L. Kilson, a scholar of black politics whom Moten describes as "a great man and a close mentor," and to whom *The Undercommons* is dedicated. He was also increasingly involved in the activities of politically minded friends—tutoring prisoners and working with civil rights activists in Roxbury. After a while he got too busy to go to class. He was also awakening to a world of ideas and intellectual debate. "We were staying up all night, we were reading everything, just none of it was for class." The group discovered Noam Chomsky, and got deeply involved in exchanges between E. O. Wilson and Stephen Jay Gould about sociobiology and scientific racism—"and we felt like we were in the debate, like we were part of it, you know, we were very earnest and strident in that way. But

eventually it caught up to me that I had flunked three classes and I had to go home for a year."

This turned out to be a transformative experience that can only be described as Pynchonesque. When he got home, he ended up taking a job as a janitor at the Nevada Test Site, busing in through the desert each day. "The Test Site was the last resort for a lot of people. If you really messed up, you might still be able to get work there," he says now. He befriended an alcoholic man from Brooklyn who'd somehow drifted west, and as they drove around he would regale Moten with wild stories about growing up in Red Hook and admonitions about falling off the wagon. "I'll never forget, he always called me 'Cap': 'I wanna succeed again, Cap!'"

"It was eight hours of job but two hours of work," Moten recounts, "so mostly what I did was read." He got into T. S. Eliot by way of seeing *Apocalypse Now* and reading Conrad. "'The Hollow Men' and 'The Wasteland,' those were very important poems for me. There was this scholarly apparatus to them, a critical and philosophical sensibility that Eliot had, that you could trace in the composition through the notes." He'd pore over a newly released facsimile edition to "The Wasteland" that included Eliot's drafts. "By the time I came back, I was an English major."

In Cambridge, it was an exciting and tumultuous time to be jumping into literary studies. He took an expository writing class with Deborah Carlin, who introduced him to Alice Walker and Zora Neale Hurston and encouraged him to write; he took Helen Vendler's Modern American Poetry class, where he first encountered Wallace Stevens, Frank O'Hara, and Allen Ginsberg, "And I realized that I could read it, I could get it." Reflecting, he adds, "I was glad that I had taken the class with Vendler and the class meant a lot to me, but I also already knew my taste differed from hers."

At the same time, Moten was cultivating a relationship to campus literary life, joining the *Harvard Advocate*, where he met its poetry editor, Stefano Harney—forming a close and enduring friendship that has also evolved into an ongoing intellectual collaboration (Harney is coauthor of *The Undercommons*). Together, they took a class taught by David Perkins on the modernist long poem, reading William Carlos Williams's *Paterson*, Robert Duncan's

"Passages," and Ed Dorn's *The Gunslinger*. "I was into that stuff, and Steve was, too, so we could cultivate our resistance to Vendler together." Parties were off campus at William Corbett's house in Boston's South End, where fellow poets like Michael Palmer, Robert Creeley, or Seamus Heaney might stop in for dinner or drinks. Moten absorbed the possibilities of the scene but his poetic sensibility is that of the instinctive outsider, attracted to all those who dwell at the fringes and intend to remain there.

A decisive turning point came when literary critic Barbara Johnson arrived from Yale to teach a course called Deconstruction, and he first read Jacques Derrida, Paul de Man, and Ferdinand Saussure. At the time, in a class on James Joyce, he was also reading *Ulysses*. "It had a rhythm I was totally familiar with, but that I didn't associate with high art. I believed, I just sensed that it was radical; it felt instinctively to me like this was against the status quo, that the reason they wrote this way was that it was like a secret, it wasn't for the bosses." He felt the same way about Derrida: "This is for the people who want to tear shit up. And we were ready for it."

MOTEN WENT ON TO pursue graduate studies in English at Berkeley. Even his earliest journal publications are intensely idiosyncratic. It's as if he were convinced he had to invent his own tools in order to take up the subjects that interested him—design his own philosophy, his own theory. "I'm not a philosopher," he says. "I feel like I'm a critic, in the sense that Marx intends in *Private Property and Communism* when he gives these sketchy outlines of what communism might look like: 'We wake up in the morning, and we go out in the garden, till the ground, and in the afternoon we engage in criticism.'"

In his criticism, Moten is especially attuned to a zone that Brent Edwards (a close friend and interlocuter) has called the "fringe of contact between music and language." He'll draw the reader's attention to the "surplus lyricism of the muted, mutating horns of Tricky Sam Nanton or Cootie Williams" in Duke Ellington's band, for example. Or, commenting on *Invisible Man*'s observation that few really listen to Louis Armstrong's jazz, he'll cut to an abrupt and unsettling assertion: "Ellison knows that you can't really

listen to this music. He knows . . . that really listening, when it goes bone-
deep into the sudden ark of bones, is something other than itself. It doesn't
alternate with but *is* seeing; it's the sense that it excludes; it's the ensemble of
the senses. Few really read this novel."

In one of *In the Break's* most transfixing passages, Moten reassembles a new
set of meanings, or understandings, of the photograph of Emmett Till's open
casket. Why should that image, out of all others, have so much power—some
even arguing, as he points out, that it triggered the mobilization of the civil
rights movement? Why has it remained so charged and fraught, so haunting?
"What effect," Moten asks, "did the photograph of his body have on death?"
His answer: captured within the image is the sexual panic occasioned by the
sound of Till's whistling, "'the crippled speech' of Till's 'Bye, baby,'" for-
ever bound up in the moaning and mourning of a mother over her dead child.
Looking at the photograph, Moten writes, "cannot be sustained as unalloyed
looking but must be accompanied by listening and this, even though what is
listened to—echo of a whistle or a phrase, moaning, mourning, desperate tes-
timony and flight—is also unbearable." Millions have viewed the photographs
of Till's open casket. His images have been infamously and controversially
reproduced, looked away from, gawked at. Moten does with extraordinary
care what most have never done for Till (or for so many other sons and moth-
ers), out of ignorance, or fear, or shame—which is, of course, to listen.

Moten is impatient with detractors who accuse him of difficulty and lack
of clarity. Many writers once thought to be impenetrable are now consid-
ered canonical, he points out. "The critics I loved and who were influen-
tial to me were all weird: Empson, Burke, Benjamin, Adorno—they all had
a sound, and it wasn't like a PMLA, academic-journal sound." The other
critics who influenced him, he continues, were poets: Charles Olson, Amiri
Baraka, Nathaniel Mackey, and especially Susan Howe—who, he says, has a
different understanding of how the sentence works. "Miles [Davis] said: 'You
gotta have a sound.' I knew I wanted to sound like something. That was more
important to me than anything." One could argue that Moten's sound reso-
nates with the "golden era" of hip-hop of the late eighties and early nineties,
when it was still audibly a wild collage of jazz, R&B, late disco, and funk:

"Styles upon styles upon styles is what I have," the late Phife Dawg raps on A Tribe Called Quest's celebrated 1991 album *The Low End Theory*.

One difficulty for outside readers encountering Moten's work is that he tends to engage more with the avant-garde than with pop. It's easy to see why the art world has embraced him: his taste gravitates toward the free-jazz end of the spectrum so strongly it's as if he were on a mission, striving to experience all of creation at once—to play (as the title of a favorite Cecil Taylor album puts it) *All the Notes*. This spring, Moten is teaching a graduate course based on the works of choreographer Ralph Lemon and artist Glenn Ligon. In recent years he has collaborated with the artist Wu Tsang on installation and video art pieces, where they do things like practice the (slightly nostalgic) art of leaving voicemail messages for each other every day for two weeks without ever connecting, just riffing off snippets from each other's notes. In another video short directed by Tsang, Moten—wearing a caftan and looking Sun Ra-ish—is filmed in "drag-frame" slow motion dancing to an a cappella rendition of the jazz standard "Girl Talk."

By way of explanation, Moten recalls his old neighborhood. "I grew up around people who were weird. No one's blackness was compromised by their weirdness, and by the same token," he adds, "nobody's weirdness was compromised by their blackness." The current buzz (and sometimes backlash) over the cultural ascendancy of so-called black nerds, or "blerds," allegedly incarnated by celebrities like Donald Glover, Neil deGrasse Tyson, or Issa Rae, leaves him somewhat annoyed. "In my mind I have this image of Sonny Boy Williamson wearing one of those harlequin suits he liked to wear. These dudes were strange, and I always felt that's just *essential* to black culture. George Clinton is weird. Anybody that we care about, that we still pay attention to, they were weird."

Weirdness for Moten can refer to cultural practices, but it also describes the willful idiosyncrasy of his own work, which draws freely from tributaries of all kinds. In *Black and Blur*, the first book of his new three-volume collection, *consent not to be a single being*, one finds essays on the Congolese painter Tshibumba Kanda-Matulu and C. L. R. James, François Girard's *Thirty Two Short Films About Glenn Gould*, a comparison between Trinidadian calypso

and Charles Mingus records composed in response to the Little Rock Nine, David Hammon's art installation *Concerto in Black and Blue*, Wittgenstein, the science fiction of Samuel Delany, a deconstruction of Theodor Adorno's writings on music, and a reconstruction of Saidiya Hartman's arguments on violence. Sometimes the collision can happen within a single sentence: "Emily Dickinson and Harriet Jacobs, in their upper rooms, are beautiful," he writes. "They renovate sequestration."

Taken together, Moten's writings feel like a Charlie Parker solo, or a Basquiat painting, in their gleeful yet deadly serious attempt to capture the profusion of ideas in flight. For him this fugitive quality is the point. We are not supposed to be satisfied with clear understanding, but instead motivated to continue improvising and imagining a utopian destination where a black cosmopolitanism—one created from below, rather than imposed from above—brings folks together.

For Moten, this flight of ideas begins in the flight of bodies: in the experience of slavery and the Middle Passage, which plays a crucial role in his thinking. "Who is more cosmopolitan than Equiano?" he asks rhetorically, citing the Igbo sailor and merchant who purchased his own freedom, joined the abolitionist movement in England, and published his famous autobiography in 1789. "People think cosmopolitanism is about having a business-class seat. The hold of the ship, among other things, produces a kind of cosmopolitanism, and it's not just about contact with Europeans and transatlantic travel. When you put Fulani and Igbo together and they have to learn how to speak to each other, that's also a language lab. The historical production of blackness *is* cosmopolitanism."

What can one learn from the expression of people who refuse to be commodities, but also once *were* commodities? What does history look like, or the present, or the future, from the point of view of those who refuse the norms produced by systems of violence, who *consent not to be a single being*? These key concerns course through the entirety of Moten's dazzling new trilogy, which assembles all his theoretical writings since *In the Break*. At a time of surging reactionary politics, ill feeling, and bad community, few thinkers seem so unburdened and unbeholden, so confident in their reading of the historical moment. Indeed, when faced with the inevitable question of the

state of US politics, Moten remains unfazed. "The thing I can't stand is the Trump exceptionalism. Remember when Goldwater was embarrassing. And Reagan. And Bush. Trump is nothing new. This is what empire on the decline looks like. When each emperor is worse than the last."

A THESIS THAT HAS often been attractive to black intellectuals (held dear, for example, by both W. E. B. Du Bois and Ralph Ellison) was that the United States without black people is too terrifying to contemplate; that all the evidence, on balance, suggests that blackness has actually been the single most humanizing—one could even say, slyly, the only "civilizing"—force in America. Moten takes strong exception. "The work of black culture was never to civilize America—it's about the ongoing production of the alternative. At this point it's about the preservation of the earth. To the extent that black culture has a historic mission, and I believe that it does—its mission is to uncivilize, to de-civilize, this country. Yes, this brutal structure was built on our backs; but if that was the case, it was so that when we stood up it would crumble."

Despite these freighted words, Moten isn't the brooding type. He's pleased to be back in New York City, where he'll be able to walk, instead of drive, his kids to school. He's hopeful about new opportunities for travel, and excited to engage with local artists and poets. His wife, cultural studies scholar Laura Harris, is working on a study of the Brazilian artist Hélio Oiticica, who is currently being "rediscovered" by American artists and critics. "I circulate babylon and translate for the new times," opens another poem in *The Feel Trio*, referring to a timely, or maybe timeless, place where "secret runway ads brush and cruise each other and / the project runaway."

Moten is not in the business of promoting optimism for the future, but he does not feel imprisoned by the past or bogged down in the present. Instead he is busy prodding about the little edges of everyday life as it is expressed by everyday people, the folkways of the undercommons. As his writings circulate within and beyond the classroom, so too does his version of theorizing from below, always seeking out sites where a greater humanity might unexpectedly break through.

—2017

Black Dada Nihilismus

Breathing real paint
Burning down a real world
—TONGO EISEN-MARTIN, "SO HE SINGS ALONG"

IT's 2018 AND two famous New Yorkers from the 1980s are on my mind: Donald Trump, who resides in the White House, and Jean-Michel Basquiat, whose paintings I'm going to see at the Louis Vuitton Foundation, a new art museum on the outskirts of Paris. Built to house the French billionaire Bernard Arnault's art collection, it's a Frank Gehry bauble that sort of resembles a modular, glassy armadillo, with curving panels mounted in a defensive crouch, as if shielding, or perhaps hoarding, its modern treasures.

I've seen Basquiat's work before, but the collective wisdom says that we are living in a new "moment," and I sense that his work has something specific to say about it. Something is afoot, disturbing the peace, the normative life-world or *nomos* that was supposed to have established a sense of order for the new millennium has unraveled into a chaotic Crossfire Hurricane only two decades in. Who could have imagined back in the days when Trump was ascending the skyscraper elevator to the top of the *American Psycho* viewing deck and Basquiat was rocketing through the Fab 5 Freddy portal between uptown and downtown art scenes—that *both* would end up beating the masters of the universe at their own game? Just last year, a quick search while

idling on the subway platform informs me, *Untitled*, a painting by Basquiat from 1982, sold at Sotheby's for $110 million. A single painting market-valued at the price point of a mega yacht, enough cold cash to buy several private jets or handsomely endow an art school or two—maybe rescue the Cooper Union, its founding charter betrayed by unscrupulous speculators caught up by the subprime scandal of 2008.

It's 2018. I might be in Paris—but a glance into the smartphone says: *This Is America*. The Times Square of the touch screen, its surface tension crazed by the battle between the old Walter Lippman stereotype and the manufacture of consent, the snake oil goop merchants, the berserkers and disinformation rabbit holes, the whole lot of them stewed together in that good ole Jes Grew gumbo. The violence, the spectacle, the long con, the confidence man and his masquerade. "This Is America" is, in fact, tellingly, a viral video loosed into the Videodrome by the occasional rap star Childish Gambino that choreo-graphs minstrel pastiche, the gunning down (active shooter–style) of a gospel choir, and conducts cakewalks in the riot zone, a work that inscribes itself in the same under-recognized expressive genealogy that Basquiat moved in: call it Black Dada.

"This Is America" has been consumed with a bizarrely earnest rapture, as though it were an encrypted message to or from the Illuminati. Doreen St. Félix points out that it is being "analyzed on Twitter as if it were the Rosetta Stone." Why this strange and palpably desperate need to extract allegorical meaning from a work produced by an artist who acquired his name by toying with an online Wu-Tang Clan name generator? Is it because Black Dada art circulates without a name—without a lineage, *sans souci*, as fodder for the masses unworthy of comment but also paradoxically mistaken for a message when it only wishes to be the messenger—carrier of the hoodoo Jes Grew free radical virus, ready to bond with any passing stray ideology or alternatively to corrode and cripple it?

Should we not name and identify this strand, this *black dada nihilismus bacillus*? Is it not possible, I wonder, as the Metro speeds underground along the Great Axis that takes aim from the square where they cut off King Louis's head and points to the socialist Mitterrand's business district at La Défense, to compile some record, some case studies, some critical exemplars of the type?

What it is: Black Dada is a response to the trauma of the American *nomos*, just as Europe's Dada was a response to the Great War. As Paul Fussell observed, the profound and disturbing irony about World War I was its participants' belief in their own innocence, an innocence and coherence shattered and shell-shocked by experience. Likewise, Black Dada is a response to white innocence and the commanding and recurring belief in its fallen state, even as that aspirational mythology presides over an unrelenting campaign to reinforce a common-sense view of black deficiency and inferiority.

What it do: makes for a cheerfully deflating anti-art, the readymade of the blues, the surrealist absurdity of the daily encounter with the irrational phantasmagoria of racial "profiling," which sounds rather artistic and sketchbook-like but really means something more like "sorting" a deeply unnerving experience of watching yourself fall through one of two very different trapdoors in someone else's mind before you've even had a chance to utter a word. Wait! You want to say: Maybe I'm walking down this wooded path on my way to see an art exhibit? Maybe I'm just a random male listening to music on his headphones? Going for a walk? What do you know? It would be nice and less tiresome if one didn't fear not just not being loved—but being despised and feared—for no reason!

That knotted feeling is at the heart of the purest Black Dada product of them all: George Herriman's Krazy Kat. A story without a story—it's a comic strip about a situation, or as Fanon would put it, "the lived experience of blackness." Krazy is a cool Kat who is mostly minding his business. He's also very fond of a little mouse by the name of Ignatz who shows no affection in return. Not only does Ignatz fail to show him love, Ignatz likes to play a game of throwing bricks at Krazy's head. Every time Krazy gets whacked between the ears with a fresh brick he thinks Ignatz only loves him more. George Herriman was a New Orleans Creole, and the comedy has a laconic Southern charm to its arrangement. It, too, is America, not in the sense that it is literally about the relationship between black folks and white folks (though it very much is that too, if you like); it's rather more of a piece with Childish Gambino's video—it's not *about* anything. Only shows a certain way of looking at things that doesn't care too much about putting it all together, and it's that very quality that we receive like the aura of an absent truth. Gambino's

lyrics don't add up to much: That's the point. "Don't catch you slippin' now" could be a line run by Ignatz, a cryptic warning that bricks can come your way. On any given day you might be the cat or the mouse. At the Cabaret Krazy Kat, that's just how it goes down.

The way things go down is always the same, but different. Amiri Baraka famously invoked the notion of "the changing same" to explain the Russian-doll quality within the evolution of African American musical expression. How each era, each branch or genre seems to include and repeat and fold into itself all the features of the styles and modes that came before it. You can still hear ring shouts and hollers, soul claps, marching band drumlines, gospel harmonies, blues talk and blue notes, ragtime and stride, jazz swing and funk, disco, R&B, and maybe all that on a single sample looped in and recorded with the latest Moog and the latest vocal styles lined up on top of it. This is the same old, same old. In a good way. It has a counterpart that tracks it in time, and that's the racial politics and money thing. It, too, is always serving up the same old, same old. In a bad way. Black Dada is sensitive to the friction of these traveling sine waves across US history, their alignment and misalignment.

For Baraka, the violence from without and the violence from within do not cancel out. Especially in the early work, the Leroi Jones collections, the pre–Malcolm X assassination and move uptown to Harlem period, the downtown Greenwich Village phase of *Preface to a Twenty Volume Suicide Note* and *The Dead Lecturer*, the poems are drenched in fear. What is *The System of Dante's Hell*, his experimental novel published in the year of pivotal crisis, but a series of night sweats? That fear, and its correlated fantasies of melodramatic or cartoonish violence, I've always had a hard time taking seriously. The poem "BLACK DADA NIHILISMUS" and its call for a black chant to rise up and murder misses its own mark more than half the time, it seems to me. Its most strident claims are too showy when they mean to be oracular, and too sincere when they want most to be ironic. The aromatic verbal violence, and I do think it is more puff and bluff than substantive invocation, is the part of Baraka that has always disappointed me. The astonishing thing, in this sense, is that he rarely makes anything that is entirely worthless. Even within poems packed with dross, he'll find his way to something, to a moment you won't forget. For me it's the dedicatory flags that come out toward the very end of the poem.

For tambo, willie best, dubois, patrice, mantan, the
bronze buckaroos.

For Jack Johnson, asbestos, tonto, buckwheat,
billie holiday.

For tom russ, l'ouverture, vesey, beau jack

Baraka's muses of black chant and black revolution cut across class and rank: High and low, the Cecil Taylors and the Kanyes, the Alis and the Mike Tysons, the Missy Elliotts and the Tyler Perrys, one's kinfolk (tom russ is his grand-father) and one's ancestors, the heroes and the villains, the good, the bad, and the ugly all have their place in Black Dada's grace. This serious playfulness is a matrix of sender and receiver that looks, even in its arrangement on the page, like a Basquiat, tags on the wall of expressive freedom to say everything and nothing all at once.

Jean-Michel's early graffiti tag was SAMO. He said once that he wanted it to work like a logo, "like PEPSI." Same Old Shit. These signs of "the changing same" started popping up on the city streets right around the time Kool Herc started DJing parties on Sedgwick Avenue in the Bronx. It's not illuminating to say that Basquiat is to painting what hip-hop is to popular music, everyone knows that. But I wanted to look at the work while listening to the music across the arc of its history. I put together a playlist specially for the occasion with artists that represented different phases or eras: Grand-master Flash, Public Enemy, Lil Wayne, Young Thug. Incidentally, could it be a coincidence that Weezy, whose undeniably Black Dada excursions ("6 Foot 7 Foot") form a bridge across two different eras and sensibilities, has a song called "Da Da Da" and a song called "Krazy"? The lineage of Baraka's nihilismus colors the Gothic spleen of Wayne's anti-anthem "God Bless Amerika":

My country 'tis of thee,
Sweet land of kill 'em all and let 'em die

For any museum art show, I find it usually takes me a while to get adjusted to what I'm seeing. You have to let the lenses adjust and let yourself pick up the rhythm the artist is playing in. With Basquiat, the enormous number of works in any given room, their size, and the Public Enemy level of deliberate noise right on the surface of the canvas is a rush that takes me several rooms to get settled into. The soundtrack I've assembled predisposes me to notice certain things, so perhaps it's not surprising that the first work that stops me dead in my tracks and forces me to whip out my notebook is *Man with Microphone* (1982).

The hand that holds the mic (like a grudge) also seems to blend into it, so that it appears more like a prosthetic extension of the body than an object in its own right. Spikes on the mic have it looking like a medieval mace—a weapon of enunciation. The emcee is surrounded on all sides by static. It's a microwave background radiation that seems to be a product of his own making, but it also fogs his face, as if the more he says, the harder it is to see through to who he really is.

The radiation surrounds him, represented by broken angles and broken shards that seem to indicate soundwaves but also could be broken fragments shorn from the crown that he wears. The graffito and the representation line have blurred, become onomatopoeic, letters and signs indistinguishable from carriers of the vibrating verbal icon. There is, strictly speaking, no way to look at the painting. You hear it. Listen and you might even hear the sound of the globe turning through the last forty years of a changing same.

Wasn't this what Basquiat always wanted? To reduce the city to an alphabet soup where every block remains mobile like the jellied luxury brands that animate Young Thug's "blanguage"? To chop up the Hannah Montana innocence of daytime television USA and strain it through the slimy haze of a street high? The challenge if anything now is to look at a Basquiat and not hear the "sssskkkkrrrttt" and squawking surplus of "Harambe" retroactively emanating from it—as though the painting not only predicts that sound but seems to have been lying in wait for the sound to catch up to it—pinching the whole circuit of black life under the neoliberal decades into a loop that reveals a continuity of derangement and ongoing disruption. Images of successful black life, or the approximation of its impossible grammar radiating

within the American night(mare) of capitalism. Incarcerated Scarfaces. The howl of electricity in the mic (the plug) the *homo-negro-americanus* walking like he talks it, swagger of the verbal artefact allegorical of the dope boy, the fallen walking among the fallen, the old dirty bastards that America requires, manufactures, falls in love with, and discards. SAMO is the racial metabolism using up the juice of "a real one" before he's turned twenty-one. His whole world platinum and gold right up to the moment his lifeless body full of pills is dragged off the private jet. The absurd life and death of shooting black stars in the American night. This is the static that fills Basquiat's image. That microphone is what he has, what covers his nakedness, his exposure to a thousand arrows aimed his way that cannot all miss, in fact have already hit, which is why the sound he makes is so raw, so pure, so hard to turn away from.

It's like a jungle sometimes . . . He is the savage. He is beastmode, paradoxically subliterate and over-articulate, overspeaking and overlaying official thinking and bien-pensant consideration, hyperfleshed and hypersexed, his self-flagellation and his private inferno conducted in public, like a hacked account spewing up a volcanic, heroic, and unrepentant excess of verb, of notation, of expression, of style without effort, of study without academy, of access without permission, of authority without authorship, of tradition without history, of art without museum, of a past beyond recollection, for a future within no future, and without a plan to get there.

THE SHOW IS a blockbuster (a term borrowed from the art of redlining neighborhoods to engineer white flight and hold black residents captive to egregious rents, ironically returning in spectral form as a corporate video rental outlet, now defunct but once a familiar sight in the suburbs the practice was designed to produce). The gallery floor is insanely overcrowded. I'm sucked into overhearing a white middle-aged couple talking in French. He explains to her that the art market "valorizes" this kind of thing, that's the only reason it's in this (Louis Vuitton) museum. I know, she says, but I find it "frankly childish."

It's not worth it. People will start to look. Security will be called. (*Sign of a local nigga unravelin'*.) These just a couple of gallic cornballs and malcontents. Still. I could get in their face. I could tell them there is not a single

childish element anywhere in Basquiat and that if they knew anything about the USA, let alone life as a black man in the USA, they would recognize and respect the stoicism the paintings express in the face of the avaricious assault that a single day in the life of an ordinary American represents, let alone one trying to make it shuttling between the streets and the vipers' pit of the New York art world. I think of Du Bois in *Dusk of Dawn* howling from behind the glass wall at a world that smiles stupidly back at him and applauds and opens its LVMH deep pocketbooks to throw money in his face, coo and coax him like Kanye West, splash his creations on their tote bags, on T-shirts and socks, thirst-trapping for content, rebranding one degree over—Off-White™:

Folks don't even own themselves
Payin' mental rent to corporate presidents

Eroica. The hero and the racial mountain, raising it up and still rising. In the big canvases—and there are so many of them—ideal urban canyon walls freed for the Promethean artist to pluck the notes out of the air and affix them to the visual symphony, the widescreen confrontation between "Morning in America" and the Zulu Nation. The genius child nappy with forethoughts: "Herein lie buried many things . . ." Every painting pronounces it, for those equipped with the Black Walkman, listening to Charlie PRKR, the Black Talkman playing it back:

Amongst the fiends controlled by the screens
What does it all mean, all this shit I'm seein'?

The writer Pierre Ducrozet published a novel in 2015 called *Eroica*, a fictional biography of Jean-Michel as black Icarus of the eighties. In one scene he has him meditate on the use of painting as analogue to anatomy, peeling back organs, nudging a lung, picking around the bones, looking always for the source of the bile, that organ most difficult to dislodge of them all, the black bile of melancholy, its river of words, lines, trapezes of color oozing into the night like New York City sirens.

I'm trying not to lose my head . . . Painting, like writing, is essentially soli-

tary. The studio late into the night. An island in the blue gulf. Each time one has to begin again, one has to face the emptiness and fill it in. Thankfully there's so much at hand, an overcoat with a crumpled pack of cigarettes in the pocket, a wrapper from a bag of plantain chips, Indian Head pennies, items concealing further combustible, creolized resources. Truth in painting a matter of the thing shown and hidden as it crosses (out) the line of its appearance viz. the flow of *sangre*, trilingual like Brooklyn, the colors of San Juan and Port-au-Prince and Avenue C bleeding into each other, frequencies low and high, a slave auction, a throne, an icon, a corpus, a grinning skull, jawbone, cabeza, a gritting of teeth, an advertisement for toothpaste, a taste of your own medicine, the hoodoo man and the problem of bad medicine, the record that stops playing in the airy loft on Great Jones Street when the artist who put it on never comes back to lift the needle, never has a chance to set it straight.

The year after he died, a number of Basquiat's paintings were offered for sale to the Museum of Modern Art in New York City. They didn't see any value in them and declined.

—2018

II

Imagination! who can sing thy force?
Or who describe the swiftness of thy course?

—PHILLIS WHEATLEY

To Make a Poet Black

Yet do I marvel at this curious thing:
To make a poet black, and bid him sing!

— COUNTEE CULLEN

O N A CRISP FALL AFTERNOON, students stream into the classroom, vibrating with nerves and anticipation. Some of them, notebooks and laptops open and seated in pole position, are already committed; others are waiting to see what's on offer, how much reading will be required, who the professor is. As the hour arrives and the lecture begins, anticipation turns to apprehension, a hushed tension. The course is called Introduction to Black Poetry, the professor is black, a majority of the students are black.* The slide projected on the screen has a line of poetry without attribution and it is in ancient Greek:

Ἔρος δ' ἐτίναξέ μοι
φρένας, ὡς ἄνεμος κὰτ ὄρος δρύσιν ἐμπέτων

At the outset of the course, the professor explains, we will not take for

granted that we know what "black poetry" is or what asserting its existence might imply. Rather, the aim will be to try to make sense of both terms— *black, poetry*—individually and then, building over a long historical sweep, to culminate the course by arriving at some comprehension of their conjunction.

First, we have to ask ourselves some fundamental questions about what "poetry" is. The word comes to us from the Greek *poiesis,* meaning "to make," as in to make something appear or to give it reality. What does poetry make? And what or who makes it? In order to find out, we need to remove the presentist spectacles that tell us that poetry is just a fancy use of words involving meter and rhyme. We have to reach back to the earliest and most primal function of poetry: the stitching of language to experience. Framed this way, we immediately see that most of our contemporary notions of poetry are only partial and parochial.

If we consider some of the oldest poetry in the world, like the Akkadian and Sumerian literature of the second millennium BC, even our most basic notions inherited from Homer break down. As Michael Schmidt has pointed out, the common recourse to labeling the Sumerian poem *Gilgamesh* as an "epic," for example, makes use of an "unauthorized generic anticipation" in the form of an Aristotelian category that came into being roughly a millennium later, and which may well "limit our ability to identify what might actually be there." To make sense of the picture of the world refracted in *Gilgamesh* and the poetry of the Mesopotamian city-states requires faculties that we can barely surmise: radically different and vertiginous beliefs about what the world is made of and how you can know anything about it. For instance, one might need to grasp oneirology, the study of dreams, and "deductive divination," both of which, the Assyriologist Jean Bottéro has argued, were central to the Mesopotamian understanding of the nature of reality. In fact, the cultural importance of divination and the need for scribes to be able to record their predictions and dream visions is quite possibly what prompted the Sumerians to invent the new technology of writing itself.

This may sound incredibly bizarre since our governments (at least officially) don't read the world as a dream-text anymore. One could make the case, however, that the Surrealists who gathered around André Breton in the 1930s did exactly that, which perhaps explains why their works sound

so much like an ancient poem that's been cut out of a beauty advertisement in a modern newspaper. In any case, poetry is never strictly utilitarian, and this often makes it radically strange, even as aspects of its imagination or form can also appear uncannily familiar. The poetry of the Sumerians, for instance, makes no use of rhyme whatsoever. They relied instead on effects like repetition, parallelism, and variation on a theme. These are especially legible in the magnificent poems about the Goddess Inanna, the Queen of Heaven, and the tale of her descent to the Underworld. The tablets with her poem were originally composed around 1750 BC and excavated at Nippur at the very end of the nineteenth century but weren't completely reassembled until Samuel Noah Kramer's edition from the early 1960s. Here are some of the lines leading up to Inanna's descent:

> *From the Great Above she opened her ear to the Great Below.*
> *From the Great Above the goddess opened her ear to the Great Below.*
> *From the Great Above Inanna opened her ear to the Great Below.*

The use of repetition is both estranging and oracular, yet from a certain point of view oddly modern, even modernist. For a contemporary reader, there's an echo of the blues, with its characteristic triadic structure of repetition and variation indebted to oral patterns of call and response that represent one of the most distinctive poetic legacies of the African diaspora. The assertiveness and self-possession of Inanna has also struck a chord with feminist scholars who have drawn our attention to the prominence of women in Mesopotamian cultures, allowing us to rediscover poets like Enheduanna, who was a high priestess at Uruk, and lived well over a thousand years before Homer. Expanding our frame of reference in this way, we can think about both continuities and differences between, say, the lyrics of Inanna's mythic self-gathering for her descent into the Underworld and the connection between poetry and spiritual journey in Ntozake Shange's celebrated choreopoem *for colored girls who have considered suicide / when the rainbow is enuf,* where her women rise up together out of an underworld of despair and regain a sense of their innate divinity in *this* world as expressed in what are perhaps that work's most famous lines: "i found god in myself / & i loved her / i loved her fiercely." The language in

each of these poems—written over four thousand years apart—ascribes to poetic incantation a mystical, transformational force.

The belief that spirituality can be activated by a poetic use of language is a commonplace encountered in all human societies. It is no accident that the sacred texts of the three major monotheisms as well as the Hindu Vedas and the Chinese Shijing are all treasured as highly for their poetry as for their theological or moral instruction. Their enduring power and appeal reminds us that they are still the conduit through which most people have access to poetry on the planet today, that most people still encounter poetic uses of language not in bookstore readings and lecture halls, but in the realm of spiritual communion. Poetry has a social existence and function and not merely a literary one. Until the practice was outlawed in the 1960s, Senegalese griots were buried inside the hollowed-out trunks of ancient baobab trees, a sign of enormous respect and a telling metaphor in itself for the generational flourishing and stability the oral tale-teller ensured to their community. Recalling her visits to the Nile Valley, not in the deep past but in the early 1980s, the Egyptologist Susan Brind Morrow says: "Men and women who could not read or write would walk for miles to listen to a blind poet sing all night, or go to a holy man to have a poetic line scrawled out on a scrap of paper. They would put the scrap in a cup of water and drink the ink for the medicinal power of the words."

What is it about poetry that gives words such extraordinary power? Morrow thinks that it has to do with the way each word itself is already a metaphor. Hieroglyphics are not only a script; they remind us that the word is itself a magic vessel, each one a fragile bottle that has traveled over the turbulent ocean of humanity's recorded life. "The flamingo is the hieroglyph for red," she notes. "All red things: anger, blood, the desert, are spelled with the flamingo." Words preserve the ecological memory of the world not only as it is, but as it was. The sea and the Nile were green to the ancient Egyptians because the waters were saturated with life-sustaining (and manuscript-enabling) papyrus. But today Morrow writes, "in Egypt the plant no longer exists. It survives only in the hieroglyph for green."

In 2015, Morrow published an exquisite translation of the so-called Pyramid Texts, a group of writings dated to the Fifth Dynasty, circa 2400 BC.

These funerary scripts were first discovered in the 1880s on the interior walls of a group of pyramids at Saqqara and remain among the oldest extant literature we know of. Whether they should count as poetry is debatable. Kurt Sethe, who did the pioneering study of the Pyramid Texts in the 1920s, cautiously called them "utterances." Many Egyptologists now prefer to call them "spells." They are undoubtedly theological and also intended to function as "speech acts" in J. L. Austin's sense, that is, a saying of words that the speaker of them understands as an action upon the world that changes it. Even in the absence of priests, the presence in the chamber of the inscriptions would assist in preserving the unity of the soul, the *akh*, of the pharaoh or queen as it made its voyage across the day sky and, in a celestial circumnavigation of the universe, back around and through to the end of the night, thereby according with the Egyptian cosmological cycle of daily resurrection. This is why the spells are so preoccupied with constellations. For the Egyptians, these quasi-poems were star maps intended to preserve the souls of the dead. For us, they preserve a distant but legible picture of an ancient civilization's view of life. In Morrow's remarkable translations one can see and hear, for the first time, a hint of their original imagist power:

The sword of Orion opens the door of the sky.

This ancient intuition of a deep consilience between death, resurrection, and astronomy is not locked away in the past. It has never left poetry. One can find the same awe that invests the Egyptian astrological mysteries sublimated in some of the most beautiful poetry of the moderns: in John Donne's "A Nocturnal upon St. Lucy's Day," Emily Dickinson's "There came a Day at Summer's full," Frank O'Hara's "A True Account of Talking to the Sun at Fire Island," and throughout the musical and poetic universe of Sun Ra and his Arkestra. Poetry, in this sense, is one of the vehicles human beings have proposed as most capable of staging an encounter with the limits of empirical experience, an art uniquely suited to expressing threshold states of being that usually suggest deep symmetries between the cosmos and its beholder. The poet is not only the singer of the collective mythos then, but one who casts a

spell in the pyramid of our oldest hopes—who weighs the power of death and resurrects the power of language over life.

One of the ancient spells that has animated poetry is the power of Eros, of Love, and it is with Eros, the professor insists, that a course on black poetry must begin.

Ἔρος δ' ἐτίναξέ μοι
φρένας, ὡς ἄνεμος κὰτ ὄρος δρύσιν ἐμπέτων

These are lines from a lyric known as "Fragment 47" composed by the poet Sappho who lived in the late seventh century BC at Mytilene, the largest city on the island of Lesbos in the Aegean Sea. In the poet Anne Carson's translation, this is how it reads:

Eros shook my
mind like a mountain wind falling on oak trees

Two thousand six hundred years later, this line is still fresh. Even if we translated Eros not as a god but, more secularly, with the *eros* translatable to our familiar word "love," there is still something decisively original in it. What makes Sappho's lyric so striking? What she is describing is so common that the clichés of "falling in love" or "love at first sight" are automatic to us. Yet the lines above sound nothing like a Hallmark card. They have a definite point of view, but they are entirely free of didacticism. There is no judgment from on high; this is not a maxim intended to impress us with the poet's wit or insight. Sappho is not speaking to a collectively culled piece of accepted wisdom. She is not idealizing a high sentiment nor satirizing a human weakness. Instead, she concentrates entirely on the roiling life of her own subjectivity. Her language draws upon and pulls into itself the imaginative resources of empirical observation, what William Carlos Williams called "the imaginative qualities of actual things." The power of language to mirror the physical world is transfigured by inverting its location and reflecting it back to us as an interior landscape.

Establishing the authority of the poet's own subjectivity in lyrical form

was an important invention that Sappho played a key part in popularizing. This doesn't mean, however, that her poetry comes entirely out of her own mind or even her own experience. It is constantly informed by her knowledge of earlier poetry and she is always reinterpreting the tradition she understands herself to have inherited. Indeed, in "Fragment 47" Sappho is performing a kind of literary sampling, toggling between her own lyrical mode and a register that her audience would have recognized as echoing the construction of the Homeric epithet. This is why, even if you haven't read the Homeric texts, you might have found yourself mulling over what may have surprised you as the odd combination of an intensely psychological event with an image of commanding physicality. Not only because the force of natural phenomena upon our senses is always startling and sublime, but also from the suggestion in Sappho's lines of a combat, a kind of wrestling match between the poet and the god of love and sex.

This is already quite impressive for two lines, but allusion and genre-bending are only the tip of what one can discover in the iceberg-like fragments of Sappho's poetic thinking. Consider, for a moment longer, the precision and tactility of the simile—the roar and density of sound when a gust of wind buffets oak trees and all around you the leaves hiss and tremble; the hypnotic undulation of branches when seen from below, or even from afar on a neighboring hillside. If we stay with the image, other latent layers of subtle abstraction emerge. Branches in a strong wind, for example, bend and strain—but don't break. They sway and dance as if inhabited by another presence, by a force animating them from within, sending them into a state of ecstasy that feels both dangerous and intoxicating. This is an uncannily vivid description of what it is like when a great love enters one's life, the shudder of *eros* that does not quite break the mind but shakes it up entirely, rattling not one or two but all of our preconceptions at once, in one fell swoop.

There's also an important ambivalence in Sappho's images. Does "Fragment 47" describe a positive or a negative experience? Is it devastating or exhilarating? Are positive and negative useful or even applicable categories for *eros*? Or is this simply a neutral observation, a statement about one's powerlessness when *eros* commands? And what does it mean that this force called *eros*—so associated with the body and its sensual impulses—shakes Sappho's

mind? As this gloss suggests, what is striking is how much these lines *know*, and how little they display that knowledge semantically. Here is another lesson about what poetry is: a constant slippage or asymmetry between what is strictly speaking on the page—the text, the serial sequence of words—and what emanates as significance from the combination of those words as they spontaneously combust in the act of reading, colliding with private experience and memory and the publicly shared history of poetry itself.

This density is what makes poetry a literature, which is to say it cannot exist without roots, without knowledge of earlier bodies of poetic expression. This is why when "Instapoetry" proudly declares itself a form of *unknowing*, it denies itself the power of the thing it claims to be. When the Instagram poet Charly Cox, for instance, writes of the history of poetry that "I didn't know a thing," but that it doesn't matter because "I just knew how to feel," the hollowness and, yes, the narcissism are distressingly naïve. Every poet from Sappho to Simone White has known that getting feeling into language isn't the same thing as having feelings.

Still, it's easy to see why people get confused. Poems are inordinately complicated creations. They come loaded with experience, are bound to rhetorical histories, myths, geographies, eccentricities of usage, and so on. A poem is immediately a knotted compound that transmits, like clumps of soil clinging to celery roots, entire chunks of human thinking and feeling as well as the poet's attitude toward those same qualities, which the rhetorical structure of the poem will always betray. Sappho's poem takes us into a mind and a voice that is both hers and that of her age, its experience crystallized and hardened into form, every facet registering the impact of the forces that shaped it. This is what Theodor Adorno means when he speaks of "the poem as a philosophical sundial telling the time of history."

With patience, attention, and careful study, we can pry our way back into Sappho's poetic line. But it, in turn, sees into us. One of the extraordinary things about Sappho is that she wrote at a time when writing, the alphabet, and literacy were all new. The capacities of the human imagination were undergoing a revolutionary expansion as her world began transitioning to a greater use of literacy from what was primarily an oral culture. In her extraordinary study *Eros the Bittersweet*, Anne Carson observes that in *any*

oral culture where what matters is maintaining contact among people through sound, "Breath is everywhere. There are no edges. The breath of desire is Eros. Inescapable as the environment itself, with his wings he moves love in and out of creatures at will. The individual's total vulnerability to erotic influence is symbolized by those wings with their multisensual power . . ."

This radiation of breathing as the principle mediating force of community is not at all unfamiliar to black life. Indeed, thanks to Ashon Crawley's recent writings on Black Pentecostalism, we are beginning to notice how consistently "the ways air, breath, and breathing are aestheticized" in black social, religious, and political practices. The dominance of the oral relationship and the poetic cultivation of orality for its own sake are easily recognizable features of black communal life. What could be a better example of the *eros* Carson describes (in the context of Sappho's Lesbos) than Zora Neale Hurston's heroine Janie in the novel *Their Eyes Were Watching God*, who when speaking of her trust in her friend Pheoby declares "mah tongue is in mah friend's mouf." The similarities of oral culture extend even to the problem of prejudice toward regional vernaculars. There is a long-standing stereotype about black speech that it is hard to understand and hard to follow, even as it is said to be unusually mellifluous and enjoyable to hear. The Aeolic Greek dialect spoken on Lesbos was treated by classical Athenians in similar terms. In Plato's *Protagoras*, a speaker from Lesbos is ridiculed for his "*barbaros*" speech, meaning not barbaric in our modern sense, but something more like "backward," hard to understand for lack of refinement, the way the Southern accent in the United States is still associated with a lack of urbanity and sometimes mocked in circles that consider themselves superior.

Oral cultures are also ones that tend to hold a more intimate relationship to music and to integrate musical performance more extensively in all aspects of life. We call Sappho's poetry lyric because it was accompanied by the lyre, by musical instruments. Sappho's name is associated with a specific stanza form that she mastered and popularized among generations of poets after her. It works by building four-line stanzas, with the first three lines counting eleven syllables and the last one only five. Combining these with a trochaic rhythmic pattern gives Sapphics a distinctive springiness that winds down as the verse line contracts. The beat of Sappho's poems mattered as much as the

accompanying musical performance. They form a whole. Music and spoken words are not separate but interpenetrating expressions of the same thing. This again is highly resonant with black poetic practices, from ring shouts to spoken word poetry to rap, but no less so in the formally literary tradition as well. To name just one example, consider the mimetic play of Puerto Rican poet Luis Palés Matos in his poem "Majestad negra" (Black Majesty). Even non-Spanish speakers can hear the conga beat built into each line:

Por la encendida calle antillana
Va Tembandumba de la Quimbamba
—Rumba, macumba, candombe, bámbula—
Entre dos filas de negras caras.

Though it may seem surprising to discuss them together, it turns out black chant and Aeolic song share similarities that are arguably more fundamental than their differences. These parallels reflect the role language plays in both cultures, its fusion of the individual and the communal, or as Fred Moten might put it, the soloist and the ensemble. The history that produced blackness out of the theft of peoples, who at the time of their deportation were bound together in oral societies, made the poetic power of language particularly important to their life-worlds. In *Slavery and Taste*, Simon Gikandi carefully analyzes the vivid impressions that rituals of dance, music, and performance made on seventeenth-century English traders in the Gambia, and how these cultural traditions and "technologies of connection" remained intact on the far side of the Middle Passage where they caused much trepidation among Jamaican plantation overseers who attempted to document and decrypt their significance. Olaudah Equiano, reminiscing on his youth in his *Narrative*, describes his people as essentially "a nation of dancers, musicians, and poets." These were cultures where poetry was at the center of all human life. As Audre Lorde puts it in her essay "Poetry Is Not a Luxury," language so conceived is a matrix (a mothering tree) that "forms the quality of the light within which we predicate our hopes and dreams toward survival and change. . . ." In an oral culture, Walter Ong says, "the cosmos is an ongoing event with man at its center. Man is the *umbilicus mundi*, the navel of the

world." This way of putting it favors a modern Cartesian subject's perception of things. It might be truer to say that in an oral culture like Sappho's, Equiano's, or Hurston's, the speaker becomes a relay to the cosmos, the woman's umbilical cord loosely tethering a single voice back to a social unity, so that it can speak momentarily *from* the center of the world without ever being alone, without ever *being* the center.

What to make of Sappho's relationship to her wider community has been a long-standing source of controversy for scholarship. Her audience has been imagined as everything from a class of students, to a circle of close friends, to a secretive erotic cult. It's very hard to say, given that we can only hear Sappho's voice intermittently in the few fragments that have survived, like a song coming through a skipping CD. Clearly, there is an intimate ring of contact, primarily with other young women in her orbit. But Emily Wilson is also surely right when she says that "Sappho appealed to later poets because she created a new way of speaking about distance, alienation and desire." When Sappho sings of desire or jealousy, there's a ferocity in her voice that tells us she is on her own. If the so-called "Midnight Poem" or "Pleiades Poem" is in fact hers, it certainly sounds like she has a bad case of what Bessie Smith called "the empty bed blues":

Δέδυκε μὲν ἀ σελάννα
καὶ Πληΐαδες, μέσαι δέ
νύκτες, πάρα δ' ἔρχετ' ὥρα,
ἔγω δὲ μόνα κατεύδω.

The moon and the Pleiades have set,
it is midnight,
and the time is passing,
but I sleep alone.

Bessie is more to the point and explicit about what she wants, but the blues are worth invoking here because the quandary of Sappho's circle might be productively considered from that modern point of view. After all, as Angela Davis has argued, one of the greatest legacies of the blues form are those blues

women who were its first stars. The lyrical space that they forged allowed them to assert controversial expressions of sexual desire, in part by subverting masculine tropes, much as Sappho does when she signifies on traditionally Homeric materials in her lyrics. The canny performance styles of Bessie Smith, Ma Rainey, and Ethel Waters show how an intensely personal, concentrated, and erotically frank utterance can be delivered to, say, a cabaret-size audience that gathers round to listen for the beauty and to bear witness. Compare the "Midnight Poem," for instance, to Billie Holiday singing from Ellington's composition "In My Solitude," with lyrics by Eddie DeLange and Irving Mills:

> *In my solitude*
> *You taunt me*
> *With memories*
> *That never die*

As we listen to the grain of Holiday's voice interpreting the song, we can ask: How far back does the tradition of the blues woman go? It's a provocation, but maybe it's not entirely wrong to picture Sappho as the Lady Day of Lesbos, always somewhat gathered in her solitude, even—or rather *especially*—when she's performing before her audience. The art of her song on the lyre is the quivering mastery that retains a blue coolness in every note even when the line is scorching: "no: tongue breaks and thin / fire is racing under skin" is Anne Carson's rendering of "Fragment 16." One could conceive of a Sappho, at any rate, who knows how to make herself alone even within her performance before an intimate collective. A Sappho recital would surely have been an unforgettable experience. Her contemporary Alcaeus (forever doomed to be *the other poet from Lesbos*) speaks of her not only as his equal but with reverence. Frank O'Hara in his elegy for Holiday remembers her performing at the Five Spot, a famous jazz club in New York City. His poem ends as he listens from a bathroom door "while she whispered a song along the keyboard / to Mal Waldron and everyone and I stopped breathing."

There has always been a lot of whispering about Sappho, of course. We know she lived on Lesbos and was exiled for a time in Sicily (she may have

been a bit of a diva). We know she was married and had a daughter. It seems improbable that she was a lesbian as we use the term today. She was, however, quite likely at least bisexual, although what seems ultimately most significant is that her name is invariably associated with a scandalously excessive sexuality. Ancient commentators, even when they admired her, accused her of being a vamp. It wasn't until the nineteenth century that French poets like Baudelaire and the self-proclaimed decadent Pierre Loüys flipped the slander into provocative praise, giving us the contemporary sense of lesbian as female homosexual desire. This "scandalous" Sappho was due in the first instance to the intensity of patriarchal relations in the Greek world. As Carson explains, Greek culture evolved intellectual and cultural reflexes for dealing with women that treated them as a threat to order and dealt with them as a kind of social "pollution," a threat to "hygiene, physical and moral." At least one scholar, John J. Winkler, thinks Sappho may have even developed something like "a double-consciousness" as she learned to see or understand her own desires through the lens of a normative masculinity that she was barred from. Whatever the case, it seems fair to say that Sappho's poetry was out of place in the sense that it defied the expectations of its time. This is why it seem reasonable, regardless of the truth of her sexual orientation, to describe Sappho as "queer" in the sense that we use that word today.

Sappho is "complicated," to use a contemporary locution, and not only because of her queerness. Two hundred years before Plato, she lived in a place and time where contact with the cultural imaginations of the Near East and Africa was strong, especially since these were regions with which Lesbos had important commercial trading relations that helped make its aristocracy, to which Sappho belonged, wealthy and cosmopolitan. The classicist Page duBois tells us that Sappho, "remembering friends and not victors, celebrating lovers not tyrants, remembering pleasure not victories, disrupts the origins of Western civilization by her eccentric stance . . ." The glint in her poetry comes from the stitching points left by an experience of life at the crossroads of several ancient cultures. Sex and love are the archetypal forces of the dissolution of boundaries and the anterior truth of our borderless world. Sappho doesn't *belong* to anyone. Her poetry is "mingled with all kinds of colors," as "Fragment 152" sings. Jason's cloak with its many myths sewn together by

Athena, dawning light over the Aegean, garlands of flowers in a girl's hair, the beauty of honeyed voices, the face of the person you love, the superiority of grace and culture over war and brute force—these are all braided, mingled, and overflowing continuities in Sappho's singing. This inescapably erotic lyricism has produced an abundant literature exploring Sappho and gender, sexuality, agency, and queerness, all of which is, of course, as it should be.

WHAT HAS BEEN almost entirely neglected by critics, however, is Sappho and the question of race. And this is surprising, because rumors about Sappho and race have also circulated since antiquity. The most prominent scholarly account we have of Sappho's blackness is from W. E. B. Du Bois in his 1947 book *The World and Africa* where he has this to say:

> Two of the most illustrious writers of Greece were called Negroes— Aesop and Sappho. Planudes asserts this; Zundel, Champfleury, and others think that the "wooly-haired Negro" on the coins of Delphos was Aesop. Ovid makes it clear that the ancients did not consider Sappho white. She is compared with Andromeda, daughter of Cepheus, black King of Ethiopia. Ovid says: "Andromede patriae fusca colore suae."

Du Bois also cites for authority Pope's translation of Ovid, whose Sappho declares:

Brown as I am, an Ethiopian dame
Inspir'd young Perseus with a gen'rous flame;

Pope enjoys the rhyme, of course, but there's no question that he is imagining an African poet. Another important source that Du Bois does not cite is Pierre Bayle's *Dictionnaire Historique et Critique*, published at the very end of the seventeenth century and an important precursor to Diderot and d'Alembert's *Encyclopédie*. In one of the long footnotes to his entry for Sappho, Bayle no longer equivocates with terms like "dark" or "brown" but says "elle étoit [*sic*] noire & petite"—she was little and black.

In truth, scholars know very little for certain about Sappho's life. We certainly do not know anything about what she *actually* looked like or what her racial or ethnic makeup was. But regardless of her actual appearance, there is nevertheless a history of people who have read Sappho as black. And there is a significance to that fact that illuminates an important but not always visible fault line running through the entire culture of the West. It matters that when Bayle says of Sappho that she is black, he is relying on the authority of Maximus of Tyre, a Greek orator who lived in the second century AD and spent the latter portion of his life at Rome. As Carson observes, it is Maximus of Tyre who connects Sappho to another great name of ancient Greece, Socrates. In Carson's translation, Maximus writes,

> Sokrates calls Eros a Sophist, but Sappho calls him "weaver of fictions" [*mythoplokon*].

In other words, Socrates, the philosopher, thinks Eros misleads us; Sappho, the poet, thinks the threads of desire are full of stories that tell us who we are. Plato's banishment of the poets from his Republic has everything to do with these opposed conceptions of the role desire plays in the attainment of knowledge. But, as Carson keenly notices, there are affinities here as well. Socrates proceeds in his search for wisdom with love; he confesses to *loving* the mental operations that produce dialogue, thought, and reasoning. "The fact is, Phaedrus, I am myself a lover of these divisions and collections," he says. Carson sees in Socrates's deflected but recuperated eroticism a kind of secret handshake between the two ways of love and the two ways of knowing: the way of the philosopher and the way of the poet.

What Carson does not notice is that this same moment where Maximus conjoins Socrates and Sappho is also one of powerful disjuncture and rejection. Yes, Ovid had already suggested Sappho's African blood but not with an emphasis on prejudice. Other ancients, including Alcaeus, described Sappho as beautiful or striking. With Maximus of Tyre something changes. In his commentary on *Phaedrus* he introduces the first real denigration of Sappho's appearance, writing "fair Sappho—so he [Phaedrus] is pleased to call her because of the beauty of her poetry, although she herself was short and

swarthy." In a separate papyrus fragment, Papyrus Oxyrhynchus 1800, an unidentified author makes the same point in even more emphatic terms: "In appearance she seems to have been contemptible and most ugly, being dark in complexion and of very small stature." The papyrus has been dated to the second century AD, making it a near contemporary for Maximus, which if it is not by him then seems likely inspired by his teaching. Since this document was not discovered until 1905, it obviously wasn't a source for Bayle, but clearly this didn't prevent him from misunderstanding Maximus's intent, which was to emphasize the link between Sappho's ugliness and the color of her skin. In between them, Medieval scholiast making his own annotations to a passage on Sappho in Lucian's *Imagines* takes the opportunity to pile on: "Sappho [was] most disgusting where the ways of her body are concerned, looking small and black, and like nothing so much as a nightingale, flapping around with its little body clad in feathers of no beauty."

Across the epochs we see the devaluation of blackness and its increasingly tight linkage to a disgust with the body in general and by implication, given Sappho's reputation otherwise, a disgust with sexuality. Descriptions of Sappho track shifting attitudes in the West from classical antiquity, through Christianity, and up to the Enlightenment as sexuality and racial blackness become metonymically bound to each other as increasing liabilities to human decency. It's notable, if not surprising, that we find the harshest assessment of Sappho in the annotations of the Medieval scholiast who not only seeks to ward off anyone from reading filthy Sappho, but also appears far more ignorant than either Maximus of Tyre or Pierre Bayle, both of whom would at least have known that the nightingale is a bird with positive associations for poetry. Classical Sappho was Ethiopian; Christian Sappho is disgusting; the European Enlightenment's Sappho is *noire*, "black" like the Code Noir that Louis XIV decreed in 1685, making color the badge of slavery in all of his possessions including French Louisiana. In the interval, race in our modern sense has been produced. And over the centuries the West has made a decision to favor Socrates *over* Sappho: *his* way of knowing over *her* way, argument over narrative, philosophy over poetry, whiteness over blackness.

No one will ever know the hue of Sappho's face when she sang under the sun at Mytilene. It's anyone's guess, although I feel fairly certain she was not

pale and blonde with a forearm like Popeye's, which is how Raphael paints her in his fresco *The Parnassus* at the Vatican. For our purposes, what matters though is not what color Sappho's skin was—but what her bizarre reception tells us about the history of how people read certain kinds of importance *into* race and poetry, and how these meanings are not stable but oscillate and change with time and place, sometimes dramatically so.

The Russian poet Marina Tsvetaeva, for instance, who lived through the early decades of the Soviet regime, seized upon Alexander Pushkin's African ancestry as proof that blackness and poetry were almost equivalent. In her essay "My Pushkin," she writes: "In every Negro I love Pushkin and I recognize Pushkin." As far as Tsvetaeva was concerned, all black people were poets, and all poets were at some level black. In the poet and in the Negro she perceived a shared identity: despised subjects feared by state authority, whether it be that of Plato, Stalin, or Coleman Livingston Blease (governor of South Carolina and author of the charming doggerel poem "Niggers in the White House"). Tsvetaeva seems to have conceived of her poetics via a kind of moralized color schemata in which black was the color of absolute good, of creativity, inspiration, and dignity. "What poet of the past or present is *not* a Negro!" she cried.

Thomas Jefferson saw the matter quite differently. For him it was just the opposite. There had never been a black poet in history and there never would be. It was contrary to natural science and furthermore accorded with the observations he made of his slaves as they built his Monticello. In *Notes on the State of Virginia*, Jefferson made a point of attacking the young prodigy of Boston, Phillis Wheatley, who had written pious and patriotic poems celebrating his revolution. She wrote a poem personally addressed to Washington. From England, the black writer Ignatius Sancho hailed her as "a genius in bondage." Jefferson was having none of it. For him, Wheatley was just another case for his negrophobic file. To his mind, the only thing she offered was an opportunity for him to promote his "enlightened" opinion that black people do not truly experience love the way whites do:

> But never yet could I find that a black had uttered a thought above
> the level of plain narration. . . . Among the blacks is misery enough,

God knows, but no poetry. Love is the peculiar oestrum of the poet. Their love is ardent, but it kindles the senses only, not the imagination. Religion indeed has produced a Phyllis Whatley [*sic*—T.J. couldn't bother to get the spelling right or quote her work]; but it could not produce a poet.

Jefferson had well-ordered thoughts about many things, and poetry was one of them. He wrote a book on English prosody that is perfectly fine, if seldom read twice. And he collected occasional poems, the Instapoetry of its day, in his scrapbooks. He essentially had the most common taste one could have in poetry. Dutifully, like a parrot, he admired the writers everyone else admired. He was inordinately fond of sentimental minor verse and doggerel.

Jefferson's thoughts on race are, to borrow a phrase from him, beneath the dignity of criticism. The thing about him that we still struggle to say honestly is that he wasn't just a racist. He was a *racialist*. He didn't just dislike blacks: He elaborated theories of race that he devoted significant time to working out, weighing his judgments, trying to discern what made black people tick or break. He was one of the most powerful and influential architects of the US state, and he had plans for what he wanted to do with us: "When freed, he is to be removed beyond the reach of mixture." Meaning, blacks must be segregated so as not to procreate with whites, an ironic injunction from a man who at forty-four gratified himself sexually with a fourteen-year-old slave, Sally Hemings. When you consider that the Jeffersonian mentality was not so rare in those days (and not as rare as one would wish even today), it becomes all the more evident why June Jordan is so right to call the first black poet of major importance in the United States "Phillis Miracle Wheatley."

In early October 1772, Wheatley was summoned to appear before the governor and leading men of the Massachusetts Bay Colony to prove she could write her own poetry. Henry Louis Gates Jr. calls this day "the primal scene of African American letters." Unfortunately, we don't have a record of what was effectively a trial not only of Wheatley herself but also to determine the humanity of all black people: the *United States vs. Wheatley*. As Gates notes, most of the eighteen men assembled to judge her owned slaves, at least one was actually a slave trader, and many were graduates of Harvard Uni-

versity. She would have faced them alone; in 1772 she was at most eighteen or nineteen years old. She had the blackest of names—a combination of *Phillis*, the slave ship that brought her from the Senegambian coast to America, and Wheatley, surname of John, the wealthy tailor who purchased her in Boston after her arrival on July 11, 1761. Wheatley passed her test that day, and her collection *Poems on Various Subjects, Religious and Moral* was published in 1773 and proved successful enough for her to go on a book tour that year to England. But Jefferson's indictment and, in time, those of critics of all stripes and colors have returned her again and again to the docket. With Wheatley, black poetry begins its modern life as a concept under duress. As Moten has said, Wheatley's "poetry investigates what it means to be on trial, her poetry reveals what it is to be on the verge of a nervous breakdown, staking out that impossible apposition as black literature's local habitation—on edge."

But the pressure of racist assumptions that pushed Phillis Wheatley close to the edge could not make her lose her head. Her love of learning, notably of astronomy, is visible in several poems, including one confidently giving lessons in ethics to students who go "To the University of Cambridge, in New England." Her imagination rings loud and clear in a poem dedicated to praising its limitless powers. And even with all the noxious attitudes bearing down upon her person, Wheatley found a time and place to explore the stirrings in her heart. Eros, as we have seen, lives in every poet, and in her poem "To S. M., a Young African Painter, on Seeing His Works," we have what is arguably the first love poem written by a black American.

Composed in heroic couplets, which she devoured in her readings of Alexander Pope, "To S.M." is a confession of Wheatley's crush on Scipio Moorhead (likewise a young African artist, owned by the Reverend Moorhead, a friend of the Wheatleys), who is thought to have been the artist behind the portrait of Wheatley used as the frontispiece for the poems of 1773. The link has never been absolutely certain because so little of substance has survived of Moorhead's life and work, including his paintings, which are lost to us. Fortunately, part of the confraternity among black artists has been an acute awareness that the tradition is riddled with neglect and loss and that half the battle is rescuing our own. This is what Kerry James Marshall did in his painting *Scipio Moorhead; Portrait of Myself, 1776*, part of a series executed

between 2007 and 2010 that represents black artists at work. In Marshall's rendering, Moorhead paints at an easel aligned orthogonally to the viewing plane, denying us any hint of his creation. The positioning is tactful. Marshall refuses to claim what he cannot know and focuses our attention instead on the artist and the space that belongs to him, a studio interior done entirely in dark ochre that throws into relief the startling whiteness of Moorhead's smock, which appears slightly stiff and awkward, almost like a straitjacket. Behind Scipio at bottom left and framed in a block of ashy rose is a sketch of Wheatley. Marshall has kept her pose from the famous frontispiece but turned her so that instead of being in profile she stares directly out at us, almost confrontationally. This "self-portrait" does, in fact, confront us: with the history of black artists and writers having to attest to the authorial capacity of their own creation; with the realization that we are in the position Wheatley would have occupied when she was posing; with the suggestion that Moorhead's representation of himself as the artist who painted the poet is also Marshall's self-portrait of the artist as a black man whose art is neglected to the point of oblivion. Or only nearly so, since what Moorhead is principally known for now is the homage black artists past and present have paid to him—their insistence then, and now, that he was loved.

Wheatley appears to have slipped "To S. M., a Young African Painter . . ." into her book at the last minute, perhaps intending to preserve an element of surprise that would please her beau. Without records we can only imagine what Moorhead's reaction might have been to seeing his initials in her title. What we have to go by is the poem itself, and the emotional tenor of it is unmissable: admiration, and unrestrained joy, the thrill of two creative geniuses finding each other in a hostile world and celebrating being young, gifted, and black. In her couplets, Wheatley flatters Scipio's brush and openly flirts with him, mingling and deliberately confusing his powers with her pleasures, celebrating their elective affinities and the good fortune of youth—a blessing insisted upon in the title and repeated emphatically in the poem itself:

> *To show the lab'ring bosom's deep intent,*
> *And thought in living characters to paint,*
> *When first thy pencil did those beauties give,*

> *And breathing figures learnt from thee to live,*
> *How did those prospects give my soul delight,*
> *A new creation rushing on my sight?*
> *Still, wond'rous youth! each noble path pursue;*
> *On deathless glories fix thine ardent view:*
> *Still may the painter's and the poet's fire,*
> *To aid thy pencil and thy verse conspire!*

Reading this poem, the literary historian Ivy Wilson observes that the word "conspire" suggests a politically subversive undertone. Surely at the very least it reflects the consciousness of two black artists who recognize that their very existence and the ambitions that they each have for themselves and for each other are revolutionary. Who knows what they might get up to? One very likely thing would be an illustration to adorn her collection of poetry. Certainly, that's how I read her conspiracy. One involving the need to get away for many "sitting" sessions. Perhaps some going rather late into the evening. Not that anything so scandalous necessarily took place. We know Wheatley was deeply pious. But *eros* can make use of its unfulfilled sublimities, and the poem overflows with them. Like all teenagers in love, Wheatley wonders to herself if they could be together forever, even beyond death.

> *But when these shades of time are chas'd away,*
> *And darkness ends in everlasting day,*
> *On what seraphic pinions shall we move,*
> *And view the landscapes in the realms above?*
> *There shall thy tongue in heav'nly murmurs flow,*
> *And there my muse with heav'nly transport glow;*

These lines are Anita Baker *caught up in the rapture of love,* and Wheatley knows it. The glow she derives from Scipio's tongue is exquisitely explicit. It's also another clue that suggests they saw a good deal of each other, enough for her to love his voice so well. Of course she would: they must have talked for hours. The erotic energy of the poem, gliding ahead on its own melting (as Frost says all good poems do), threatens almost to get out of hand. Wheatley

has been fantasizing all evening as she writes, and so she catches her own desire in its flight like Juliet at the balcony: "Cease, gentle Muse! the solemn gloom of night / Now seals the fair creation from my sight."

These dreamy visions of bliss remained just that. Scipio Moorhead's paintings exist only indirectly in the image attached to Wheatley's poems, and in the studio of the imagination where Kerry James Marshall has reinstated him. Wheatley herself ended up in an unhappy marriage and living in considerable poverty, passing away on December 5, 1784, at the age of thirty-one. "What will survive of us is love," said Philip Larkin. It's true of Phillis and even more so of Scipio. Through her art, Phillis was able to conspire and bind two black geniuses together in the only immortality they could share: the intimacy of her book.

What can one say about an imagination that treats love like that? Jefferson's mind, degraded by his racism, couldn't see that eros gave the black poet an imagination not less capacious but more so than his own. The young woman he carelessly denigrated defiantly inaugurated an entire tradition that has flourished ever since. Jefferson was wrong about black people; he seems to have known that at some level he *was* wrong but still was unable to give up his opinion. The country is still torn between his way of thinking and hers. But Jefferson was also wrong about his own celebrated "classical" heritage. He had no inkling of its true scope, complexity, and beauty, or the vast poetic geographies that flowed into it. Much about the truth of that cultural past was, and would forever be, as obscure to Jefferson as the political instincts that made him "tremble" for his country were, paradoxically, lucid:

> Indeed I tremble for my country when I reflect that God is just: that
> his justice cannot sleep for ever.

Despite his apocalyptic fears, Jefferson did genuinely hope that the country would eventually rid itself of slavery and make a peaceful transition to emancipation. He understood that what the United States had embarked upon would involve all of us forever in each other's lives, and that the only question would be the terms upon which we understood each other. Who knows what he would make of the country now? Even in his worst dreams or nightmares,

could he have ever fathomed the full spectrum of students in the classroom today? One imagines how flummoxed he would be at the sight of a course taught at the University of Cambridge, in New England, called Introduction to Black Poetry. A course that begins with a reading of Sappho, whom Plato called the Tenth Muse, one of the greatest poets of antiquity and, on the authority of learned men ancient and modern, a black queer woman.

—2020

Back in the Day

IN 1988 no one in France took the hip-hop movement seriously. It was the rec-room era. JoeyStarr and Kool Shen were just two kids from Seine-Saint-Denis, the 93rd ward, a neglected tract of housing projects on the northern outskirts of Paris. One black, the other white, they shared a love and talent for breakdancing and got together practicing moves in bleak lots and house parties. They started crews and listened to Doug E. Fresh, Masta Ace, Grandmaster Flash, and Marley Marl. DJs played the breaks looped over jazzy horn riffs, cats sported Kangol hats and Cosby sweaters, and they tagged the walls of the city with their calling card: NTM, an acronym for "Nique Ta Mère" (Fuck Your Mother). There were no labels, no official concerts or shows, and the only airplay was after midnight on Radio Nova, a station dedicated to underground and avant-garde music, created and directed by French countercultural hero Jean-François Bizot.

I was at a house party in a spacious bourgeois apartment somewhere in the 16th arrondissement when I first heard DJ Cut Killer's track "La Haine," better known by its infamous refrain "Nique la police" (Fuck the police). I hadn't yet seen the film *La Haine* (1995), which made the song famous, and which remains arguably the most important French film of the 1990s. I was at a *boum*, slang for a teenage house party and a tradition of Parisian coming of age that involves a great deal of slow dancing and emotional espionage. Sophie Marceau immortalized it as a mesmerizing ingénue in the greatest French teen romance ever produced, *La Boum* (1980). But I wasn't dancing with Sophie

Marceau. I was dancing with Caroline. A young dude interrupted Ace of Base and popped in a cassette he had brought in his jacket pocket. The party came to a jarring halt as everyone looked at everyone else trying to figure out what to do. The shock of hearing someone actually say "fuck the police" and repeat it again and again stunned me. The owner of the tape was bragging about how he got it. How it was banned, and you could only find it "underground." This turned out to be true, though I didn't believe it at the time. Caroline insisted she was impressed, but her body was limp, her eyes vacant. The song made a big impression on me. Even without fully understanding everything on the record, the exhilaration of open rebellion was palpable. Over an onslaught of breaks and scratches a voice shouted: "Who protects our rights? / Fuck the justice system / The last judge I saw was as bad as the dealer on my corner / *Fuck the police / Fuck the police!*" KRS-One samples collided with a looping of Édith Piaf's "Non, je ne regrette rien." We understood the symbolism perfectly. The difference between Sophie Marceau's world and ours was the existence of the ghetto as an undeniable fact. The party was over.

I arrived in France in 1992, the year the Maastricht Treaty creating the European Union was signed and Disneyland opened its first European theme park outside Paris. I was still a kid and spoke not a word of French. It was not going to be easy figuring out how to grow up as a black American in Paris. The skin game was complicated. I was too light-skinned to be from Senegal, but dark enough to be from Algeria or Morocco. Declaring my American-ness, I soon learned, was necessary for avoiding a certain nastiness of tone specially reserved for the postcolonial subject. On the other hand, as an expatriate American at an international school, I was moving in bourgeois circles. Money cushions social realities and creates a haze of similarity among peers until you get to around sixteen, the age in Paris when you start to roam the city alone, have your first real crush, and learn how to roll a cigarette while waiting for the Métro.

The peripheral zone known as the *cités* or *banlieues* was terra incognita to me at that point. Nobody I knew had ever been that far off the map. You glimpsed the *banlieue* from the train, on your way to the countryside or the airport; its inhabitants lived there, trapped beyond the city walls, as though feudal relations had never really collapsed in the capital of the Revolution.

I did know the symbol for that space: HLM, an acronym signifying a set of social-housing block towers grouped in pods of dreary urban sprawl. They were built during the years of the post–World War II economic boom the French call *les Trente Glorieuses*, when ex-colonial immigrants were imported into the republic as cheap labor for a country still rebuilding from the catastrophe of 1939–1945. The HLMs were exalted for their modern incarnation of Le Corbusier's ideal of sleek "towers in a park" and satirized for their sterile futurism by Jacques Tati in his classic film *Playtime* (1967). France has always had a rather anxious, and occasionally schizophrenic, attitude toward modernization.

But the architects of the utopian HLM did not account for the social and political effects of racial and historical prejudice. By the 1980s the boom had petered out, and the cheerful attitude toward cheap immigrant labor soured into an austerity-driven desire to push the immigrants and their children— born with French citizenship—back out. If not out of the country altogether, then out to the social housing blocks on the fringe of the cities—out of sight.

Resistance began in language. The French state has an obsessive attachment to the purity of the tongue. It maintains an academy devoted to policing grammar and ratifying vocabulary. In the early 2000s it declared that email would henceforth be called *courriel*, a derivative of *courrier* (mail). To this day all government employees have to send *courriel*. The rest of the country sends *mail*. Against this stodginess, the *banlieue* gelled around an outsider culture and generated its own idiom. "*Verlan*" is a play of word-flipping, where the first and last syllables of a word in French are inverted (*femme* becomes *meuf*, *l'envers* becomes *verlan*, etc.) By importing words from American English, and most of all Arabic words from across the Maghreb, the outsiders created their own counter-French, the creole of the ghettoized.

And yet, at least in the world of music, it seemed the newcomers would have to bend to the rules of French culture rather than the other way around. That strategy produced the first crossover hip-hop star, MC Solaar. It was Solaar who single-handedly established the literary imperative in French rap on his first album, *Qui Sème le Vent Récolte le Tempo*. Solaar made a point of demonstrating his fluency beyond the street, taking on a hybrid troubadour-griot persona that situated him just within the orbit of *chanson française*,

provocatively making himself heir to the likes of Jacques Brel, Georges Brassens, and Serge Gainsbourg. In one of his singles he raps, "L'allégorie des Madeleines file, à la vitesse de Prost"—combining an allusion to Proust's madeleine with a nod to Alain Prost, France's Formula One racing hero of the nineties. The near pun is not accidental.

Qui Sème le Vent was one of the first CDs I ever bought. The first couple of songs, heavily Gang Starr–influenced, were snappy enough. The second half of the album was less appealing, a half-baked dub collage. But smack in the middle was the track that would make Solaar instantly famous, a love ballad called "Caroline." I listened to that song over and over again. It was cheesy and sentimental and yet undeniably a feat of lyrical virtuosity. It evoked everything you could feel about first crushes all at once. The whole album still sounds in its very grain "old school," a term that has come to hover as a halo over a golden age of hip-hop bathed in what from our current standpoint looks like a shocking and enviable innocence. But there really is a greenness in Solaar's soft-spoken, almost-whispered delivery that connects with the green of Parisian sidewalk benches, where first cigarettes and first kisses imprint their weightless marks of identity. Solaar had the perfect pitch at the perfect moment: the overwrought saxophone riffs, the fanciful turns of phrase, the dub connection, the long Proustian sentences carrying over sixteen bars in a song. But it was for these same reasons that his artistry became instantly outdated, an artifact of nostalgia, something that could not keep in step with the cultural supercollider that hip-hop was forcing down the line.

FILA SNEAKERS, LACOSTE CAPS, Sergio Tacchini tracksuits, one sock rolled up, a fur-lined bomber jacket, shaved heads, fanny packs for holding sticks of hashish the size and color of a caramel bar wrapped in tinfoil, tricked-out Yamaha scooters. By the mid-nineties the profile had been established and the term *racaille* had entered the popular lexicon to describe a disaffected young man from the *banlieues*. Their arrival within the city walls was turbulent and disturbing. For the first time I was faced with a definitive "other." We knew that they didn't belong in our world any more than we belonged in theirs. There was no question of integration. And so it always seemed, at least to me, that everything was contested in the only public spaces we

shared—in the public transportation system. I can never entirely dissociate *racailles* from the RER commuter trains with their acrid, low-grade plastic smell, the pallid lighting of underground transfer halls, the whine of the electric motors, and the fear of police patrols with German shepherds. There were acts of violence, some symbolic and others very real. You readied yourself for tense showdowns on empty platforms, you dreaded menacing whistles directed at your presence, and you practiced running up flights of stairs to the street. Entire areas in central Paris—Les Halles, Beaugrenelle, and even the Champs-Élysées—became off limits, even in broad daylight. Of course there was a complicating factor, namely that you also sought the same guys out to buy hash and weed. Dealers dropped by the high school on scooters to take numbers and chat about video games. But sometimes they were the same ones who got a crew together and jumped you for your wallet or your cell phone.

For most people, even in France, the idea of Paris is still heavily indebted to figments of a romantic Belle Époque strain, whether colored like a Toulouse-Lautrec dorm-room poster, lifted from a black-and-white photograph of May '68, or raised to an arch postcard fantasia, as in Woody Allen's *Midnight in Paris*. Frenchness in this sense seems incompatible with hip-hop; even the language itself seems somehow unfit for rapping. To put it bluntly, this vision of Paris does not include immigrants of color. Despite my being on the bourgeois side of the class line, the Paris of color, of difference, could never be invisible to me. It troubled me, made claims on me that I couldn't fully understand. Perhaps it bridged my own invisible loneliness. But it wasn't just me, or people like me. In our generation you had a choice: it was Suprême NTM or Daft Punk. And the choice felt deeply existential. Certain people would never be friends because of it. Plenty of kids chose to tune out the world and immerse themselves in the pill-popping scene of techno, house, and electronica. Caroline was one of them. We never openly admitted why we grew apart. But it was there all the same. She wanted to go clubbing at the Rex on Saturdays; I tried ecstasy and decided it wasn't for me. From there it was two roads peeling away forever.

The club kids looked to London. If you were hip-hop, you turned to the USA. The most powerful impulse came from the West Coast, as Dr. Dre and the G-Funk era made their way across the Atlantic. Groups like Reciprok and

Mellowman suddenly had the sounds of summer, and for the first time in its history, France had summer jams that weren't cheesy pop tunes à la Claude François. Tracks like "Libre comme l'air" (featuring a guest appearance from Da Luniz), "Balance-toi," and Mellowman's "La voie du mellow" were saturated with warm P-Funk chords usually heard whining out of low-rider trunks in Inglewood and Oakland.

In Paris the king of this sound was Bruno Beausir, aka Doc Gynéco. More than any other French rapper, Gynéco incarnated the ideal of adolescence. Laid-back, good-looking, smart, fresh gear, the guy who gets all the girls, has the best comebacks, has the best weed, and wears the latest sneakers. He made having as your primary interests sex and getting high look really good. He sported a tight just-got-back-from-the-French-Open look: clean designer polo shirts, headbands under his natty dreads. On the cover of his album he slouches under a big Afro, showing off creased slacks and all-white Adidas classics. He took the game up a notch. His rhymes were funnier, his references broader but also more popular: soccer, politicians, soap-opera starlets—in other words, television. His biggest hit, "Nirvana," is a quintessentially adolescent expression of ennui. "The hottest girls / You can have them / I'm tired of all that," he complains. "Tired of the cops / Tired of the gangs / Tired of life." In the refrain he gives a dopey lament about how he'd rather shoot himself in the head like Pierre Bérégovoy, François Mitterrand's prime minister, or go out fast like Ayrton Senna. You can't be too serious when you're seventeen, as Rimbaud says.

JUST AS HIP-HOP in the United States was concentrated for a time around East vs. West Coasts, the hip-hop scene in France quickly became oriented around two distinct and rival poles: Paris and Marseille. In Paris the three letters that mattered were NTM. In Marseille they were IAM. The latter were latecomers, but with their album *L'Ecole du Micro d'Argent* the Invaders Arriving from Mars (short for Marseille) blew up instantly. IAM's rappers styled themselves after the Wu-Tang Clan and their tracks reflected a close study of RZA's production. In the mid-nineties there was even a glimmer of hope for a transatlantic hip-hop empire, as rappers from New York collaborated with their French counterparts, with fascinating if somewhat mixed results.

Like Wu-Tang, IAM presented themselves as a warrior horde. They took the names of Egyptian kings and kung-fu masters: Akhenaton, Shurik'n, Kheops, Imhotep. For a listener from Paris there was also the peculiar flavor of the southern accent, with its long vowels, and the insistence on the importance of Islam and political solidarity. But the rappers of IAM transcended geography and race; unlike their American counterparts, their case was built on a deeply entrenched class consciousness.

In the *quartiers nord* of Marseille the race line is blurry at best. Its residents are African, Arab, Creole, but also southern Europeans, particularly Portuguese, Corsicans, and Italians, of which Akhenaton (Philippe Fragione) is a descendant. And most of the hip-hop generation comes from families that are likely to be mixed. In a port city like Marseille, though, the neoliberal factor is more readily evident than anything racial. What matters is inequality. The costs of the shadow economy are high, and the violence that comes with trafficking and corruption is unavoidable. In songs like IAM's "Nés sous la même étoile," drug money and the nihilistic culture it fosters are denounced for destroying youth, equality, and promise. The answer in the hook is bitter: "Nobody is playing with the same cards / Destiny lifts its veil / Too bad / We weren't born under the same star."

THERE'S AN ARGUMENT to be made that no French rapper has ever matched the verbal dexterity and range that you can find in the verses of classic American MCs like Nas, Biggie, Tupac, GZA, or Rakim. I mean that real cutting showmanship, the dazzling shell fragment that makes American rap so pungent. In part this is due to the fact that American rappers use verbal ingenuity as a kind of evasive tool, enlisting black vernacular to stay one step ahead of accepted, assimilated "white" discourse.

But the runaway success of songs like IAM's "Petit frère" or NTM's "Laisse pas trainer ton fils" demonstrates that in France there is no schism between alternative rap and the commercial mainstream current. There is no French equivalent of artists like Immortal Technique, Mos Def, or Talib Kweli; IAM and NTM never set out to "be socially conscious," as we might say in the US. This has given French hip-hop artists an intellectual and emo-

tional license that can be enormously compelling. It's why the NTM rappers can growl like DMX and at the same time talk about how a father needs to love and listen to his son. On the hook of their biggest hit single Kool Shen raps, literally translated, "They shouldn't ever have to look elsewhere to find the love that should be in your eyes." You can't find a line quite like this anywhere in the Def Jam catalogue. In the big leagues of US rap only Tupac could convincingly deliver this kind of sentimental sincerity, and even then it came encased in the heavy armor of thug life.

Suprême NTM was always a much harder outfit to classify, perhaps because they have been in the game the longest and are also the truest reflection of hip-hop in France. They embodied all the contradictions, circumvented all the traps. Of all the music produced in France over the last two decades, their contribution remains perhaps the most important, the most influential, and the most popular among young people across all social categories. What JoeyStarr and Kool Shen gave us was the nearest possible translation of freedom—the smack of liberty that they copped by listening to the best records from the golden era of American hip-hop. They weren't flowery like Solaar, or preachy like IAM, or above the fray like Doc Gynéco. Somehow NTM nailed the anger and the cool in the same note, bypassing categories like Miles, voice in command like Rakim. They would break out dancing at shows, something virtually impossible to imagine in the world of US hip-hop where the role of the MC has remained strictly verbal. They defined an entire generation and gave it a conscience. There's no way to give an account of Paris at the turn of the millennium without them.

NTM were never political in the sense of pushing a message. But they effortlessly controlled the terms of debate. The establishment attempted to paint them as dangerous and cop-hating hooligans, but one of their biggest singles, "Pose ton gun" (Put Down Your Gun), hauntingly backed by a Bobby Womack sample, became a national anthem to nonviolence. Yet they murdered whole institutions in the space of a verse, in the turn of a rhyme. They relentlessly exposed the hypocrisy of the French establishment, the Pasqua-Debré immigration laws, censorship, political corruption, and so on. When a television interviewer asked JoeyStarr about the violence of his lyr-

ics, he corrected her. "It's not violence," he said, "*it's virulence.*" No political actor or social commentator has been as articulate about the current social impasse in France.

With time, the rap game in France has evolved along the same lines as everywhere else. The new artists attempt to use Auto-Tune. They splurge on knock-off versions of Hype Williams videos, with interchangeable *Miami Vice* sports cars and booty girls; they abuse a plethora of mistranslated cultural references. Sefyu, the heir apparent to the hip-hop game in France today, is a morose and standoffish figure who refuses to show his face in videos and is more interested in coordinating his sneakers with his outfit than in paying for a decent beat. In a bizarre turn, Doc Gynéco veered politically to the right, infamously cheering Nicolas Sarkozy's rise to power and reinventing himself as a cynical court jester to the elite. He told people he had grown up. But really he'd just grown into what he was all along: a jerk.

When I look at the contemporary situation, I confess it's hard not to get depressed. Nothing seems fresh anymore; nothing seems green with life or genuine yearning. Across the Atlantic come similar grumblings that hip-hop is at last postmortem. Then again, maybe I'm just older.

Hip-hop is an adolescent genre of music. Between the lines you can plainly see attempts to tackle critical issues: social inequality, sex, religion, mortality, boredom, fear. But, ungainly and awkward, it indulges in the most ridiculous immaturity. Still, the stupidity of adolescence is not without its rush, its exhilaration. Freshness has its place. The music of our youth is tinged with a special effervescence. It is imbued with meanings we can only barely articulate, colored with feelings couched in half-remembered conversations, in old friends and half-forgotten crushes, stored amid all the whirring dynamos of the unconscious. Maybe this is why on a personal level French hip-hop is so easy for me to forgive, even though it still has a kind of embarrassing stigma. French hip-hop? *Really?* Well, yes. I actually can't listen to JoeyStarr shouting out, "Saint-Denis Funk Funky-Fresh!" without cracking a huge smile. *Saint-Denis, c'est de la bombe bébé!*

But emotional immaturity doesn't imply historical insignificance. If we could borrow Zola's eyeglasses and look down on the city of Paris to take stock of the last two decades, what would instantly stand out is a series of

kaleidoscopic collisions seething with energy and frustration: the *banlieues*, the stalemate of the ghetto, the restless periphery of the marginalized sons and daughters of the postwar immigration and their uncertain fate. Hip-hop has registered and encoded this historical narrative and expressed it in a native tongue.

> *Tout n'est pas si facile,*
> *Les destins se séparent, l'amitié c'est fragile*
> *Pour nous la vie ne fut jamais un long fleuve tranquille*

> *Nothing is so easy,*
> *Destinies separate us, friendship is fragile*
> *For us life was never a long tranquil river*

When I hear Kool Shen rap on lost friendships it pulls me back to a certain time and a certain place. It wasn't easy for anyone. But we were all there and hip-hop was our music; and because we were adolescents it was also our conscience. Now when the beat flows and I nod my head, the grain of Kool Shen's voice still has the power to evoke certain truths. It's hard coming up in the world. You have the best of times and the best of friends. Then things fall apart. Or maybe things just change. You grow older and you don't always figure shit out. Ralph Ellison defined the blues as "an impulse to keep the painful details and episodes of a brutal experience alive in one's aching consciousness, to finger its jagged grain." Hip-hop is steeped in this sensibility. The verbal dexterity, the allusive sampling, the poses and the braggadocio, they all amount to one underlying message: *I rock the mic—life's a bitch, and then you die.* It's about snatching good times from the teeth of times that couldn't be worse. Life is not a tranquil river. It's like that, and that's the way it is.

THE WAY IT IS. The Caroline I knew from the days of MC Solaar, who danced with me all night at my first *boum* and looked prettier in a dress than Sophie Marceau, dated a drug dealer. She lived in London for a while. She dropped in and out of design schools. She moved to Milan with a new boyfriend who she found on Myspace. Years went by, college. We sent each other messages,

emails sometimes. The last time I saw her she was hung over and embarrassed. She looked very beautiful. We didn't talk about music. We didn't really talk about anything. She doesn't know that when I hear MC Solaar's song "Caroline" I still think of her. It wouldn't mean anything anyway. The last time I saw her was in the summer of 2008. NTM officially split up in 2001, but they decided to reassemble one last time to play a live farewell show. 1988–2008: the end of an era. The show was the hype of the town. I asked Caroline if she wanted to go. She gave me the same vacant stare she gave years ago and ducked the invitation. She asked me if I intended to see them. I said I was thinking about it, but I knew the truth was I would never go.

—2014

Notes on Trap

They are the music of an unhappy people, of the children of dis-
appointment; they tell of death and suffering and unvoiced long-
ing toward a truer world, of misty wanderings and hidden ways.
— W. E. B. Du Bois, *The Souls of Black Folk*

Numb the pain with the money, numb the pain with the money
Numb the pain with the money, numb the pain with the
—21 Savage, "Numb"

. . . the inspiriting, locomotive foundation of the theory and his-
tory of blackness—in the form of some hyperbolic liner notes . . .
—Fred Moten, "Preface for a Solo by Miles Davis"

For Lil Snupe (1995–2013), L'A Capone (1996–2013), Chinx
(1983–2015), Bankroll Fresh (1987–2016), Lor Scoota (1993–2016),
Da Real Gee Money (1995–2017), Nipsey Hussle (1985–2019), the
many thousands gone.

1.

The beat, when it drops, is thunder, and causes the steel rods in whatever
you're riding to groan, plastics to shudder, the ass of the seat to vibrate right
up into your gut. The hi-hat, pitched like an igniter, sparks. Snare rolls cre-

scendo in waves that overmaster like a system of finely linked chains snatched up into whips, cracking and snapping across the hull of a dark hold.

2.

It is only in his music, which Americans are able to admire because a protective sentimentality limits their understanding of it, that the Negro in America has been able to tell his story.
—JAMES BALDWIN, "MANY THOUSANDS GONE"

3.

Rubber band man, like a one-man band
Treat these niggas like the Apollo, and I'm the sandman
—T.I., "RUBBER BAND MAN"

Howard "Sandman" Sims had a standing gig at the Apollo for decades as a tap performer who would "sweep" failing acts off the stage. It's stuff like this that makes up what Henry Louis Gates Jr. calls "motivated signifying," the inside joke that's on you before you know it, the razor wit—always the weapon of the underdog. The pleasures of dialect, hotly pursued by the holders of capital, the clout chasers of Madison Avenue, enclose a self-referential universe, a house of belonging in sound and word. A statehouse of language for a stateless people. Trap is an extension, a ramification of that vocabulary of radicalized homelessness: people creating a living out of a few grains of sand, hustling, sweeping anything that can't compete out of the way.

4.

Trap, *some definitions from the* Oxford English Dictionary:
A contrivance set for catching game or noxious animals; a gin, snare, pitfall: cf. mantrap, mousetrap, rat trap.
transf. *and* fig., *and in figurative expressions. Often applied*

to anything by which a person is unsuspectingly caught,
stopped, or caused to fall; also to anything which attracts
by its apparent easiness and proves to be difficult, anything
deceptive.

A concealed compartment; spec. (Criminals'), any hiding place
for stolen or illegal goods, etc.; a 'stash.' U.S. slang.

5.

I just wanna get that money — flip that money
I just wanna stack them hundreds,
I just wanna spaz out — cash out

—KODAK BLACK, "SPAZ OUT"

Q. What is the subject of trap?

A. Money, aka skrilla, paper, green, gwop, currency, stacks, bands, bundles, racks, currency, fetty (confetti), ends, dead presidents, bankrolls, $100,000 in just two days, fuck-you money, fuck up some commas, money long, run up a check, fuck up a check; a master signifier in falling bills, floating, liquid, pouring down on bitches in the proverbial rain, exploding like cold fireworks, screen-printed or projected onto surfaces human and otherwise, occasionally burned, often tossed into the impoverished streets left behind, kids trailing the whip, their arms outstretched, often bricked up in bundles held in a grip, or cradled to the ear like, say, a call from the highest authority in the land, or fanned out in a masking screen, or caressed, the cold frisson of Franklin morbidly displacing the erotic potential of sexual attraction.

6.

An attitude toward luxury. Brands of old-world "foreign" opulence sound better in the escaped slave's mouth. The "Go-yard" bag, the "Phi-lippe" watch, "the Lambo" supercar pronounced like a Creole dish, every accou-

trement of inaccessible lavishness smashed into pinball frenzy, a world where everything is always dripping, VVS diamonds are always dancing, every swatch of color given the player's ball touch, the planet WorldStarHipHop, a black satellite circling around a diamond white sun where the Protestant work ethic is always being converted into its rhythmic opposite, "You get the bag and fumble it / I get the bag and flip it and tumble it" (Gucci Mane feat. Migos, "I Get the Bag"). From the SoundCloud backpacker to the superstar trapper, the ideal of a supremely luxurious attitude toward luxury. "I'm spittin' fire like an arson / Hop out the Lam and don't park it" (Migos, "Forest Whitaker").

7.

Nigga: as rhythm, a trochee (from the Greek for *running*, at root a runaway) coursing through the verse marking soundings, like a heartbeat; the nasal occlusive a vocal withholding, a negative that releases into a velar plosive, a voiced relief; as person, a real one; as word, a neologism indigenous to the American crucible, the umbilical cord of blackness: raw, intimate, original, word as bond.

8.

Trap is the only music that sounds like what living in contemporary America feels like. It is the soundtrack of the dissocialized subject that neoliberalism made. It is the funeral music that the Reagan revolution deserves.

9.

The musical signature embedded in trap is that of the marching band. The foundation can be thought of, in fact, as the digital capture and looping of the percussive patterns of the drum line. The hi-hats in double or triple time are distinctly martial, they snap you to attention, locking in a rigid background grid to be filled in with the dominant usually iterated instrumental, sometimes

a synth chord, or a flute, a tone parallel that floats over the field. In this it forms a continuum with the deepest roots of black music in America, going back to the colonial era and the Revolutionary War, when black men, typically prohibited from bearing arms, were brought into military ranks as trumpet, fife, and drum players. In the aftermath of the War of 1812, all-black brass bands spread rapidly, especially in cities with large free black populations like New Orleans, Philadelphia, and New York. During the Civil War, marching bands would aid in the recruitment of blacks to the Union. At Port Royal in the Sea Islands, during the Union Army occupation, newly freed slaves immediately took to "drilling" together in the evenings in public squares, men, women, and children mimicking martial exercises while combining them with song and dance—getting *in formation*. The popularity of marching and drilling was incorporated into black funerary practice, nowhere more impressively than in New Orleans, where figures like Buddy Bolden, Louis Armstrong, and Sidney Bechet would first encounter the sounds of rhythm and trumpet, joy and sorrow going by in the streets of Storyville. This special relationship, including its sub rosa relation to military organization, persists in the enthusiasm of black marching bands, especially in the South, where they are a sonic backdrop of enormous proximate importance to the producers of trap, and to its geographic capital, Atlanta.

10.

But closer to home, Traplanta is saddled with too much of the same racial baggage and class exclusion that criminalizes the music in the eyes and ears of many in power. The same pols who disgrace their districts by failing to advocate for economic equity find themselves more offended by crass lyrical content than the crass conditions that inspire it. Meanwhile, systemic ills continue to fester at will. It's enough to make you wonder who the real trappers are in this town.

—RODNEY CARMICHAEL, "CULTURE WARS"

11.

Trap's relation to hip-hop retains the construction of a song around bars and hooks, but the old-school chime and rhyme, the bounce and jazziness of nineties production, is gone. Instead, empty corners space out patterns that oscillate between compression and distension. The drum machine popularized by the (black and gay) "jacking" sound of eighties Chicago and Detroit is put to use in a way that is less mechanical than its forebear, more syncopated, wavy, elastic. But it retains the overall flatness of effect, the orientation toward the (strip) club, a music to obliterate self-consciousness and the boundaries of the self. Bass is the place and when the 808 drops, or one should say detonates (an effect imitated in the proliferation of amateur dance videos by a jagged shake of the camera), the signature is quickly established and the pattern rolls over. Songs don't develop or progress. Sometimes, as in an iconic track like Future's "Stick Talk" or "Wicked," the song appears to materialize and dematerialize out of a vacuum. A squealing siren pops out of the ether. His roving, overdubbed voice rides slightly off or apart from the pattern playing off a few variations. The track begins, then ends, like weather.

12.

How will cultural history come to grips with the fact that the era of the first black presidency is also the era of trap—a metaphor for a suckering, illusory promise one falls for, only to realize things are worse than ever before?

13.

> *You can't understand us cause you're too soft*
> *Taliban bands, run 'em straight through the machinery*
> —Future, "Stick Talk"

Trap indexes the fever dreams of a declining imperial power. It irrupts within a wounded unconscious, seeking scapegoats, boasting, lashing out, categori-

cally refusing any sense of responsibility for its actions. The frustrations and failures of military adventurism on the frontiers and borderlands are internalized; they find sites for expression in the fractured, neglected wastelands at the periphery of the power capital, in the ghetto, the hood, the slums, the bricks, the barrio, the mud, the bando, the trap house. The metaphors of imperial fantasy, of limitless power and wealth—and its nightmare, endless, and pointless wars without issue—cross-pollinate and mutate. In rap of the nineties, the memory of Vietnam still resonated; Capone-N-Noreaga (C-N-N) gave us *The War Report* of the Persian Gulf War years. By the mid-'00s the war abroad and the war at home would fuse into the hard edges of a bloody portmanteau: Chiraq. The pressure of the proliferation of high-powered weapons, the militarization of everyday life, an obvious and pervasive subtext in trap, is also one of the most obvious transformations of American life at the close of the American century: the death of civilian space.

14.

That music, which Miles Davis calls "social music," to which Adorno and Fanon gave only severe and partial hearing, is of interdicted black social life operating on frequencies that are disavowed—though they are also amplified—in the interplay of sociopathological and phenomenological description. How can we fathom a social life that tends toward death, that enacts a kind of being-toward-death, and which, because of such tendency and enactment, maintains a terribly beautiful vitality?
—FRED MOTEN, "THE CASE OF BLACKNESS"

Trap is social music.

15.

Consider the voice of Meek Mill. The inscription of dreams and nightmares in the grain. Its breathlessness, always on the verge of shrill hoarseness, gasping for air, as if the torrent of words can't come fast enough—as if there might not

be enough time to say the things that need to be said. Every syllable eked out through grit, the cold facts of North Philly firing through a monochromatic hollow, like a crack in a bell.

16.

Trap videos for obvious reasons continue an extended vamp on the visual grammar developed in the rap videos of the nineties, a grammar that the whole world has learned to read, or misread, producing a strange Esperanto of gesture and cadence intended to signify the position of blackness. In the "lifestyle" videos, the tropes are familiar, establishing shots captured in drone POV: the pool party, the hotel suite, the club, the glistening surfaces of dream cars, the harem women blazoned, jump cuts set to tight-focus Steadicam, the ubiquitous use of slow motion to render banal actions (pouring a drink, entering a room) allegorical, talismanic, the gothic surrealism of instant gratification. In the harder, street-oriented version, luxuries are replaced by what one has, which is only one another: gang signs interlock, boys on the verge of manhood huddle and show they have one another's back. Women occasionally appear in an accessorizing role, but more often are simply absent. In the video for L'A Capone's track "Round Here," the indication is blunt: "Whole block got cane / But stay in your lane / Cause niggas getting changed." Like David Walker's graphic pointers in his *Appeal*, one of the key punctuation marks of this gestural grammar is the trigger finger, pointing into the camera—through the fourth wall—into the consuming eye. The very motion of the arm and finger are perversely inviting and ejecting. You are put on notice, they say. You can get touched.

17.

Trap is the soundtrack to America in the years of the "opioid crisis." The drug crisis initially thought to be merely a breach in the hull of the underclass confined to the black ghetto spilled out into white rural America with meth and prescription painkillers, segueing to black tar heroin as the pill mills (but not Big Pharma) finally came under legal scrutiny. It now exceeds, as all great

social disasters do, the class boundary. The hyped-up drug war of the 1990s and early '00s began to morph under the tenure of the great campaigner of hope into a normalized social fabric, a generalized landscape of dope. For the middle and upper-middle classes, Molly became a favorite, whether consumed casually at unabashedly corporate festivals or in warehouses not yet colonized for gentrification at the edge of town. An antidepressant, it could be said to provide the softer psychiatric analogue to the morphine class of painkillers that relieve the body or allow relief to occur passively with limited consent (its popularity being closely associated with the allure of sexual willingness).

For the ambitious children of the bourgeoisie, high achievers raised on Adderall, Xanax, and a raft of discreet legal narcotics, drugs are the norm just to get to sleep, to deal with anxiety, to avoid crushing bouts of abjection and the relentless pressures to exceed and excel. In the hood, promethazine, the syrup of Houston, became the fashionable coping agent for those living in the free-fire zones of America, where turf wars regulated with cheap handguns cut down lives in a vicious spiral. From so many points of view, then, one looks out into the Trump era with a prevailing numbness, nihilism, cruelty, ambient anxiety, disarticulation seeping in from all sides.

The music records all this. It sounds like this. Future's lyrics are mocked for their lack of sophistication, but the veritable pharmacopeia in his verses is not dishonest or inarticulate about an affect that is pervasive, or the origins of this malaise: "Percocet keep 'em motivated / Good drank keep a nigga motivated / Lortabs on my conversation / Talk a lot of bands then we conversatin' / I was on my way to Rice Street in the paddy wagon and it had me numb / The pain from the slum had me numb" ("56 Nights"). A preoccupation with depression, mental health, a confused and terrible desire for dissociation: this is a fundamental sensibility shared by a generation.

18.

Just past the sliding doors in a Rite Aid in Manhattan about 2 a.m., Mike WiLL Made-It's producer tag and the familiar melancholic two-tone of Rae Sremmurd's "No Type" announces that soon Swae Lee's Floydian vamp on

the trap sound will remind you of what you don't need to hear: "I ain't living right." The bored cashier there to assist you with self-checkout murmurs the chorus, lightly tapping at her side: "I make my own money, so I spend it how I like." Among other things, it's clear there has never been a music this well suited for the rich and bored. This being a great democracy, everyone gets to pretend they, too, are rich and bored when they're not working, and even sometimes, discreetly, when they are.

19.

Imagine a people enthralled, gleefully internalizing the world of pure capital flow, of infinite negative freedom (continuously replenished through frictionless browsing), thrilled at the possibilities (in fact necessity) of self-commodification, the value in the network of one's body, the harvesting of others. Imagine communities saturated in cynical postrevolutionary blaxploitation, corporate triumphalism, and the devastation of crack, a schizophrenic cultural script in which black success was projected as the mogul status achieved by Oprah or Jay-Z, even as an angst-ridden black middle class, gutted by the whims of financial speculation, slipped backward into the abyss of the prison archipelago where the majority poor remained. Imagine, then, the colonization of space, time, and most importantly cultural capital by the socially mediated system of images called the internet. Imagine finally a vast supply of cheap guns flooding neighborhoods already struggling to stay alive. What would the music of such a convergence sound like?

20.

Trap is a form of soft power that takes the resources of the black underclass (raw talent, charisma, endurance, persistence, improvisation, dexterity, adaptability, beauty) and uses them to change the attitudes, behaviors, and preferences of others, usually by making them admit they desire and admire those same things and will pay good money to share vicariously in even a

collateral showering from below. This allows the trap artist to transition from an environment where raw hard power dominates and life is nasty, brutal, and short to the world of celebrity, the Valhalla of excess, lucre, influence, fame—the only transparently and sincerely valued site of belonging in our culture. It doesn't hurt, of course, that insofar as you're interested in having a good time, there's probably never been a sound so perfectly suited to having every kind of fun disallowed in conservative America.

21.

A social life strictly organized around encounters facilitated by the transactional service economy is almost by definition emotionally vacant. Hence the outsize importance of the latest black music (trap) in selling everything: Sweetgreen salads prepped and chopp'd by the majority minority for minimum wage, real estate roll-outs, various leisure objects with energetic connotations, the tastefulness of certain social gatherings. In the city of the mobile user and their memes, the desperate energy and beauty produced by the attempt to escape the narcocarceral jaws of death become a necessary raw fuel, a lubricant for soothing, or rather perfecting, the point of sale.

22.

"Mask Off": an inaugural processional for the Trump years. Some were inclined to point to Taylor Swift's "Look What You Made Me Do" as signaling the bad feeling, the irruption of a nasty, petty, and reactionary whiteness willing to bring everyone down, to debase everything, including oneself, in order to claim victory. But Metro Boomin heard something more. He went back to the seventies, to Tommy Butler's "Prison Song," a soulful chant intended to accompany the marchers in Butler's 1976 civil rights musical *Selma*. The counterpoint of Future's openly vacuous and nihilistic pursuit of power and the undercurrent of an unbroken spirit of black resilience, resistance, and hope—the old news meeting the news of today—creates an intoxicating, gothic aura, the sound of a nation not under a groove but underwater, trying

to hold on to the shores of light, but decidedly heading out into dangerous and uncharted depths. "Fuck it, mask off . . ."

The game of polite power politics is up. The veneer is gone. America will show its true colors; Amber Rose and Future will drive a Terminator-chrome Bentley through streets where "mere anarchy is loosed upon the world." It is the hour of radical disillusionment. As Walter Lee says in Lorraine Hansberry's *A Raisin in the Sun*, "There ain't no causes—there ain't nothing but taking in this world, and he who takes most is smartest—and it don't make a damn bit of difference how." The grand years of the Obama masque, the glamor and pageantry of Ebony Camelot, is closed. *Les jeux sont faits.* The echo of black resistance ringing as a choral reminder to hold out is all that stands between a stunned population and raw power, unmasked, wielding its cold hand over all.

23.

Raindrop. If the mark of the poetic, of the living force of lyric in the world, is the ability to change the inflection and understanding of a single word, to instantly evoke and move speech into song, then what better example do we have than the poetics of Migos and their breakthrough album, *Culture?* "Like a wreath, *culture* is a word we place upon the brow of a victor," William H. Gass once wrote. As the title attests, Migos crowned themselves, like Napoleon. Their trap trips off the tongue, three steps to get it poppin', three more to get it started. Everything done in triplets. Quavo, Offset, Takeoff, their supergroup a triad. The message of the massive hit "Bad and Boujee" is simple and, thanks to its lullaby-rocking lilt, irresistible: the cosmopolitanism of the underclass is good enough for them. In this, everyone wins. The fetish of class and racial transgression is given a smooth membrane across which to exchange approving glances. Hence the appropriateness of Donald Glover's role in assisting the song to the top of the charts. No figure better represents the amphibious role of blackness slipping back and forth across lines of class, taste, and career.

The Migos lyric, with its love of onomatopoeia, annotating itself like

comic speech bubbles, offers itself up as a kind of doubled, mirroring space for ludic play. The drug world of the streets is sublimated, neutralized as a background of merely referential content that has no bearing on the tenor of life that has been achieved. In the video for the single "T-Shirt," Migos are figured as "trappers"—the hunting and gathering kind—on a supermodel-clad Siberian steppe. It is the linguistic turn applied to the Atlanta music machine. Opening an entirely new horizon for expression. An attitude might be expressed with just a shift in emphasis, a teasing chiasmus: "Raindrop, drop top" ("Bad and Boujee"). The language of the corporate record label exec slashed with the syntax of the trapper blossoms into the office catchall phrase you never knew you needed but now can't stop murmuring under your breath: "Hold up, get right witcha (I'ma get right witcha)" ("Get Right Witcha"); "Bitches need to call casting" ("Call Casting"). The flavor of the South, the sauce, the endless capacity for flow, reimagines the bourgeois subject—even makes being one, under this conception, seem badass.

24.

I have always heard him deal with death.
I have always heard the shout, the volley.
I have closed my heart-ears late and early.
. . .
The red floor of my alley
is a special speech to me.

 —GWENDOLYN BROOKS, "THE BOY DIED IN MY ALLEY"

25.

It's a lot of violence round here
So a lot of sirens round here
A lot of people dying round here
A lot of people crying round here

 —L'A CAPONE, "ROUND HERE"

The connection between martial drilling, funeral drilling, and recreational drilling finds a haunting but fitting contemporary expression in the so-called drill scene, a more aggressively bleak subgenre of trap that emanates from the post-Cabrini-Green teardown of the housing projects in Chicago. Drill trappers like Montana of 300 refer knowingly to the streets as "the slaughter-house." They celebrate the same qualities that Sandburg did when he wrote, "I have seen the gunman kill and go free to kill again," and that he found the Windy City's inhabitants "proud to be alive and coarse and strong and cunning." Only they are not so optimistic or romantic about the implications of living in the maws of lawless, unregulated industrial capitalism. There is nothing uplifting about G Herbo's view of the season of violence, which is the only season his city knows. In "Red Snow," a strident song with thundering and throbbing orchestral groans, he denounces the staggering cost of violence in his hometown:

> *I know I rap a lot 'bout being dead or dead broke*
> *But my city starving, it's the 'Go, that's just the way it go.*

A track like "Everyday," by S.dot, is typical: simple and alluring, conflating fraternity and fratricide, a bass line boosted like a massive heartbeat ready to give skinny boys in jeans toting weapons the courage to keep going outside, to step off the relative safety of the porch, to numb oneself to fear, to ready oneself for the repetitive and cyclical encounter with fatality. The hook slams down the facts of life like dominoes connecting an inevitable pattern to a breaking point:

> *Gangbangin', chain snatchin', card crackin'*
> *Closed caskets, trap houses, drug addicts*
> *Chiraq, everyday somethin' happen*
> *Bodies droppin', red tape, guns clappin'*

The deep patterns of the funeral drill, the bellicose drill, the celebratory drill overlay each other like a sonic cage, a crackling sound like a long steel mesh ensnaring lives, very young lives, that cry out and insist on being heard, insist

on telling their story, even as the way they tell it all but ensures the nation's continued neglect and fundamental contempt for their condition.

26.

Trap is invested in a mode of dirty realism. It is likely the only expressive form that will capture the structure of feeling of the period in which it was produced, and it is certainly the only American literature of any kind that can truly claim to have a popular following across all races and classes. Points of reference are recyclable but relatable, titillating yet boring, trivial and très chic—much like cable television. Sports, movies, comedy, drugs, *Scarface*, reality TV, food, trash education, bad housing: the fusion core of endless momentum that radiates out from an efficient capitalist order distributing itself across a crumbling and degraded social fabric, all the while reproducing and even amplifying the underlying class, racial, and sexual tensions that are riven through it.

27.

Riding through the city, windows tinted, AC blast
I got bitches wanna fuck me, so so wrong, do me bad
I got cash in my pants, I got cash on her ass
AP dance, bitches glance, cause my diamonds look like glass
 —YOUNG THUG, "WITH THEM"

When young black males labor in the plantation of misogyny
and sexism to produce gangsta rap, white supremacist capi-
talist patriarchy approves the violence and materially rewards
them. Far from being an expression of their "manhood," it is
an expression of their own subjugation and humiliation by more
powerful, less visible forces of patriarchal gangsterism. They
give voice to the brutal, raw anger and rage against women that
it is taboo for "civilized" adult men to speak.
 —BELL HOOKS, *OUTLAW CULTURE*

The emo trap of Lil Uzi Vert, his very name threading the needle between the cute, the odd, and the angry, might be thought, given his Green Day–punk styling and soft-suburban patina, to be less invested in the kind of misogynistic baiting so common to trap. But this is not the case. Like the unofficial color-line law that says the main girl in any rap video must be of a lighter skin tone than the rapper she is fawning over, there is a perverse law by which the more one's identity is susceptible to accusations of "softness" (i.e., lack of street cred), the more one is inclined to compensate by deliberate hyperbolic assertions of one's dominance over the other sex. When Lil Uzi says of a woman who has given herself to him—

> *Suckin' me up, give me brain now she dumb*
> *Tell her it's repercussions*
> *Play her just like a drum*
> *Make in a night what you make in a month*
> —"ERASE YOUR SOCIAL"

—the percussion lands on a cymbal crash aimed at a "you" that is really "us," the audience, who are invited to voyeuristically watch his performance (wordplay as foreplay), of which the unnamed woman is the desensitized object, but "we" are ultimately the target, the losers in the winner-take-all game of life, the suckers who work for a monthly paycheck who can't possibly compete with the value the market has bestowed on the speaker.

28.

The quirky particles coming out of the cultural supercollider of trap prove the unregulated freedom of that space: that in spite of its ferocious and often contradictory claims, nothing is settled about its direction or meaning. The hard-nosed but unabashedly queer presence of Young M.A; the celebratory alt-feminist crunk of Princess Nokia; the quirky punkish R&B inflection in DeJ Loaf; the Bronx bombshell of Cardi B: to say that they are just occupying the space formerly dominated by the boys doesn't quite cut it. They are completely changing the coordinates and creating models no one dared to foresee.

The rise of the female trap star is no longer in question; an entire wave of talent is coming up fast, and the skew that they will bring to the sexual and gender politics of popular culture will scramble and recode the norms of an earlier era in ways that could prove explosive in the context of increasingly desperate reactionary and progressive battles for hearts and minds.

The boys are not quite what they were before, either. Bobby Shmurda's path to "Hot Nigga," before landing him in prison, landed him on the charts in no small part because of his dance, his fearless self-embrace, and his self-love breaking out in full view of his entire crew. People sometimes forget that for the latter half of the nineties and the early aughts, dancing for a "real one" was a nonstarter. Now crews from every high school across the country compete to make viral videos of gorgeous dance routines to accompany the release of a new single. The old heads who grumble about "mumble rap" may not care for dancing, but the suppression of it as a marker of authentic masculinity was the worst thing about an otherwise great era for black music. Its restoration is one of the few universally positive values currently being regifted to the culture by trap.

29.

Young Thug enacts a Charlie Parker theory of trap. Virtuosity, drugginess, genius, vulnerability, an impish childishness almost as a compensation for the overabundance of talent, the superfluidity of imagination. A Cocteau from East Atlanta, he teases the beat, skipping off it like a yo-yo, yodeling, crooning, blurting, squawking, purring, working his game on you, finessing, playing ad libs like Curtis Mayfield worked strings, or scatting and growling low like Louis Armstrong if he were sweating it out in a freestyle battle with James Brown, bouncing back and forth between personalities. His polymorphously perverse sexuality is so insistently graphic and deadpan that it has virtually zero erotic charge, au courant pimp talk channeled through a kind of private board game of his own imagination, a Candyland fantasia slimed in promethazine. By contrast, his persona oozes sex. In leather jackets, ultratight jeans, and Janet Jackson piercing arrangements, he's a Mick Jagger–ish rake on the make who is also shy and easily wounded, suddenly open for a hug. A

favorite and telling picture posted to Instagram account thuggerthugger1 (5.2 million followers) captures him with his arm around Sir Elton John, posing like a polite politician in photo-op mode (Obama-alt) next to Sir Elton, who is dressed in a gold-trim Adidas tracksuit and a black thugger cap.

If the outlandish persona were all there was to it, he might be written off as a variant to Weezy that went nowhere. But the music really does, somehow, sound like the future, like something that's never been tried before, a radical experiment. His concern for innovating, like his persistent concern for his kidney health, is a marker of identity, not just a lifestyle. The boundaries he pushes are only partly for our benefit; his chameleon love affair with the frisson of the louche, the lawless elasticity of language, and the plasticity of the self-fashioning body in motion is all of a piece. He insists on being the soloist and chorus all at once; his is an orchestral impulse, a surround sound lyricizing every inch of space on the track. Words aren't about what they mean but, in the spirit of Baraka's "Black Dada Nihilismus," only how they sound. They are rhetorical and lyrical ammunition, raw material to freak like Jimi, not satisfied until the instrument wails, weirds out, trips over itself with a surplus that is no longer within respectable or even recognizable bounds—hence Thugger's fundamental *queerness* in the most capacious sense of that word. The music critic for the *Washington Post* writes that "if he lived inside a comic book, his speech balloons would be filled with Jackson Pollock splatters," which is halfway there (why not Basquiat?). Thugger is more exciting than Pollock, who never wore a garment described by *Billboard* as "geisha couture meets *Mortal Kombat*'s Raiden" that started a national conversation. Thugger's work is edgier, riskier, sans white box; if anything it is closer to Warhol in coloration, pop art without the pretension. It is loved, admired, hated, and feared by people who have never and may never set foot in a museum of "modern art."

30.

He . . . loved that he could look out of his window and see an open horizon over the water, where the waves from the Gulf quietly lapped the shore, where the oak trees in the median stood

witness over centuries to wars, to men enslaving one another,
to hurricanes, to Joshua riding along the Coast, blasting some
rap, heavy bass, ignorant beats, lyrical poetry to the sky, to
the antebellum mansions our mother cleaned whose beauty we
admired and hated. —JESMYN WARD, *MEN WE REAPED*

31.

The opposition to seeing the next man get ahead, the zero-sum game, crabs
in a bucket, colors, gang, the division of self against other, the envy that
breeds envy, Girard's triangle of mimetic desire, the division of self against
self. Everyone has the wants that they want, and so everyone universally has
opposition. Generic, unspecified in name, number, location, or time. A con-
dition of belonging. Opposites attack. Those who you don't fuck with. Who
don't fuck with you. The opposition. Opps.

I grew up in the projects which is one room
So I had to sleep on the floor in the front room
Me and my cousins on the block tryna thug
Nigga you a school boy, nigga we was sellin' drugs
 —LIL SNUPE, "RAP BATTLE"

DJ SMALLZ EYES
Now, why is there always beef, especially amongst rappers?

DA REAL GEE MONEY
Don't nobody want to see the next man ahead of him, so like . . . it really
be hate for no reason . . . 99 percent of the beef . . . don't have no real street
meaning behind it.

DJ SMALLZ EYES

Now, let me ask you this. Can this be stopped? Can this be fixed? Do you see this ever changing?

DA REAL GEE MONEY

I always used to feel like maybe one day . . . they'll just stop and maybe we can all get money together, you know. But like, the way it's going? Like, the way it's been going for years? It looks like it ain't going to change, you know. I don't know.

—DA REAL GEE MONEY, YOUTUBE INTERVIEW
WITH DJ SMALLZ EYES, APRIL 9, 2017

RIP to Eddie B wish I could bring you back
. . . Do anything to bring ya nappy head ass back

—LOR SCOOTA, "PERKS CALLIN FREESTYLE"

They killed my lil nigga Snupe
My lil nigga was the truth
And all he wanted was a coupe

—MEEK MILL, "LIL NIGGA SNUPE"

I love my niggas unconditionally

—MOZZY, "I LOVE MY NIGGAS"

32.

Black-boy blues articulated pitch-perfect
If nothing else your words make the whole world worth it

—JOSHUA BENNETT, "16 BARS FOR KENDRICK LAMAR"

33.

What if this music, Future's DS2, the Drake/Future What
a Time to Be Alive, Vince Staples' Summertime '06, Kanye
West's Life of Pablo, the numerous individual points that are
sounds and words that emerge from laptops, artists who live
within this surround, the formation that is trap music. . . . Let's
call it "possibility"—let's call it now, cracked time of where we
are and where we are going now. We don't have the words for
how broken. And yet we are warned.

—SIMONE WHITE, *DEAR ANGEL OF DEATH*

The problem of the overdetermination of blackness by way of its representa-
tion in music—its tar baby–like way of standing in for (and being asked to
stand in for) any number of roles that seem incongruous and disingenuous to
impose upon it—is the central concern of *Dear Angel of Death*, by the poet
Simone White. Her target is the dominantly male tradition in black literary
criticism and its reliance on a mode of self-authorization that passes through
a cultivated insider's knowledge of "the Music," which is generically meant
to encompass all forms of black musical expression, but in practice almost
always refers to a canonical set of figures in jazz. It's clear that she's right, also
clear that it's a case of emperors with no clothes. It may have been obvious,
but no one had the courage to say so. Take these notes on trap, for example:
they neatly confirm her thesis, and fare no better under her sharp dissection.
Though she could easily not have, White makes her point in a spirit of care
and generosity. "We must agree to think about the work we have asked the
Music to do," she writes, "whether it is still able to do that work, and how that
work might be done elsewhere."

What would that elsewhere be? I ask seriously, even as I agree with the
urgency of alternatives. Could black intellectuals abandon wholesale our
favored set of metaphors, drop our reflexive turns to improvisation, to dis-
cursive riffs meant to signify a kind of mimetic relationship to the sound?

Could we begin our conversation over again, at a tabula rasa of black creative freedom, and, importantly, one that would avoid the circle jerk that Simone White correctly implies? Surely the answer is yes, especially in terms of who is talking to whom and about what. And yet part of me thinks the answer is also partly no—or at least not without what I would think is an irresponsible and even decadent relationship to the very cultural forces that have guided black thinking, feeling, and interest, much of it informally political to be sure, but a form of talking about all things, including formal politics nonetheless. Who, after all, should be in a place to characterize and define the daily grind of contemporary life under the post-Reagan US internet tech empire to which we have set the musical tone? Would we consign that sprawling undertaking to the ash heap, would we accept the view that the white bourgeoisie holds of it? That it is cheap, trashy music, useful for frat parties and little else, the usual jitterbugging of "the blacks" who can't help themselves, the great sly replacement of minstrelsy by an even better show, to which the only prohibition, and this not even necessarily followed, is that one mouth along all the lyrics except for *that one*—passed over in thrilling hum?

Let's be clear: White's larger point stands. Looking to trap music to prepare the groundwork for revolution or any emancipatory project is delusional and, moreover, deaf. If we start from the premise that trap is *not* any of these things, is quite emphatically (*pace* J. Cole) the final nail in the coffin of the whole project of "conscious" rap, then the question becomes what is it for, what will it make possible. Not necessarily for good or ill, but in the sense of illumination: What does it allow us to see, or to describe, that we haven't yet made transparent to our own sense of the coming world? For whatever the case may be, the future shape of mass culture will look and feel more like trap than like anything else we can currently point to. In this sense, White is showing us the way forward. By insisting that we abandon any bullshit promise or pseudopolitics, the project of a force that is seeping into the fabric of our mental and social lives will become more precise, more potent as a sensibility for us to try and communicate to ourselves and to others.

34.

Trap is what Giorgio Agamben calls, in *The Use of Bodies*, "a form-of-life."
As it's lived, the form-of-life is first and foremost a psychology, a worldview
(viz. Fanon) framed by the inscription of the body in space. *Where you come
from.* It never ceases to amaze how relentlessly black artists—completely
unlike white artists, who never seem to come from anywhere in their music—
assert with extraordinary specificity where they're from, where they rep,
often down to city, zip code, usually neighborhood, sometimes to the block.
Boundedness produces genealogy, the authority of a defined experience. But
this experience turns out to be ontology. All these blocks, all these hoods,
from Oakland to Brooklyn, from Compton to Broward County, are effec-
tively *the same*: they are the hood, the gutter, the mud, the trap, the slaughter-
house, the underbucket. Trappers, like rappers before them, give coordinates
that tell you where they're coming from in both senses. I'm from *this* hood,
but all hoods are the hood, and so I speak for *all*, I speak of ontology—a
form-of-life.

The peculiar condition of being ceaselessly co-opted for another's profit
could arguably point to an impasse, to despair. But here's the counter: the
force of our vernacular culture formed under slavery is the connection born
principally in music, but also in the Word, in all of its manifold uses, that
believes in its own power. That self-authorizes and liberates from within. This
excessive and exceptional relation is misunderstood, often intentionally.
Black culture isn't "magic" because of some deistic proximity of black people
to the universe. Slavers had their cargo dance on deck to keep them limber
for the auction block. The magic was born out of *a unique historical and mate-
rial experience* in world history, one that no other group of people underwent
and survived for so long and in such intimate proximity to the main engines
of modernity.

One result of this is that black Americans believe in the power of music, a
music without and before instruments, let alone opera houses, music that lives
in the kinship of voice with voice, the holler that will raise the dead, the power
of the Word, in a way that many other people by and large no longer do—or
only when it is confined to the strictly religious realm. Classical European

music retained its greatness as long as it retained its connection to the sacred. Now that it's gone, all that's left is glassy prettiness; a Bach isn't possible.

Meanwhile, in the low life of blackness, there is a running fire that even in the midst of its co-optation exceeds the capacity of the system to soak it up. Mozzy is not a tragedian for the ages, but he is closer to the *spirit* of tragedy, as Sophocles understood it, than David Mamet.

The people who make music out of this form-of-life are the last ones in America to care for tragic art. Next to the black American underclass, the vast majority of contemporary art carries on as sentimental drivel, middle-brow fantasy television, investment baubles for plutocrats, a game of drones.

35.

Coda: What is the ultimate trap statement?
Gucci Mane: "I'm a trappa slash rappa but a full-time G."

—2018

An Open Letter to D'Angelo

Black Messiah is a hell of a name for an album. It can be easily misunderstood. Many will think it's about religion. Some will jump to the conclusion that I'm calling myself a Black Messiah. For me, the title is about all of us. It's about the world. It's about an idea we can all aspire to. We should all aspire to be a Black Messiah. —D'ANGELO, *BLACK MESSIAH*, LINER NOTES

FOR THE LONGEST TIME I contemplated writing D'Angelo a letter. It wasn't going to be a real letter that I would put in the mailbox and send to Richmond, or New York City, or London, or wherever the man might have vanished to. What I envisioned was something more like a James Baldwin essay, an open letter where the prose discovers something about the world, answers a set of questions posed by its very appearance. I wanted to write D'Angelo a letter from a region of my mind. But now in lieu of that lost letter to an uncertain future, I can address his prodigal return in the present.

If you never listened to *Voodoo*, or *Brown Sugar*, and didn't spend a significant portion of your life thinking about your place in the world, sexually, racially, lyrically—that holy trinity of black music—then you won't necessarily understand the overwrought emotion that the sudden unannounced appearance of the first new album by D'Angelo in fourteen years might arouse. But there are a lot of folks out there who have been waiting, or forgot

they were waiting, for this moment, and for everyone else now is the perfect time to discover why people have been holding out hope for so long.

To situate things, one has to recall that in a generation in which black music was defined (often in conflicting ways) by a dialectical tension between hip-hop and R&B, with myriad generational and intracultural implications, D'Angelo was a rare point of consensus. In the 1990s *Brown Sugar* was one of the few albums that fans of 2Pac and Toni Braxton could instantly agree on. And it went beyond the music. It was him—it was us. Maybe because he had the swagger of Pac without the rap sheet, this radiant self-possession, a slim cross on his chest, those neat cornrows and butter-soft leather jackets; and yet he could sing like Smokey Robinson, and carried about him everywhere the endearingly hushed softness of a choirboy. He was synthesis and expression, and *Brown Sugar* seemed to embody a set of collective fantasies that we were all having, but given the ruggedness— *remember the ruggedness!*—of the era, would never dare to express out loud. I'm talking about those of us who were caught out in that New Jack Swing moment when Teddy Riley somehow pulled everything together, and we thought—in a brief brightly colored MTV thought bubble—that we might actually get through the '90s with a smile, a hi-top fade, hammer pants, and a keytar. When New Edition came through puberty as BBD, roller-rinks were hot, Brandy was down, Latifah was Queen, Lauryn was the most beautiful woman you had ever seen, Motown Philly was back again, Arsenio was on, and you made mixtapes recorded off FM radio, lovingly labeled in wildstyle Sharpie.

. . . Dear D,

What happened in that last decade of the millennium? So many things came together. So many things fell apart. Walter Benjamin, writing in the last days of his own life, as the Gestapo closed in, prophesized that in the hour of danger, the angel of history with the disaster of the past blowing his wings forward would teach us how to look upon the past with the *nec-essary* perspective, "to seize hold of a memory as it flashes up at a moment of danger." Is that why we still think Tupac is alive somewhere? . . .

Remember Shakur: Black Icarus, Negro Monte Cristo, how a nation of millions could not hold him back? Icon, actor, ballet dancer, musician, poet, son of the revolution, soldier, hustler, comedian, sex symbol, sex offender, gangster, prisoner, gothic avenger, Patrick Henry, Thug Lifer. Remember the last photograph? Las Vegas. His last image in life, caught in surveillance, a visible trace of malaise in his eyes, like he knows, and he's reluctant, but he's weary most of all. Who has failed him? Was it us? The money dangled in the light of a jail cell? Death Row—a prophetic phrase hanging like a vulture in the high desert breeze, the car pulled up to a stoplight on the strip, the American night filled with Egyptian names viciously illuminated, the wail of the ambulance come to remove the ark, the body, whose prophecy is completed. Dead at twenty-five. Biggie dead within a year, only twenty-four. Two years later Big L who once asked on a record, "How will I make it?" and answered, "I won't, that's how," shot to death in a drive-by in Harlem. Twenty-four years old. A partial list. Looking at those Harlem slums fifty years earlier, Baldwin asked a crucial question. "Something in me wondered," he said, *"what will happen to all that beauty?"*

. . . Dear D,
You know Langston's poem they teach you in middle school:

The Night is beautiful,
So are the faces of my people

You know that feeling you get when Magic makes a no-look pass to Kareem, or Jordan pulls up with his tongue wagging, that feeling Hurston called "Cosmic Zora," the grain of Maya Angelou's voice when she says, "Yes," the way Hortense Spillers' prose gets you high. . . .

Among other things, D'Angelo offered a mindscape, a haven for a certain kind of beauty, a track on the mixtape that—no matter who you made it for—was guaranteed gold. It sounded right. And that counted for a lot. After all, with the release of *Voodoo* D'Angelo could have capitalized and turned out a

commercially minded R&B crossover. He was primed for mainstream suc-
cess. But he didn't go that route. The years he spent hanging in New York City
with the *Soulquarians* and *The Ummah*, that truly luminary set of producers
and artists including Ali Shaheed Muhammad of A Tribe Called Quest, Bob
Power, J Dilla, Raphael Saadiq, DJ Premier, and, of course, Questlove freed
him up to make something no one had really heard before. Somehow on *Voo-
doo* he sponged it all in: the clutch jazzy sample, the boudoir bohemian vamp,
the street suave after-hours playa's game, as nimble at crooning behind a
Method Man verse as whispering vintage Roberta Flack, the whole thing liq-
uid and simmering, an extended hymn to intoxicating presence, a dope sound.

Listening to tracks like "One Mo' Gin," "The Line," and "Chicken
Grease," you can hear all the key ingredients of that special recipe. The
way the arrangements are textured but stripped down, like the Delphonics
are playing underwater in the room next door, allowing Bootsy-worthy
bass to guide you upward to the ambient afro-stereo molasses built around
D'Angelo's husky falsetto that he loves self-harmonizing to, always a little
behind the beat, in eccentric orbit, so that the lyrics are always swallowed
back into the groove, stirred back into the mix.

If it sounds like there's a lot of Prince in the grain that's no accident:
D'Angelo has always claimed him as a musical idol. Sometimes you hear it in
hints of Jesse Johnson's guitar, like on the heaving, electrified cover of "She's
Always in My Hair." Like Prince, he exudes an unbracketed and unclassi-
fiable sexuality—though his own inflection is homey and rounded where
Prince tends to the flamboyant and angular. D'Angelo grew up a preacher's
kid in his father's Pentecostal church in Richmond, Virginia, and I have often
wondered if the intense inwardness of his erotic charge is not exactly what
the clash between a musical awakening to Prince and the law of the Father
in a Southern church ought to produce. The flashpoint of glory where the
sacred tips over into the secular. This is the kind of music that does things
for people, a strong medicine that works you down, that produces space for
self-knowledge. *Voodoo* was one of those life-raft albums, a record that I give
credit to for helping me get through college. It was also—and still is—a kind
of password between postmillennial afronauts, one that sets conversations

you've been wanting to have flowing, that makes people close their eyes a bit with a smile, just by bringing it up.

IN THE HOUR OF the die-in, Ferguson on fire, interstates shut down by chains of willing bodies, in the hour of unending police shootings, and inevitable police acquittals, of "Hands Up, Don't Shoot" and "Black Lives Matter," D'Angelo's *Black Messiah* dropped seemingly out of the ether, a flash of black hope in the hour of chaos. The decision to put the record to wax in the winter of 2014 invests the record with inevitable historical resonance. The fists in the air on *Black Messiah*'s cover art, like the red, white, and black flag on Sly Stone's touchstone 1971 *There's a Riot Goin' On*, speak directly in the language of the black freedom struggle.

Yet as the liner notes attest, the political vision of the album is internationalist in scope. D'Angelo's sweeping triangulation of Ferguson, the Arab Spring (Egypt), and Occupy Wall Street speaks to the interlocking diaspora of democratic aspiration that continues to define the politics of our time. In his acceptance speech at the Oscars for the song "Glory," Common made the same move, connecting Selma to the Southside of Chicago, the Charlie Hebdo solidarity rallies in France, and the movement for democracy in Hong Kong. That songs in the key of black American life willingly accept these wider commitments and explicitly advocate for them is a fact that deserves more attention than it often receives.

Black Messiah takes solidarity seriously. If you want an index, check Fred Hampton in full jeremiad sampled on "1000 Deaths": "they're a bunch of megalomaniac war-mongers . . . and we've got to fight 'em, we've got to struggle with 'em to make 'em understand what we mean!" The voice of Fred "To Die for the People" Hampton, a Black Panther famously assassinated by police in Chicago on a record called *Black Messiah*, released in response to a spate of highly mediatized police killings, is about as bold a political statement as anyone—let alone an R&B artist—can make. D'Angelo is tapping into the function of black music as a site of resistance in American life, including its insistence on alternative futures and lifestyles directed from below and not imposed from above.

He is not alone in sensing a sea change. In fact, it's possible at the dawn of 2015 to begin to distinguish the outlines of a new aesthetic in black music that is looking back to the late '60s and '70s to repurpose a latent countercultural energy that got sapped away in the Reaganomic "get rich or die trying" fantasies that pervaded so much of hip-hop and R&B in the new millennium. It may be that *Black Messiah* heralds not just the return of D'Angelo but the hinge opening the door to a new school of funk-fugitives with one foot in the analog past and another in the digital future. You can see this in the rising stars of hip-hop, artists like Joey Bada$$, or Kendrick Lamar's *To Pimp a Butterfly*, which similarly connects Pac and the sounds of the '70s to a new insurgent sensibility. You hear similar strains in Janelle Monae, but also in more underground currents like Flying Lotus and Shabazz Palaces. They are all pointing toward a freer mode of black vanguard expression, a focus on minor-key sensibilities—including unpleasant ones like melancholia—that go under the skin, that are willing to explore black interiority and deliver it raw, unreconstructed, unpolished for smooth consumption.

On *Black Messiah* tracks like "Really Love" and "Another Life" reverberate with the lushness of early Curtis Mayfield simmering like a background radiation of remembrance, informing a return to a political moment thought to be past, but that in D'Angelo's interpolation is a messianic collective energy just on the cusp of breaking through. The chugging locomotive tracks "Charade" and "1000 Deaths," interspersed with off-tempo soul-claps and peaking under an onslaught of ghosting Hendrix cries, form a soundtrack for marching, for marches past and present, from Selma to Montgomery, from Harlem to the Brooklyn Bridge, and from Ferguson to Jefferson City. But the energy of irrepressible black life and affirmative black love saturates every inch of the album. Each track speaks plainly to the unquenchable, unmistakable sweetness of black life.

D'Angelo's proud insistence on the analog "no digital" production subtends what we might call the album's "analog politics," the orchestra of the grassroots, the kinfolk-just-kickin'-it power of the black commons, of blackness in situ, already organized in its own laid-back fashion, a model of everyday resistance by everyday people, by any means necessary, yes, but also by all means available, including whatever's cooking in the kitchen right now,

including love in all its forms. Which explains why so many of the tracks on this album, and really throughout D'Angelo's discography, are always on the threshold of the instrumental, of the Quiet Storm erotic whisper, dense with atmosphere, soaked in vernacular funk, or as D puts it: "Being carefree and lucid, just natural, you know, just chillin." It's why the tracks always feel occasional, attached to spaces of casual assembly, conceived out of moments of gathering, summer block parties, backyard cookouts and stoops. Sure, you can float around your apartment all day to the record, but what you really want to do is call up whoever matters in your life and fill the room to capacity, get the house to sway together like a church on Sunday.

THE GRAMMAR OF HASHTAGS is necessarily reductive. We know black lives *matter*, and anybody who doesn't agree isn't going to be converted. The thing to grasp, as D'Angelo says in his notes, is that we should all be aspiring to *lead lives* that require us to expand solidarity and demand dignity. Not out of obscurantist racial identification, but for the happiness of human mutuality, the sensuous, even sacred, joy that comes with everyday people being together rather than apart. To think about blackness as a kind of categorical imperative, a duty first to ourselves and therefore to all, to expand the reach of freedom from domination, to understand blackness as a way of being in the world that *necessitates* a political project, that orients our expression inevitably toward a confrontation with injustice. It is also to understand that Black Humanism, with black music at its core, is the foundation that has cracked open a hollow American democracy by force and continuous resistance, and that remembering and carrying on the burden of that struggle continues to be the only hope for making this country a place worth living in, a nation with something to offer other than the cold hand of business ruling over a glass-tower gentry, a pauperized and fearful suburban petty bourgeoisie, and underneath both the abyss of the carceral archipelago.

. . . Dear D,

Let's talk for a minute about the Spanish Joint. About nights in Richmond and nights in Havana, and what they both know about New Orleans. About Africa. How America's greatest music comes out of her greatest

slave ports. How there's this thing in your music that Fred Moten would call its "surplus lyricism," a saturation of sweetness so thick it threatens to curdle the notes, and maybe it does, the way Cootie kept Duke's elegance just ratchet enough to keep folks from sitting through a concert comfortably. . . .

It's a false track, of course, when you let things get too abstract. The greatness of D'Angelo can be appreciated aside from the struggle for racial justice in America. But concretely, the texture of his music is intensely embodied, and the troubled history of the representation of black bodies is inseparable from the force of the music he makes, just as the thirst for dignity is central to the protest movement against police brutality. It's worth insisting on this point, because one of the subplots embedded in D'Angelo's greater narrative is that of an artist wrestling with his own overrepresentation—with the abjection of his body.

The attempt to canonize D'Angelo as a sex symbol only ever made sense to his label. He was comfortable in his skin, no doubt, but anyone could see he was shy, even introverted, the sensitive son of a preacher with small town roots. The infamous video for the single "Untitled (How Does It Feel)" that essentially consisted of three minutes of a periscope trained on his midsection was successful for a minute in selling records, but the objectification and scrutinizing of his body for sexual gratification was obviously damaging. It was an important part of what sent him into reclusion. People laughed about it, but in the accounts that trickled down the grapevine there was reason to be concerned. For a number of years it seemed like D'Angelo might not be able to make it back, that we might lose him to his demons, that he might go the way of David Ruffin.

AMONG OTHER THINGS to praise on *Black Messiah* is a protest of self-love. In a touching note we shouldn't overlook, D cracks wise: "So if you're wondering / about the shape I'm in / I hope it ain't my abdomen / that you're referring to." What's true of our mistake is also true of our body politic at large. Self-love is something we can work on and recover no matter how badly we've been bruised. Sometimes it's just that you have to go back to find your way

forward. The testament of love is what survives us, what the future looks back
to remember in the imperiled hour:

> . . . Dear D,
>
> Man, where you been all these years? Promise to tell me sometime about
> it. It's all good though. Your record is everything it's supposed to be. It's
> a point of light. Shining. We hear you and we're going back. And we're
> gonna take the country back too. Fela Kuti said, "music is the weapon of
> the future." Sometimes digging in the crates is where you find the new
> salvo. But we need you now for real. So do your thing. Be our bridge over
> troubled water. Your music gives us a glimpse of the world we want to live
> in all the time, of another life. It reminds us how beautiful the struggle
> can sound.

<div align="right">

—2015

</div>

Language and the
Black Intellectual Tradition

One can speak, then, of the fall of an empire at that moment when, though all of the paraphernalia of power remain intact and visible and seem to function, neither the citizen-subject within the gates nor the indescribable hordes outside it believe in the morality or the reality of the kingdom anymore—when no one, any longer, anywhere, aspires to the empire's standards.

—James Baldwin, "Notes from the House of Bondage"

WE ARE LIVING THROUGH a moment of national reckoning. Ugly revelations daily unravel the pieties we normally tell ourselves about America's special character, her leadership and destiny. The ship of state heaves in choppy waters, its Ahab-like captain driven by wretched obsessions. Yet the crisis is not limited to one particular political figure or any single social struggle. Rather, one feels a sense of collective dislocation, a momentous shift as Americans of all backgrounds and political persuasions feel instinctively that they are experiencing the breakup of a world they had taken for granted, the loss of assured privileges, and, to evoke a phrase James Baldwin used in the context of the contest over desegregating the South, "the end of safety." Conservative intellectuals see themselves fighting a last-ditch battle for the very soul of the country—rushing the cockpit to avert

catastrophe, the language of their metaphors revealingly warped by a still feverish and morally bankrupt usurpation of the national tragedy we have endured since 9/11 under the rubric of the War on Terror. Liberals for their part shake their heads and mutter that they no longer recognize the country at all. Discarding stereotypically bleeding hearts, they scowl at their fellow countrymen with a hardened and at times astonishingly vitriolic contempt. Progressives swing between visions of romantic liberation spearheaded by viral social protest but equally riven by sectarian virulence, proliferating micro-divisions, the ardent policing of internal dissent. On all sides a tone of apocalyptic fear-mongering is considered fair game. Against this backdrop of disarray, the coalition of ideologies we might call Trumpism has swiftly and successfully captured one of the nation's two major political parties, a good portion of the public imagination, and, of course, the summits of executive power, with as yet unforeseeable long-term consequences.

The oft-touted analogizing between this moment and the rise of fascism in Europe between the world wars must reckon with the resounding fact of that epoch's economic calamity and volatility, and our own relative economic calm, with unemployment among other significant measures not only low, but by many indications declining over the same period in which considerable social fury and political dysfunction increased.

THAT DOESN'T MEAN that economic pressures are not partly to blame, but it is to say that a monocausal explanation will not suffice. There is no doubt the financial crash of 2008 ripped a new gash in what remained of an already battered American working class that had suffered decades of decline under both Republican and Democratic leadership. The Obama administration never effectively addressed the anger ignited by the meltdown, and their technocratic assurances did little to alter the perception that they were looting the public treasury in order to prop up moneyed interests and corporations. Americans did not need to understand anything about credit default swaps to know that they had been hornswoggled. It is this precise historical juncture, when the establishment needed to step to the left and failed to do so, that Stephen Bannon identified as the breach that allowed the argument of a forceful step to the right to take hold, entering the national discourse as a narrative

of betrayal of the common man by a detached and corrupt liberal elite, with the (historically familiar) ethno-nationalist trimmings that we have come to know as the "alt-right."

Yet the fiercest anger did not initially emerge from victims of the recession. Rick Santelli, whose rant on the floor of the Chicago Mercantile Exchange was credited with launching the Tea Party movement, was not a laid-off factory worker, but a well-off trader and cable news commentator who called his fellow Americans hurt in the downturn "losers." Despite all the efforts to depict it as a working man's revolt, in 2016 it was not working-class whites, but middle-class whites with average incomes approximating $72,000 a year who formed the demographic backbone of Trump's ticket to victory at the ballot box. The internet-based alt-right coalition that pushed hard for his victory is made up of well-educated, and even highly educated, young white Americans who cannot plausibly be those who lost significant wealth, savings, and advantages in 2008. Economic woe alone, in other words, cannot account for the toxic turn in American politics that became the everyday oxygen fueling a storm of paranoid and aggrieved rhetoric clouding the nation's first black presidency. Indeed, the vitriol, hysteria, and relativistic tendencies of public discourse seemed to increase in ferocity at the close of the Obama presidency, just as economic conditions were beginning to show real signs of health. The unemployment rate in Germany in 1932 is estimated to have hovered around 30 percent. In the last year of Obama's term it went below 5 percent on a steady downward trajectory, halved from when he took office, and a rate lower than any achieved during Reagan's two terms, a period reflexively praised by the new Right as incarnating the time when America was "great" that they hoped Trump would restore.

THE STRONGEST ALTERNATIVE argument that explains our contemporary politics is the thesis that the rise of Obama to the presidency caused a decisive rupture in the American cultural imaginary. Although many observers have commented on this issue, the argument is most closely identified with Ta-Nehisi Coates and in particular his October 2017 essay, "The First White President."

Coates argued that Trump successfully seized on the "eldritch energies"

of white redemption politics, a strategy with roots in the violent overthrow of Reconstruction when black ex-slaves succeeded in incorporating themselves into the American body politic before being cast out again by Jim Crow law and lynch-mob terrorism. Trump cast himself as a new redeemer who in similar fashion would remove and correct for the anomalous stain on white honor of the first black presidency. In the absence of any history of public service, a staggering record of repugnant words and deeds, he also in effect made the restoration of white power his *unique* qualification.

As Coates puts it, Trump is "the first president whose entire political existence hinges on the fact of a black president. And so it will not suffice to say that Trump is a white man like all the others who rose to become president. He must be called by his rightful honorific—America's first white president."

But Trump's mobilization of the politics of white grievance and ressentiment can hardly be said to be either shocking or unprecedented. That playbook, as Coates himself notes, is almost a cliché of American politics. One of the shrewdest and most respected observers of the formation and political character of American democracy, Alexis de Tocqueville, thought white race prejudice the single greatest threat to the vital experiment in democracy in the New World that he championed:

> The Indians will die in isolation as they lived; but the destiny of the Negroes is in a way intertwined with that of the Europeans. Although the two races are bound to each other, they do not blend together. It is as difficult for them to separate completely as to unite. The most formidable of all the evils that threaten the future of the United States arises from the presence of Blacks on their soil. When you seek the cause of the present troubles and future dangers of the Union, you almost always end up at this first fact, from no matter where you start. . . . So after abolishing slavery, modern peoples still have to destroy three prejudices much more elusive and more tenacious than slavery: the prejudice of the master, the prejudice of race, and finally the prejudice of the white.
>
> . . . Racial prejudice seems to me stronger in the states that have abolished slavery than in those where slavery still exists, and nowhere

does it appear as intolerant as in the states where servitude has always
been unknown.

Tocqueville's point is that the problem with race cannot be solved strictly
through the solution of formal political recognition that abolition would
bring. Race prejudice is a matter of mores, of deeply ingrained attitudes that
he thinks will be even harder to stamp out than the economically motivated
exploitation and commodification of fellow human beings.

It's certainly true that Trump appealed to the deep taproots of white prej-
udice, but the model of the president as an avatar for the interests of white
virility reveals continuity with the past rather than disjuncture, with anteced-
ents in figures like Teddy Roosevelt or (as Trump acolytes appear to fancy
it) in Andrew Jackson, not to mention Andrew Johnson, who, it should be
remembered, opposed passage of the Fourteenth Amendment. Rather, it is
the model of the president as Eagle Scout, a person embodying the most noble
and aspirational characteristics of the nation, of gentlemanly statesmanship
or heroic stature acquired through military or public service that was uncer-
emoniously thrown aside in truly unprecedented fashion. The willingness of
the country to debase itself, its own self-image and self-regard for the sake of
white redemption is the most damning, and the more telling aspect of Trump's
ascension. Trump bypassed and mocked the normative conventions of Amer-
ican institutions, implicitly equating them with the bureaucratic red tape that
slows business development projects. In Trump's classically demagogic style
of rule, the ends always justify the means (if a lie helps to win, whether it's an
election or a debate or a real estate venture, you tell people what they want to
hear); people whose feelings get hurt along the way don't count; they are soft,
they are Rick Santelli's "losers"; they are both literally and figuratively objec-
tified women, handles to be groped on your way up, as you bestride the earth
putting your name down on the map, grabbing what you want on your way.

To be sure there is a good deal of evidence that the decency, good charac-
ter, and talent of the first black family in the White House renewed the vigor
of a strain of white nationalist feeling that had never been entirely dormant,
but also never faced such a prominent challenge. Obama did his best on a near-
impossible tightrope, as he tried to normalize, but not completely efface, his

blackness. He did his best to calibrate and mediate, to explain (with increasingly evident weariness and strain) the two warring sides of his country to each other.

Deploying his characteristic poise, and "brush that dirt off your shoulder" cool, Obama exercised perfect control over what he could: his persona, his political brand and message. But there was nothing he could do about the coarsening of conduct around him, and in the country at large. When it did surface, he never seemed to fully anticipate it, or to be able to bring himself to decisively confront it. Obama, like the Clintons, came into political maturity at a time when the conventional wisdom in Democratic circles was to hold up the mantle of a serious, high-minded Kennedyesque liberalism: tough on foreign policy, progressive on domestic issues (in attitude rather than substance).

His celebrated rhetorical style was poached from the Ted Sorenson textbook, updating it, depending upon circumstance, with the more contemporary Tom Friedman "big ideas," or "thought leader" style. This technocratic loftiness was praised by the commentariat; but beyond the Beltway it read as faintly antiquated and was repeatedly criticized for coming across as "aloof." His speech patterns were eloquent, but they were perfectly formatted for a media ecosystem that was just then being phased out, disassembled and scrambled by the internet and social media upstarts as consumers of news abandoned the Sunday morning talk shows for the echoing cave structures of online viewing, where, thanks to the perfection of surveillance capitalism, content is now delivered piecemeal, catered to one's predispositions. The winning formulas here are marked by shock-value tactics, clickbaiting, cynicism, vulgarity, relativism, "trolling," a puerile and distinctly geeky debate club style of interlocution where opponents get "ripped" and "reckd."

IN HIS FAREWELL ADDRESS, his last speech as the first black president of a nation that for the majority of its existence has espoused in part or in whole white supremacist values, Obama echoed George Washington's warning that we must guard our principles of self-government with "jealous anxiety," enjoining Americans "to be those anxious, jealous guardians of our democracy; to embrace the joyous task we've been given to continually try

to improve this great nation of ours." But his political party had been deci-mated at the state and local level. Americans of all stripes showed an increas-ingly jaundiced relationship to democratic ritual. Affairs of public interest never seemed more joyless, paranoid, and vindictive, the theater of Amer-ican politics more mirthless and repugnant. For all these reasons, and with the ascendant presidency of Trump as a spectral backdrop, Obama's farewell speech (with its strong dose of Capra-like optimism in civics and decency), took on an air of unintended detachment and awkward hectoring, like George Bailey rising to the stump to knock good old sense back into the people of Pottersville.

The country Obama exhorted to civic re-enchantment had experienced a massive deterioration in the nature and tone of public discourse upon which political deliberation depends. Supposedly respectable news outlets now read off Twitter feeds and cycle through opinion and hot-take reaction. Educated citizens accredit news discovered on a friend's Facebook wall or through a comedy clip, where they might previously have tuned in to listen to Gwen Ifill leading a discussion. And that is before one dives into the volcanic rage spewing up from the "comments sections," the bobble-heads of YouTube, the trolls of Reddit, the chat-room warriors, the motormouths of talk radio. The Orwellian neologism of "fake news," a phrase the critic Tobi Haslett rightly calls "a rhetorical teargas," was deployed against a press corps that has taken the bait hook, line, and sinker as they mount an imaginary barricade from which in the stinging fog they can see nothing and are of use to no one.

The federal state apparatus likewise has spiraled into a netherworld of palace intrigue, of investigation and counter-investigation, spy vs. spy, of murky dossiers, planted leaks, various factions of the state's intelligence ser-vices duking it out with each other on cable television as they seek in Joan Didion's perfect words to "run the story." The "Russia investigation" and the attempts to derail it are not only what we talk about instead of talking about poverty, or education, or mass incarceration; they are the stuff of imperial courts, the intrigue of Versailles: they are what fills and spews out of the abscess of a republican democracy in decay.

Many have wondered in this bewildering and fractious atmosphere at the resurgence of passionate interest in the life and writings of James Baldwin.

Ta-Nehisi Coates turned to him to reinvigorate a style of address he could not believe we had so carelessly discarded. The results are electrifying, and not just for the critical establishment: his books are best sellers. The Baldwin renaissance shows that there's a deep yearning in our society not only for sensate, intelligent, moral reasoning, but also for the prophetic witness unique to the black radical tradition. By tapping into it, Coates cleared the air in a public sphere crowded with shrill and shallow analysis. Even when people openly disagree with him, as I have, they respect and perhaps fear the rhetorical power that crackles in his prose like fire behind a furnace door. They recognize that he is carrying the torch of the black intellectual, and though they may seek to deny it, they know in their hearts that its flame is the essential, foundational ingredient of our country's moral and political imagination. Indeed, where would we be without Sojourner's assertion of truth, Douglass's stand for freedom, Ida's crusade against lynching, Baldwin's difficult love, King's table of brotherhood, Fannie Lou Hamer's fire?

Perhaps the black intellectual we still have the most to learn from is David Walker. Born in 1796 in Wilmington, North Carolina, in a community composed of both enslaved and skilled free blacks, Walker grew up in a relatively mobile black community with deep ties to the shipbuilding and maritime trades important to that city. We know that as a young man he moved to Charleston where he first became affiliated with the new African Methodist Episcopal Church that Bishop Richard Allen had just founded in 1816. We know that he traveled up the Eastern Seaboard likely making use of the close ties binding the black Atlantic communities in cities like Baltimore, Philadelphia, and New York. He arrived in Boston in 1825 and set up a second-hand clothes store in the black neighborhood of Boston that occupied the area to the north of Beacon Hill, occupying much of what is now the complex for Massachusetts General Hospital.

Walker was immediately active in abolitionist circles and the underground resistance movement to the slave power. He was the Boston agent or representative of *Freedom's Journal*, the first African American newspaper, founded by Peter Williams Jr. and edited by John Russwurm and Sam Cornish out of New York City, which ran from 1827 to 1829.

In 1829 Walker published his famous *Appeal* dedicated "To the Colored

Citizens of the World, But In Particular, and Very Expressly, to Those of the United States of America." Walker's use of the term "citizen" here is extraordinarily important in a context in which citizenship for Blacks was still largely unthinkable, even an oxymoron, as the Supreme Court would confirm in Dred Scott in 1857. Walker's Appeal is part of the major thrust of free black intellectuals who in the 1820s were determined to have a voice in the mounting tensions, debates, and conflicts in the public sphere over the fate of African America. They realized that momentous decisions about the fate of black folks hung in the balance. In particular the question of emigration, which would continue to be debated among black leaders throughout the nineteenth century. The ACS, the American Colonization Society, was championed by some of the most powerful figures in American politics at that time including James Monroe, Abraham Lincoln, and Henry Clay, senator from Kentucky and secretary of state to John Quincy Adams during Walker's years in Boston. A desire to evacuate the rising number of manumitted blacks in the Upper South and North back to Africa was stimulated by the rising threat of massive and retaliatory slave revolts (notably Gabriel's suppressed revolt of 1800 in Richmond, Virginia, and Denmark Vesey's 1822 plot in Charleston, South Carolina). These plots were informed and modeled on the successful Revolutionary War for Freedom and Independence carried out against the French on Saint-Domingue by Toussaint Louverture and Jean-Jacques Dessalines that gave birth to the republic of Haiti in 1804. The height of the ACS support for emigration coincides with this tumultuous period; the American colony of Liberia was founded by the ACS in 1822.

In the *Appeal* David Walker mounts an extensive and erudite refutation of Thomas Jefferson's attacks on the intelligence and character of blacks in *Notes on the State of Virginia*, notably Jefferson's contention that Phillis Wheatley cannot have written poetry because blacks are incapable of feeling love. But Walker's main concern, which he devotes a good third of the *Appeal* to prosecuting, is to persuade his fellow black Americans to refuse to be lured in by the siren calls of Henry Clay and his associates in the American Colonization scheme. I will not rehearse all of his arguments here, that is not our concern. However, some of his language, and some of his thinking, informs what is at least my own interpretation of one deep and enduring strand of what the late

historian Cedric Robinson called the Black Radical Tradition. For me the key passage in Walker has to do with how the descendants of American slaves have viewed our relationship to the nation into which we are born. Here is Walker taking aim directly at Clay and the ACS mixing his exhortation with a characteristic militancy:

> Will any of us leave our homes and go to Africa? I hope not. Let them commence their attack upon us as they did on our brethren in Ohio, driving and beating us from our country, and my soul for theirs, they will have enough of it. Let no man of us budge one step, and let slave-holders come to beat us from our country. America is more our country, than it is the whites—we have enriched it with our *blood and tears*. The greatest riches in all America have arisen from our blood and tears:—and will they drive us from our property and homes, which we have earned with our *blood*? They must look sharp or this very thing will bring swift destruction upon them.

When I learned about the now infamous Unite the Right rallies taking place in the summer of 2017 in Charlottesville, Virginia, and the widely cir-culated videotape of white men in ill-fitting khaki pants and tiki torches chanting Hitler's National Socialist slogan, "Blood and Soil," I immediately thought of Walker's alternative formulation of "Blood and Tears," both for the affective difference they imply in the bond between person and place, but also the comfort I take personally in the painfully obvious argumentative fail-ure that must weigh on America's boldest racists. An argument about whose blood is in the soil of this country is not an argument a white supremacist is going to win. Beyond the question of rhetoric, however, there is the messianic and appropriative conception of identity that Walker bequeaths us. He views, as I do, black Americans as a people bearing a unique historic destiny, a role to play in the history of the world that has everything to do with how we shape the country that we find ourselves in. To understand the country as moved fundamentally by the dialectic of a racial history should not really be so dif-ficult to see; but crucially it is black Americans as often as whites who more often than not have never been able to see or articulate this self-conception,

who have been encouraged to see themselves as hopelessly held hostage to a power they cannot move, rather than agents with a revolutionary role to play in the distribution of social equality, the form and tenor of a more egalitarian culture, and the nurturing of the intellectual foundations of a world destined in the coming years to shift away from several centuries of essentially European domination.

WALKER DIED IN 1830, either from illness or from poisoning by Southern agents determined to silence him. His *Appeal* got reprinted and read by abolitionists and powerful black leaders in the nineteenth century like Henry Highland Garnet and Frederick Douglass, but the text has never found its way into the mainstream American imagination. Like many intellectuals, Walker is in some ways too learned, too comprehensive and complex in his thinking, to be popular, despite his populist leanings.

The conundrum of the black intellectual has persisted. Indeed, the path of the black intellectual is unenviable, often appearing at cross-purposes with one's self-understanding. It has been in a state of "crisis" since at least 1967, if one goes back to Harold Cruse's famous title of that year, *The Crisis of the Negro Intellectual*. In the evocative words of Hortense Spillers, who no less than bell hooks has remained one of the leading black intellectuals of the last thirty years, the black intellectual finds herself "an uncanny site of contradictions." However defined, the path is fraught on all sides. Will white readers sample you as the "black spokesman du jour," the latest remedy for soothing their conscience? And how will you do right by a world of dire circumstances and life-threatening urgency that you are as ill-equipped to transform as most anyone, even though you might be (slightly) better positioned to speak about it? Harold Cruse for his part had some definite feelings on the matter:

> The special function of the Negro intellectual is a cultural one. He should take to the rostrum and assail the stultifying blight of the commercially depraved white middle class who has poisoned the structural roots of the American ethos and transformed the American people into a nation of intellectual dolts. He should explain the economic and institutional causes of this American cultural depravity.

He should tell black America how and why Negroes are trapped in this cultural degeneracy, and how it has dehumanized their essential identity, squeezed the lifeblood of their inherited cultural ingredients out of them, and then relegated them to the cultural slums. They should tell this brainwashed white America, this "nation of sheep," this overfed, overdeveloped, overprivileged (but culturally pauperized) federation of unassimilated European remnants that their days of grace are numbered.

This is a tall order, but also a genuine challenge. The black radical tradition in this country has never merely asked for redress or understanding, or as I have elsewhere argued, strictly monetary reparations. The tradition questions the nation's self-understanding, and in so doing claims for itself—the tradition, not the person who happens to invoke it—a moral authority grounded largely in a Christian ethics, an authority based on witness, suffering, perseverance, and vigilance.

Coates's diagnostic in the light of the tradition that he writes out of is unsurprising in its conclusions. The fatalism of his attitude does, however, mark a shift. There's nothing wrong with that—we should welcome and seek to understand new directions in black thought. But I also think Coates has to acknowledge that his predecessors make his own work possible, and if they could imagine and make a way for him, then he ought to think at least as hard about what he in turn can do to push beyond the impasse that his work repeatedly gravitates toward, which raises our anguish only to leave us fatally stranded.

My concern is any tendency that threatens, as I think it might well do, to prove de-politicizing. And there is no question that pessimism will undoubtedly continue to flourish if the avenue of pragmatic political participation remains as dispiriting as it currently is. This is why I think a major task of black intellectuals is forcing a reckoning between the interests of black Americans and those of the Democratic Party. The insurgent movement by young black conservatives to peel off black voters should not be lightly dismissed.

Clintonite triangulation has been devastating to black communities, and blacks, as so often, are increasingly open about the fact that they find them-

selves politically homeless. Their support of Obama, as Coates perceptively chronicled, often came despite a rhetoric that alienated them. During the Obama years, black disappointment could be mitigated by the satisfaction of voting for a black president. That enthusiasm will not be replicated.

In his assessment of the Trump election, Coates vents his frustration over the national obsession with working-class whites as the main protagonist of American politics, and in this regard he is again justified. But it would be equally foolish to pretend that the largest demographic bloc in the US population can simply be dispensed with by fine-tuning an electoral calculus or abolishing the Electoral College. Any sincere and realistic political project will have to talk to those people, and not just talk *at* them—they have to be appealed to and won over; that's what the art of politics is about. The best answer to white supremacy is to go about creating what it fears. It's to do the work of building solidarity, even in the form of antagonistic cooperation; to link struggles and build up popular-front movements that speak to the interests of the downtrodden and disinherited.

Consider the following sentence from "The First White President": "White workers are not divided by the fact of labor from other white demographics; they are divided from all other laborers by the fact of their whiteness." Yet some of the evidence Coates cites in his own essay seems to undermine that first clause. For instance, the wide gap in educational attainment of a college degree between Trump and non-Trump white voters is quite obviously a substantial marker of a class divide. One could draw up a list of other data points, including incarceration rates and geographic mobility, but it's not really necessary, because Coates isn't saying that a white working class doesn't exist; he's saying that a *virtuous* white working class, unmotivated by racism, is a myth, one chiefly created and perpetuated by wealthy white liberals with a bad conscience. I entirely agree.

Still, this moment in his essay is worth examining more closely. For why can't both halves of Coates's sentence be true? That white workers *are* divided from other whites by their class rank, *and* that they are also divided from all other laborers by their whiteness? What stands in the way of an overlapping conjunction of class and racial markers, as opposed to a story that Coates feels he needs to tell about the triumph of one over the other? The answer most

readily supplied by the structure of his essay is that he's engaged in a battle with commentators and journalists whom he sees, often quite rightly, as de facto apologists for white working-class racism; if they will overstate the case of class, he must counter with the overstatement of race. It's understandable as a matter of tactics, and in a loud and diffuse public sphere perhaps it is necessary to get a point across. But the truth of our present miserable politics lies, I think, precisely in our inability or unwillingness to parse these aspects out clearly and address both in tandem.

Bringing an agenda focused on poverty, on social vulnerability to drugs and violence, on education and civic pride—making the vast numbers of both black and white working-class citizens the engine and focus of the party's interests instead of the consulting and Wall Street firms is a matter of vital necessity.

How could that be done? One way would be to reinvigorate the campaign for the nation's soul that was being waged at the height of the revolutionary fervor of the 1960s, the vision for a spiritual regeneration that was violently cut down. To return and renew the work Martin Luther King Jr. was doing when he was murdered fifty-one years ago at the height of a never-completed campaign to dismantle unnecessary poverty, disenthrall the state from militarism, and dislodge the power of avarice and racial hatred from our politics.

The Poor People's Campaign of 2018 has issued "a national call for moral revival" and already begun serious political mobilization, descending upon state capitol buildings across the country to peacefully protest and make their voices heard. Led by the Reverend Dr. Liz Theoharis and the Reverend Dr. William J. Barber II, the movement grew out of the "Moral Mondays" protests supported by the NAACP that began in North Carolina in 2013.

On April 2, 2017, Reverend Barber delivered a sermon at Riverside Church in New York City called "When Silence Is Not an Option" that paid homage to King's April 4, 1967, Riverside address, "A Time to Break Silence." Exactly one year before his assassination, King publicly broke with the Johnson administration by denouncing the war in Vietnam, calling for "a radical revolution of values" and warning that "when machines and computers, profit motives and property rights, are considered more important than

people, the giant triplets of racism, extreme materialism and militarism are incapable of being conquered." Thundering from the pulpit half a century on, the Reverend Barber reminded his audience of this radical King and, by way of the biblical parable of the valley of the dry bones, he enjoined them to breathe life into the dry bones scattered across the country:

> Silence is not an option because we *must* have a living word . . . not just an analysis of the pain, but a word that points us toward the kind of subversive hope that gives people the possibility to fight up out of valleys of dry bones. We must dare to raise the question: Is America possible? . . . And then we must say *yes*, and join our place among the generations before us who faced and had to raise the same questions against odds that were much greater than the ones we face today. If they said something in the face of slavery, if they said something in the face of Jim Crow, if people said something in the face of the Holocaust, if they said something in the face of apartheid, *surely* we can say something and sound a living word.

I believe that Ta-Nehisi Coates is not wrong about the white redemption politics of Trump or the importance of racial animus and its role in Trump's rise to power. Nor is he wrong to say that it is also the central dialectic of American history, conditioning and revealing our most intense contradictions, our most vicious crimes, our unique endurance, our character and our fate. But his analysis always seems to end precisely where I think we ought to begin: where the tradition of black radical organizing and subversive hope has taken up the burden that the white leaders of this country have, since 1787, simply kicked down the road. What of our magnificent insistence that we will pull this country into righteousness and justice by our own hands, by our own words and deeds and witness, by any means necessary? Not out of naïve optimism about the grand intellectual project of the Enlightenment; not out of a sentimental faith in the innate goodness of our former masters; not out of a facile comfort in providence or a self-loathing desire to improve ourselves; not because the universe necessarily bends in a hopeful direction, whatever that might mean.

Our tradition impels us and gives us confidence quite simply because our souls look back in wonder; because we are endowed at birth with that special vertigo inherited from our foremothers and forefathers; *how they got over*; how they came through "the blood-stained gate"; how they made a way out of no way; what it cost to be alive; to be unbroken in spirit; to know the value of freedom; to know one another's beauty in a world ceaselessly mocking and denigrating its dignity; and yes, to laugh like Zora and sharpen our oyster knives—the price of the ticket paid.

A little over a century ago, W. E. B. Du Bois prodded white America in words that echoed those of David Walker's in 1829: "Your country? How came it yours?" He continued: "Around us the history of the land has centered for thrice a hundred years; out of the nation's heart we have called all that was best to throttle and subdue all that was worst." That "we" is a proud black people whose labor and indomitable determination made the very notion of American greatness possible.

One should never underestimate the force of black love for this country. Not for its flag, or its army, or its national anthem, nor any of the other superficialities trotted out by jingoists, hucksters, and political opportunists; but our love for the people—the everyday people of America, which is so obvious in the gift of our music, our irrepressible desire to see people free to be themselves, free from bondage of every kind. It is, as Baldwin understood, a love that is greater than the sum of all the violence directed against it, the rash of slander and injustice that ever threatens to break out and destroy the black soulfulness that proves the foundational lie of American slavery and the mentalities slavery bequeathed.

In *The Fire Next Time,* James Baldwin ends his letter to his nephew by reminding him that he too has a rich inheritance to draw upon:

> It will be hard, James, but you come from sturdy peasant stock, men who picked cotton, dammed rivers, built railroads, and in the teeth of the most terrifying odds, achieved an unassailable and monumental dignity. You come from a long line of great poets, some of the greatest poets since Homer. One of them said, "The very time I thought I was lost, my dungeon shook and my chains fell off."

When Baldwin tells his nephew that the black folk whose survival and endurance have brought him forth are poets, he has in mind not the narrow sense of writers of verse, but the largest sense of the word in its Greek root *poiesis*: the will to make, to create, to transform. His invocation of the spiritual "My Dungeon Shook" is meant to serve as a reminder that the moment of fiercest despair can also be the catalyst for piercing clarity, for action and self-liberation. One day, the American state will be forced to acknowledge that black lives matter. Coates is deeply skeptical of this ever happening, and understandably so. But like all those who have taken up the pen to strike at America's racial injustice, he is also the inheritor of a proud tradition that has relentlessly and defiantly believed that we have it in our means to break the spell of oppression, and that speaking truth to power is not an act of despair, but one of candescence.

This is the task of the black intellectual today. To remind us of our own resources, as Imani Perry so beautifully has in her book *Breathe* dedicated to the raising of her sons, or her biography of Lorraine Hansberry, or her history of James Weldon Johnson's Negro National Anthem, "Lift Every Voice and Sing." To renovate neighborhoods with what is at hand, as the artist Theaster Gates is doing by binding together artistic, social, and communal revival as a unified project on the South Side of Chicago. To teach the foundations of a tradition of thought and social struggle both in prisons and at elite universities as Cornel West does; to meditate on the role of race in American art, literature, cultural, and political discourse as Toni Morrison continued to do to the end of her life.

The pragmatic question today is how to return the great force of this tradition into our political body, into our political culture, our rhetoric, our candidates, our meetings and conversations, our workplaces and relationships. We have a moral language and a popular tongue at our disposal—but we need to learn to use it again. The language of our politics should come from the street, not from think tanks, think pieces, not the academy. Our ordinary words are already spiritual and moral; we can carry them into the public square and be respectful and confident, open and engaged, not fearful, controlling, or defensive. And for those who doubt whether this can come to pass, or believe mine is simply another empty rhetorical exercise, I would ask

you to look to the Poor People's Campaign begun in 2018; listen to the folks who are assembled under its banner; consider their backgrounds, racial and otherwise; listen to how they talk; listen to the Reverend Barber sermonize; ask yourself if you really believe these people assembled in moral indignation at poverty are wrongheaded; ask yourself what would be possible if ever such a movement swept like a prairie fire through the nation. Ask yourself, too, why neither the Democratic or Republican party has put their weight behind that movement. Why none of the major organs of the liberal or conservative press have taken an interest in covering their actions.

In some respects, I will grant, the outlook for a black intellectual might look particularly bleak at this hour. I do not underestimate the task and the challenges that face us. I do not doubt the specter of white supremacy haunting the corridors of American power is a clear and present danger. But I also know the song-lit race that American slavery ignited carries an even more powerful and precious light, and it cannot be put out.

—2018

III

Black culture is critical culture.

—Hortense Spillers

Underground Man

COLSON WHITEHEAD HAS written a zombie-apocalypse novel, a coming-of-age novel set in the world of the black elite, a satiric allegory following a nomenclature consultant, a sprawling epic tracing the legend of the African American folk hero John Henry, a suite of lyrical essays in honor of New York City, and an account of drear and self-loathing in Las Vegas while losing $10,000 at the World Poker Series. In an era when commercial pressure reinforces the writerly instinct to cultivate a recognizable "voice," his astonishingly varied output, coupled with highly polished, virtuosic prose, makes Whitehead one of the most ambitious and unpredictable authors working today.

Whitehead has gained a reputation as a literary chameleon, deftly blurring the lines between literary and genre fiction, and using his uncanny abilities to inhabit and reinvent conventional frames in order to explore the themes of race, technology, history, and popular culture that continually resurface in his work. In a country where reading habits and reading publics are still more segregated than we often care to admit, his books enjoy a considerable crossover appeal. His first novel, *The Intuitionist*, is a detective story that regularly turns up in college courses; the zombie thriller *Zone One* drew praise from literary critics and genre fiction fans alike; *Sag Harbor*, about black privileged kids coming of age in the 1980s, was a surprise bestseller.

Beyond the books, Whitehead swims effortlessly in the hyper-connected moment: he maintains an active presence on Twitter, where his sly and dyspeptic observations on the curious and the mundane have gained him a devoted

following. A sampling includes sagacious tips for the aspiring writer—"Epigraphs are always better than what follows. Pick crappy epigraphs so you don't look bad"—and riffs on Ezra Pound: "The apparition of these faces in the crowd / Petals on a wet, black bough / Probably hasn't been gentrified though." In the pages of the *New York Times Magazine* and the *New Yorker*, he has wryly dissected contemporary mores and the light-speed metamorphoses of language in the age of social media. In a widely shared essay from last year, he parsed the current attachment to the "tautophrase," as in "you do you" and "it is what it is." Or Taylor Swift's popularization of "Haters gonna hate." Swift makes an easy target, of course, but Whitehead takes aim at the rhetoric of those in power too, and the narcissism in our culture more generally. He's more gadfly than moralist, but there is a Voltaire-like venom to his sarcasms. "The modern tautophrase empowers the individual," he observes, "regardless of how shallow that individual is."

At forty-six, Whitehead is approaching the midpoint of a successful writing career. He exudes the confidence and ease of a man settled in his craft, and for that reason is also inherently restless, driven to test his limits and keep himself vivid. In recent years, some observers have questioned whether he was taking up subjects rich and deserving enough of his abilities. Dwight Garner, in his review of *The Noble Hustle* (the poker book), vividly praised Whitehead's talent—"You could point him at anything—a carwash, a bake sale, the cleaning of snot from a toddler's face—and I'd probably line up to read his account"—while making it very clear he felt it was being wasted. Garner called the book "a throwaway, a bluff, a large bet on a small hand," and questioned the sincerity of the undertaking: "You can sense that he's half embarrassed to be writing it."

As if to answer that criticism, Whitehead's new novel, *The Underground Railroad*, pursues perhaps the most formidable challenge of all: taking readers through "the blood-stained gate," as Frederick Douglass called it, onto the historical ground of American slavery. The uncompromising result is at once dazzling and disorienting, the work of a writer flexing, firing on all cylinders.

DURING A RECENT CONVERSATION at an Italian café in the West Village, Whitehead at times seemed slightly distracted. It's clear he does not enjoy

talking about himself. He has always been highly skeptical of confessional modes. When he gives public talks, he likes to tell the audience he was born poor in the South—and then reveal he's just quoting Steve Martin from *The Jerk* (in which Martin plays a white man who believes he is born to a family of black sharecroppers). "I never liked Holden Caufield, *The Catcher in the Rye*," he declares with a wink in his eye, in a promotional video for his most autobiographical book, *Sag Harbor*. "I feel like if he'd just been given some Prozac or an Xbox, it would have been a much shorter book, and a much better book."

In person, this stance becomes a kind of awkward warmth, even nerdiness: the eccentricity of the "blithely gifted," to borrow John Updike's 2001 assessment of "the young African-American writer to watch." In dark blue jeans, his dreadlocks draping over a crisp white shirt, his glance slightly diffident behind neat glasses, Colson Whitehead is unmistakably a New Yorker— from Manhattan. He speaks in the native tongue—a streetwise blend of ironic nonchalance and snappy precision, a jolting rhythm not unlike that of the subway, always with an eye toward the next stop.

Whitehead was born in New York City and grew up mostly on the Upper West Side. He lives in Brooklyn now, but recalls Manhattan with affection. "I like how Broadway gets really wide up there, how close the Hudson is," he says. "I'd live up there again if I could afford it." Asked what it was like growing up, *back in the day*, he brushes off the perceived roughness of that era: "New York was pretty run-down in the '70s and '80s, but if you think that's what a city looks like because you don't know anything else, then it seems normal. When I got out of college, I lived in the East Village and on cracked-out blocks in Brooklyn, and that seemed pretty normal, too."

He paints a picture of a loving and kind of average household. He was always surrounded by readers. "My mother reads a lot, and I had two older sisters, so their hand-me-down libraries were always around. I didn't need to be pushed." In a rare autobiographical essay, "A Psychotronic Childhood," he has described how this period of his life was deeply saturated by television, comics, and the "slasher" and "splatter" flicks, then in vogue, that he watched in New York's B-movie theaters. A self-described "shut-in," he "preferred to lie on the living-room carpet, watching horror movies," where one could acquire "an education on the subjects of sapphic vampires and ill-considered

head transplants" while snacking "on Oscar Mayer baloney, which I rolled into cigarette-size payloads of processed meat." Unsurprisingly, he read "a lot of commercial fiction, Stephen King—the first thick (to me) book I read was in fifth grade, King's *Night Shift*. I read that over and over." His early literary ambitions, he has said, were simple: "Put 'the black' in front of [the title of] every Stephen King novel, that's what I wanted to do."

After graduating from Trinity School, Whitehead entered Harvard. It was the late 1980s, and the way he tells it makes it sound like he was a poster boy for Gen X slackerdom. (The archetype must feel almost quaint to the hyper-networking Zuckerberg generation.) It's not that he didn't enjoy his time at Harvard—he did attend his twenty-fifth reunion, he informed me— but he seems to have been determined not to try too hard to be involved in anything, or to stand out in any way. He read in his room a lot, he says, absorbing a wide range of things. But it was the way he was absorbing these strains that is most revealing: "I think it helped that, for my first exposure to Beckett, I took it to be a form of high realism. A guy is buried up to his neck in sand and can't move; he has an itch on his leg he can't scratch. That sounds like Monday morning to me." (Responding to the suggestion that his novels suggest the influence of Ralph Ellison and Thomas Pynchon, Whitehead is noncommittal but open to the idea: "What excited me about writers like Ellison and Pynchon was the way you could use fantasy and still get at social and political themes," he says. "That was very revealing to me . . . like here's this serious book on race, but it has all this wild stuff in it.")

At Harvard, Whitehead played the role of young aspiring writer the way he imagined it. The results were not necessarily promising. "I considered myself a writer, but I didn't actually write anything," he says. "I wore black and smoked cigarettes, but I didn't actually sit down and write, which apparently is part of the process of writing." He applied to creative-writing seminars twice—and failed to get in both times.

The most important undergraduate legacy has been his lasting friendship with Kevin Young, an aspiring, charismatic poet from Kansas who was already involved with The Dark Room Collective, a gathering of young black writers that has played a major role in shaping contemporary poetry during the past two decades. Whitehead, never more than peripherally involved,

says, "Kevin was always more serious than I was. He already knew where he was going, what he was about. . . . I wasn't much of team player."

After graduation, Whitehead gravitated back to New York City. He went to work at the *Village Voice*, writing album reviews and television criticism. He soon mastered the magazine's signature downtown stir-fry of pop-culture fluency, melding high- and lowbrow, theory and snark, punk and hip-hop: an inevitable rite of passage, given his influences. "I came up in the seventies and eighties reading *CREEM* ["America's Only Rock 'n' Roll Magazine"], stuff like that, so I knew pretty early on that I wanted to be involved in that scene," he says. Working in the book section at the *Voice*, he says, "was where I learned how to be a writer."

That writer debuted in 1999 to instant acclaim with the disquieting *The Intuitionist,* set in an unspecified midcentury Gotham, a noir metropolis straight out of Jules Dassin and Fritz Lang. In its conceit, the world of elevator inspectors is divided between rival schools: Empiricists, who work by collecting data and making methodical observations; and Intuitionists, a minority of gifted inspectors who have a second sight that allows them to read elevator mechanics intuitively—an ability scorned and feared by the dominant faction. The novel follows Lila Mae Watson, a member of the Department of Elevator Inspectors, as she tries to solve the case of a suspicious crash, and also untangle the mysterious aphorisms of one James Fulton, whose gnomic text, *Theoretical Elevators,* may provide clues to a secret about its author and the nature of Intuitionism itself. It's impossible not to like Lila Mae, a black woman occupying a role stereotypically identified with the square-jawed private eye, who uses her cool and wits to navigate this murky underworld and stay one step ahead of the men trying to frame her. Part of the fun is in the writing itself. Whitehead's prose oscillates playfully between the pulpy, telegraphic neo-noir à la James Ellroy and the allegorical ruminations of Ralph Ellison's *Invisible Man*.

This gives the novel a slippery feeling, a cool detachment that makes it easier to admire than to love. It's as though Whitehead built that book on the principles of stealth technology, every facet rigorously designed to achieve what it is also about: a game of camouflage and detection, the irony of invisibility in plain sight. His interest in unstable visibility suggests the theme of

racial passing, a concern with a long history in the African American novel. As the scholar Michele Elam pointed out, *The Intuitionist* can be read as "a passing novel in both form and content." The familiar hard-boiled detective plot turns out to be merely a lure, a skin-thin surface masking a speculative novel of ideas.

As a first novel, *The Intuitionist* registered as a shot across the bow, as though Whitehead were daring readers to box him in. It was also a first glimpse of what has since become something of an authorial signature: an ironic deployment of genre as a mask for an eccentric but also cutting vision of American culture. It's an approach that can remind one of Thomas Pynchon in novels like *The Crying of Lot 49* (critics have compared its heroine Oedipa Maas to Lila Mae Watson) and *Inherent Vice*; or to the filmmaking of the Coen brothers, with their affectionate but sinister parodies of Hollywood noir in *Barton Fink* or *Fargo*. Like them, Whitehead delights in recasting the iconography of Americana, troubling its conventions and clichés by pressing them to their limits, and releasing that energy in the form of bleak satire and an impassive attitude toward violence.

In 2008, novelist Charles Johnson published an essay in the *American Scholar* titled "The End of the Black American Narrative," in which he argued that the history of slavery in America had become a crutch for understanding any and all experiences of black life—that at the dawn of the twenty-first century it had "outlived its usefulness as a tool of interpretation," and should be discarded in favor of "new and better stories, new concepts, and new vocabularies and grammar based not on the past but on the dangerous, exciting, and unexplored present." It's an argument that has analogs in academic circles as well, where a movement around Afropessimism has prompted debates in recent years over whether contemporary black life can ever transcend the historical experience of slavery. Whitehead hasn't read the essay, but he says the argument makes sense to him if it means black writers need to have the freedom to write whatever and however they want. (He resists attempts to theorize his own work, and it's clear he's fairly allergic to the scholarly efforts to categorize his literature. He's an excellent parodist and, whether aiming his wit at the sophistications of academic vernacular or the flummery of marketing lingo, he's a master at deconstructing jargons.

Yet his work has been viewed along these lines. His 2009 coming-of-age novel, *Sag Harbor*, follows a group of "bougie" black kids as they try to survive the summer of 1985 in the black enclave their parents have carved out in the Hamptons. A good part of the comedy revolves around the ways the main character, Benji Cooper, and his friends try and fail to act "authentically black": city boys with toy BB guns awkwardly grasping at gangsta status. Reviewing the novel, journalist and cultural critic Touré, known for popularizing the term "post blackness," inducted Whitehead into a constellation of figures opening up the scripts of blackness: "now Kanye, Questlove, Santigold, Zadie Smith and Colson Whitehead can do blackness their way without fear of being branded pseudo or incognegro," he declared.

"Post-blackness" should not be confused with the "postracial." "We'll be postracial when we're all dead," Whitehead quips, alluding to *Zone One* (2008), in which his hero, an Everyman nicknamed Mark Spitz, is part of a sweeper unit clearing out the undead in post-apocalyptic downtown Manhattan. In fact, no one has more deliciously julienned this particular bit of cant. In a 2009 *New York Times* essay, "The Year of Living Postracially," Whitehead offered himself to the Obama administration as a "secretary of postracial affairs," who like the hero of his 2006 novel *Apex Hides the Hurt*, will rebrand cultural artifacts to meet new societal standards. *"Diff'rent Strokes* and *What's Happening!!* will now be known as *Different Strokes* and *What Is Happening?"* he suggested, and Spike Lee's *Do The Right Thing* would be recast with "multicultural Brooklyn writers—subletting realists, couch-surfing postmodernists, landlords whose métier is haiku—getting together on a mildly hot summer afternoon, not too humid, to host a block party, the proceeds of which go to a charity for restless leg syndrome . . ." The essay suggests the influence of Ishmael Reed, whose hallucinatory satires mine the absurdities of racism for comic effect, highlighting how their surreal and grotesque contortions are refracted in language and sublimated in collective phantasmagorias: television shows, music videos, and the movies.

The critic James Wood has complained about a "filmic" quality in Whitehead's writing. It is undeniable—but younger readers may find that that quality is its own kind of literacy, a clear picture where Wood sees only static. Rightly or not, there is something contemporary and vivid in Whitehead's

direct apprehension of the way lives are overdetermined and bound by chains of mediated images. It's a gambit that has surfaced as a question for the contemporary novel before: David Foster Wallace famously worried that television had repurposed irony to commercial ends, defanging it as a weapon in fiction. Whitehead has drawn just the opposite lesson, wagering that irony not only sustains the postmodern novel—but that it can even deepen the stain of allegory.

Can this ironic method successfully take on American slavery? It might seem intimidating, perhaps even overwhelming, to write about a subject where the stakes feel so high. In recent years, the history of slavery, never far from the surface of American life, has seeped back into popular consciousness with renewed urgency. On television, *Underground*, which debuted this spring, follows the fugitive slave trail; and this past spring The History Channel remade *Roots*, the groundbreaking 1977 miniseries based on Alex Haley's novel. On film, black directors are also thrusting slavery to the fore, notably Steve McQueen in *12 Years a Slave* (2013) and now Nate Parker's *The Birth of a Nation* (2016), about Nat Turner's rebellion. This year has also brought at least two other novels that will frame the reception of Whitehead's: Yaa Gyasi's *Homegoing* reconsiders how African identities interlock but also diverge from the "black narrative"; Ben H. Winters's *Underground Airlines* imagines a counterfactual history in which the Civil War never took place, and bounty hunters roam a contemporary United States seeking runaways. And all this still pales before the inevitable comparisons with major writers on the same theme. Whitehead anticipates these questions, and instantly brushes aside comparisons. "You have to do your own thing, right? Morrison already wrote *Beloved;* you're not going to compete with that. I have to write the book that makes sense to me, that's entirely my own vision."

The Underground Railroad follows Cora, a slave on a cotton plantation in Georgia, as she makes a break for freedom. She becomes a runaway, a "passenger" who must elude capture as she makes her way northward on the famous Underground Railroad—in Whitehead's conceit, made literal rather than metaphorical. "When I was a kid I always thought it was a real railroad," he says with a flashing grin. It's a testament to the power of metaphor, and, like the ghost in Morrison's *Beloved* that haunts the former slaves of Sweet

Home plantation even as they try to re-create their new lives in freedom, it marks an assertion of the novelist's supreme freedom: the freedom that allows fiction to breathe and stand on its own, and writers to carve out a personal dimension within material fraught with communal and ideological strictures.

If *The Underground Railroad* seems to give in to the inescapable pull of "the black narrative" that Whitehead had been celebrated for evading, the new novel isn't as new it may appear. "This project has been on my mind for at least ten years," Whitehead says. "I started thinking about it around the time I was doing *John Henry Days* but I set it aside. I didn't feel like I was ready yet to tackle it, the way I was writing then. . . . I'm much more into concision now, in my writing, and I think this book needed that."

For it, Whitehead did a good deal of research—looking to Eric Foner's *Gateway to Freedom* (2015) to depict the cat-and-mouse game between slave-catchers and freemen scouting for runaways along the docks of New York Harbor, and reading the Works Progress Administration's collection of slave narratives for material details of slave life. But above all, Whitehead drew on the rich literary history to which he is adding a new chapter, refashioning famous scenes in Harriet Beecher Stowe's *Uncle Tom's Cabin* and Harriet Jacobs's *Incidents in the Life of a Slave Girl*—especially her account of seven years spent hiding in an attic (a passage he singled out as having profoundly marked him when he read it in college). The ominous figure of the slave-catcher Ridgeway suggests more recent antecedents. Cormac McCarthy's *Blood Meridian*, with its vision of bounty hunters chasing scalps on an American frontier steeped in apocalyptic gore, echoes in Whitehead's chronicling of the orgiastic violence that haunts the hunting grounds of slavery.

The novel explicitly links slavery to the engine of global capitalism. The theme has gained prominence in recent years, notably through studies by historians like Walter Johnson and Sven Beckert, which have enlarged the context for our understanding of slavery and resuscitated neglected arguments put forth at least a generation earlier by black Marxists like Eric Williams and Cedric Robinson. The idea of a capitalist drive behind slavery always seemed intuitive to Whitehead, he says. "Being from New York," he suggests, "you can see the drive for exploitation all around you. It just always seemed obvious to me."

Rather than centering on one site or aspect of slavery, *The Underground Railroad* presents readers with a kind of composite. The novel proceeds episodically, with each stage of Cora's voyage presenting a variation on the conditions of enslavement and emancipation. Caesar, a fellow slave on the Randall plantation who encourages Cora to run away with him, compares their predicament to that of Gulliver, whose book of travels his more lenient master has allowed him to read. He foresees a flight "from one troublesome island to the next, never recognizing where he was, until the world ran out." This sense of variation on a theme—with no exit in sight—creates a sense of blind forward propulsion without "progress": scenes of medical experimentation that recall the infamous Tuskegee syphilis studies appear side by side with those of coffles, auction blocks, abolitionist safe houses, as well as the vision of Valentine farm, a haven in Indiana founded by a successful mixed-race free black who believes that hard work and exposure to high culture will secure the acceptance of his white neighbors. "I wanted to get away from the typical, straightforward plantation," Whitehead says. His novel doesn't seek to reenact history, but rather to imagine and represent simultaneously the many hydra heads of a system designed to perpetuate the enclosure and domination of human beings.

The genre of fugitive-slave narratives has long been haunted by sentimentality. As the scholar Saidiya Hartman has suggested, the use of the pain of others for readers' own purification or enlightenment—or at worst, entertainment—is a deep problem for this genre. Many have argued that the truth of slavery can only be understood first-hand. William Wells Brown, who published an account of his own escape to freedom in 1847, famously asserted that "Slavery has never been represented; Slavery never can be represented."

To write about slavery is to face head on this risk of representation. *The Underground Railroad* can feel at times overrepresented, almost too explanatory—seeking at every turn to demonstrate how this or that aspect of slavery worked, flagging a character's motivations by relating them back to that system. There's precious little room for characters to be something other than what they appear to be, something more than allegorical props. At one point, Cora, staying at a temporary haven in South Carolina, goes up to the rooftop to look out over the town and up at the sky. The scene's only function

seems to be to give the reader a chance to overhear some of her thoughts and hopes, something of who she is when she is not engaged in the business of trying to stay alive. Despite Whitehead's best efforts, Cora remains sketched rather than known, a specter seen through a glass darkly. She is a Gothic woman in the attic, haunting the national consciousness, a symbol more than a person. It's a connection Whitehead makes explicit: "Now that she had run away and seen a bit of the country, Cora wasn't sure the Declaration described anything real at all," says his narrator. "America was a ghost in the darkness, like her."

Yet there is something new and perhaps unprecedented in the way Whitehead has reasserted the agency of black writers to reconstruct Johnson's "Black American Narrative" from within. Whitehead interleaves *The Underground Railroad* with invented runaway-slave advertisements by planters seeking to recover their property. But in the last one, the hand of the author and that of his protagonist are momentarily overlaid, as though we are reading an advertisement Cora has left us, "written by herself," as the subtitles of slave narratives habitually put it. "Ran Away," reads the title and declares below: "She was never property." The device harnesses the power of fiction to assert impossible authorship, to thrust into view the voice that could not have spoken—but speaks nonetheless. Cora becomes, in the last instance, a mirror not only for the drama of slavery, but for the whole problem of *writing* about slavery: a vector that points away from something unspeakable and toward something unknown—and perhaps unknowable.

Interestingly, *John Henry Days*, the book by Whitehead that deals most substantially with the history of black America, is also almost certainly his least-read. Its hero, J. Sutter, is a freelance writer drawn from New York to an assignment in Talcott, West Virginia: the US Postal Service is hosting a festival celebrating a new John Henry commemorative stamp. Whitehead uses the mythical man and J. Sutter's pursuit of his meaning to transect the sediment layers of black history. His novel starts at the surface of a media-frenzied America circa 1996, simmering with racial unease and tortuous political correctness, then tunnels down to the labor of steel driving gangs in the 1870s. Along the way, it stops to recast figures like Paul Robeson or rewrite the rioting at Altamont Speedway. Suggesting another history, or set of histo-

ries, behind the one we think we know, Whitehead poses the thorny problem of how to interpret the stories we inherit.

In *The Grey Album,* his collection of essays on black aesthetics, Whitehead's friend Kevin Young has advanced the idea of the "shadow book"—certain texts that, for a variety of reasons, may fail to turn up: because they were never written, because they are only implied within other texts, or simply because they have been lost. One might add to this a category of books that are *eclipsed.* For *John Henry Days*, it was *Infinite Jest.* Both are postmodern leviathans, ambitiously unwieldy and bursting with insight, indelibly products of the 1990s. Yet Whitehead's book has never acquired the kind of cult following that David Foster Wallace's has. Published in 2001, it seems to have been eclipsed at least in part by historical events (though it can't have helped that Jonathan Franzen wrote a review for the *New York Times* that ignored any discussion of race, a stupefying lacuna; Whitehead says that Franzen in fact later apologized for it). If *John Henry Days* is the "shadow book" of the nineties, the other great masterpiece behind the masterpiece everyone knows, it is also a powerful complement to this new novel on slavery. In time it may be recognized that these books are among Whitehead's defining achievements, capturing the black experience in America with a wide-angle lens, carrying both its mythic and realistic truth, and delivering it over the transom into the maw of our digitally mediated internet age.

In the meantime, with *The Underground Railroad* gone to press, Whitehead has been catching up on the reading he loves. He's reading a lot of crime fiction, Kelly Link's short stories, and he's well into the latest Marlon James novel. His daughter is an avid reader of comics, so he's catching up on those as well. Asked what he might work on next, he answers that he's still focused on promoting the new book, of course—but possibly something about Harlem, something set in the nineteen sixties. After lunch wraps up, he heads down the block, walking smoothly, smoking a cigarette, back into the thrumming heart of the city.

"You are a New Yorker when what was there before is more real and solid than what is here now," Whitehead writes in the opening pages of *The Colossus of New York.* A strain of apocalyptic foreboding, tempered by a refusal to sentimentalize trauma, courses through Colson Whitehead's fiction. It's present

in the books he wrote even before 9/11. But the attacks of that day inevitably cloud the lyrical essays gathered in *Colossus*, a collection published in 2001, a time of disaster and mourning in the place he has always called home.

Yet unlike so much writing about New York, Whitehead's deliberately shies away from emphasizing what makes it special and unique. Whitehead writes instead of the invisible cities that everyone knows and carries within memory, not necessarily the ones that still exist in brick and mortar. He writes about the universal qualities of arrival and departure, loneliness and haste. His second-person address to "you" contains within it the gentle pressure of Walt Whitman's "I too," from "Crossing Brooklyn Ferry." Whitehead's answer to the calamity of terrorism is to insist, like Whitman, on the unbreakable power of the city to transform the vulnerability of the huddled crowd into a heightened, even universal empathy.

"Talking about New York is a way of talking about the world," Whitehead writes on the last page. True, but it is also a way of reflecting the world through one's own experience of it. It seems not entirely a coincidence that elevators and underground trains, two of New York's most iconic modes of transportation, are the symbolic vehicles Whitehead has invoked as he grapples with the wider meanings of America. Whether he is writing about the city he knows best, or the lives of characters in almost unimaginable circumstances, Whitehead has demonstrated time and again a remarkable capacity for turning what appear to be evasions into encounters, the historical arc we want to hide from into the narrative arc we can't avoid. He is a writer who stands squarely in our present dilemmas and confusions, and suggests lines of sight no one else seems to have considered or dared to imagine.

—2016

Fathers and Sons

IN AN ADDRESS at the Library of Congress in 1964, Ralph Waldo Ellison mused upon his relationship with his father, who had bestowed on his son a somewhat curious literary forename. "Why," Ellison wondered, "hadn't he named me after a hero such as Jack Johnson . . . an educator like Booker T. Washington, or a great orator and abolitionist like Frederick Douglass? . . . Instead, he named me after someone called Ralph Waldo Emerson, and then, when I was three, he died."

Ellison's question connected the perennial anxieties that have haunted African American artists for generations—questions of inheritance, tradition, and belonging—with a more personal and painful one about fatherhood: What was the meaning of a father's legacy, in particular one who died early in one's life? And what did it mean to be stamped by a name so intimately connected to his ideals?

Ellison's experience was not every child's. But the mark of sudden and premature loss, the haunting ambiguities created by an uncertain past, has constituted an overwhelming theme in African American literature. From the struggle over literary parentage between Richard Wright and James Baldwin, to the unclear family histories and patrimonial legacies in Barack Obama's *Dreams from My Father* and the philosopher Kwame Anthony Appiah's *In My Father's House*, to the letter from father to son in Ta-Nehisi Coates's *Between the World and Me*, one can sketch out a veritable subgenre of literary work

devoted to the struggle between black fathers and sons to give some kind of meaning to their shared fate and common past.

This fraught inheritance, the missed recognitions and ambiguities between family members, in particular fathers and sons, is one of the deep chords animating the life and writings of John Edgar Wideman, whose latest book, *Writing to Save a Life*, is perhaps his most desperate and bracing endeavor yet to "make some sense out of the American darkness that disconnects colored fathers from sons, a darkness in which sons and fathers lose track of one another."

JOHN EDGAR WIDEMAN, now seventy-five, is a towering figure in American literature. His prolific career, spanning half a century, is widely recognized for achievements in the novel, but Wideman is also a brilliant short-story writer, essayist, critic, and memoirist. He was twice the winner of the PEN/Faulkner Award for fiction and a recipient of the MacArthur "genius" grant. He is also known for his love of basketball, a passion that reverberates throughout his works. A standout athlete at the University of Pennsylvania, Wideman was an All–Ivy League star on the basketball team, which allowed him to become, in 1963, the first black American to win a Rhodes scholarship to Oxford since Alain Locke in 1907. Wideman returned to Penn in 1967 to teach English, and in 1971 he founded and chaired the Afro-American Studies Program, now part of the university's renowned Center for Africana Studies.

Despite these accolades, Wideman has never achieved the kind of name recognition of writers like Toni Morrison and Amiri Baraka. Nor is he a touchstone in the way that W. E. B. Du Bois and Langston Hughes were for earlier generations and James Baldwin appears to be for ours. Instead, he has long had the unenviable reputation of being a "writers' writer," which was very much how I was introduced to his work. This might be partly because of his long career teaching at MFA programs, including his current post at Brown. But there is something more. For nerdy, bookish black writers, especially dudes, his books have long constituted something of a passcode. The books' jackets seemed to offer a protective cover, an imagined hardness and coolness that one yearned for, and that could be carried like a shield. The author's photo said it

all: Wideman out on the streets staring down the camera, six-foot-plus, with a leather-fleece bomber jacket and inscrutable frown, can't-touch-this arms crossed like he's done with you already— a literary Bobby Seale.

Riffing on the alienation of the black writer, Thomas Sayers Ellis once observed that "a minority of black people calling themselves writers (in America) is a UFO to some and a mothership to others." For some years now, Wideman has been the latter, exerting a considerable influence on younger writers through his teaching and association with the influential journal *Callaloo.* This is especially true of black writers interested in experimental fiction, like Gayl Jones and John Keene, but also of writers deeply attached to place, like Edward P. Jones, whose magnificent story cycles are set in Washington, DC.

BORN IN PITTSBURGH in 1941 to working-class parents, Wideman was raised in and around the neighborhood of Homewood, the section of the city where waves of African Americans fleeing the South during the Great Migration settled and put down new roots. There they found work in Pittsburgh's burgeoning steel and manufacturing sectors and built new communities. Wideman's father served in World War II and then worked as a waiter in Kaufmann's department store. Later in life, he became a sanitation worker for the city; as Wideman relates in his memoir *Fatheralong,* he was "nicknamed 'Sweetman' by his fellow garbage-men." Wideman's father clearly cast a long shadow in his life, but the figure who most impressed the young writer-to-be was his maternal grandfather, John French, a tall, light-skinned, hard-drinking teller of tall tales, an almost larger-than-life character who constantly appears under the same name in Wideman's books, and who appears to play the role of a surrogate paterfamilias.

The intergenerational saga of black working-class folk, of "people who hope and cope," as Wideman once put it, became his great subject. This panorama of migration and settlement, of old patterns of life persisting and adapting to new conditions, of a people buffeted by history, saturates almost all of his fiction, even when he veers far away from his native Homewood.

In this, Wideman shares ground with a remarkable group of local talents: most prominently the playwright August Wilson, whose "Pittsburgh Cycle" is in many ways the theatrical analogue of Wideman's project; Charles "Tee-

nie" Harris, the photographer of black midcentury life; and also the many jazz musicians and composers of Pittsburgh, including Art Blakey, Mary Lou Williams, Billy Strayhorn, and one of the last living giants of the jazz piano, Ahmad Jamal, who wrote an album dedicated to the city.

The stories of Homewood offered Wideman a way to transform social history into art, to manifest through the microcosm of one working-class neighborhood the black experience over the last century. It may sound bold to state this, but it is true: No other American writer since William Faulkner, and perhaps Philip Roth (in chronicling the fate of Newark, New Jersey), has made such a determined effort to create a universe out of a community, to transform everyday biographies into epic history.

And yet when Wideman began writing in the late 1960s, he appeared to be forging a very different and somewhat unlikely path. At Oxford, he had studied eighteenth-century literature and became fascinated with the origins and experimental possibilities of the novelistic form. Like Ellison, he was attracted to T. S. Eliot and to the modernist emphasis on dislocation. He was also drawn, as Ellison and many in his generation were, to James Joyce's use of stream of consciousness. Wideman's first three novels—*A Glance Away* (1967), *Hurry Home* (1970), and *The Lynchers* (1973)—were studies in alienation and experiments in style and expression. Their protagonists were variations on the kind of figures who haunted late nineteenth- and early twentieth-century literature: the uprooted intellectual seeking, but never quite achieving, reconciliation with his community.

From a distance, these early modernist forays appear to have been something of apprentice works, and Wideman has been content to let that notion stand in interviews over the years, comparing them at one point to "wood-shedding," the jazz-slang term for the period when a musician is still honing his skills. It is hard to deny that the books are stilted; a love of wordplay and musicality cannot make up for a missing plot line. And yet there is something refreshing in Wideman's daring allusiveness, especially when set against the narrow, pop-saturated lanes demanded of contemporary prose.

WIDEMAN'S EARLY WORK often seems to have a lot in common with those lost experimentalists—figures like Leon Forrest and William Melvin Kelley—

who came up too late for modernism, but also too early to trim their sails to the slick, brat-pack confessional postmodernism that was then becoming the new commercial norm.

One suspects that Wideman might well have shared their fate, if his work hadn't pivoted in the late '70s and early '80s toward a sustaining, and arguably Afrocentric, belief in the role of the writer as the conscience of a community. A number of changes in his outlook and life seem to have converged in this period. The African American literature courses he was teaching at the University of Pennsylvania brought a renewed appreciation for works in that tradition. He was particularly drawn to Zora Neale Hurston's folk-story collecting and auto-ethnographic writings, which were then being recovered by feminist writers and scholars like Alice Walker. Another influence came from African writers, especially Chinua Achebe, from whom he learned the Igbo saying "All stories are true," which Wideman adopted as a kind of vocational credo. But the most significant turn was his brother Robby's 1975 involvement in a robbery and murder, his flight from justice, and his subsequent incarceration on a sentence of life without parole.

The process of reckoning with Robby's crime, his surprise visit to Wideman's home in Wyoming (where he was teaching at the time) while on the lam, and the struggle to piece together what had gone differently in his brother's life eventually led Wideman to a broader meditation on the meaning and consequences of mass incarceration that became his most celebrated (and probably most widely read) book, *Brothers and Keepers*.

Published in 1984, *Brothers and Keepers* weaves together layers of personal biography and public history, literature and sociology. It was framed as a memoir but was ultimately a threnody, a blues testimonial for a generation headed into the maw of mass incarceration. It is rare for a book to so immediately and vividly make clear the old truth that there is a special humanistic work that can only be achieved in great writing. *Brothers and Keepers* does it by grappling with a personally painful case without sentimentality.

If there's one book by Wideman that young black men tend to know, it's this one—sometimes provided by a parent or uncle, sometimes by a teacher or counselor, and sometimes discovered while doing time. For many, Wideman's use of the letters he exchanged with Robby will not only evoke literary

antecedents like George Jackson's *Soledad Brother* and Angela Davis's *An Autobiography*; it will also remind them of the way Nas binds friendships fractured by prison on his classic "One Love," or of Kendrick Lamar's deservedly praised storytelling on tracks like "Sing About Me."

The effect of his brother's incarceration and of his grandmother's passing brought Wideman back home, inspiring him to press his ear to the Homewood streets and use his gifts to quilt together the story of his family. The story collection *Damballah* (1981) and two novels, *Hiding Place* (1981) and *Sent for You Yesterday* (1983), find Wideman hitting his stride and achieving a distinctive voice that is more confident and vernacular than in his early work, as well as more penetrating in his study of character.

Published together as *The Homewood Trilogy* in 1985, all three novels interweave tales of Homewood and its cast of interrelated family members. *Damballah* interjects lyrical stories of ancestral origin and historical resistance with stories of contemporary disarray and dissolution, suggesting both the deep resourcefulness of one's past and the brutality and despair of the present. *Hiding Place* and *Sent for You Yesterday* are more closely concerned with the reconciliation and forgiveness afforded by family, especially for men who are running from their past.

The terrible strain and countervailing desire for redemption in family bonds had another important echo in Wideman's life. In 1986, his younger son Jacob, then sixteen and suffering from mental illness, murdered another boy while away at a summer camp in Arizona. After a brief flight, Jacob was arrested and attempted suicide while in jail. His parents fought to have him tried as a minor so that Jacob could be held in a mental-health facility, but the court refused. After Jacob pleaded guilty at his trial in 1988, he was sentenced as an adult to twenty-five years to life. In 2011, his first opportunity for parole was denied, and he remains in prison today.

"THE SIGN OF SILENCE presides over my work," Wideman declared in a 1999 essay for *Callaloo*. "Silence marks time, saturates and shapes African-American art. Silences structure our music, fill the spaces—point, counterpoint—of rhythm, cadence, phrasing. Think of the eloquent silences of Thelonious Monk, sometimes comic, sometimes manic and threatening."

The novels that Wideman produced in the wake of his personal tragedy and loss are filled with these silences and absences. *Philadelphia Fire* (1990) and *The Cattle Killing* (1996) are riddled with fragmentation, shards of confession, and prophetic rage.

In the Homewood books, Wideman had attempted to bind black social and family histories together through narrative. In these later novels, metaphor and allegory serve to grapple with the fear of cultural collapse, of a nation locked in a pattern of self-destructive violence.

In recent years, Wideman has taken this mandate even further. His novels not only seek to recover a lost past but also take on a certain archival quality. His last novel, *Fanon* (2008), adopts a playful, almost Brechtian approach, centered around an aging writer who attempts to write the life of Frantz Fanon, the revolutionary theorist and hero of the Algerian Revolution. But while Wideman gets some mileage out of arch set pieces like a visit by Jean-Luc Godard to Homewood to discuss the working script for a Fanon biopic, there's also a sense of impending exhaustion and frustration in the novel. As Wideman eased into the "late" phase of his career, the pain and disappointments of life and artistic expression seemed almost to have turned him against the novel.

"Writing fiction marginalized me as much as I was marginalized by the so-called fact of my race," writes Thomas, the novel's narrator, in a letter to Fanon. "Fiction writing and art in general are scorned, stripped of relevance to people's daily lives, dependent on charity, mere playthings of power, privilege, buying and selling."

THE MANY DIFFERENT STRANDS of Wideman's work are all present in *Writing to Save a Life*. There is the alienated, brooding intellectual from his modernist phase; the vernacular storytelling from his Homewood books; and the sense of marginalization and futility from his later years. But looming above all of them is Wideman's own exhaustion and moral pessimism, his desire to write but perhaps no longer to write fiction.

A book about a novelist not writing a novel, *Writing to Save a Life* appears to set foot in numerous genres—history, memoir, biography, literature—but it is framed as an investigation into the life and death of Louis Till, the father

of Emmett Till, the fourteen-year-old boy whose 1955 lynching shocked the nation when photographs of his mutilated face and body, made at his mother Mamie Till's insistence, were published in *Jet* magazine. Wideman's long-standing preoccupation with the Emmett Till case goes back at least to 1997, when he published an essay in *Essence*, "The Killing of Black Boys," in which he revealed that he suffered from recurring nightmares about Till's murder. But the new book isn't exactly about the infamous lynching of the son; rather, it discusses the murky circumstances surrounding the life and death of his father, who was tried and executed by the US Army in 1945 after being charged with a rape and murder committed in Italy, near Civitavecchia, some ten years before the gruesome murder of Emmett.

One of the many disquieting things about *Writing to Save a Life* is its indulgence in misdirection. Initially, we get the impression that Wideman is setting out to write a novel about Louis Till and, along the way, perhaps to right a historical wrong. In books by Alice Kaplan, a professor of French at Yale, Wideman learns of the railroading of dozens of black GIs accused of capital offenses during World War II. (Of the sixty-nine soldiers executed for rape and/or murder in the European theater, fifty-five were black, despite the fact that black men made up less than 10 percent of all soldiers.) But it quickly becomes apparent that Wideman is up to something else as well.

Wideman's motto "All stories are true," which served him so well in the past, becomes a kind of fog machine in *Writing to Save a Life*. His faith that every story—even the fabricated ones—contains some truth causes him to spin out hypotheticals, deliberately blurring the lines between the facts of this case and his freely fictionalized re-creations and annotations of it. Wideman celebrates his own interventions into the textual evidence: He tells of excursions and digressions, interweaving re-creations of Louis Till's early life with his own visit to the American Cemetery and Memorial in northern France, where Till lies buried among the dishonorably discharged, or to coastal Brittany, where Wideman walks the beaches ruminating as he writes. Personal vignettes spark into life, like cigarettes lit in a dark room: a boy's fear at his father's brooding presence, the warmth of a family Thanksgiving dinner, roses outside his grandmother's home in Pittsburgh.

"I assume the risk of allowing my fiction to enter other people's true sto-

ries. And to be fair, I let other people's stories trespass the truth of mine," Wideman writes. His method is to turn the trial report into a palimpsest. "The file writes fiction," Wideman asserts. "To mimic reality, the Till file writes fiction."

THE RESULT OF these efforts, with respect to uncovering some sense of Louis Till the man and of his guilt or innocence based on the file, is mixed at best. By the end of the book, we're left with a scumbled portrait of a man who is unlikable: Till abused his wife Mamie, who took out a restraining order against him, and if he didn't exactly do the things recorded in the trial report, he certainly seems to have been involved in some way in some pretty horrific events on the night of June 27, 1944.

It's not clear at times whether Wideman is arranging his presentation of the facts for literary effect, or if he is genuinely wrestling with the murky results of a trial record full of ambiguous information. But what is clear is that he believes the official report is full of lies. Till may have been guilty, but it seems quite likely that he did not—indeed, could not—receive a fair trial because of the racial prejudice in the Army at the time. When Wideman says that "lying is a weapon nobody in the Till file can afford to surrender," it is the rare example of an assertion we know to be true.

The point of foregrounding the inconsistencies and selective witness accounts in the military's report is to unveil a systemic corruption and indifference to justice in the very people who are supposed to deliver it. It's a tactic famously used by the dashing French lawyer Jacques Vergès, who defended Nazis like Klaus Barbie and Algerian militants like Djamila Bouhired: He did not seek to justify their actions, but instead reminded the court of the French state's complicity, of Vichy's collaboration, of the country's colonial brutalities and exploitation.

Wideman's book certainly gives us a striking procedural look into the racism in America's Jim Crow military. Because of this, it is frustrating that the book misses an opportunity to show how Till's trial offers us insight into the broader landscape of racist politics in America at midcentury. Wideman could have emphasized, for example, the disgusting attempt by Mississippi senators James Eastland and John C. Stennis to leak Till's military records in

an effort to smear his murdered son, an act of racism impressive for its ugliness and depravity even for these stalwarts of white supremacy. In the end, though, Wideman seems to realize that his book about the inability to write a novel about an unsolvable case has little to do with Louis Till per se, and much more to do with his own fears, a sense of impending mortality and of business left unfinished:

> Louis Till not stuck like a bone in the country's throat. America's forgotten Louis Till, no sweat. It's me. I'm the one who can't forget. My wars. My loves. My fear of violent death. I'm afraid Louis Till might be inside me. Afraid that someone looking for Louis Till is coming to pry me apart.

There is a terrible pathos in *Writing to Save a Life*. Its naked confessions and disjointed attempts to recall and restore a past that is dark with ambiguity, brutality, and violence have a stormy Lear-on-the-heath quality about them. At times, it is also unclear whose life Wideman is writing to save: Louis Till's? Emmett Till's? His own? One comes to realize by the end of the book that the answer might well be: all of the above. "The Louis Till project," Wideman admits, "is about saving a son and brother, about saving myself."

WRITING TO SAVE A LIFE appears at a moment of renewed despair over the senseless and seemingly unstoppable deaths, more often than not of young black men, at the hands of police or through gun violence on the streets. While the bleakness of this slim book only obliquely addresses our contemporary moment, one cannot help hearing the ricochets in its pages. At some points, it feels like Wideman is reminding us of how often we have been here before.

In this way, Wideman's book—and perhaps much of his later career—offers us yet another indication of the powerful current of pessimism that has paradoxically swelled in black intellectual circles over the course of the nation's first black presidency. There is an ashen, bitter taste in this new work, which sometimes reads like an autopsy report for the murdered hopes of an entire generation.

In all of Wideman's work, there's a sense that much more might have been

said. Couldn't the harrowing gulf between black fathers and sons have been paired with the often astonishing resilience and joy that one can also find in great abundance among black families? (I think of Fraser Robinson III, who worked as a pump operator in Chicago's water department while raising a hardworking daughter on the South Side; she would later earn a law degree from Harvard and become the current first lady.) There's a lot of evidence to suggest, in fact, that many black fathers struggle but persist mightily in raising children against the odds.

Indeed, as studies confirm, not only do black fathers spend as much time caring for their children as those in any other demographic, but by some metrics even more so. I think inevitably, too, of my special relationship with my own father, who struggled with drug and alcohol addictions in the late '80s. I met him for the first time when I was nine, and we've been making up for lost time ever since.

But despite the many pockets of hope and resilience in black life today, one cannot deny the force of Wideman's vision and the measure of his grief and moral concern. The great body of work that he has gifted us carries voices and memories from the past into our present. And they have, even in their unhappiest moments, the ability to cause us to remember the extraordinary vitality, humor, grace, and courage of ordinary folks up against terrible odds. Homewood is a place in the mind, a down-home (whatever down-home is for you) bastion of resilience and hope, joy and pain, and all sorts of other human feelings that we carry like a tortoise shell as we make our way in the world. In its living web of stories, there is a kind of safety—but there are warnings, too.

There's a price to be paid for every evasion of our past, Wideman's work seems to tell us. Every fib we peddle, every political cop-out, has its costs on our emotional and moral lives, and Wideman places these stakes before us without hesitation. Here is how he ends his essay on Emmett Till, written fifteen years before the murder of Trayvon Martin:

> I cannot wish away Emmett Till's face. The horrific death mask of his erased features marks a site I ignore at my peril. The site of a grievous wound. A wound unhealed because untended. Beneath our nation's pieties, our self-delusions, our denials and distortions of his-

tory, our professed black-and-white certainties about race, lies chaos.

The whirlwind that swept Emmett Till away and brings him back.

For eight years now, our country has clung to the rhetoric of hope; we've repeatedly been told that it is our aspirations that define us, that our best days are still to come. But it is just as true today that we are the sum of all that we continue to ignore, all that we've buried, all the skeletons we refuse to name out of fear, anger, and shame. Writers can remind a society that these ghosts are alive, that they never pass into the past, and that when they cease to be remembered, the whirlwind that Wideman speaks of can grow, sometimes suddenly, into a howl capable of tearing our living bonds apart.

—2016

The Protest Poets

OUTSIDE OF POETRY CIRCLES, few people have heard of the Dark Room Collective or Cave Canem, but over the last thirty years these two communities have nurtured a profound and ongoing transformation in American letters. Sharan Strange and Thomas Sayers Ellis, two black students who met at Harvard, founded Dark Room in 1987. As young fledgling poets they traveled together to New York to attend the funeral of one of their literary heroes, James Baldwin. They were inspired by the extraordinary sense of fellowship at that event and vowed to try and re-create it in their own lives.

Back in Cambridge they set up a meeting space in a Victorian on Inman Street that had formerly housed a photo lab, which lent the group its name. For almost a decade they constituted a kind of experimental writer's community. They organized a reading series and pooled money to bring black writers, scholars, and musicians together to share and recognize each other's work.

The Dark Room revealed a cohort of talented poets who have since gone on to major careers. Among the most prominent are Kevin Young whose 2003 collection *Jelly Roll* was a finalist for the National Book Award, Natasha Trethewey who won the 2007 Pulitzer for her collection *Native Guard*, and Tracy K. Smith who won the Pulitzer in 2012 for *Life on Mars*.

Just as the Dark Room Collective began to come apart in the mid-nineties, the poets Toi Derricotte and Cornelius Eady were preparing the relay. Derricotte moved to New York City in 1967 at the height of the Black Arts Movement, but her introspective style and concern for gender made her an outsider

to a movement that was intensely preoccupied with asserting an often quasi-paramilitary virility. She began publishing collections of poetry in the late 1970s, and Eady, roughly a decade her junior, published his first in 1980. They met at workshops where they traded stories of being treated like "tokens," and feeling like their work was exoticized. In 1996 they launched Cave Canem, a foundation to bring together black poets across the nation for workshops and retreats and to give them a proper sense of belonging. It quickly acquired the reputation of being the unofficial "Black Poetry MFA" program, and in many respects, it still fulfills that function, even if it has become more of an institution and less of a community. Many Dark Room members merged with the new poets seeking fellowship at Cave Canem. The results of all this community building have been an extraordinary flowering of black poetry, and an unprecedented reception by the publishing, academic, and literary magazine worlds.

The idea of creating independent institutional spaces for nurturing black creativity is not new. Magazines and journals like *Opportunity, The Crisis,* and *The Messenger* were crucial to the development of the Harlem Renaissance. In the 1960s the Black Arts Movement produced an array of organizations and collectives that sustained black artists in its heyday. The little-known experimentalists of the Umbra Workshop met on the Lower East Side of Manhattan in the 1960s. Shirley Graham Du Bois, W. E. B. Du Bois's wife, edited the important journal *Freedomways,* which ran from 1961 to 1985. Amiri Baraka, the central luminary and whirlwind force behind BAM, famously moved uptown to Harlem to found the Black Arts Repertory Theatre School, and when that project foundered, re-created it as Spirit House in Newark. Haki Madhbuti founded Third World Press, which remains the largest black-owned independent press in the country.

But in some cases the separatist politics of these organizations, which had worked to their advantage in the Movement days, increasingly served to isolate them as the political, economic, and cultural winds shifted rightward in the 1980s. By the time Sharan Strange and Thomas Ellis got together to found the Dark Room Collective in the mid-'80s, most of the institutions and journals of earlier eras had disappeared or had become so marginalized that they were of little relevance. One exception was *Callaloo,* the literary journal

founded by Charles Henry Rowell in 1976. Rowell was committed to providing black writers and artists with a haven for expression and creativity free from what he saw as the over-determining need to engage in protest politics, the central tenet of the Black Arts Movement.

This inevitably created a conflict within black poetry circles over how much to engage with the social and political sphere, and with the legacy of the Black Arts Movement itself. In 2013 that conflict erupted into view when Amiri Baraka, just a year before he died, pilloried Rowell over *Angle of Ascent*, an anthology of contemporary African American poetry Rowell had edited for Norton. In an essay for *Poetry* magazine, Baraka charged him with championing a politically reactionary and assimilationist aesthetic in the collection, which includes work by Young, Trethewey, and Smith. For Baraka, Rowell's selections minimized the achievements of politically engaged writers, and championed poetic mediocrity written by "university types, many co-sanctioned by the Cave Canem group, which has energized [U.S.] poetry by claiming a space for Afro-American poetry, but at the same time presents a group portrait of Afro-American poets as [MFA] recipients."

Noting the remarkable absence of major figures like Langston Hughes and Sterling Brown (presumably too political) but also the neglect of contemporary contributions like rap and spoken word (presumably not literary enough), Baraka argued that the chronologically oriented anthology, rather than reflecting a historical progression, was "simply a list of poets Rowell likes," who had nothing in common apart from their disavowal of the Black Arts Movement. Much of that criticism sticks. Rowell for his part was quite explicit about his biases. The publisher's promotional copy explains:

> It is a gathering of poems that demonstrate what happens when writers in a marginalized community collectively turn from dedicating their writing to political, social, and economic struggles, and instead devote themselves, as artists, to the art of their poems and to the ideas they embody.

The mainstream success of the Dark Room and Cave Canem poets may make it appear as though Rowell ultimately came out on top in this debate. But some

of these old divisions may be losing their sway. For the young writers coming up now, the Black Lives Matter movement is creating a new context in which opportunities have emerged for transcending both Baraka and Rowell's partitioning of the political and the lyrical. On the one hand, Rowell's insistence on the poet's disengagement from social life is looking ever less feasible and less appealing. On the other hand, Baraka's belief that any integration into the MFA system would necessarily be assimilationist appears to have underestimated the ways in which black poets might actually change the terms upon which the system depends. Sadly, he also passed away just as the Black Lives Matter movement was born, and he never lived to see its energy harnessed by a generation that continues to build bridges between university students and the communities they come from, a model pioneered by the Dark Room Collective and Cave Canem.

Some of these divisions are collapsing thanks to social media, which has empowered more self-directed and socially vibrant projects. When a grand jury declined to indict officer Wilson in the killing of Michael Brown, a group of Cave Canem poets came together to come up with a collective response. They decided to create a virtual space where poets could post videos of their own poetry readings in response to the events. Poets Amanda Johnston, Jonterri Gadson, Mahogany Browne, Jericho Brown, and Sherina Rodriguez-Sharpe created the hashtag #BlackPoetsSpeakOut and set up an accompanying Tumblr where other poets could add their own submissions.

Other poets are revisiting and reconfiguring old forms of their craft and challenging conventional boundaries of both race and poetry. Roger Reeves, one of the most promising new voices, melds a Keatsian pitch to a Southern Gothic aesthetic in his work. His meditation on Emmett Till, "The Mare of Money," from his debut collection *King Me* harkens back to the anti-lynching poems of the 1920s and '30s, drawing on that tradition of literary protest while casting an acutely ironic gaze on contemporary America. Fred Moten is both a highly regarded vanguard poet and activist and one of the country's most influential theoreticians of black literature and radical politics. Poets like Zora Howard and Joshua Bennett, who come out of the spoken word tradition, are closely engaged in today's protest movements and have massive followings online and on college campuses across the nation.

Two of the most prominent poets who are challenging assumptions about how black poets wear their politics are Terrance Hayes and Claudia Rankine. Hayes, a native of South Carolina, is one of the longstanding members of the Cave Canem collective. He won the National Book Award in 2010 for his fourth book, *Lighthead*, and in 2014 was named a MacArthur Fellow.

CLAUDIA RANKINE IS the author of *Citizen: An American Lyric*, the first book ever nominated simultaneously by the National Book Critics Circle Awards in two categories, for poetry and criticism. The book is rapidly finding a place on required reading lists of college students around the country, an entire generation who have come of age at a time when online videos of black death circulate as easily as postcards of lynchings once did in the days of Jim Crow. Rankine is a graduate of Columbia's MFA program, and her remarkable breakthrough serves as a direct challenge to Baraka's notion that nothing radical can come from "university types."

At the emotional center of *Citizen* is Zora Neale Hurston's observation, "I feel most colored when I am thrown against a sharp white background." It's a famous line from Hurston's 1928 essay "How It Feels To Be Colored Me," in which she explores the relativity of color while passionately denying it the power to disrupt her life. The sentence appears in *Citizen* courtesy of Glenn Ligon's eponymous artwork, in which the line is repeated in black oil stencil blocks that cascade into an illegible mass blotting out the white page. Incidentally, in her essay Hurston goes on to say exactly where she feels her isolation most sharply: "I feel most colored when I am thrown against a sharp white background. For instance at Barnard." "Beside the waters of the Hudson, I feel my race."

In 1925 when she arrived at Barnard, Hurston was, in fact, the only black student on campus. That setting—the elite college campus—is also one of the key backgrounds to Rankine's book, which sifts through moments of racial dissonance that are particularly acute not only because of color but because of class.

Rankine explores the way racism ripples through the spheres of everyday life, how it shifts between foreground and background, what is said and what isn't. She uses the second person pronoun "you," a technique that provokes

self-examination while positioning a reader of any possible background as a raced subject who will share (for a time) in this stifling and maddening experience.

Waiting outside a conference room the poet overhears one man say to another, "being around black people is like watching a foreign film without translation." How should she react? Are they talking about her? The problem of "overhearing" recurs in *Citizen*, as seemingly casual anecdotes build toward moments of moral panic. The most banal situations are filled with trip-wires that force her to question what she's heard, to scrutinize and doubt her own reactions. "Waiting in line for coffee, a stranger has just referred to the boisterous teenagers in Starbucks as niggers. Hey, I am standing right here, you responded, not necessarily expecting him to turn to you."

How can she not respond? And yet the last clause suggests hope that a confrontation might be avoided. "They are just being kids. Come on, no need to get all KKK on them, you say." This appeal to reason, coupled with a reciprocal hyperbole meant to point out the man's excessive language is an overly generous off-ramp, an attempt to defuse an awkward social situation rather than to do the right thing. But what is the right thing to do? "Now there you go, he responds. . . . There I go? you ask, feeling irritation begin to rain down." The stranger knows this script all too well; race is your (her) problem, you are playing the race card and now everyone in the coffee shop is staring at you.

Rankine is not naïve about the likely audience for her work. The paperback retails for $20 in bookstores, and the aesthetic of the book's packaging, right down to the Helvetica font and the epigraph from Chris Marker's cult art film *Sans Soleil*, signal the objet d'art, the experimental installation.

The class implications of black politics continue to be a sensitive topic but Rankine treats class frankly. One of the key symbolic figures in the book is that of the black tennis player—the sport nicely expressing the power of conservative space, with its crisp white lines of demarcation policed by higher ups, and Serena Williams as its heroic black avatar. The symbol is resonant for a class of black folks that Rankine (and I too) belong to—not just some essential black subjectivity. It's a metaphor about controlling yourself under surveillance in a social space identified as upper-class and white, in which you

are readily admitted (perhaps even prized), as long as you consent to wear the correct uniform and to never step out of line. Rankine doesn't hide her class affiliation. Instead she uses material and cultural markers from her world to effect a sardonic realism: a bottle of Pellegrino or a casual reference to cultural theory or filmmaker Claire Denis come off as a bitter tonic to black life on the right side of the tracks.

Rankine makes class conspicuous, so she can confront the conflicted emotional guilt that accompanies being a bourgeois subject caught in a largely privileged relationship to racist violence. This is why so much of *Citizen* is involved in spectatorship. If the threat to one's body is not nearly as severe as that of a poor person caught in the deadly violence of the streets—though by no means immune to it either—the threat to one's sanity is omnipresent. The specter of racism haunts every corner of culture high and low: a white tennis player playing the Venus Hottentot at the US Open, Zinedine Zidane snapping under a racial slur at the World Cup, Hennessy Youngman's satirical YouTube guide to being a successful black artist, historical photographs of smiling lynch mobs, Turner's great painting *The Slave Ship*.

This positioning is the source of the book's agonizing undertow. It is precisely this angst about passivity, the poet's feeling for the jagged oscillations between sudden outrage and near-clinical detachment, that allows the book to connect with a surprisingly broad spectrum of middle-class readers, for whom it renders plausible and even familiar the experience of racial anxiety. This is what's so striking and radical about Rankine's poetry. It makes people uncomfortable not by attacking them, but by unsettling and reframing what is most familiar to them. They've been in that Starbucks. They have stood outside offices and heard those comments. Her poetry is prismatic: they, you, we—no one's class, good intentions, friendly demeanor, or sound education can free them from being implicated in a society that deploys force and assigns value based on the color of one's skin.

If Rankine represents a poet stepping out of the comfortable groves of academe to embrace a more radical, protest-oriented aesthetic, Terrance Hayes offers a different kind of crossover—he uses vernacular poetics to interrupt and overturn the assumptions and expectations of the poetry establishment.

The title of Hayes's latest volume, *How to Be Drawn*, alludes to his work

in the visual arts, a medium he has increasingly taken up in recent years, which includes portrait painting, drawings, and what he calls "visual essays," where he diagrams lines of imagination, creativity, and influence. Many of the poems are formally experimental in their layout on the page, like "Some Maps to Indicate Pittsburgh" and "How to Draw a Perfect Circle." Others engage directly with the theme of representation, like "Self Portrait as the Mind of a Camera," which pays homage to Charles "Teenie" Harris's photographic portraits of black Pittsburgh. You could say that this volume is Hayes's version of a "Self-Portrait in a Convex Mirror," his poetry maneuvering the way John Ashbery painted Parmigianino's hand in his opening lines, "thrust at the viewer / And swerving easily away, as though to protect / What it advertises."

How to Be Drawn opens with the poem "What It Look Like" addressed to the late Russell Tyrone Jones, aka Ol' Dirty Bastard of the hip-hop group Wu-Tang Clan, who died in 2004, two days before his thirty-sixth birthday. These the opening lines:

> *Dear Ol' Dirty Bastard: I too like it raw,*
> *I don't especially care for Duke Ellington*
> *At a birthday party.*

There's a confident swagger in these lines that's embedded deep in the American grain, but it's also not quite what one would expect. The formal address and colorful cognomen set up a whiplash of dissonant registers before settling into a debonair tone that's more Frank O'Hara than house party. The speaker's mannered and seductively intimate voice belies that of a self-conscious observer of goings on. His eccentric inventory of his own feelings at this party makes him an outsider to it. Or only apparently so, since the nub of his soliloquy is the realization of his indivisibility from the good, the bad, and yes, the ugly—that the raw sound evokes. Ellington is a mood; but sometimes only getting *"off on a natural charge bon voyage"* will do. The poem wades into the superego quandaries of a respectability politics that it rejects—but it understands that it has to go there in order to find its way back to the frank celebration of the expressive blackness that ODB embodies: sexual, unpreten-

tious, unselfconscious, unscripted, swinging just off-kilter like RZA's clanging Thelonius Monk piano samples that give Wu-Tang songs their special air of high-brow funk—a description that fits Hayes's poetic style as well. This is just a taste of the layered ironies Hayes displays with such unnerving facility; in a few lines, he casually straddles traditions, defines his own sensibility, and slyly serves up a poet's code, his ars poetica.

As the poem progresses we learn the speaker is still hungover from a birthday rager. The fragmented recollections of the night before become a reflection on the party's music and the fate of the artist. These are distilled into a personal motto: *"Never mistake what it is for what it looks like,"* later reversed: *"Never mistake what it looks like / for what it is."* These injunctions announce the major themes of the entire collection: the distance between perception and belief, belief and reality, reality and its representation, everywhere the slanting shadows fall. It's a prickly pear, and Hayes seems to brace himself and his readers for inevitable failure. The misprisions that ensnared Othello are invoked. And then, in a characteristically brilliant turn, Hayes extends the Shakespearean allusion as he circles back in the poem's last lines to his addressee:

> *You are blind to your power, Brother*
> *Bastard, like the king who wanders his kingdom*
> *searching for the king. And that's okay.*
> *No one will tell you you are the king.*
> *No one really wants a king anyway.*

For those who know the music (and their Shakespeare) it's no stretch of the imagination to envision Ol' Dirty Bastard playing the Fool to America's King Lear, when you put it that way. But who ever puts it that way? Well, think of Basquiat's crowns; or take Kendrick Lamar's recent vamp on the trope, "King Kunta": "Now I run the game, got the whole world talkin', King Kunta, / Everybody wanna cut the legs off him." Hayes can see where the circles of folk traditions meet; like his subject he keeps planets in orbit, compressing into lyric what Ralph Ellison was fond of calling "shit, grit and mother-wit." Notice the work that line break between "Brother" and "Bastard" does, open-

ing the former to its colloquial warmth, and the latter to its potent allusions; the challenge, for instance, of being a "bastard of the West," as James Baldwin described himself in *Notes of a Native Son*.

This kind of daring intellectual play exercised around subjects well outside the traditional bounds of academic poetry are evidence of a new kind of audience for black poetry that Hayes can lay claim to, an audience whose tastes, interests, and points of reference are transcending older distinctions of high and low, detached and engaged politics. It is telling, for instance, that Hayes is as deeply influenced by the poet Robert Hayden, a touchstone for Rowell, as he is by Etheridge Knight, a key figure of the Black Arts Movement, two individuals who in a previous era were thought to be incompatible and even antagonistic models for a black poet to follow. In fact, in some ways, Hayes's work feels like a throwback to some of the neglected high peaks of the Black Arts Movement that have too often been overshadowed by its more provocative statements, dazzling works like Gwendolyn Brooks's *In the Mecca* (1968), Audre Lorde's *Cables to Rage* (1970), and indeed the early poems of Amiri Baraka when he was still writing as Leroi Jones.

"What It Look Like" is a portrait of the young artist trying to forge a path in the face of an antagonistic society, a culture that seems intensely hostile both to lyric expression and to black life. It is about struggling to find an oppositional voice in the teeth of violent dispossession. It sounds, in other words, like the country we live in today.

Poets like Claudia Rankine and Terrance Hayes see, like everyone else, that the nation's language when it comes to race—to the famous conversation we are always told we ought to be having—is exhausted. "We have come to the end of a language and are now about the business of forging a new one," James Baldwin declared at the end of a late essay. These poets are forging that new language.

—2015

On Afropessimism

Each generation must, out of relative obscurity, discover its mission, fulfill it, or betray it, in relative opacity.

—FRANTZ FANON

THE MEMOIRS OF black revolutionaries have been, almost by definition, exceptional in their narratives, exemplary in their aspirations, and dispirited in their conclusions. Traditionally, the disappointment of unfinished and unrealized ambitions is mitigated by a rhetorical appeal to continued struggle and hope for a future black liberation that the memoirists themselves will not live to see. They look to the future to say: *one day*. In *time we will find our way to freedom, equality, self-loving, and self-respecting—to fully enjoying whatever the best of the human condition ought to entail.* But what if the condition of being human is so thoroughly racialized that even appealing to it only further distances them from the possibility of its realization? What if, moreover, the destruction of black people is not a contingent difficulty that can be corrected, but a necessary fate because the very category of "the human" is premised on their negation? As Frank Wilderson puts it, what if "Human life is dependent on Black death for its existence and for its conceptual coherence"?

Understanding how Wilderson has come to such a conclusion requires

a glance at his own exceptionally restless and revolutionary life. Frank Wilderson III was born in New Orleans but grew up primarily in Minneapolis, where his father was a professor of educational psychology at the University of Minnesota and his mother worked as a school administrator. The family was part of the generation of black middle-class folk that strived to integrate the world of their white counterparts, making upwardly mobile incursions across the color line in the workplace and in housing. The Wildersons were the first black family to move into the exclusive neighborhood of Kenwood. One senses in his writings the painful alienation and racial isolation of a black boyhood in a white suburban world. Wilderson's parents hoped their son would take advantage of their social gains but it was the revolutionary turbulence of the 1960s that impressed the young man who, even as a teenager, had already thrown himself into the whirlwind of the standoffs in Berkeley, the militancy of the Black Panther Party, the world of SDS, Kent State, the murder of Fred Hampton, and the assassination of Martin Luther King Jr. *Afropessimism*, Wilderson's philosophical memoir, is full of extraordinary portrait miniatures, fragmented scenes of the American leftist underground recollected from the point of view of one of its survivors, the souvenirs of an elder revolutionist for whom the battle scars of yesteryear are still fresh as yesterday.

For Wilderson the energies of the revolution never fully dissipated. He enrolled at Dartmouth in 1974, took up and then abandoned the idea of being a football player, and quickly gravitated back to politics, involving himself in organizing immigrant workers on campus, activities that eventually got him expelled for two years, during which time he led an itinerant life before returning to finish his degree in 1980. Fellow students recall visions of a handsome and charismatic man striding across the campus wearing a military-style vest and sporting a black beret. During the 1980s, Wilderson spent a period he dismisses as "eight ethically bankrupt years" working as a stockbroker for a string of prominent firms including Merrill Lynch and Drexel Burnham Lambert, the latter made infamous for its junk-bonds business. In 1989 he got out of finance by going to Columbia University to get an MFA in fiction writing. He used a summer research grant from the

Jerome Foundation to go to South Africa, a voyage that would prove a decisive turning point.

It was a propitious time and place for an ardent militant determined to wage war against white supremacy. F. W. de Klerk's apartheid regime was beginning to buckle, as the heinous and increasingly desperate campaign of state terrorism it had ramped up throughout the 1980s failed to dissuade the African National Congress (ANC) from its contrasting mission to liberate the country from white rule. The leaders of the ANC had established a military wing known as Umkhonto we Sizwe (MK), "The Spear of the Nation," in response to the Sharpeville Massacre of 1960, which taught them that the regime would respond to the nonviolent civil disobedience championed by Robert Sobukwe with violent repression and indefinite detention. By the late 1980s, when the apartheid regime was struggling against MK, it suffered a death blow as a result of its involvement in the Angolan Civil War, with the South African army losing to Cuban and Angolan independence fighters at the battle of Cuito Cuanavale in 1988. When Wilderson arrived the following year, the revolution was by no means completed, but the endgame was essentially in sight. Much of the tension now centered on what the political transition from a white to a black state would look like and how it would be carried out.

For Wilderson, the choice was clear: either the state would transition to a compromised liberalism under Nelson Mandela or a Marxist socialist regime quite possibly headed by the charismatic ANC party leader, and favorite among MK's militants, Chris Hani. In the end, that choice would be dictated by bloodshed, with Hani's assassination in 1993 followed by Mandela's historic election in 1994, which also led to the disbanding (on Mandela's orders) of MK's military brigades. Wilderson is unapologetic and explicit about his anger at Mandela, who he believes betrayed the revolution and more or less personally forced Wilderson to leave South Africa in 1996 by declaring him an individual threat to national security. Chris Hani's murder is a pivotal moment in Wilderson's life; it marked the death of his faith in a Marxist-Leninist revolutionary politics and the birth of the thinking that would come to replace it—a theory elaborated over roughly a decade of doctoral studies at UC Berkeley after his return to the United States, a theory he developed

with other scholars and academics including Saidiya Hartman (his advisor at Berkeley), David Marriott, and Jared Sexton and that he is sometimes called the godfather of: the theory of Afropessimism.

DESPITE ITS FORBIDDING ALLURE, the term Afropessimism does not designate a philosophy or a doctrine; nor, in spite of some of its more histrionic critics, does it describe some nefarious sect. It is by all accounts, and more modestly, an ongoing conversation among people interested in a set of inter-related questions, a conversation that has aroused particular interest primarily within the American black intelligentsia, among whom it began to gain a wider hearing sometime during Obama's second term. It has chiefly preoc-cupied scholars working within Black studies, as well as circulating in certain networks beyond the academy, garnering notable interest among black high school debate teams. Sexton, one of Afropessimism's most brilliant expo-nents, describes the improbable origins of its discourse as "a highly technical dispute in a small corner of the American academy." As Sexton rightly points out, a natural question that needs to be asked is why such a seemingly arcane argument should gather as much attention as it seemingly has today.

A sign of this success was the anticipation and excitement surrounding the announcement of Wilderson's *Afropessimism*. The book appeared poised to fill the gaps in the many scattered journal articles that treated the sub-ject and to explicate for a more mainstream audience what the thrust of this intervention into conversations on race is meant to achieve and how its ideas work; to serve if not as a manifesto for a wider movement, then at least as a guide for the perplexed. Instead, Wilderson proposed what he himself calls a "hybrid seed," one that "weaves the abstract thinking of critical theory with blood-and-guts stories of life as it's lived." Put differently, *Afropessimism* is a memoir that would like its life-lessons to serve as both occasions and exempla for expounding Wilderson's adopted philosophy. There's nothing wrong with this so far as it goes; some of the most extraordinary works in Black studies function this way. One thinks of Saidiya Hartman's magnificent memoir *Lose Your Mother*, of the autobiographies of Du Bois, Malcolm X, Angela Davis, and Assata Shakur, among many others.

The deeper root of this genre is, of course, the slave narrative. There is

a complicated sense, as we shall see, in which Wilderson has written a slave narrative *in the present*, insofar as it is his contention that he actually is, under the terms of his philosophy, a slave right now. Even more provocative (if that's possible) is his claim that, unlike the traditional author of a slave narrative, Wilderson not only has not, but cannot ever, escape the state of bondage.

Needless to say, these are difficult views for most people to accept, or to even begin to comprehend. To understand them, and to arrive at a reaction to them, requires clambering up the rather imposing theoretical scaffolding that supports the Afropessimist thesis, a hurdle that immediately raises questions for those invested in touting its popular reach. That doesn't mean a vulgarization isn't possible, but it does confirm the accuracy of Sexton's description of Afropessimism's "technical" origins and suggests only technicians with advanced degrees will really ever be in a position to elucidate it. I will hazard my own reconstruction of the argument, but I don't pretend to any ex cathedra authority. These theories are still actively debated in many quarters and there are those like Calvin Warren, for example, who runs the argument differently in his book *Ontological Terror*, which has grown influential in the field.

"BLACK PEOPLE IN THE United States differ from all other modern people owing to the unprecedented levels of unregulated and unrestrained violence directed at them." This is the opening sentence of the 2001 preface to Cornel West's *Race Matters*, originally published in 1993. It is a strong assertion, one that insists the situation of black populations in the US is exceptional in important ways that make any understanding of race subject to special scrutiny, and any facile analogy fallacious by default. As a shorthand, we might think of this simply as the "exceptionality thesis" with respect to blackness. Derrick Bell's *Faces at the Bottom of the Well* (1992) notoriously proposed that the time had come to accept the premise that "Black people will never gain full equality in this country." Call this the "immutability thesis."

Yet another key formulation from the 1990s—making its mark in the academic field of Black studies, however, and not as a popular bestseller like the two books just mentioned—is Lewis Gordon's *Bad Faith and Antiblack Racism* (1995). While Gordon did not coin the term "antiblack" or "antiblackness," he was the first to theorize and use it in a rigorous and systematic

way, and his pioneering work on the life and thought of Frantz Fanon, as well as his own original contributions to formulating a philosophy of black existentialism, are widely credited with popularizing the use of the terms within Black studies and those limited elements of the academy that engage with its precincts.

In this literature, "antiblackness" is a technical, not a subjective or impressionistic, term. It does not refer to prejudice or dislike, as might easily be supposed. Rather, it is used to capture the idea that an underlying racial antagonism can come to structure the social fabric of a given society. Race, in this description, operates like a function that overdetermines outcomes and relations between people regardless of any particular actor's personal disposition or attitudes. It says that there are disparate and antagonistic sets of what Durkheim would call "social facts," matters of objective analysis about the relative position of power, and more importantly even, of value, that inhere in populations that are racially marked and bounded. The racial fault line is therefore not a regrettable byproduct of behaviors that can be reformed or improved over time; it is not like a tumor that can be excised from the body politic. On the contrary, it is a necessary and even vital ingredient of the social order, a division that pulls two socially defined groups apart but simultaneously binds the larger edifice of society together like mortar in between bricks, holding them in place. Let us call this the "structural antagonism thesis."

Finally, although chronologically prior, Orlando Patterson's *Slavery and Social Death* (1982) is a comparative study of slavery across recorded history, examining its institutions, its economics, but most importantly of all its ideological justifications. Patterson argued that slavery in all times and places can, in fact, be shown to bear a common underlying ideological framework, which he called "social death." This term is intended to convey the way slavery imposes "the permanent, violent domination of natally alienated and generally dishonored persons." When slaves are stripped of access to their own heritage and to the normal rights of kinship over their offspring and thus their future, they are natally alienated. This is compounded by the mark of social dishonor resulting from slavery's profound connection to warfare. Patterson finds that slavery is almost universally understood as an outcome reserved for

the defeated in war who have not died (honorably) in battle. In other words, slavery can be conceived as essentially a suspended death sentence—hence the notion of existing in a suspended state of "social death." This we might refer to as the "abjection thesis."

Racial exceptionalism, political immutability, "antiblackness" as structural antagonism, and abjection in the form of "social death": each of these concepts predates Afropessimism, and as I see it, together they form its foundation. Indeed, it is the synthesis of all of these ideas into one purportedly coherent worldview that I take to be the innovation of Afropessimism. I have deliberately chosen the writers, scholars, and thinkers cited above, however, precisely because *they do not* come to the same conclusions as Wilderson. Several could be said to be strongly opposed; even Derrick Bell (whom Wilderson might have suggested as a predecessor but does not cite in *Afropessimism*) ultimately counsels in his book's epilogue that we move "beyond despair" and calls on us to "fashion a philosophy that both matches the unique dangers we face and enables us to recognize in those dangers opportunities for committed living and humane service." Part of my point here is that those who disagree with the Afropessimist worldview cannot be simply dismissed as "soft" or naïve. Nor should anyone infer that simply because one critiques the Afropessimist synthesis, one cannot also hold strong views in agreement about any number of more specific points of analysis.

To what extent will Afropessimism ultimately be comprehended as something of a historical "mood" related in ways to the underlying dynamics of our historical epoch we are still unable to fully elucidate? Like the related terms "affect" or Raymond Williams's "structure of feeling," a "mood" is notoriously difficult to analyze. We grasp it only indirectly, like the sounds from a party in the building next door. It circulates in the hyperactive synapses of our society where different registers of language agglutinate into shorthands and neologisms, "doomscrolling," "canceled," "triggered," "killing it," "I'm dead," that suggest some of it just by association. Every once in a while, a handle comes along that electrifies a whole swath of experiences at once, moments of rupture when a philosophy, a political slogan, or even bit of jargon throws the table over, gathering all those affective undercurrents under a single collectively recognized shout.

There is, of course, precedent for this, both within and without the tradition. For at least a decade after Stokely Carmichael's emblematic use of it in 1966, the slogan (and sometimes philosophy) of Black Power became the rallying cry closely associated with the rise and fall of the Black Panther Party. One can wonder if, retrospectively, Afropessimism, Black Lives Matter, and the Obama presidency will be similarly linked. Then there is European pessimism itself as refined into philosophical discourse by Schopenhauer, and more generally as a distinctive angst that swept through fin de siècle Germany, becoming especially fashionable among elites who called it *Weltschmerz*, literally a "worldpain."

The psychological woundedness implied in the compound "worldpain" reflects the intensity of the role that injury plays in these theories, and helps us to understand why Wilderson chooses to narrate his journey into the bondage that his pessimistic worldview holds him in in ways that sometimes approach something like talk therapy. Indeed, *Afropessimism* wades into what sometimes feels like the very frightening quagmires of an extremely intelligent and also deeply unsettled psychological state of mind. This is not entirely unfamiliar terrain. Wilderson has written intimately about his inner and outer turmoil before. His previous book, *Incognegro: A Memoir of Exile and Apartheid* (2015), is a riveting account of his time working as a militant and intelligence liaison for the ANC in South Africa at the height of the anti-apartheid struggle there. But *Afropessimism* feels much more scattered in its composition and, at times, even alarming in its confessions, which begin in the opening sentences and essentially never let up. Wilderson appears to believe this rawness strengthens and clarifies the stakes of his philosophy (which I wish he had given to us straight), and maybe for some readers it does. But his need to perform his own suffering for the reader's instruction persistently undermines the lucidity of his arguments, and his caustic tone bears the impress of an auto-da-fé, the book offered up as an act of sacrificial martyrdom. I have to say shocking things out loud that all blacks think but are afraid to say, Wilderson implies, and it becomes clear that he has in mind, in particular, the political correctness of the academy.

Indeed, one of the most frustrating aspects of *Afropessimism* is how much of it is devoted to recounting scenes of conflict that occur in, or very near,

to academic campuses, when one might have expected mass incarceration, police brutality, and unfair hiring practices to be the crises most urgently representative of its thesis. Yet there is very little this book has to say about the prison abolition movement, labor organizing, or even specific cases of brutalization and lethal instances of racial violence. This turns out to be consonant with the theory, though, since the activism around these issues is, from its own point of view, both pointless and beside the point. The actual scenarios we get instead are drawn from the interstices and banal marginalia of academic life: roommate situations, sharing a car with people of different ethnic backgrounds on your way to the airport, attending awkward racial sensitivity training exercises, going to conferences in foreign countries.

In a scene bordering on satirical farce, Wilderson agrees to travel to a small leftist conference in Copenhagen only on the condition that the organizer find black participants for his workshop. When the Danish organizer is only able to come up with a few brown and non-black people of color, Wilderson accepts this compromise, flies to Copenhagen, and proceeds to scold them for disallowing a real discussion of black suffering by insisting on what all participants have in common. Wilderson is scornful and admonishing, but also insists they leave the room understanding that in a sense nothing at all has been achieved since "there is no coherent form of redress" for black suffering. The value of the workshop is at best therapeutic at some unresolvable distance. The participants have learned the incommensurability of their own sense of plight with that of the black. "Your participation in this workshop with the Black people in Marronage is an act of solidarity," Wilderson tells them. Who these "Maroons" are, and what that term actually represents in this context—African immigrants living in Copenhagen, black Europeans in general, black Americans visiting Denmark—is not clear.

Wilderson moves on to a conference in Berlin, where he presents a paper demonstrating his thesis that the obscure docudrama *Punishment Park* (1971), a film by the English director Peter Watkins, thinks of itself as a leftist critique of creeping Nixonian fascism when it is in fact unconsciously a narrative vehicle reinforcing antiblackness. Things don't go well in the Q&A and Wilderson loses his temper. "My presentation shits on the inspiration of solidarity," he tells a white woman described as "an Oxbridge-educated

don" who he believes had been flirting with him before his talk. "I don't give a rat's ass about solidarity," he insists as the woman absorbs his comments in shock and dismay. As he tries to leave the conference she blocks his passage and demands that he consider his audience next time he's invited to give a talk. "I'm not even talking to anyone in this room. Ever. When I talk, I'm talking to Black people. I'm just a parasite on the resources that I need to do work on behalf of Black liberation," he retorts.

Does giving papers on the limits of interracial solidarity in activism and film theory in Copenhagen and Berlin qualify as "talking to Black people"? Is this what working on behalf of black liberation looks like today? "Afropessimism is not an ensemble of theoretical interventions that *leads* the struggle for Black liberation," Wilderson observes in an aside to his Copenhagen lecture. "One should think of it as a theory that is legitimate because it has secured a mandate from *Black people at their best*; which is to say, a mandate to speak the analysis and rage that most Black people are only free to whisper." To claim a "mandate" is a grave and inherently political pronouncement. I certainly do not, and frankly cannot conceive, claiming a mandate to speak on behalf of *anyone*, let alone "Black people at their best." In democratic discourse, "securing a mandate" is, of course, a phrase invoked to assert that one's ideas, decisions, and actions are justified as the direct translation of the popular will. But how plausible is it that what black people want from Frank Wilderson, or from any black intellectual for that matter, is for him to fly to Europe and tell non-black activists and white academics about our suffering and how nothing can change it? The language of a "mandate" strikes me as revealing an anxiety rather than asserting a self-evident, and conveniently unverifiable, truth.

Wilderson's preoccupation with the academy as a site of antagonism seems to me of a piece with his protracted insistence on the problem of what he calls "the ruse of analogy." This deception is particularly noxious, he argues, because it is deployed not by the enemies of black freedom and equality, but by non-black people of color who purport to be its allies. Wilderson warns:

> The antagonism between the postcolonial subject and the settler (the Sand Creek massacre, or the Palestinian Nakba) cannot—and should *not*—be analogized with the violence of social death: that is the vio-

lence of slavery, which did not end in 1865 for the simple reason that
slavery did not end in 1865. Slavery is a relational dynamic—not an
event and certainly not a place in space like the South.

As an example, Wilderson recounts an interaction with his friend Sameer, a
Palestinian from Ramallah whom he meets during a spell working as a guard
at the Walker Art Center in Minneapolis. Wilderson believes they share a
revolutionary worldview and solidarity, until this sense is shattered when
Sameer casually remarks in passing that being searched at an Israeli check-
point is more shameful and humiliating "if the Israeli soldier is an Ethiopian
Jew." Wilderson is plunged into existential shock as he must come to grips
with "the realization that in the collective unconscious, Palestinian insurgents
have more in common with the Israeli state and civil society than they do with
Black people." The scene is modeled on the famous moment of racial hailing
in *Black Skin, White Masks*, in which Frantz Fanon finds himself seized by
the white gaze: "Look, a Negro!" It's a powerful moment, and Wilderson has
a point: the fact that someone is oppressed due to their race does not make
them impervious to anti-Black racism; and, if you agree with Wilderson, then
you see evidence in this anecdote that it could not be otherwise. Palestinians
cannot fail to be racists, since their humanity is premised, like all non-black
peoples of the world, on denigrating blackness. Afropessimism, says Wilder-
son, "allows Black people to not have to be burdened by the ruse of analogy—
because analogy mystifies, rather than clarifies, Black suffering."

Analogy does not mean equivalence, however, and among the important
notions that the word "analogy" conveys is that two things can be comparable
on the basis of an underlying *proportionality*. For instance, two extreme events
like the Jewish Holocaust and the Rwandan genocide, though very different
in countless important ways, still might be said to share the underlying sim-
ilarity of intent and even to a certain extent scale (though not the technology
of killing or its method). Analogy and metaphor are also constitutive of our
cognitive processes: without them there is no possibility of producing the-
ory, no production of thought. The question is not whether analogy should
be allowed, but what constitutes a good analogy as opposed to a bad one: to
what extent does an analogy *work*.

A major problem with Wilderson's inveighing against the "ruse of analogy" is that his book routinely deploys analogies and metaphors that are at least as questionable as the ones he denounces. What are we to make, for example—keeping in mind Sameer for a moment—of Wilderson's description of telling his mother that a white neighbor had asked him how it felt to be a Negro? Wilderson says that this was a learning moment for his mother about the lengths whites might go to injure a black person, in this instance by psychologically attacking their children. "She knew now how it must feel to be killed by a guided missile," Wilderson comments. I don't doubt the psychological violence of the incident in question, but that doesn't make moving into Kenwood *like* having a Hellfire missile hit you in the Gaza Strip. Why does Wilderson reach for this hyperbole at all? If he wanted to make the point that housing integration involved terroristic violence, there are plenty of data and events to point to. Black homes in cities across the country were bombed and burned throughout the 1950s and '60s. But instead of martialing the historical facts of racial oppression, we get a distorted rhetoric that has to stretch the boundaries of reality in order to justify the theory.

The most troubling aspect of Afropessimism, however, may be its treatment of slavery. Despite the fact that Wilderson knows this is one of the most fiercely contested components of his worldview, he treats it as if it were a minor point, relegating an important statement of his position to a footnote: "It is worth reiterating that, through the lens of Afropessimism, slavery is, essentially, a relational dynamic, rather than a historical era or an ensemble of empirical practices (like whips and chains)." I submit that there is something deeply troubling about a casual parenthetical that proposes to evacuate the significance of the entire material history of antebellum slavery. It's also logically bizarre, since it seems constitutive of the entire project that slavery have been real at least at some point in order for the relation to obtain in the first place. But these issues are brushed aside, since this erasure is necessary for the theory to do what Wilderson wants it to do; slavery must be transformed into a portable and fundamentally *psychological* relation unrelated to any historical memory and founded purely on the basis of melanin and the antagonism that an all-encompassing and all-powerful "whiteness" poses to it.

For many of us such a leap is neither ethical nor comprehensible. But for

Wilderson the portability and paradoxical fungibility of slavery fits perfectly with his interest in film and his Lacanian and Fanonian readings of it. How else to explain passages in *Afropessimism* in which incidents involving a terrible white roommate situation he and his girlfriend find themselves in circa 1979 are, for Wilderson, obviously comparable to Steve McQueen's 2013 film *12 Years a Slave*, which was based on Solomon Northup's 1853 slave narrative. This is not a jest, but a sustained and intensely explored analogy in which the whipping of Patsey (played by Lupita Nyong'o in the film), descriptions of the cool sadism of Mary Epps (the slaveowner's wife) from Northup's 1853 narrative, and Wilderson's troubles with a batty white roommate in 1979 all share the same stage. We are asked to imagine them as coequal and even coeval psychological theaters of cruelty, whose mise-en-scène simply involves different props. The plantation is everywhere and all the time. It is ontological, which means that it attaches trans-historically to all black persons regardless of their social position.

How far does this go? In his academic monograph on film studies, Wilderson forthrightly asserts that black academics are not subalterns in the academy but "Slaves of their colleagues." Is being talked down to in the faculty lounge really *the same* as being whipped at the post, or slinging rock on the corner, or being placed in solitary on Rikers Island as a juvenile? Is working at Merrill Lynch in New York as a black woman really the same as working shifts as a black gay man in a McDonald's in Alabama? Is it ethical or desirable to confound all of these into a tortuous equivalency while telling those who propose to fight at your side to shut up because you don't like the analogies they are using to connect themselves with your suffering?

It is fair to ask of a "lens" whether it actually sharpens our view and, if so, to perform demonstrations of clarity. A major problem for Afropessimism is that its claim to revealing the underlying structural truth seems to repeatedly require abandoning any significant contact with historical reality. With social categories like class, gender, and material facts made irrelevant, the theoretical work is forced to concentrate itself in rhetorical aphorisms that seem to be slouching their way toward slogans. "The antagonist of the worker is the capitalist. The antagonist of the Native is the settler. *But the antagonist of the Black is the Human Being*," Wilderson tells us. The problem with this,

apart from its faux-syllogistic form, is that human identities are not fixed and rigid boxes, but dynamic rings of change that merge and overlap. The black Americans involved in the colonization scheme of Liberia in the nineteenth century were both black (formerly enslaved on US plantations) *and also* settlers. Obviously, there are black capitalists just as there are black workers. Is there a double-jeopardy principle for antagonisms or some calculus by which they can be selectively negated?

"Blackness and Slaveness are inextricably bound in such a way that whereas Slaveness can be disimbricated from Blackness, Blackness cannot exist as other than Slaveness," Wilderson assures. Was Joseph Jenkins Roberts, the first president of Liberia, not capable of really *being* a settler or a capitalist because of the inescapable "Slaveness" of his Blackness? How should we evaluate the categories both legal and political that black people themselves brought into world history? The only antagonists Jean-Jacques Dessalines recognized in 1804 were the French whom he violently reviled, refused to grant any rights to, and often cruelly put to death (in the context of what is arguably the most just war ever fought and the only successful example of a slave revolution in history)—while simultaneously decreeing that *all citizens* of the republic of Haiti henceforth would be considered *black*, even the small Polish population on the island which had joined forces with the slaves against the French slave power. Dessalines also believed that a convergence of interest and identity with the "native" population was both possible and desirable, which is why he called his forces *L'Armée Indigène* and changed the name of the island from the colonizer's Saint-Domingue to Haiti, a word from the language of the indigenous Taino people.

What are we to make of those black Americans who owned slaves themselves, the imbricated weave that historians Michael P. Johnson and James L. Roark describe in their classic study *Black Masters*, and that Edward P. Jones meditates upon in his great novel *The Known World*? What of the fact that black and white laborers banded together and fought against the planter elite during the years leading up to and including Bacon's Rebellion in 1676? And if the categories of racial blackness and whiteness are key, why is none of the scholarship on the historical production of "whiteness" (Theodore Allen, Noel Ignatiev, Nell Irvin Painter, David Roediger) cited in either *Afropessi-*

mism or *Red, White & Black?* Where do the unique polities of the Jamaican Maroons and quilombos of Brazil fit into this picture? Can it really be true in the full light of history that there is no blackness *at all* that is not slaveness? I understand Wilderson's point about his Palestinian friend, but what does his theory clarify for us about that Ethiopian Jewish soldier?

CARTER G. WOODSON, in *The Miseducation of the Negro*, said that "to handicap a student by teaching him that his black face is a curse and that his struggle to change his condition is hopeless is the worst sort of lynching." There is no reason to think Afropessimism is anything that severe. But I invoke Woodson here to remind us that more pragmatic points of view are neither new nor the product of superficial analysis. They cannot simply be breezily dismissed. Let's not pretend that there are no voices that represent *the best of Black folk* as much as anyone else, and yet take a radically different point of view on race, racism, and what to do about it. Whatever position one eventually comes to, they are owed some serious account, not consignment to the oubliettes of history, as if intelligent thinking on the positionality and politics of blacks in the United States only began yesterday.

No serious black intellectual today thinks anti-black racism is not a matter of life and death. The question is still the old one: What is to be done? There has to be room for a serious debate and the flexibility of open-minded conversation on that score. It's simply implausible that the answers are easy, obvious, or one-dimensional. The fact that Black Lives Matter has done more to explode the Overton window in American politics than any movement since the 1960s has to be fully and duly appreciated for the extraordinary achievement that it is. But Adolph Reed Jr.'s countervailing contention that Black Lives Matter is merely a rebranding and retreading of Black Power for millennials is a barb nonetheless worth reflecting on seriously.

Because he tends to be caustic in his writing and impolitic in his interventions, Reed is sometimes dismissed or caricatured as a class-reductionist. But that charge doesn't stick when one bothers to read him carefully or examines his decades-long track record of painstaking political organizing among black workers. And Reed has been right before, most famously about Obama with whom he crossed paths in Chicago in the mid-1990s when he diagnosed

him as "a smooth Harvard lawyer with impeccable do-good credentials and vacuous-to-repressive neoliberal politics." The ease and celerity with which multinational corporations and political elites rushed to eulogize George Floyd, instantly adopting the performative repertoire of genuflection and the mimeographed consultancy lingo of McKinsey et al. through the issuing of carefully worded "statements," should give us pause. It is possible for a nom-inally leftist rhetoric, especially one that is explicitly ethno-nationalist and directed by actors professionally linked to the governing class, to weaponize superficial and symbolic gains in ways that serve to advance their own pro-fessional and middle-class interests. This work happens at the expense of broadly based and genuinely popular political strategies that could have oth-erwise advanced the interests of the black poor and working classes who are most vividly affected by the forces that the movement alleges it is dismantling. Everything in black political history suggests that the danger of this kind of cooptation is very real. As Imani Perry observes, a robust Black feminism is critical at this juncture precisely because it is so uncompromising vis-à-vis "the self-congratulatory posture of the neoliberal state" and its constant attempts to funnel the energy of righteous discontent back into market-driven and customizable "lean in" conceptions of activism.

At the same time, it seems clear that whatever its eventual failings and misfires, the spectacular and urgent appeal of BLM among the younger gener-ation (not just in the United States but around the world) is a rational response and rejection of the style of racial politics that wound-licking left-liberals fashioned in the late Clinton and Bush years, and that reached its apogee in both the persona and policy offers of Obama's presidency. That generation's rose-tinted conception of politics as the transactional but egalitarian rule of the demos by the best and the brightest was enshrined, as the commentator Luke Savage cannily pointed out, in the sanctimoniocracy of Aaron Sor-kin's television show *The West Wing* (1999–2006). The main threat in that world was understood to be the crude morality and venality of Republicans and the threat of terrorism emanating vaguely from the Middle East. But the real Vietnam that threatened this new breed of "whiz kids" (whose failures and educational pedigrees uncannily resemble those of Halberstam's famous book on Kennedy's "Best and Brightest" men) was not brewing in the (unde-

niably real) quagmire abroad, but in the neglected quagmire at home, one that was captured in the other signal television show of that era, David Simon's *The Wire* (2002–2008).

These two shows represent the schizophrenic, split-screen personality of the governing elites in the United States at the dawn of the new century: on the one hand, a sunny republic governed with the best of intentions and yielding the best of all possible worlds as it checks religious fanaticism and regressive social views with perfectly timed quips and Lincolnian citations; on the other, the entrenched poverty of a gutted and deprived racial under-class mired in a violent web of drugs and deindustrialization overseen (quite literally in the show) by a hapless and hopeless police force given the cyni-cal task of "managing" its casualties for periodic and parasitic gains by the nasty, brutish, and often short lives of the most ruthless operators patrolling its wastelands. Yet both shows were popular and aimed at the same demo-graphic. This incoherence and paralysis—liberalism as optimism of the intel-lect and impotence of the will—white people making the world a better place and black people dying in a pointless inferno, finally became untenable under Obama. There are arguments to be had over whether the response of this new activist generation got the analysis entirely right, but they cannot be faulted for throwing the emergency brake on a ruling-class consensus that had pre-sided over decades of dysfunction and despair, being ping-ponged back and forth between two political parties that had nothing to offer, while the basic minimums for social cohesion were being repeatedly breached.

The question of the responsibility of black intellectuals with respect to this ugly stalemate is a heavy one. There are those who believe the verdict of history will look very unfavorably upon the ultimate balance of accounts. I tend to think that this is ungenerous given the enormity and complexity of the challenge. Either way, it cannot change the fact that the situation of black America is unacceptable and that the debates over race versus class, structure versus culture, statism versus market liberalism—have all led us to where we are today, which is to say that there is no agreement that any policy has worked, nor any theoretical view prevailed. The only consensus across all political factions is that the country is adrift and disoriented on the question of how to realize the fullest aspirations of a racially integrated democracy.

It makes perfect sense that pessimism, whether of Wilderson's variety or some other, should seek to fill this vacuum. And yet beyond the noise of social media and well outside of academic groves, the black working and middle class has little interest in seminars about the power of whiteness or its fragility. It is looking for tangible, pragmatic answers and solutions in the present that will enable people to protect black boys and girls from being mowed down without a chance; to exercise control and agency over police, schools, courts, and prisons that act with indifference or hostility to their humanity. There is frustration at the lack of consistency and depth in institutions; decline and corruption within HBCUs, traditional civic organizations, and religious leadership. There is a simmering class hatred and material envy fueled by the conspicuous consumption of those who have hustled their way to riches and flaunt them in the hood, and those who, having secured the bag, resent the rest. There is a deep moral insecurity and confusion about the legacy of a civil rights movement and affirmative action, which gave some a foot in the door but often not the means to secure and reproduce security for their children. There are deep and traumatic histories of violence that have never been addressed as issues of not only individual, but communal mental health.

In this context, a theory of Afropessimism still holds an understandable appeal to those of us who for whatever reason hold positions of greater social security and standing. Who feel ambivalent and insecure about the balance of power in our lives between black and non-black friends—and who can thus find in Wilderson a language that speaks to our survivor's guilt. It feels good to suture your identity back to the collective, to pronounce that you share in equal measure the plight of all black people throughout history. But that doesn't make it so. This doesn't mean there is anything wrong with the impulse; nor should the pain of an alienated bourgeois intelligentsia be dismissed. Indeed, if history is any guide, it is always out of this very class that important revolutionists from Robespierre, to Trotsky, to Che, to Wilderson himself have always emerged. If Afropessimism does end up provoking factions within the black postgraduate body to radicalize and take up political projects that advance the interests of black folk generally, then I will stand corrected and simply be shown to have been short-sighted and mistaken in my analysis. This would be a most welcome outcome.

Nonetheless, the fact that the main current of Afropessimist thinking runs counter to all of black political history and tradition thus far; the fact that the foundational thinker for this perspective, Frantz Fanon, came to completely opposing conclusions with respect to the nature of politics and solidarity in struggle; the fact that the theory often appears to evade scrutiny or contestation by proclaiming itself "meta-theoretical" and "ontological"; the fact that it asserts a "mandate" for which no empirical evidence is provided and in the face of overwhelming evidence that it constitutes at best a minoritarian and class-specific position—all of this has to be reckoned with by those who want to take Afropessimism to heart.

Perhaps it's worth reminding ourselves that when he was murdered, Fred Hampton was encouraging poor whites to analogize their position to that of poor blacks. At the time of his assassination, Malcolm X was embracing and actively seeking to incorporate a cross-racial coalition into his new organization. Ella Baker actively encouraged the deepening of organizational ties and activist links across different communities by emphasizing common struggle and common oppression. What evidence do we have, on the other hand, that the power behind the status quo is quaking at the thought of black folk gathering in isolation to mourn the end of the world?

If the challenge is more narrowly intellectual and what is needed are correctives to white Marxist hubris, Cedric Robinson's *Black Marxism* (1983) already exists. Black feminist thought offers its own counter-narratives. Of course, Wilderson doesn't have to agree with Robinson or the Combahee River Collective. But isn't it a problem that they aren't cited even once in his books? Are we to jettison our entire tradition? Were all those who came before us so hopelessly naïve? Are we going to cast aside Vincent Harding's *There Is a River* and read nothing but Fanon, Lacan, and Heidegger? Is Bantu philosophy overdetermined by social death even if its worldview was constructed in the absence of the white gaze? Afropessimism has yet to tackle these questions, to take its opponent's counter-arguments and positions seriously.

David Marriot, who *is* cited by Wilderson as a fellow Afropessimist, asks in his own work: Whither Fanon? I couldn't agree more with the question. Wilderson says he is the figure he modeled himself on as a young man. Clearly

Fanon is central to all of his thinking; indeed, all Afropessimist theorists consider *Black Skin, White Masks* (1952) a cornerstone text. It is an extraordinary philosophical work, and they are right that it is too often underappreciated. But it is also an extremely complicated intellectual experiment. The second sentence of that book is: "I'm not the bearer of absolute truths." Fanon proposes to work *through* the problem of the abjection of blackness, and that process extends beyond the book into the engaged existentialist revolt and the analysis of colonial relations that he explicitly argues involves the colonized subject, regardless of their race, in *The Wretched of the Earth* (1961). But even if one were to read only *Black Skin, White Masks*, it is impossible to miss the humanist assumptions that it opens onto in its conclusion. What else can one make of Fanon stating that "I am not a slave to slavery that dehumanized my ancestors," and that "the density of History determines none of my acts. I am my own foundation"? How can one miss the assumption of a shareable humanity when he insists that "at the end of this book we would like the reader to feel with us the open dimension of every consciousness." How can Fanon's trajectory into the Algerian War of Independence be reconciled with the null trajectories that Afropessimism proposes?

If Afropessimism pushes us to pose harder and sharper questions as Fanon prayed his black body always would, if it serves to break the shallow cant of the media class and its operatives—then certainly it will have done some good. But on the terms of its own presiding genius it needs to be understood as a way station and not a terminus on the road to *disalienation* that Fanon argued is the only path to freedom for black people in the modern world. That path, which he described in terms of building a "new man," required him to first understand the depth of abjection that blackness had been cast into, and then to undo that abjection by mobilizing its ejection from the political order of the West in a grand historical struggle to reconstruct that civilization from the side of the oppressed, an embrace that clearly involves a radical solidarity with non-black people. This was the mission Fanon was on when he died, and it was a mission he believed black peoples would have a special, indeed foundational, role in ultimately seeing through.

Realizing these goals does not mean adhering to a formulaic principle

or that black people need to think, act, or speak as a monolith. Fanon and Wilderson are both fond of citing Aimé Césaire's phrase about "the end of the world" from his poem *Notebook of a Return to the Native Land*:

> *One must begin somewhere.*
> *Begin what?*
> *The only thing in the world worth beginning:*
> *The End of the world of course.*

These lines do not appear at the end of the poem, however, but roughly halfway through it. The interjection "of course" stands in here for the French word *parbleu*, which even in the late 1930s when Césaire was composing his poem in Paris carried a folksy and bathetic ring that is only dimly captured in the English but easier to hear if you imagine these lines as having strayed from a play by Samuel Beckett. Wilderson intones this phrase repeatedly in his book, wielding it like a totemic hammer portending world-destroying events that in light of the commitments of his own theory seem to suggest, and possibly wish for, a zero-sum war between the races.

But Césaire's usage is far more ambivalent and ironic, the cry of a man whose revolutionary action must first and foremost be directed inwardly toward a poetic reconstruction of the self, a liberation that requires a self-determined and self-realizing pursuit of truth. Fanon admired and respected no intellectual more than Césaire. We know from his letters to his French publisher François Maspero that he imagined his writings as addressed, in no small part, to and for him. The idiosyncratic prose style of *Black Skin, White Masks* is Fanon's way of signifying upon a correspondence with Césaire's poetics. Both writers are acutely aware that the black thinker is poised precariously between the poles of reflection and action. But both are committed to a humanistic pursuit of truth and both believe in the promise of a radiant blackness whose time is not yet come. This is why even as the Algerian War raged around him, Fanon continued his psychiatric research, convinced that understanding the traumas of war and torture would be necessary for healing the postrevolutionary body politic. He wrote for the present and for the future in pursuit of an understanding of himself and of human nature, and for the

cause of a political independence and freedom that he hoped would set the entire African continent on a new course. Had he lived, he would have persevered until every colonialist regime from Algiers to Cape Town (the title he had in mind for his last book was *Alger–Le Cap*) had been driven off the continent. Fanon was no pessimist: true revolutionaries never are.

BUT MUST WE REVOLVE AROUND Fanon in the first place? Today many activists are more inspired by Fannie Lou Hamer. The US context has its own problems that Fanon only barely understood and addressed. Why not return instead, in this hour of national contestation, to a figure like David Walker and his *Appeal to the Coloured Citizens of the World; But in Particular and Very Expressly to those of the United States of America* from 1829? We still underappreciate the importance of this text, one of the seminal documents that captures the first great black intellectual debate in the United States, which was an argument over whether or not we ought to stay in the country at all. Walker believed we should, and he was the first to define and defend the monumental implications of that choice. He attacked the powerful lobby of the American Colonization Society, which included the powerful senator Henry Clay, Abraham Lincoln, and many leading black intellectuals of the day, who were convinced full equality for blacks in America was neither possible nor desirable and advocated emigration. Their plans revolved around evacuating the black population to the Pepper Coast, now the country of Liberia, which emerged from colonial schemes like "Mississippi-in-Africa" that the American Colonization Society founded in the 1830s.

We could have abandoned the country. History could have taken a very different course. American slaves could have returned to Africa and the United States could have become a white ethno-state, a second Europe. The 1820s and '30s were the last possible moment of undoing or preventing the existence of a black America. But black American intellectuals made the choice to stay—to hold this ground and make something new here that the world had never seen. As the political scientist Melvin Rogers points out, Walker's *Appeal* not only staked this argument in terms of a principled black nationalist claim based on the enormous sacrifice of "blood and tears" in slavery; the rhetorical address of the text was also intended to awaken black Americans to

their own potential as a nationally self-consciously political community with a global outlook. "For him [Walker]," Rogers writes, "African Americans did not need a prophet to whom they should *blindly* defer. Rather they needed a community willing to confront practices of domination, capable of responding to their grievances, and susceptible to transcending America's narrow ethical and political horizon."

Wilderson's *Afropessimism* insists that we are still slaves. Walker insisted in 1829 that the slaves are (and were even then) "colored citizens" of the United States and of the world. That if we are oppressed it is only because we are ignorant of our true strength, because we have been taught to disbelieve and disavow our worth to the world, to the nation, and to each other. Which of these two views is the correct one? I think the historical record and the present state of our politics tells us all we need to know on that score. For it is no coincidence that today it is black Americans who are once again trying to save the country, to invest in finishing the work of making this place a home that we can live in. In what is a long-standing pattern, the "colored citizens" of this country are at the forefront of practicing civics. Indeed, what could be more republican than risking one's health to restore the health of the body politic? To ensure that one of the most basic promises of the state is properly fulfilled: that it apply its law enforcement equally, humanely, and in a manner accountable to the people it serves.

As in past struggles, our principled defense of an ethical civil code has attracted others with its moral force. We have seen a massive response, including from sources traditionally opposed to these concerns, who recognize the profoundly dysfunctional culture of US policing, prisons, and courts. Even many of those who do not agree that these are the result of *actively* racist policies and attitudes no longer deny that our exceptionally poor record cannot plausibly be unrelated to a long history of anti-black violence and antagonism. For this same reason, likeminded people around the world are hoping for a decisive break with the past, taking to the streets across the globe to demand that state actors acknowledge that there really is a history of injury that needs to stop being denied, and that we can and should work together to design a new social contract that will restore the perceived legitimacy of law enforcement and criminal justice in the eyes of all citizens and not just some.

The generation undertaking these endeavors does not seem to require a narrative of optimism in order to take the great risks they have incurred. They have a healthy indifference to both optimism and pessimism alike. Perhaps it results from the demands of carrying out politics in the real world. The incredibly difficult task of organizing and strategizing in order to elevate and amplify the best responses and to rein in and temper the counterproductive ones that delay and diminish a good cause. That's hard to do in the best of cases: in a turbulent, paranoid, and instantly videotaped public sphere, it's a Sisyphean task that bad-faith commentators take advantage of.

None of this diminishes the fundamental need for greater self-capacity of the kind Walker called for two hundred years ago. Much of the work ahead will necessarily involve a growing capacity for self-reflection, self-criticism, irony, and joy in our politics. It will require acknowledging that struggles against white oppression will never be successful without deepened self-healing in our communities: repairing the relations in families, between men and women, ending the violence directed at trans, queer, and otherwise nonconforming people in our neighborhoods, ending the heinous blood feuds between rival gangs and sets, restoring education and communal trust as our highest priorities and most cherished aspirations. These will always remain preconditional to the realization of freedom and autonomy. It is pursuing these aims as an ongoing collective activity that will make unavoidable the realization, as Walker said, that this country is "more ours" than anyone else's—that we are a historic people with a world-historical destiny that understands our suffering as endowing us with both the right and the responsibility of *civilizing* the United States in such a way that it reflects the values that our historical experience bring to it, the freedoms, equalities, and cultural pluralisms that we have made vital and central to its identity.

One doesn't need to hang on desperately to a mirage of hope. If we look to history we can see more than enough concrete evidence and example to support the conclusion that a racially defined caste system is unlikely to ever again prevail. Of course, that doesn't mean history is a smoothly upward-trending curve. We have known terrible setbacks. Yes, the violent defeat of Reconstruction was successful. But the building of black institutions and the Niagara Movement proceeded anyway. Tulsa was burned to the ground.

But its black citizens turned right around and rebuilt it out of the ashes. The civil rights movement was checked by the forces of reaction and the assassin's bullet; but the world of unquestioned white superiority and authority that George Wallace hoped to preserve is reduced now to a twinkle in David Duke's blue eye. Yes, creepy white supremacists still crawl out from under mossy stones at opportune moments to wail about their Nordic fantasies in their oversized khaki pants. Yes, like the militants of the Islamic State, they are capable of carrying out horrific acts of terror and violence. But like that barbaric and fanatical sect, white supremacy is permanently confined to such rear-guard actions because it has already lost—it is trying to reverse a clock going forward—which explains the virulence and incoherence of its outbursts of spastic violence.

We are not at the end, but near the beginning of something new. The coronavirus pandemic and the multiple underlying crises and fractures it has revealed make vivid that one need not wait so very long for "the end of the world." The problem, as generations of millenarians have discovered, is that it turns out there's a morning after the end of the world. And one after that too. The hardest truth is that all the uncertainties that govern the question of what can be done, what will be done, and the difference between the two remain in our hands. What would Frantz Fanon, or David Walker, or Ella Baker tell us if they saw the streets today? Surely, not that we are at an impasse against an implacable enemy. They would insist that we lift each other and rise together with the spirit of history at our backs. We have done it before. Every time we do it's a new day.

—2020

Who Will Pay Reparations on My Soul?

I N THE SUMMER OF 1960, James Baldwin wrote an essay he styled "Fifth Avenue, Uptown: A Letter from Harlem." Among the host of ills he observed in the neighborhood where he was born and raised, he gave a prominent place to the dynamics of racialized policing:

> The only way to police a ghetto is to be oppressive. . . . Rare, indeed, is the Harlem citizen, from the most circumspect church member to the most shiftless adolescent, who does not have a long tale to tell of police incompetence, injustice, or brutality. I myself have witnessed and endured it more than once.

Like so many of us watching events unfold on the live feed from Ferguson, Missouri, I thought about how depressingly familiar it all looked. How many times has this very script played out in our lives? What year wasn't there a prominent slaying of a black citizen under dubious circumstances, followed by an outbreak of rioting? Here is Baldwin in 1960, describing the archetype in his characteristically lucid way, with empathy but also a stern moral clarity:

> It is hard on the other hand to blame the policeman . . . he too, believes in good intentions and is astounded and offended when they are not taken for the deed. . . . He moves through Harlem, therefore, like an occupying soldier in a bitterly hostile country; which is precisely

what, and where, he is. . . . He can retreat from his unease in only
one direction: into a callousness which very shortly becomes second
nature. He becomes more callous, the population becomes more hos-
tile, the situation grows more tense, and the police force is increased.
One day, to everyone's astonishment, someone drops a match in the
powder keg and everything blows up. Before the dust has settled or
the blood congealed, editorials, speeches and civil-rights commis-
sions are loud in the land, demanding to know what happened. What
happened is that Negroes want to be treated like men.

The vulnerability of racially marked bodies to power, particularly police
power, and the lack of justice—the singular and persistent evidence of gross
unfairness where race and the law intersect—reveals a bloody knot in the
social fabric that is as vivid in Ferguson, Missouri, today as it was in Bald-
win's Harlem half a century ago. What can be done to end this awful cycle
of violence? What still prevents so many blacks from being treated with full
humanity—treated, in Baldwin's words, as men?

In German, the word *Schuld* signifies both "guilt" and "debt." In the
context of the American debate about race relations, "reparations" likewise
reflects both sides of the coin. The principal difficulty with reparations, as
with black history in America more generally, is that guilt is an unpleasant
feeling, susceptible of clouding judgment. Guilt colors the whole conversa-
tion. Today nobody can deny that being charged with racism is one of the
most incendiary charges one can levy in public life. People are genuinely
mortified by the accusation; many fear to even approach racial topics, or tread
though them like a minefield. This legacy of political correctness has proved
double-edged. On the one hand, a certain kind of public discourse is far less
poisonous and injurious than it was a few decades ago. On the other hand, we
have made race a relentlessly personal issue, one that often shields and dis-
tracts us from the harder questions of structural inequality, racial hierarchy,
and social control.

Ta-Nehisi Coates joined a long tradition of black American writers
stretching back to early abolitionists like Sarah Parker Remond, Mary Ann

Shadd, and Frederick Douglass by calling upon America to live up to its moral promise; to reimagine itself and take concrete actions that reflect, in Coates's words, "the full acceptance of our collective biography and its consequences." His essay "The Case for Reparations" renewed the enduring debate about the possibility of reparations as payment for racial injustice in the United States.

The popularity of the piece has led, predictably, to a considerable backlash, notably among black conservatives, with much of the criticism grounded in the notion that the topic of reparations is harmful rather than helpful to a conversation about racial politics. But Coates is right to take us back: in "reparations," he has resuscitated a word with the rhetorical heft necessary to shift a conversation on race that has become too personalized, and too complacent. It is far more productive for us to argue about reparations than about, say, graphic suffering in *12 Years a Slave*. Talking numbers, legal cases: all this may not be as jolting as the prostrate flesh at the whipping post. Yet it represents what we still don't seem to know: for whites, the extent to which blacks were defrauded and stolen from; for blacks, an oft-forgotten history of resistance, like Chicago's Contract Buyers League, laying the groundwork for renewed action in the present.

At the same time, I want to seize on the opening Coates has provided to suggest a different emphasis, one which ultimately comes down to thinking about reparations for racial injustice as a moral rather than a material debt, and one that must be repaid politically, not compensated for economically.

I should make a few things clear here. First, Ta-Nehisi Coates *does* think America owes a moral debt to African Americans; it's just that he believes one way of discharging that debt is through material compensation. I agree that compensation is owed, and, like Coates, I am not impressed by the usual objections, many of which Coates anticipates and counters in his own essay. Typically these involve throwing up one's arms over the practical conundrums of determining who is owed what, how much, how to be accounted after so many years, etc. What about people of mixed race? What about recent immigrants? What about all the white Americans who fought with the Union and bled and died to defeat the Confederacy? These are difficult (some would say intractable) hurdles for a theory of reparations to overcome; but while I

think Coates is right that at least some of them are spurious, they do not form the basis for why I think such a conception of reparations is flawed.

Ultimately, I think we ought to reject a program for material reparations in America for two reasons. The first is that no amount of monetary compensation can rectify a debt that consists in the broken promise of a social contract; this contract is a moral good, and therefore its abrogation a moral debt.

What do I mean by a moral debt? It is not fashionable these days to talk about the principle of a social contract. But the American founders were intimately attached to the idea, and placed it at the center of their reasoning and justification for creating a democratic republic. That this framework for freedom and flourishing was built over and against a massive system of black enslavement is at the heart of the American contradiction. There is a strong belief today that the civil rights movement redeemed that sin for all time. But a real democracy doesn't live on its laurels—it has to be "worked out in terms of the needs, problems, and conditions of . . . social life," as the philosopher John Dewey reminds us. Can anyone today seriously maintain that there isn't urgent work to be done to integrate poor black communities politically and socially, or that there is not a strong case for favoring such work over other potentially worthwhile objectives?

My second objection is pragmatic, although not in the sense described above. Despite the justifiability of the case for material reparations, it is vastly improbable that they will ever be mandated politically, whereas reasonable new initiatives in education, policing, prison reform, community empowerment, and sentencing reform, even if difficult, should all be realizable within the horizon of contemporary politics.

Ta-Nehisi Coates knows that the chance of restitution resulting from a reparations bill passing in Congress is nil; the gambit is that even without enforcement the required return to forgotten history could provoke "a national reckoning that would lead to spiritual renewal." I agree that we need to have the kind of conversation that would lead to a national reckoning. I just think the issue of monetary loss and compensation is not the right angle from which to pursue it.

Let me be clear: Coates is not wrong to address the wealth gap. Far too few Americans understand the way black poverty has been systematically

contoured and shaped by white power, by whites refusing black populations access to the levers of upward mobility that they then endlessly complain blacks fail to take advantage of. Yet Coates's overarching emphasis on material loss can make it seem as though our affective reaction should primarily be motivated by material inequality. Coates writes that "no statistic better illustrates the enduring legacy of our country's shameful history of treating black people as sub-citizens, sub-Americans, and sub-humans than the wealth gap." The wealth gap is obviously a significant metric for blacks today, but I would argue it is not nearly as significant as the black incarceration rate, as the death rate of blacks at the hands of police, as the number of failing schools in black school districts. The "Colored Only" sign says to a black person that they have been robbed of much more than what could or should be in their wallet.

Toward the end of his article, Coates draws a comparison to the case for German reparations after the Holocaust. The comparison is thought-provoking but inexact. One obvious problem is that, in the German case, the reparations were paid to the state of Israel. A state can collect and allocate large-scale resources in ways that can generate gainful investments benefiting the population it speaks for. In the case of reparations to American blacks, there is no state organ on the side of the collector. More importantly, the Israeli Jews on the receiving end of German reparations were citizens of a separate nation from the one that was paying them. The reparations we are concerned with here are not for foreigners, or a group of African Americans with their own state in, say, Liberia. The taking and giving in this instance would be from the same people; black American taxpayers would be handing money back to themselves. Within its own borders the way for a state to do justice to an oppressed minority is not by paying it off, but by creating the conditions for it to flourish equally.

Reparations as cash equivalent, even if justified, would be inherently superficial in this sense. But there is another way of thinking about reparations. Instead of arguing about wealth, we could talk about freedom from domination, community control, and justice before the law. Reparations in the form of political and legal reform, a recognition that blacks still need and deserve greater control over their communities, and the resources to make

that control efficacious. The disturbing images from Ferguson are clear: a police force with a local power structure that is overwhelmingly white coupled with jurisdiction over a community that is predominantly black is a recipe for disaster. None of this should be surprising given our history—but that does not make it intractable. We have addressed such problems with democratic principles and reform-minded politics before.

"I WANTED THE PROTECTION of the law," Clyde Ross responded when Ta-Nehisi Coates asked him why he left Mississippi for Chicago. Ironically, Mr. Ross would find himself again the victim of unjust housing policy in the North. The protection of the law is not something that white Americans are used to thinking of as a luxury. But for black Americans the law has only rarely functioned as a protection, and then only after it has been struggled for mightily. I don't use the word *luxury* casually. It's astonishing how often people talk about civil rights without considering how deeply illogical it is that civil rights needed to be passed in the first place—how it took a hundred years after Emancipation for blacks to have protections to which they understood themselves entitled even in bondage.

The hypocrisy of white power in the United States has long flowed through illegal, extralegal, or flagrantly immoral channels. It is black Americans who time and again have called for ensuring truer and broader justice in the land— for America to live up to the formidable ideals of its charter and not just pay lip service to them. That deep sense of corrective justice suffuses King's "Letter from a Birmingham Jail" with its profound meditation on just and unjust law, and with its memorable and timely chiding of the "white moderate, who is more devoted to 'order' than to justice; who prefers a negative peace which is the absence of tension to a positive peace which is the presence of justice." From Ida B. Wells's anti-lynching campaign, to Freedom Summer, to the ongoing campaign against the unconstitutional "stop-and-frisk" policy in New York City, black Americans have relentlessly advocated for a nation of laws, for respect for constitutional rights and for freedom from domination, the cornerstone of republican participation and inclusion in the social body.

And yet the poisonous dynamic that Baldwin described hasn't shifted an inch. Blacks in the most vulnerable and poorest areas of America continue

to experience the law as a raw power relation, the police as a hostile enforcer to be distrusted or openly resisted. People continue to be astonished at "no-snitching" attitudes, even as police continue to justify coercion and abuse by framing their captives in the same light as the Bush and Obama administrations have painted terrorists: folks beyond the reach of the law, folks that bad things (like torture) happen to, because—implicitly—they deserve it. This situation, one of negative tension rather than positive justice, has all but drowned out the voice of Mr. Ross. But his desire to simply be "protected by the law" has always burned behind black demands for *access* to the law, for an instrument that respects their moral agency and values their lives accordingly.

We would do well to recall images that we have allowed ourselves to forget. Like that famous photograph of old Mose Wright, standing and pointing in the courthouse in Tallahatchie, Mississippi, to identify the men who abducted and murdered Emmett Till. He risked his life to do what was right, and in faith that the law would bring justice. It did not. The all-white, all-male jury acquitted the killers, who left the courtroom smiling. People who watched and rewatched videotape of police beating Rodney King in 1992 were sure the LAPD would finally have to be held accountable for a practice blacks knew was routine in their neighborhoods. The police were acquitted. LA exploded. In 1997 Amadou Diallo, a black immigrant from Guinea, pulled out his wallet to produce identification and was shot forty-one times by police who claimed they saw a gun. Officers were acquitted. In 2006 Sean Bell was leaving his bachelor party when he was gunned down by plainclothes officers, also acquitted. In 2009, Oscar Grant was shot in front of a packed rush-hour train while lying facedown with his hands over his head on the subway platform. Riots had to be suppressed in San Francisco. Blacks felt sure that in 2012 with a black president in the White House, history could not repeat itself in the case of Trayvon Martin. But it did. Even the O. J. Simpson case of 1994, a "victory" that proved terribly pyrrhic, revealed how deeply American blacks wanted to believe that they could have the power of the law *serve* them.

Earlier this summer, the death of Eric Garner—a black man selling illegal cigarettes—at the hands of police who were videotaped taking him down in an illegal chokehold, revived racial tensions in New York City. A report from the New York District Attorney's office that adolescent inmates at Rik-

ers Island have for years been systematically physically abused and had their rights violated will perhaps shock some white New Yorkers, but it is only a small part of a pattern that is common knowledge to the city's blacks. The cases continue in their ugly procession. Today the nation knows the name of Michael Brown, dead at the hands of a white policeman in Ferguson who shot the unarmed teenager six times in broad daylight.

These are only the most publicized cases, the tip of the iceberg. There are innumerable examples that don't grab headlines, like that of sixteen-year-old Corey Stingley—who in December 2012, about ten months after Trayvon Martin's death, stupidly shoplifted some wine bottles he was too young to buy from a corner store in suburban Milwaukee. He was restrained at the store by three older white men, and held in a chokehold that ended his life. In a VICE News documentary on the case, Corey's father, Craig Stingley, says, "I'm not going to stop pursuing the justice that my son deserves, until I know that there is no justice. And that will be an indictment on the system in and of itself."

Would the local DA have taken the case to trial, instead of dismissing it, if Corey were a sixteen-year-old white boy and had been pinned down by three grown black men? What if the DA had been black instead of white? Forget the racial dynamics for a moment. Consider simply that Corey's father is moved with extraordinary calm to seek justice in the law; all he asks is that his son's death be allowed to go to trial. Even that has been denied. The father has spoken on what that lack of justice means. But the failure of justice spreads like a ripple, and for Corey's white girlfriend Maddie, and particularly the other black citizens of Milwaukee, a wave of ominous questions must now cloud their lives.

Injustice has an affective, emotional dimension that is deeply corrosive, but which can never be quantified. The rage and pain that blacks feel when white officers are acquitted has no useful coefficient—yet I would submit it is precisely this kind of injustice that most seriously frays black confidence in integration, by reinforcing already deeply ingrained attitudes toward institutions. The point is that injustice inflicts primarily a moral cost, and only incidentally a monetary one. Thomas Piketty may have recently revived a conversation about inequality of income, but many Americans fail to fully

recognize that a well-segregated subset of their fellow citizens still do not see equality before the law.

Such a blow can be literally fatal. The deaths of unarmed black men at the hands of police cannot be attributed to the wealth gap: plenty of poor whites come into police custody all the time. But the deaths of black men at the hands of police can, by destroying and warping moral confidence in society, contribute in very real ways to the persistence of a wealth gap. If black men feel confirmed in their status as outlaws, as rejected and unwanted bodies, it's more likely to harden patterns of antisocial behavior that will isolate and impair them. How can you in good faith enter a society that treats you more like an enemy combatant than a citizen?

IT IS UNDENIABLE THAT the ghettoes experienced a brutal shift in the 1980s and 1990s, as the government ramped up the so-called War on Drugs and the neoliberal state retreated from social care, in favor of what sociologist Loïc Wacquant has called "punishing the poor." This climate of violence and fear damaged solidarities and communities in ways we still haven't come to terms with. You can hear the shift in black music, as hip-hop hardened between 1988 and 1994. Biggie's "Things Done Changed" and a litany of similar tracks show a deep awareness of a change in conditions that isn't about poverty, but about violence, incarceration, and drugs. When Nas says in the song "Halftime," from *Illmatic* (1994), that he "raps in front of more niggas than in the slave ships," the historical continuity is telling. It speaks volumes that his imagination can seamlessly recast the projects as nothing but the long, hardened shadow of the slaver's hull.

When I used to teach at a high school in Red Hook, Brooklyn, I would assign a beautiful book by the photographer Jamel Shabazz called *A Time Before Crack*. Shabazz grew up in Red Hook in the late seventies and eighties, documenting the nascent hip-hop generation that was coming up around him. My students loved seeing images of an optimistic youth that had "swag" but didn't appear to look or feel criminalized, "gangster." They saw images of a generation that was ready to live, not ready to die. They couldn't recognize themselves in it. The issue wasn't money—the kids in the pictures didn't seem any poorer or wealthier than them. Something else was missing.

THE PRINCETON POLITICAL THEORIST Philip Pettit has been a proponent of a return to republican (with a small "r") values in political philosophy. Republicanism, a tradition founded in classical Rome that flourished in the city-states of Renaissance Italy, conceives the relation of the individual to the state primarily as a subject bound by laws and duties. But its most essential feature, according to Pettit, is non-domination. In his 2012 book *On the People's Terms*, he reminds us that for republicans "the evil of subjection to the will of others, whether or not such subjection led to actual interference, was identified and indicted as the iconic ill from which political organization should liberate people." This evil was described as "being subject to a master, or *dominus*"—suffering domination—and was contrasted with the good of *libertas*, liberty. The state must guarantee citizens freedom from domination from each other, but, importantly, "it also needs to guard against itself practicing a form of public domination." For republicanism to work the people must "demand a rich array of popular controls over government."

It is no accident that blacks in the United States would be attracted to a republican conception of politics. Black Americans are the only population in US history to have known complete lack of lawful protection in regular peacetime society, a condition described by Giorgio Agamben as the "bare life" of *homo sacer*: the human being whom the sovereign treats as existing beyond the reach of the law, capable of being terminated at any time and without any legal or moral cost. (Sociologist and cultural historian Orlando Patterson famously named this condition "social death.") The black man in America has often been imagined as an outlaw, but in truth blacks more than any other group have fought for the sanctuary of the law, seeing in it their best weapon for securing freedom from domination.

Arguably it is that intangible freedom that subtends the possibility of all other goods; where it is eroded or negated, all else fails. It won't help Mr. Ross to pay off his mortgage with a reparations check if he has to continue living in a neighborhood that is patrolled like a war zone. No material reparation of any kind would have made a difference to Michael Brown's fate as he ran from an ugly encounter with a cop. His family cannot be consoled by a check in the place of a son going off to college. And the black citizens of Ferguson cannot trust they are safe, or believe they are equal, if they don't see justice.

Think about how the world looks from one of the black ghettos we hear about—say, on the South Side of Chicago. Think of the real pressures of domination that shape the perspective of so many young black men, who by reasonable inference from their immediate environment see themselves in an overtly antagonistic relationship to a Foucauldian state that expends considerable resources to discipline and punish them, and none to secure a basic foundation for their flourishing. They are born squeezed between what Hobbes would have recognized as a war of all against all, where life is "nasty, brutish, and short," and what Michelle Alexander has called "The New Jim Crow," a society that has shamefully crowned America with the highest incarceration rate in the world, with the federal inmate population increasing by 800 percent between 1980 and 2013. Unfreedom is everywhere, nowhere is safe, justice is the law of the gun. Let's focus on changing these conditions. When we do, I'm confident blacks will reconstitute all the wealth they need.

GIL SCOTT-HERON HAS a beautiful song I wish Ta-Nehisi Coates and all of us would listen to again. It's called "Who Will Pay Reparations on My Soul?" The title is also the refrain, but the force of the rhetorical question lies in its pithy yoking of materialism and slave capitalism to a logic that transcends the material. This is also the crux of my dissent: What can reparations mean when the damage cannot be accounted for in the only system of accounting that a society recognizes? Part of the work here is thinking about the value of human life differently. This becomes obvious when commentators—including Coates—get caught up trying to tabulate the extraordinary value of slaves held in bondage (don't forget to convert to today's dollars!). It shouldn't be hard to see that doing so yields to a mentality that is itself at the root of slavery as an institution: human beings cannot and should not be quantified, monetized, valued in dollar amounts. There can be no refund check for slavery. But that doesn't mean the question of injury evaporates, so let us ask a harder question: Who will pay reparations on my soul?

Black American music has always insisted upon *soul*, the value of the human spirit, and its unquenchable yearnings. It's a value that explicitly refuses material boundaries or limitations. You hear it encoded emblemati-

cally in the old spirituals. Black voices steal away to freedom. They go to the river. They fly away. Something *is* owed.

But the very force of this debt lies in the fact that it cannot be repaid in the currency that produced it. There is a larger question at stake, a question of values and social contracts, and about dismantling the intimate relationship between white supremacy and capitalism, which makes a mockery of the republican promise of freedom from domination.

Reparations should be about bending the social good once again toward freedom and the good life. The War on Drugs and its corollary, mass incarceration, represent a massively unjust and abusive use of state power with massive consequences. It will go down as a terrible blight on American history. For the work of reparations, dismantling its legacy and restoring confidence in a demilitarized social life is urgent. Thankfully, there are some signs that—however belatedly and feebly—Eric Holder's Justice Department is inching in that direction.

In other areas, too, there are divinations of progress. The nation is slowly recognizing the absurdity of its sentencing guidelines, with New York's judge John Gleeson serving as a powerful voice to reform mandatory minimums with infamously disparate racial impacts. In Newark, newly elected mayor Ras Baraka is championing citizen involvement and empowerment at the neighborhood level, in part by organizing concerned citizens to monitor and patrol high crime areas in coordination with city police, making them stakeholders in neighborhood safety and not just collateral damage to police enforcement. Prison reform that would track juvenile nonviolent offenders into spaces isolated from a harder prison population should be explored. Accountability and reform that prevents the physical and sexual assault too often endured by American prisoners is needed. Examining the hiring and training of local and state police, and ensuring that communities have a say in how they are policed, and who is policing them, is an urgent business. And black Americans must strive to reinvigorate a communal, grassroots politics that brings pressure from below, a pragmatic social politics that black intellectuals like Eddie Glaude Jr. have been advocating for years now. These practices and demands of civic inclusion are what a republic is supposed to embody: a freedom where people care for each other and hold each other accountable.

AFTER TA-NEHISI COATES'S ESSAY was published, he was interviewed by the popular liberal pundit Ezra Klein. There is a touching and awkward moment in that interview when Coates tells Klein that he is interested in the question of whether a state can have the kind of memory that a parent has for a child: a love unconditional, but that doesn't shy away from recognizing vices and flaws. Klein takes up the point, but not the metaphor. It struck me as a fascinating moment because in some ways this is a very "black" way of thinking about society, of the body politic, one that makes perfect sense for Coates to evoke, but which Klein would likely never articulate in quite that manner.

Black Americans have long maintained an understanding and practice of kinfolk acknowledgment, born from the condition of subordination in a racially hierarchical society, that extends kindred belonging to all those in need of it. Black men who don't know each other are "brothers"; a black woman I give directions to in the street will say, "Thank you, Baby." And we've never had any other choice than to make white America a part of the family; our self-understanding as Americans depends in part on it. Chris Rock makes the joke that Uncle Sam is kind of like the uncle who molested you, then paid your way through college. Everyone knows that Jefferson and Washington are more likely than not to be black family names.

Blacks have often understood family, and the love of family, as a metaphor for society, an affective relationship based on mutual respect and realistic expectations. The American state, initially constructed by and for whites only, has never fully relinquished its conviction that blacks are subjects who need to be dominated. There is no way forward, no path to King's "table of brotherhood" where we sit together as family, without demolishing the remnants of that mindset. We won't see a republic of socially responsible, free and equal persons until the ugly damage of racial domination in America is repaired.

—2014

⊰ IV ⊱

. . . the continuing development of a collective consciousness informed by the historical struggles for liberation and motivated by the shared sense of obligation to preserve the collective being, the ontological totality. —CEDRIC ROBINSON

The Work of Art in the
Age of Spectacular Reproduction

O N December 13, 2014, ten days after a Staten Island grand jury declined to indict a New York City police officer in the killing of Eric Garner, as many as 50,000 people marched down Fifth Avenue from a rally in Washington Square Park to voice their anger, their dismay, and their resolution to end the reign of unchecked police brutality directed at black citizens. Leading the cortege was a line of protesters carrying black-and-white posters that formed a massive close-up of Eric Garner's eyes. An image of the vigil was widely circulated by observers, the press, and organizers. It was powerful, spectral: the disembodied gaze of a dead man staring out at the city whose lawmen had needlessly and callously ended his life.

The poster assembly was the creation of a young French artist and unabashed humanitarian who goes by the moniker "JR," and who has emerged in recent years as one of the most ambitious figures in the world of art. JR's work blends protest and entertainment, high art and street art, the global and the local, the photograph and the guerrilla fly-poster, into one continuous and potentially open-ended venture. In 2011, he was awarded a TED Prize to create his INSIDE OUT project: Participants take portraits of people in their own communities and send them to JR, who transforms them into posters and returns them to their "cocreators" for pasting on the streets, buildings, and sidewalks where they live. According to the project's website, more than 230,000 posters have been printed and distributed in this way, to at least 124 countries around the world. Human faces a story tall and eyes the

size of shipping containers have materialized in slums outside Nairobi and in favelas in Rio; on the Israeli separation wall in the West Bank; on buses and trucks in Sierra Leone; among peace activists in Juarez and gay-rights activists in Moscow; and on buildings in Tehran, Medellín, Jaipur, and the South Bronx. A poster of a young girl designed to be visible to US drone pilots was unfurled in an undisclosed location in Pakistan. At the solidarity march in Paris after the *Charlie Hebdo* massacre, the eyes of the magazine's murdered editor, Stéphane Charbonnier, like those of Eric Garner in New York, hovered over the crowd.

JR then turned his attention to the experience of immigration to the United States. He created an installation at the abandoned Ellis Island Immigrant Hospital, pasting archival images of the interned arrivals to the New World onto its ruins. In April, the cover of the *New York Times Magazine* featured an installation by JR about a young man walking in the city. The subject, Elmar Aliyev, from Azerbaijan, was one of sixteen newly arrived immigrants whom JR had photographed on the street. In the early-morning hours of April 11, JR and his crew pasted Aliyev's portrait onto the pavement of the plaza in front of the Flatiron Building. The work was largely invisible to pedestrians because of its size, but was legible from a great height: time-lapse photography taken from the Flatiron Building's roof captured the making of the portrait for the *Times* website. JR then ascended in a helicopter to snap the cover shot, a bird's-eye view revealing an anonymous friendly giant framed by yellow cabs, crosswalks, and the restless people of New York. The result is both spectacular and almost worthy of Escher in its recursive visual form: an aerial image of a poster of a photograph—all by JR. The installation, like all of the artist's work, was designed to be ephemeral. Made of only paper, ink, and glue, it was no match for the city's Department of Sanitation and was gone by nightfall.

The brief life of these works is fundamental to their iconographic power. While JR prizes and even showcases the fly-posting process, methodically recording the work of art as a site of collaboration and production, he knows that his art will only find its true audience online, multiplied indefinitely in the internet's wilderness of mirrors. It is the virtual aura surrounding the pasted image that gives the work its special currency. Like a hacker, JR intervenes

suddenly and, it seems, randomly anywhere in the real world, but relies on his ability to retreat just as swiftly and neatly into the anonymity of the virtual realm. The act of appearing and disappearing, like the magician's hat trick, is part of the show.

JR FIRST ATTRACTED attention in 2005, when riots erupted in Clichy-sous-Bois and other *banlieues*, the highly segregated ghettos on the periphery of the French capital. President Jacques Chirac, in close consultation with Nicolas Sarkozy, then minister of the interior, declared a three-month state of emergency. The riots were sparked by the death of two teenagers, who were electrocuted while trying to hide from the police in a power substation. The French call such events a *bavure* (a smudge, an ugly streak or stain), a suggestively graphic term for police brutality. The magnitude of the 2005 riots was unprecedented, but the circumstances fit a pattern of violence and stagnation that has marked the last thirty years of French public life. Mathieu Kassovitz said he was inspired to write the screenplay for his groundbreaking 1995 film *La Haine* in response to the killing of a young Congolese man who was shot while in police custody, an event that sparked riots in 1993. Deaths at the hands of police set off new riots at Villiers-le-Bel in 2007, and yet again at Firminy and Montreuil in 2009.

JR's response was to humanize the inhabitants of the *banlieues*. Working in Clichy-sous-Bois and Les Bosquets, he used a 28-millimeter lens to create fish-eye portraits of mostly black and North African men making faces for the camera, and then illegally fly-posted the images in the bourgeois heart of Paris. He called the project *Portrait of a Generation*. At first, the municipal authorities tore the pictures down. Then, recognizing the project's popularity and warm reception by cultural critics, they changed their mind and invited JR to line City Hall with his work. It was his first big break.

Like Banksy and other street artists, JR prefers to operate with a level of anonymity. He is intentionally vague about his background and always appears in public wearing a trilby hat and dark Ray-Bans. To me, his accent and diction strongly suggest certain well-to-do arrondissements of Paris, but I'm open to correction. What JR has publicly shared is that when he was fifteen, he began spray-painting graffiti on the streets and rooftops of Paris as

part of a tagging crew. Soon he started documenting the crew's exploits with a camera and sticking the black-and-white images on city walls, signed and framed with aerosol paint in what he called *galleries de rue*, or street galleries. He described his new vocation as that of a *photograffeur*. Both of these clever coinages aim for street cred while nodding to the professional art world.

The underlying principle of JR's work is visual democracy: the idea that anyone and everyone, regardless of background or social status, can occupy a public space with images—a privilege typically reserved for the state or commercial interests. One of the lessons that JR learned from his early street galleries was that he could leapfrog over institutional boundaries, reordering the relationship between artist and patron and scrambling the one between artist and audience. He was also quick to grasp the ways that the internet would amplify this effect by separating the work's site of production from its site of dissemination, thereby democratizing access to the power of images and allowing remote installations to circulate virtually and attract attention from distant audiences.

In one of JR's most iconic pieces, a black man faces the camera menacingly, brandishing a DVCAM in such a fashion that it could be mistaken for a gun. A group of young boys stands directly behind him. In London in 2008, I was surprised to find myself staring down the barrel of the camera as I came to the Millennium Bridge; JR had fly-posted the image opposite it, on the facade of the Tate Modern. The picture perfectly embodies his idea of visual democracy: It tells us that the dispossessed—here represented almost entirely by race—possess a weapon they intend to train back on us, their viewers. The image equates filmmaking, and image-making more generally, with urban guerrilla warfare, while also playing on the stereotype of the gun-wielding black man, forcing the viewer to recognize how deeply etched that trope is in our visual culture.

THE CAMERA-TOTING MAN is Ladj Ly, a black documentary filmmaker and producer from Montfermeil, with whom JR has long collaborated. Their relationship can't be gleaned from JR's image, however, and despite all the ways the image seeks to scramble certain symbolic meanings, it also seems to rest on actual relations of power. Ladj Ly's image has made JR famous; but for all of JR's good intentions, the reverse cannot be said of him. At the 2015 Tribeca Film Festival, JR presented a short work called *Les Bosquets*, which tells Ladj

Ly's story through a combination of images of Montfermeil and a modern ballet choreographed by JR. The dance was also performed last year at the New York City Ballet. It's an audacious project, reminiscent of Kanye West's forays into the fusion of hip-hop and classical music, but it's quite clear that JR is necessary for Ladj Ly's story to be told: No one invited the black documentary-maker from Montfermeil to present his own films about the French ghetto.*

If JR is self-conscious about the "optics" (to use an Obama-era locution) of a white Frenchman swooping into the "developing world," or even the highly racialized ghettos of his own country, on a mission to give them a face and tell their stories, he never shows it. The humanitarian universalism typical of French attitudes toward race and cultural difference probably accounts for some of this: It is hard to imagine an American artist operating with quite as much insouciance. (They would probably want to talk about their own identity.) Which is not to say that JR is inattentive or indifferent to context. On the contrary, all of his projects emphasize the role of communal participation and direction, and he's made a special point of drawing attention to the plight of women, something the communities he enters sometimes resist. The best introduction to JR's project is his 2010 film *Women Are Heroes*, a stunning panorama of women on three continents, whose courage and dignity these photographs strive to capture and make visible, both within their own communities and to the wider world. JR insists that his art is engaging rather than *engagé*, but that he does want it to be a vehicle for the political voices of others. Think of him as a visual amplifier, a platform that plugs dispossessed communities into the global economy of significant images under the sign of "art."

But visual democracy is something of a mirage, because everyday relations of power have a way of reasserting themselves. It is highly ironic, for instance, and perhaps not entirely coincidental, that the increasing prominence of JR's (and Banksy's) "high art" graffiti has coincided with the sharp decline of illegal "street graffiti," even though both artists have traded on its radicalness. In Paris today, there is far less illegal graffiti than when JR was getting his start in the late 1990s, and tagging subway cars or buildings in

* This hasn't stopped him from persisting. In 2019, Ladj Ly's first feature-length film, *Les Misérables*, was released to great critical acclaim.

gentrifying New York City is now uncommon except in some corners of the outer boroughs. It's true that JR has worked without government support or corporate sponsorship, but in the last resort, holding the right passport and having the right connections matter greatly—as does the content of the message. In 2012, JR collaborated with the Cuban-American artist José Parlá for *The Wrinkles of the City*, a project in Havana that involved portraits of elderly citizens who had lived through the Revolution. But when Danilo Maldonado Machado, a Cuban graffiti artist and dissenter who tags as "El Sexto," inscribed "Raúl" and "Fidel" on two live pigs last year, he was thrown in jail and remains there to this day.

The political power of the image, harnessed to the internet's viral lightning rod, has often promised more than it can deliver. At the height of the so-called Arab Spring, there was a heady sense that the rapid dissemination and sharing of images and information enabled by Facebook and Twitter, in the hands of a savvy young generation, might provoke revolutionary transformation. Five years on, the power structure in Egypt is very much unchanged, with only the figureheads exchanged like masks at a ball, and Libya is under the control of terrorist cartels. The images of Eric Garner's murder, replayed like a snuff film before the entire world, were not able to secure him justice. A painful lesson of the last few years has been that real democracy is not nearly as easy to come by as public attention, even when that attention is produced in massive doses. None of this invalidates JR's investment in promoting the dignity of common people, or the impressive array of causes and coalitions that have flourished because of his interventions. His work is far more attentive and consequential than most of what is called "hashtag activism."

And yet it's hard to shake the sense that JR's work is overly slick. There's a fascinating scene in *Women Are Heroes* that takes place in the Kibera slums outside Nairobi. In one of his few interjections in the film, JR records himself pitching his project to a group of skeptical men from the community. Two men in the crowd start arguing about the proposal. The first one asks, "But how will it help?" The other responds, "It will help because it is going to show the picture of Kibera." "And after showing the picture?" "After . . . it is like marketing. It is going to market Kibera." It's a credit to JR that he includes this exchange in the film, but it inadvertently raises some discomfiting ques-

tions: Is "marketing" here an analogy or a strategy? Is JR "marketing" the dispossessed? *And after showing the picture?* It's the right question.

WHEN SUSAN SONTAG WROTE in 1977 that "today everything exists to end in a photograph," she sounded oracular. In the era of the smartphone and Instagram, that statement is banal, perhaps chillingly so. Sontag famously warned that photographs can give us an unearned understanding of things past. One could say by extension that the internet tends to give us an unearned relation to the present. If there is a seductive facility to JR's images (and I think there is), it lies in the temptation of this unearned relation. Like the language of advertising, these images short-circuit our affective instincts, compressing emotion and attention into currency; they promise (falsely) to snap us into mutual connection, without the cost and friction of lived experience. In JR's model, art is predicated not just on exploiting but also literalizing the digital realm's economy of attention, creating works that are inherently "about" generating "views" in more or less the same way that much online content is produced and organized with the aim of attracting eyeballs, creating a voyeuristic "event" that is then serially reproduced, shared, and re-created (where possible) until the motif has been exhausted.

In many ways, JR's work is perfectly aligned with the ethos of social media. He "crowd-sources" most of his projects, persuading people to give him personal photos—their own social and cultural capital—and then transforming them into the materials of mass spectatorship. Participants get to look at themselves, and their profiles are beamed and wheat-pasted around the world. JR gets to profit, and his own growing stature feeds an ever-expanding operation of virtual presence. Whether or not the intentions are noble, and the images appear on the sides of buildings or on Facebook, the practice is, formally speaking, parasitic. Like so much of the tech industry, it cannot escape the lure of boosterism; it lives or dies by relentlessly producing and attracting ephemeral attention. Whatever one thinks of JR as an artist or a humanitarian, he is a manifestation and manipulator of the moment, and he has tapped into something fundamental to our zeitgeist.

When Guy Debord published *The Society of the Spectacle* in 1967, the internet was still only a dream being hatched in a US military installation.

Fifty years on, you don't have to be a Marxist or a Situationist to appreciate the extent to which our lives are dominated by the rhythm of spectacular media events and their rippling diffusion, and by platforms designed to make consumption and transactional relationships, even at the most intimate levels, a ceaseless precondition of experience. Debord's definition of the spectacle as "a social relation among people, mediated by images," is a succinct and accurate definition of the internet. His analysis of the spectacle's relationship to the commodity is a Cassandra's view of social-media platforms like Facebook: "The spectacle is the moment when the commodity has attained the total occupation of social life. Not only is the relation to the commodity visible but it is all one sees: the world one sees is its world." Debord's point can be perceived without the fancy spectacles of theory: We now live through the interface; everywhere "face time" declines and "screen time" asserts a burgeoning priority and ever-wider scope. Everyone seems to know that watching and being watched, being "followed," is of paramount importance to the way we live now. It can make fortunes, destroy careers, suddenly and cataclysmically divulge our private lives, or assure our only access to intimacy. It can also, as JR seems to have discovered, fundamentally transform the possibilities of artistic practice.

In 2013, JR set up a photo booth near Times Square. It was the site, he pointed out, of the "Photomaton," the first commercial photo booth in the world, which was operated on Broadway by Anatol Josepho in 1925. JR allowed random passersby to take pictures of themselves in the booth, and then helped to print and paste them across a stretch of pavement in Times Square. JR's team also commandeered a massive billboard at the corner of Seventh Avenue and 47th Street and covered it with a mosaic of faces. Every night during the entire month of May, for three minutes before midnight, the Jumbotrons that are normally ablaze with ads were programmed to project the black-and-white faces of the crowd, turning Times Square itself into a Photomaton, a vast arcade of narcissistic delight. The spectacle at the heart of America's visual empire was interrupted, but in a way that made it more whole. Thousands stopped to hold their phones up in awe and take a picture.

—2015

What Is a Café?

L IKE GAUL UNDER CAESAR, the common Parisian café is divided into three parts: the *comptoir*, the *salle*, and the *terrasse*. This wouldn't be particularly worth remarking on if it weren't for the fact that this familiar formula can no longer be taken for granted. The New World has spawned its own rival version of the café, and the French have by no means remained immune to its seductions. There are important differences between them, however— differences that, whether we embrace them or not, will have a lot to do with what life in many capitals will look like in the future, and metaphors for what they mean to us in the present.

To properly understand the difference you have to know something of that first space, the one we "Anglo-Saxons" (as the French like to call us— still enumerating the tribes like the Romans) are least likely to be familiar with, that is the *comptoir*, what in plain English we might call "the counter." Traditionally plated in zinc, so that the French will sometimes simply refer to it as "le zinc," the *comptoir* is the beating heart of any café. It sets the tempo, like the conductor, establishing the dominant tenor thence transmitted by the waiters who orbit outward like comets as they make their excursions to the adjoining zones. It is a distinctly audible space, producing an irregular clatter that ought to annoy yet is unexpectedly narcotic. The whorl and hiss of the espresso machines, the clinking of spoons and cups shuttled across the zinc like shuffle pucks, the empty vessels snatched up again often with alarming alacrity; the squawk of wine bottles being opened, poured, and restocked; the

vigorous rinse of beer glasses. This is the aura surrounding what a Marxist might call the café's distinct mode of production.

Visually, the *comptoir* is a focal point. Upon entering any establishment you inevitably face it, and it won't take but a few steps to find yourself beached at its side, whether for a few minutes—or an hour, for part of its genius is that it is neither so charming as to encourage indefinite visits, yet inviting enough to make unexpectedly long stays always tempting. It promises that distinctly Parisian formula: leisure without comfort. Unlike the American diner, our nearest equivalent, a *comptoir* never has seating. It is open, ambulatory and fluid, and unlike the diner serves everything from the hardest alcohol to coffee or tea round the clock. So it is not uncommon to catch your postman drinking a glass of white wine before attending to those early morning rounds, nor is it unusual for someone to order a coffee surrounded by office workers enjoying their happy hour aperitifs. The drunks, the local "characters," the hustlers, and the silent eccentrics all gather there; the very busy who haven't the time to sit share the same strip of zinc, perhaps longingly, with those who are always in between some occupation, who loiter with a vague melancholy written in their faces like sailors waiting for a ship to come in. And while there are any number of distinguishing traits that might cue the passerby as to the clientele a particular café would wish to have—the vast majority at all times serve people of all ages and all backgrounds. At the Comptoir des Saints-Pères on the rue Jacob, construction workers eat alongside office workers, medical students, and wealthy old ladies who have been coming there for the same meal for decades.

One of the ironies of the popular democratic space that the café represents today is that its origins, both in the cultivation and brewing of the coffee bean itself, and the sociality of consuming it, are African, or rather a byproduct of the rich trade routes from East Africa into the Arabian Peninsula and the Indian Ocean, routes that among other things were operated for the trafficking of slaves. The trading post of al-Makha, or Mocha, in Yemen, was once the coffee hub of the world. The Ottoman love of coffee and Western conquest in the Balkans ensured its introduction into Europe where, at the height of their mercantilist ventures, the British, Italians, and French, not only became fiendish devotees, but realized titanic fortunes could be made by turning their colonial possessions into slave plantations for cultivation on

a massive scale. From the merchant's perspective, drinking coffee (and tea) was then compounded (rate of return) by the complementary boom in the demand for sugar. Entire islands were turned into sugar factories, a notoriously brutal and grueling crop. Because of the high mortality rate, more slaves were imported by the French onto the small island of Guadeloupe than into all of North America. Before Toussaint Louverture and Jean-Jacques Dessalines swept the French off the island, Saint-Domingue was the gold mine of the Caribbean. The blood of its slaves produced the astonishing opulence and Hall of Mirrors at Versailles. To this day—*to this day*, if you look at a sugar packet in a French café the odds are better than even that it will say "Saint Domingue," next to a little trademark, an irreticent trace of the colonial unconscious.

The odds of seeing the same packet of sugar are so high in part because all cafés share a common stock of furnishings, certain shabby but comforting props: the silver sugar dispenser ajar like a knight's helmet, the plastic saucers—usually yellow, occasionally blue—in which patrons leave their coins. The *grille-pains*, or "toasters," ecologically dubious but much-appreciated heat lamps that allow the average sensual tobacco smoker to puff stoically through the capital's long season of pallor, damp gusts, and general grumpiness.

From a practical point of view, the *comptoir* is essential to maintaining the proper distribution of leisure and goods, an equilibrium that allows the café to meet its diurnal obligations—serving all three daily meals, as well as the accessorial needs of loiterers, passersby, the lost, and the transient, who are always flitting in and out in search of cigarettes, gambling cards, and the ritual punctuations of the day devoted to caffeine, alcohol, and conversation. This last being, all things considered, the most important. Indeed, the *comptoir* is a hub of maundering gossip, a hive of yak, the great junction of the capital's most obvious and reliable product: the ebb and flow of gratuitous conversation. You don't get coffee to go. You go to a café precisely because it allows you *not* to be on the go, to do instead that most marvelous thing the "Anglo-Saxons" find so inconvenient, which is to stay and chat with someone, anyone, with no particular end in mind, for no reason at all, or to echo a Kantian phrase, because time spent casually in social company is a worthy end in itself.

I haven't yet spoken of the *salle* or the *terrasse*, those radial appendages with their striped awnings, wicker chairs, and distinctive tripodal tables; but the same general point applies to both. They are spaces designed primarily for socializing, for people with time on their hands, at least some spare money in their pockets, and no particular desire to get on with anything. The least social of these spaces is undoubtedly the *salle*, where if introspection is your thing then, like a good philosopher, you'll select a distant corner where the din is only a little less intrusive, the coffee more expensive, but most importantly the atmosphere, in a word, suspended. Yet even here, the slightly removed social relation leads only to its further reinvigoration. The muted thrum of the polis proves ideal for reading and writing, especially the writing of letters and postcards to people who are far away, in Tangiers or Port Townsend or New Orleans. A period of time in the *salle* of the café inevitably heightens one's reinsertion, so that when you step back into the flow of the boulevards you feel the collective life keenly, and perhaps especially when alone, one feels primed for certain Cortázar-like jump cuts in the ordinary, those "privileged states" the Surrealists liked to invoke, in which passing footsteps, a poster for Breton soap or the latest Batman, the escalator of the Metro, or the ring of a rushing bus, suddenly overtake the mind with an air of insurrectionary mystery.

Granted this is all a tad too literary. But if you stop and try to imagine Paris without its cafés the result is not only unbearable: it's absurd, unthinkable. Not all the monuments, museums, and cathedrals put together could make it possibly worth living there. I realize many good and well-intentioned people will object to the metaphor given the incurable and inextricable connection between French cafés and cigarettes—but the fact is that the cafés are the alveoli of the city. Little pods of exchange and vitality oxygenating and circulating the stream of its social fabric. And they convey a basic principle of Parisian life. The notion that although life may in the main be an arduous thing, what principally alleviates our weariness are the little rituals of collective exchange, the firm conviction that the portion of life where we are neither at work, nor in our domestic spheres, is the vital mediating term, the one that makes the other two bearable.

Now. What happens when you enter the trendiest café in New York or San Francisco or Portland? The same thing as at any Starbucks: you wait on

line. On our side of the Atlantic, the focal point of the café is the commodity itself—our interest primarily in its purchase. Pragmatists before all else, we are directed to a site of transaction. This is indisputable, and in fact the trendier the café is, the more the commodity is fetishized and its production foregrounded, so that in the really high-end cafés you will be invited to gaze upon the site of production itself, where young people with the right haircuts and bicycles "prove" to you, the customer, that the commodity you are buying is quite locally roasted. One goes to a higher-end café because they promise a higher-quality product, not a more pleasant or social atmosphere to drink it in. The wait line itself, leading up to the "point of sale," lends the space the feel of the workhouse and reveals its dispensary function. Upon entering, you are essentially on a conveyor belt, waiting to be processed or potentially in the way of this establishment's efforts to process others. At the point of transaction, you feel obligated to socialize out of politeness but are constrained by the line behind you and by your awareness that you are really only hindering the barista or server before you. What remains of the typical Parisian *salle*, which is inevitably less comfortable with a line going through it, is filled primarily with people who are each isolated from each other, typically frustrated and annoyed by the presence of others. Everyone is occupying space—renting is what it feels like—and all for one purpose: working.

In our model, the café is not the antidote of the office, but its annex, a well-lit atelier for the young urban professional. A string of new concept spaces that have sprung up in Paris in the last several years, appropriately named Anticafé, make this explicit. They are living room retreats for displaced but affluent workers. Their clientele is uniform, their connection to the neighborhood and its street life severed. The social model of the café is thrown out in favor of the bespoke refinement of the commodity served there. On our side of the Atlantic this social severing has gone even further, possibly to its logical limit. Recently, Starbucks launched an app that allows one to order and pay for a coffee before even setting foot in the establishment, allowing you to purchase "without speaking a word," as tech reviews gleefully proclaimed. Now even the exceedingly minor friction of interacting with another human being at the register, already purely perfunctory, is erased, and the dream of instant and seamless connection with the commodity fulfilled. This is the

logical expression of the neoliberal fantasy: frictionless consumption; human interaction reduced wherever possible, and when necessary then only for the sake of the transaction itself; the maximizing of an efficiency that optimizes the social while simultaneously recasting it as just is another form of business. You don't have time for coffee. You have to get back to work.

But, "I hear you saying, "isn't the coffee in *our* cafés just better?" Without a doubt. No one can deny that the quality of the coffee in your average French café is wretched, much worse than any Starbucks. But those who love the leaf-print in their lattes fail to understand that people don't go to cafés for the coffee. The commodity is a mere excuse, a mediating instrument—not an end in itself. The strangeness of this, the very fact that such a point needs to be articulated, illustrates the difference political economy exerts on our commonsense cultural assumptions. In fact, it is not a bad way of expressing the difference between capitalism and socialism: a world where some of us are constantly reinventing ourselves at the mercy of newfangled commodities, versus a world where we impose a boring but reliable framework on commodities because that's what we know works best for the vast majority of folks who mostly just want to enjoy each other's company for as little or as long as we can afford.

—2020

In the Zone

M ATHIAS ÉNARD IS NOT by any means a household name, but he is increasingly viewed in France as one of the country's foremost novelists. Born in 1972 in the small southwestern town of Niort, Énard originally planned on studying art history and attended the prestigious École du Louvre in Paris. A nascent interest in Islamic art and literature led him to study Persian and then Arabic at the National Institute for Oriental Languages and Civilizations, a change of course that sent him on a long series of travels across the Middle East before he eventually took up a position teaching Arabic at the Autonomous University of Barcelona.

In 2003, Énard published his first novel, *La Perfection du Tir* (which one could translate as "The Sniper Prepares"). A tense and unsettling portrait of a gunman in an unnamed war-torn city that could be Beirut (but also, just as convincingly, Sarajevo), it reminded Énard's French readers of the eurozone's proximity to, and complicity in, the many ethnic and religious animosities roiling just beneath the surface of the ostensibly harmonious trade bloc piloted by Brussels. Since then, he has published four more novels and a handful of novellas, as well as translations of classic Persian and contemporary Arabic poetry.

Énard is best known for his sprawling, violent 2008 novel *Zone*. Written as one unbroken, amphetamine-addled sentence stretched across a canvas of some 500 pages, *Zone* rummages through the mind of its narrator, Francis Mirkovic, an intelligence agent with a past, who is traveling by train from

Milan to Rome with a dossier he intends to deliver to the Vatican that cata-
logs evidence of war crimes committed throughout the 1990s in the Balkans.
Ranging across the Mediterranean—the titular "zone"—Énard weaves
geography and history together in a manner worthy of the French historian
Fernand Braudel, and he does so while pitching the reader ever forward into
a confessional of violence and alienation reminiscent of William Burroughs.

Presenting a nightmarish vision of post–Cold War Europe, *Zone* was
unabashedly epic in scope and high-modernist in execution. Justly hailed by
critics at home and abroad, it cemented Énard's reputation as a novelist with
major ambitions who was operating at the height of his powers.

After *Zone*, Énard did not let up. In 2010, he published a new novel, *Rue
des Voleurs*, which moved his focus away from the northern ridge of the
"zone" to its lower, southern half. (*Rue* was translated into English by Char-
lotte Mandell and published by Open Letters as *Street of Thieves* in 2014.) Fol-
lowing Lakhdar, a young Moroccan from Tangier, *Street of Thieves* continued
to explore the portents of violence just beneath the surface and the different
valences of cultural identity and belonging found on both sides of the Strait
of Gibraltar. As with so many of Énard's characters, Lakhdar is a voracious
and omnivorous reader. Language and the world of letters destabilize him
and open him up to new horizons. In a statement that echoes Tennyson's
"Ulysses," Lakhdar declares a credo that Énard himself might espouse: "I
am what I have read, I am what I have seen, I have within me as much Ara-
bic as Spanish and French, I have multiplied myself in these mirrors to the
point of losing myself or constructing myself, a fragile image, an image in
movement."

This "image in movement," a picture of the destructive and creative pos-
sibilities forged by the Mediterranean "zone," is not just a literary device for
Énard; it can be found in his personality and public persona. He has spent his
own life moving from one end of the zone to the other, without entirely giving
up the French language or his attachment to its literary traditions. His manner
is soft-spoken and gentle, but he is also gregarious, gestural, and charismatic.
One can easily picture him sitting at a café table in Algiers or even running a
small Lebanese restaurant, as he in fact did for several years in Barcelona, the
city that he now calls home and where he has written all of his books.

The image of Énard as a voyaging romantic is perhaps helped by the fact that he is physically striking, almost Dickensian in appearance: a man of diminutive and compact build, whose tangled curls and receding hairline frame a pair of unruly sideburns more reminiscent of Stendhal than a twenty-first-century writer taking on the challenges of a world enthralled by Google and ISIS. Énard can seem in his very person to be somehow seeking to contain and resolve these apparent contradictions, the dislocations of place, the fractures of culture and historical frames. Can one person, through the force of erudition and poetic sensibility, turn literature into a healing salve—one that we can all believe in? With humanitarian crises and terrorist mayhem delivering fresh horror in the daily news, the prospects appear daunting. Yet this is precisely the wager that Mathias Énard has taken up.

Énard's new novel, *Compass*, just published in the United States in an English translation by Charlotte Mandell, came out in France at the height of a bloody and destabilizing year for the country. On January 7, 2015, gunmen affiliated with Al Qaeda in Yemen assassinated members of *Charlie Hebdo*'s editorial staff in the heart of Paris and later terrorized a kosher supermarket; then, in March, ISIS-inspired terrorists killed twenty-one people at the Bardo National Museum in Tunis.

In a gesture of solidarity and defiance of the terrorist threat, the jury for the 2015 Prix Goncourt, France's most prestigious literary prize, decided to announce that year's finalists, which included *Compass*, at the Bardo museum. One week later, on November 3, it was officially announced that Énard had won. In France, literary prizes are still followed with the kind of media blitz and fanfare that normally accompany movie festivals. For Énard, there was little time to celebrate: Just ten days later, France saw the worst bloodshed on its soil since the turmoil of the Algerian War, when a team of ISIS commandos sent from Syria detonated suicide vests, shot up café terraces, and massacred concertgoers they had taken hostage at the Bataclan theater. At the same time, the surge of refugees and migrants attempting to cross the sea into Europe reached catastrophic proportions, with hundreds drowning by the month.

This atmosphere of tension and spectacular cruelty directly informs the pages of Énard's crepuscular narrative, which is set in the immediate present of 2014–15, with the Syrian conflict and the rise of the Islamic State as its

backdrop. The plot of *Compass* is really more of a frame, an anchoring point for a series of loosely strung, impressionistic fugues that follow the streams of thought of one man over a single night. Our hero is Franz Ritter, a middling Franco-Austrian musicologist living in Vienna. Ritter suffers from a grave but unnamed illness, and with a good deal on his mind, he reflects on his unremarkable but well-traveled career as an academic. He also considers his fledgling love affair with Sarah, another unspecified member of the contemporary academy (her dissertation's title is "Visions of the Other Between East and West") who shares his passion for pursuing the obscure and forgotten translators, poets, and spies who—not unlike Franz and Sarah themselves—have, throughout history, gone flitting to and from the region's old cities like Istanbul, Damascus, and Aleppo, cross-pollinating their cultural contacts along the way.

Chapters divide the night into bouts of insomniac reverie, as Franz fidgets and bumps about an apartment stuffed with books and mementos, piecing together for us the phases of his romantic pursuit of Sarah, while indulging in an uninterrupted cavalcade of soliloquies and scholarly sidebars, including several chapters from a hypothetical essay, "On the divers forms of lunacie [*sic*] in the Orient." By dawn, Franz will have looked up old e-mails, consulted journal articles, listened to the radio, and compulsively refreshed his inbox far too often in the hopes of getting word from Sarah, who is conducting her research on the other side of the world.

Énard's style is difficult to place, shifting through registers that shade romantic and even baroque, but are often tinged with ironic doses of self-mockery. This tonal play can be difficult to parse even in the French, and Charlotte Mandell is brilliant at finding solutions to bring these subtleties into English, though the overall effect is a kind of detachment and coolness less evident in the original. Énard's subject matter, after all, is deeply erotic, and his prose in the French strives to intoxicate, to inundate the reader with particulars.

Of the four major cities that Franz and Sarah explore together, and that Franz recounts on his sleepless night in Vienna, the most intensely realized love scene takes place in Tehran. "The gliding automobiles, the smells of tar, rice and saffron that are the odor of Iran," Franz tells us after describing their

encounter, will be "forever associated, for me, with the salty, rainy taste of Sarah's skin."

While Énard limits the book's frame to Franz's recollections, he also occasionally moves outside them with Sebaldian insertions that feel more like hyperlinks, as Franz absentmindedly pulls up Sarah's old articles from his hard drive and treats us to facsimiles of academic jargon, reproductions of postcards, and frontispieces to Goethe and Balzac. Presumably, the upshot for Énard in making his narrator an academic is that it's a useful contrivance for dredging up the literary arcana and necessarily minor figures who populate his area of inquiry (we learn about the spy and explorer Alois Musil, cousin to the novelist Robert Musil, and the orientalist polymath Joseph von Hammer-Purgstall; we are also introduced to the Iranian writer Sadegh Hedayat and the Iraqi poet Badr Shakir al-Sayyab). These excurses in Énard's field of expertise also allow the narration to oscillate between the first person and a more scholarly, invitational "we" that, one suspects, is supposed to include Énard and his readers.

But there is an obvious downside here as well. Even if one is willing to suspend one's frustration at being made to feel ignorant, there's the added unkindness of being stranded in a room with a pedant. Franz has an irrepressible fondness for the sound of his own voice. It's insufferable to have to listen to a man prone to saying things like "life is a Mahler symphony, it never goes back, never retraces its steps"; it becomes intolerable once you realize this man is going to talk to himself all night, and it's not yet one in the morning! True, Énard is mostly poking fun at the self-important gassiness of contemporary academia, and yes, everything suggests he is well aware that this is a wild fantasy of academic life bearing not the slightest resemblance to the real thing. But that still leaves it as an inside joke, and Franz Ritter, while occasionally droll, is not a sparkling wit.

One begins to get the sense that there's another game at play, one that was perhaps not Énard's intention when he set out to write *Compass*, but that a reader can't resist surmising in the wake of its publication. Outwardly, Énard's Franz Ritter has a lot in common with François, the hero of Michel Houellebecq's *Submission*, which appeared early in 2015. Both men are undistinguished, middle-aged academics; both maintain a keen interest in unlocking the potential of the Orient. Both desire some kind of deliverance from

women, something beyond sex but also resolutely and insistently related to it. In Houellebecq's novel, women are emotional and sexual dead ends: François experiences his girlfriend as a source of indifference and sexual despair, and finds release in the company of sex workers; he also finds his mother's death barely worth mentioning. Franz is just the opposite, in this and many other ways: Sarah is his passport to the world, to further knowledge, an almost ludicrously erotic vessel for what are primarily his own needs and realizations.

Both writers seem aware of the awkward limitations of this kind of female essentializing, but it doesn't exactly deter either of them. And while Houellebecq's François is far more repugnant, he is also a much more believable representative of the kind of reactionary mind-set that Énard is trying bravely—but, one feels, a bit abstractly—to refute. Houellebecq's "depressive realism," as the critic Ben Jeffery has called it, may be about as appealing as paint thinner, but it is also a solvent that quickly exposes all the hollow bits that come with Énard's brand of idealism.

The contrast between the two writers is hard to overstate. Where Houellebecq's prose is famously clinical and cunning, Énard's tends toward inflation and mannerism, as though puffing itself up to handle a burdensome but heroic act of diplomacy. He writes passionately, with a boundless faith that the accumulated wisdom of centuries of learning, art, music, and philosophy on all sides of the Mediterranean zone will prevail over the desiccated vision of Islamists and ethno-nationalists of all stripes. In a 2016 interview with the Algerian writer Kamel Daoud, in an exchange about stereotypes of Islam in the media, Énard invoked the eighth-century poet Abū Nuwās, a Walt Whitman–esque figure of the classical Arabic tradition, who celebrated "liberty, humor, drunkenness. . . . That, too, is in Islam today," Énard insisted, "but it has to hide itself the most, so we see it the least."

It's the kind of statement that Houellebecq has no truck with, and he is hardly alone. For the French, the clash between the two writers reads like a Rorschach test for the left- and right-wing reactions to several decades of jihadist violence: half the country in thrall to the fantasy of throwing an undefined "immigrant" population out, and the other half, stunned and wounded by vicious acts of terror, still struggling to reverse the trend of half a century of failed integration.

Which side Énard is on is clear enough, but how his work might serve as a guide is less so. It's not easy to find a solid plank for the reader to rest upon amid all the geographical and cultural disorientation in *Compass*. Believe it or not, tucked away in the pocket of Énard's novel are not one but two compasses. The first is a replica of the compass that Beethoven is said to have carried around with him on his walks, which Franz has bought as a souvenir and left unattended on his bookshelf. The second is a symbolic one that he has come to appreciate from his travels in the Muslim world, and it points to the powerful geographic imaginary of *Dar al-Islam*:

> In Muslim hotels they stick a little compass for you into the wood of the bed, or they draw a wind rose that can indeed serve to locate the Arabian peninsula, but also, if you're so inclined, Rome, Vienna, or Moscow: you're never lost in these lands. I even saw some prayer rugs with a little compass woven into them, carpets you immediately wanted to set flying, since they were so prepared for aerial navigation.

It's an irresistible conceit, and one can see why it immediately appeals to Énard, who has built all of his books, like a latter-day Ibn Battuta, out of repeated circuits, voyages of circumambulation, with the purpose of knowing each time something more of the world and yet revealing to his readers what they have long not known.

But compasses are not the flexible devices that Énard depicts or perhaps wishes them to be: They may be open to interpretation, but they nonetheless reflect an unmoving geography. The impediments that ordinary people face when determining their own course in the face of rigidly prescribed doctrines are very real. Does knowing that our sense of orientation comes not from the East or the West, but from some kind of intermediate Mediterranean zone in which both interact, help to liberate us? Isn't this cross-cultural inheritance as much to blame for our violent times as anything else? Can we shed our marks of identity (to borrow a phrase from the late Juan Goytisolo, another drifter in the zone) without fueling more hatred and confusion, the existential violence of alienation?

Cultural mutations are unpredictable and not always benign, after all, and they can sometimes create violent counterreactions. As Franz mulls over the strange case of the orientalists hired by the Austrians and Germans in 1914 to help incite jihad against England, he observes that even Islamic jihad is "another horrible thing constructed by both East and West . . . at first sight an idea that's as foreign, external, exogenous as possible," but that is in fact "a long and strange collective movement, the synthesis of an atrocious, cosmopolitan history."

Énard hopes that his novel will offer an alternative kind of cosmopolitanism. Literature, he believes, can be something of a universal translator for the heart, recognizing how essential the discovery and exchange of beauty between people and cultures are to their mutual creation. But the poetry of his vision has its blind spots. And in France, across Europe, and farther afield, the blind spots of those of us for whom the wealth of the world is tangible in cheap airfare and study abroad and transnational business opportunities are being called out. Without some decisive change in social outlook and a reordering of the priorities of political economy, the contours of the present crisis will harden.

In *Compass*, Énard has created a giant fresco, a dream sequence parading the history of cosmopolitan Europe before us. But even as we crane our necks to stare in awe at his creation, it is hard not to notice the cracks in the ceiling, fissures that go right to the foundation and may bring the house down sooner than we think. Houellebecq, for his part, can and will find all his preconceptions and bile reconfirmed every time he turns on the news. His fiction perfectly captures the materially fluid and emotionally abrasive texture of modern life—its violence and sexism, the thinness of its cosmopolitanism and the callousness of its social relations—but he cannot get out of his own head.

Yet what's remarkable is that both of these major novelists miss the story on their very doorstep, the human face waiting to be recognized. It's astonishing, for instance, that in Énard's novel Franz never once meets a Muslim character of any substance living downstairs on his street, operating the cellphone shop on the corner, standing in line at the grocer's, going to pray in a mosque tucked discreetly into a former gymnasium or community center. When he and Sarah go to Paris, they visit the tomb of a dead Muslim poet,

but there's no attempt to find the living ones, or to meet a few of the millions of people—many of them crowded into the projects on the far side of the city ramparts—whose lives and futures embody the tradition they are so obsessed with.

Houellebecq has never cared to pen a character that is not basically an alter ego. He complains a good deal about the people who surround him, but for all intents and purposes he has never met them in life, and he cannot bring himself to imagine them in his fiction. Indeed, with the exception of a few groundbreaking writers like Marie NDiaye and Abdellah Taïa, for the most part the novels that actually explore the lives of Muslims living in France have yet to be written.

One hopes that they will be soon, and that the best of Énard's encyclopedic vision of a truly interwoven Mediterranean will eventually prevail. But I will confess for my part that, as I gaze warily at the events unfolding on both sides of the Atlantic, it is neither Franz Ritter nor Houellebecq's misanthropic François who seems to capture the spirit of the times. Rather, we must look to Énard's earlier creation, the haunted Francis Mirkovic, whose flight from the nightmare of history and all of Europe's bloody fault lines is suspended at *Zone*'s close as he sits on a bench in the Roma Termini station. Énard ends the book with quiet words that offer no hope of redemption, just the fear of living on borrowed time. Time for a shared cigarette, Mirkovic tells us, "one last smoke before the end of the world."

—2017

The Time of the Assassins

*The disaster ruins everything, all the while leaving everything
intact. It does not touch anyone in particular; "I" am not threat-
ened by it, but spared, left aside. It is in this way that I am
threatened . . .*

—MAURICE BLANCHOT, THE WRITING OF THE DISASTER

I. The Ends of Histories

The Bataclan is one of the oldest music venues in Paris. Situated on the Bou-
levard Voltaire and named after an 1855 operetta by Jacques Offenbach, it has
operated as an entertainment venue more or less continuously since its open-
ing in 1865 under the Second Empire. After a period of decline in the sixties
and seventies it was reopened in 1983 with a particular emphasis on providing
a platform for post-punk and rock on the Parisian scene. Perhaps befitting
its name, onomatopoetic for a sonorous cacophony, it has long maintained a
reputation for eclecticism.

Offenbach's 1855 *Ba-ta-clan* is an orientalist comic operetta about a Chi-
nese emperor whose subjects are ostensibly in a conspiracy to revolt and over-
throw him. It turns out, however, that the emperor and the conspirators are
all French aristocrats who share a desperate homesickness for the gay life of
Paris that they enjoyed in their youth. It's a light satire spoofing Napoleon

III and the hapless members of the courtier class around him. But it also suggests a pervasive French fantasy: that cultural differences are really more like costumes, and that underneath those exotic garbs, which are amusing but insubstantial, all people wish to be French—or at least to live the life of pleasure as the French conceive it. When things are set aright, as they must be at the end of any comic play, all will sing together as one. All will be dissolved in the irresistible cheer of a French republican chorus.

Though it hasn't been much commented on, the former owners of the Bataclan, who are Jewish, had received threats in 2008 and 2009 over fundraisers they held for pro-Israeli causes at the height of tensions around Israel's incursions in the Gaza Strip. Yet in May of 2015, in the wake of the *Charlie Hebdo* attacks that took place just a few blocks south of the concert hall, the Bataclan hosted a show called "Who Is Malcolm X?" honoring Malcolm on his birthday and featuring performances by Muslim rappers as well as a conference, coordinated by the Association of African Students at the Sorbonne, calling for a reissuing of *The Autobiography* in France, where it has long been out of print. With this uneasy combination of identity politics, sometimes heightened and sometimes secularized religious affiliations, and hedonistic popular music and youth culture, the Bataclan embodies many of the tensions of contemporary French life.

In the turbulent aftermath of terrorist attacks news outlets want the quantitative goods: how many, what nationality, how old, how young? They seek the official statements and reactions. Invariably we are told that our values have been attacked, but that we won't change our way of life. If such statements always feel trite and perfunctory, it is because much of what hurts us is peripheral to the site of wounding—isn't contained in the death toll figures, however grim. These intangible abrasions, which cannot be compressed for expediency, are experienced as a collective loss, a bruising that spreads out from the point of impact as bonds of basic trust are frayed, social perceptions distorted, crucial memories and critical nuances submerged in the onslaught of sound and fury.

One reason for this is that in the wake of such events the categories of belonging collapse: we put out flags that only yesterday we might have considered vulgar and corny. Last November it became a trend on Facebook to

drape one's user profile in the French tricolor, a veil of solidarity placed over the converted face, apparently without irony. In the absence of enforceable vengeance, we settle for what the state has left to offer us, what we usually mock or ignore or take for granted: our firm desire in moments of doubt and danger to be retold the fable of our origins, our identity, our destiny.

I RETURNED TO PARIS last December, about a month after the attacks, to see my family and friends. I grew up in Paris; my parents are journalists and, following their work, moved our family to France when I was eight years old. Ever since I've lived a life tethered on two ends of the Atlantic. When people ask me where I feel most at home, I like to quote Josephine Baker, who sang of two loves: *J'ai deux amours, mon pays et Paris.* On the evening of November 13, I was in Princeton, New Jersey, at the university where I work. I was about to take a train into New York with my girlfriend who lives in Paris but happened to be visiting me, when I received a text message from my father with a warning in all caps that simulated the cable news crawl he was probably watching: MAJOR TERROR. STADE DE FRANCE. HOLLANDE EVACUATED. ATTACKS IN 10TH & 11TH. Those numbers hit me hard and fast: they designate an area on the eastern side of the city where many of my friends live and where we often go out. I ran calculations in my head. It was Friday; a six-hour time difference would make it around ten in the evening there. I'm going to lose people, I thought.

Then, like everyone else, I opened tabs on my computer for French television, American news outlets, and French radio, which is often the most reliable and up-to-date in these kinds of incidents. Facebook, email, Skype. Every minute without a response was unbearable. The messages that came back were a relief but also upsetting. People hiding in basements, lying face down between cars. I thought of other people around me who would be going through the same thing. My friend in the French department. It turned out she knew people inside the Bataclan—she had even encouraged her fiancé to attend, but he had decided not to go at the last minute. He was in his apartment. He wanted to help his friends, but leaving the house was no longer an option. The army was in the streets.

My girlfriend started getting messages too. The little colored speech bubbles multiplied. One of her friends had been out having drinks on a terrace. She had been shot in the back, presumably as she turned away from the firing. She was going into surgery. The girl she was having drinks with, who had come down to visit for the weekend, was dead.

Within a few hours I could account for everyone—I was lucky. But it had been close. My friend Charlotte was standing just up the street when a hail of bullets smashed into the Petit Cambodge, a cheap noodle restaurant we used to go to.

II. The Disasters of War

Amnesty International estimated that from January 2014 through March 2015, over three thousand people in the ancient city of Aleppo were killed in indiscriminate barrel bombings by Bashar al-Assad's air force. Barrel bombs are crude oil drums packed with explosives and metal shrapnel, often shoved by hand out of helicopters. The victims are overwhelmingly civilians, women and children, as well as emergency responders and doctors, who are frequently murdered as they arrive on the scene to rescue survivors by so-called "double-tap" bombings on the same target.

The Al-Shaitat are a Sunni tribe who live in a string of towns along the Euphrates to the south of the city of Deir ez-Zur in eastern Syria. In the summer of 2014 ISIS was metastasizing; having taken Mosul, they spread south and eastward toward the Iraqi border. When they arrived in Deir ez-Zur, the Al-Shaitat initially agreed to an open-city rule: no resistance in exchange for peace. But when skirmishes broke out they finally rebelled. The repression was swift and brutal: firing lines, beheadings, crucifixions, mass graves. The raw footage that surfaced on YouTube is so horrific the State Department recuperated it as anti-ISIS propaganda. At one point the executioners place a severed head on the ground in front of a prisoner, to taunt him, just before his own is cut off.

Obtaining figures for civilian deaths that result from American and European bombing sorties in Syria is not easily done. The Pentagon acknowledges

civilian casualties from time to time, always careful to assert that they are minimal. Russian bombings, the same sources will assert, have killed hundreds; naturally the Russians deny it.

AT THE BATACLAN, on November 13, 2015, the Eagles of Death Metal were in the middle of their set when three men got out of a black Volkswagen Polo, entered the theater, and started killing. They covered each other commando style, aiming to maximize the efficiency and certainty of murder. All three were European citizens in their twenties. All three had traveled to Syria via Turkey in or around 2013 and had reentered France without being detected by the authorities. The youngest, Foued Mohamed-Aggad, was a twenty-three-year-old native of Wissembourg, an Alsatian town on the Franco-German border. After graduating from high school he had tried and failed to pass the exam to become a police officer, and had similarly been rejected when he tried to join the army. He left to join ISIS in Syria with a group of young men, including his older brother Karim, apparently under the influence of a jihadist pied piper by the name of Mourad Fares, who boasted about the success of his YouTube jihad recruitment videos in an interview with Vice in 2014. The majority of the others, including Foued's brother, gave up, returned, and were arrested on charges of terrorist conspiracy. Aggad stayed on, married a French woman who came to join him in the cause, and kept up an active profile on social media. He was also in touch with his mother, who was desperately trying to convince him to return. These exchanges were intercepted, including one in which Aggad declared that if he came back to France, "it wouldn't be to go to prison, but to blow things up."

The two older men, Samy Amimour and Ismaël Omar Mostefaï, both in their late twenties, grew up in the suburbs of Paris and, like Aggad, embraced religion not in their homes but online, and then only seriously around 2012. Mostefaï and his family moved to Chartres in 2005, a move that seems to have left him adrift. Shortly after arriving he started getting into run-ins with the police for minor delinquencies. Between 2008 and 2010 he was working in an industrial bakery, and his radicalization is thought to have occurred around the end of his time there. Amimour had tried studying law and after

failing got a job working as a bus driver in 2012. He also started dressing in ultra-conservative Salafist garb, behavior that earned him an interview with French intelligence officers, who marked him in the now infamous "Fiche S" database as at risk for radicalization. Despite this, both men left for Turkey in 2013, where they were followed and observed together by Turkish intelligence, who in turn claim they contacted their French counterparts without ever getting a response.

The three men went about executing concertgoers with remarkable composure. Reports suggest that they had studied the layout of the building before the attacks and had positioned themselves to trap those fleeing; hostages were placed strategically to serve as human shields. One of them set up an encrypted laptop, presumably to establish communication with other ISIS affiliates, in the middle of the mayhem. With so many people crammed and panicking, much of the killing must have taken place at near point-blank range.

Conservative Muslims, and even many radical Salafists, denounce ISIS. One trope that often comes up is that the black-flag jihadists are "too easy with the blood." They have an obscene taste for death. For them bloodlust, not faith, marks the final shape and meaning of their lives. In January, the Islamic State released prerecorded video profiling each of the men declaring their intention to carry out the attacks and demonstrating their allegiance by beheading prisoners. The youngest, Bilal Hadfi, who had been a college student in Brussels just the year before, was only twenty years old, and is said to have cried profusely when saying goodbye to his mother. He blew himself up outside the Stade de France, killing only himself.

WHAT IS TERRORISM? Without answering the question directly, one thing we can say is that it stands in for communication. It is the way an organized group communicates a desperate will to power, especially when the verbal expression of that will is felt to be impossible, or incommensurate with the desired end. It is always a sign that the thirst for power has outstripped the capacity of language to comprehend or satisfy it. This is why I think it is important to try and write, not only for or about Paris, or France, or Syria; but against the gangrene that threatens every day to spread further and deeper among all of

us as we are tempted to give up on words, give up on thinking—are seduced by cheap simulacra, the lure of imagined community, the fever of Manichean folly, the pornography of violence.

WE KNOW THAT the disasters of war overwhelmingly unfold elsewhere, that our lives are safer and more sheltered than they've ever been; and yet a crowded subway entrance, an airport terminal check-in desk, anywhere the density of human traffic accrues is liable to provoke an invisible wrinkle of dread. And when some terrible event does happen, we now consume it with a sense of helpless foreknowledge. The newsreels arrive not as a shock of surprise, but of recognition, like the sudden recall of a nightmare at midday. We live in a state of passive suspense, like Goya's figure of Reason who sleeps seemingly at ease as the monsters of Superstition and Folly crouch over him and close in from above.

The genius of terror is that it feeds on reason's weakest link, its perverse need to proliferate explanations—to account for all possibilities, its obsession with minimizing uncertainties. Will ISIS attack the discount shopping center where I buy my groceries? That would be madness; or is that precisely why they might blow it up? Will they attack the movie theater I'm in? They are showing the latest Bond film, and England is in the crosshairs—should I have picked the art house instead? A new sign with a red triangle in the entryway to the municipal library asks all patrons to return books to the desk and not deposit them in the drop box. Even librarians must do their part to combat terror. High schools are evacuated because of a bomb threat. Parents come racing across town in a panic. Children stand behind armed soldiers waiting for them to arrive. The mentally ill discover they too are members of ISIS and commit spastic and hopeless attacks. Men with beards provoke waves of fear and shame in people just by passing them in the street or stepping onto a subway car. Mosque-goers find themselves staring down the barrel of a gun in the middle of the night, are detained without recourse and released without explanation. The normal laws are suspended because of the state of emergency, which the parliament votes overwhelmingly to extend.

Arendt coined the "banality of evil" to characterize the kind of bureaucratic, routinized, and orderly murder that Eichmann directed, emphasizing

the impersonality of its application. What is striking about the new terrorism is its chaotic and intensely personal character. Not in the sense that it is carefully directed at particular victims, of course, but that the human vehicle for it is a passionate, zealous hatred. The leader of the Paris attacks, Abdelhamid Abaaoud, is alleged to have returned to the scene of the shootings, mingling unnoticed with the crowds of wounded, first responders, police, and reporters, to check up on his work. A widely circulated video from Syria in 2014 shows him beaming and laughing as he drives a pickup through the desert dragging several bodies tied to the fender. For him one is tempted to speak of the "gaiety of evil."

WHAT CAN AND CAN'T be said. What is and isn't "our" history. In the press after November 13 we are repeatedly told that this is the worst attack on French soil since the Second World War. This is not true. It is the worst attack since the 18th of June 1961. On that day members of the "Organization of the Secret Army" (OAS), a neo-fascist splinter group with connections at the highest levels of the French military, furious at Charles de Gaulle for refusing to crush the Algerian resistance and reclaim the colony they considered a natural part of France, bombed a train traveling between Paris and Strasbourg, killing twenty-eight people. This forgotten terrorist attack resulted in less loss of life than the anti-Algerian police riots in Paris of that same year, 1961, "events" still virtually unmentionable in France and for which there are no official death tolls, though it is generally accepted that hundreds of protestors were killed, many of their bodies thrown in the Seine. *"Ici on noie les Algériens"* was the message tagged on the Pont Saint-Michel. "Here we drown Algerians."

In 1983, in the face of rising anti-immigrant violence and Islamophobia—as well as the first electoral breakthrough of the Front National—Christian Delorme, a French priest from Lyon, decided to rally a movement against racism. Inspired by Martin Luther King Jr.'s civil rights marches, he organized the "March for Equality and Against Racism." It was the first anti-racist protest of its kind in France. Starting with only a few dozen people in Marseille, Delorme crossed the country on foot with people gathering to support him along the way. By the time they arrived in Paris fifty days later

nearly 100,000 people marched in solidarity. President François Mitterrand personally received them and promised minimal reforms, few of which he delivered on. In the years that followed, the French right ignored the problem. The French left paid lip service to the spirit of the movement, but did nothing substantial to nourish and encourage change on the ground, and by some accounts misused and misdirected anti-racism activists for corrupt ends.

Meanwhile the situation in the streets worsened. In 2005, after yet another lethal interaction between police and youths, the ghettoes exploded and several weeks of rioting forced the last major declaration of a state of emergency. Nicolas Sarkozy, at the time a young and ambitious minister of the interior, called the rioters "scum," praised the police, and vowed to "hose out" the *banlieue.* Two years later, Sarkozy mobilized the fear and anger stoked by those riots to appeal to voters on the extreme right to back him as a law-and-order candidate for the 2007 elections. It was a successful strategy, which allowed him to consolidate a right-wing coalition and win the presidency. Once in office, however, he returned to the passive and indifferent attitude of neglect that characterized his predecessors. Thus several decades of profound social crisis, with no shortage of handwringing in the media, has resulted in little more than cynical electioneering. The civil rights movement that France desperately needs has yet to be born.

III. The Opium of the Intellectuals

One of the best-selling books last year in France was a bitter treatise by the journalist and cultural critic Éric Zemmour called *Le Suicide français*, The French Suicide. Zemmour has made a name for himself in recent years by attacking and, in his view, exposing what he sees as the dangerous influence of post-1968 France, the generational cohort colloquially referred to as the *soixante-huitards*, who came of age in the heady days of revolutionary May, overthrew Charles de Gaulle, and have dominated the politics and culture of the Fifth Republic.

Zemmour opens predictably enough with a lamentation for de Gaulle, the last great patriarch of France in a line stretching back to Napoleon Bonaparte. This tragically sincere eulogy concludes on a timely note: "Soon, the

most turbulent and most iconoclastic children [of '68] would come to spit on his grave: 'Tragic ball in Colombey, 1 dead' sarcastically sneered the cover of *Charlie Hebdo*." Zemmour is referring to a famous *Charlie Hebdo* cover that mocked de Gaulle's death in 1970. It's one of the great *Charlie* covers, a slaughtering of France's most sacred cow. It represents all of the magazine's founding traits: an anarchist's radical disdain for authority, for tradition, for any and all hints of militarism, a willfully pubescent sense of humor that loves to stick a finger, or more likely a cock, in the eye of the headmaster.

In Zemmour's account, the crisis of values and identity facing France originated with the accursed *soixante-huitards*, who introduced a relativism that spawned two major threats: the feminization of society (and its associated "gay ideology"), and the Islamic culture of France's North African immigrants. These are mutually reinforcing; a weak, "feminized" people is less likely to be able to stand up to the aggressive Muslim population swelling in its midst. This creeping process, he believes, originated in French deconstructionism, was incubated and radicalized in American universities (where it spawned gender studies), and is now being foisted upon an unwitting French society by a conspiracy of multiculturalist transatlantic liberals who, refusing to see the dangerous errors of their ways, are willingly destroying traditional France—committing the titular suicide.

To say that Zemmour is a crude thinker would be an understatement. He is also a highly polished speaker, perfectly groomed for French television, where he fits in alongside Alain Finkielkraut and Bernard Henri-Lévy as mainstays who have made a name for themselves by attacking "multiculturalism." Like their American analogues, these writers insistently paint themselves as marginalized and speaking courageously in the face of the liberal leftist indoctrination of the country. This despite Zemmour's best-selling status, not to mention that of Michel Houellebecq's novels, Finkielkraut's election to the Académie Française, the massive and at times violent demonstrations against gay marriage in 2013, and the persistent inroads of the extreme right in elections.

There is, in fact, a terrible need for intellectuals to challenge the dominant assumptions and calcified binaries that are poisoning the possibilities of change—of opening France to the future. But in doubling down uncritically

on a republican universalism that axiomatically asserts neutrality while *protecting* a great deal of condescending and paternalistic racism, Zemmour and Finkielkraut encourage the French state to pursue a policy that suits their preconceptions but is empirically failing. The result is wish-fulfillment politics, some notion that a return to the baguette-and-beret postcard of France—one that has never existed outside of posters for Pétain's Vichy and Le Pen's Front National—will somehow become possible.

This moldering climate, abetted by an aloof, nepotistic, and irresponsible political class on both sides of the political spectrum, has been crippling France for decades. Irrespective of outcomes in Syria, or new terrorist attacks, France will require a civil rights movement, a sustained social movement to involve and empower deeply marginalized communities so that they are equal stakeholders in the nation's future. As it is, the stubborn evasion of reality in the pages of Zemmour, and the governing class's complacent reassertions of a Frenchness that has little connection to any social reality, is the suicidal tendency that worries me most.

IV. Fluctuat Nec Mergitur

The cartoonist Cabu, one of the founding members of *Charlie Hebdo*, began publishing his drawings in his high-school paper in the small Alsatian town of Châlons-sur-Marne. He came to Paris in 1954 to work at commercial drawing for a small studio. He fell in love with American jazz, which would remain a lifelong passion, and became an avid chronicler of the scene for local reviews and journals. His career was interrupted in 1958 when he was drafted into the army and sent to Algeria, where France was struggling to put down the anti-colonial independence movement. He was enlisted in the 9th Zouaves, a branch of a military unit famous for its role in the original conquest of Algeria in 1830. That conquest: Who remembers now how it came about? Who now recalls that France owed the Dey of Algiers money, refused to pay her debt, and then invented the flimsiest pretext (a slap in the face of the French consul) to invade, overthrow, and colonize their creditor? The war against the FLN in Algeria disgusted Cabu, as it rightly did so much of his generation. He left the army in 1960 a confirmed anarchist.

Cabu's most famous and lasting caricature is a figure known as the "beauf." This is short for *beau-frère*, brother-in-law. Cabu thought this was a particularly French type, annoying the way only your brother-in-law can be annoying; a provincial jerk who assumes he knows everything because he's heard a little about everything; who has all the right opinions at the right time, because all his opinions are the latest conventional wisdom. It's a pointed self-examination of the French temperament, and that's what makes it funny. The word has since passed into the language. The beauf, Cabu liked to say, is a part of us all: it's the person we love to hate, but the one we hate because we know him so well.

The response to the *Charlie Hebdo* attacks was an impressive outpouring of solidarity and grief for personalities who had been familiar faces in French life for at least thirty years. But the "#JeSuisCharlie" hashtag and the dogmatic demand to adhere to it, reminiscent of the Bushism "You're either with us or against us," also exemplified much of what is wrong with the discourse on identity and race in France. Wasn't it clear that the demand for identification risked alienating precisely the swaths of the population that need to be brought into the fold? Besides, nothing could be more absurd than sententious displays of solidarity with one of the most virulent antiestablishment rags ever printed. Let's not get it twisted: over the years *Charlie Hebdo* has most definitely printed racist cartoons; almost no issue of *Charlie* isn't profoundly sexist or misogynistic. They also printed material that was coded anti-Semitic; and their anticlerical offensiveness is legendary. The cartoons of the Prophet were in particularly bad taste, but for the *Charlie* crew pretty much run-of-the-mill. Not all humor is equal; when it is deployed without intelligence it opens itself to questions of judgment and intent that one should have to answer for. But not in blood. Bad humor is a crime against comedy. No humor is a crime against humanity. One thing that always gives away the fascists: that degree-zero sense of humor they carry around like a nightstick.

IN THE DEAD GRAY of January, I went for a walk in the neighborhood where the November attacks took place. I started in the little streets of the Faubourg Saint-Antoine. I walked up the rue de la Forge Royale and turned onto the rue de Charonne. Even from the distance of a block or two you could make

out the shoal of flowers and cards in front of La Belle Equipe. It means the "Beautiful Team." The night of November 13, Hodda Saadi brought together her group of friends for drinks on the terrace. She was celebrating her thirty-fifth birthday. Her friends were her coworkers—bartenders, waiters, and waitresses from the nearby Café des Anges. Hodda's sister Halima, who had recently moved to Dakar with her husband to start a life there, was also on hand to celebrate. Then the black car rolled up and the Kalashnikovs started firing. The whole group of ten friends were murdered together. Khaled Saadi, their younger brother who was working inside, emerged to discover both of his sisters dead on the sidewalk. The owner of La Belle Equipe, Grégory Reibenberg, survived. He lost his wife Djamila. Their daughter will grow up with her Jewish father; she was robbed of her Muslim mother.

I made my way up to Place Voltaire, where the Mairie stands. Weddings in the 11th arrondissement were canceled for months because of the need for funerals. From the square I pursued the boulevard up to the Bataclan just past the intersection with Richard Lenoir. Shuttered and still surrounded with police barricades strewn with flowers, I was surprised to find myself thinking about how small the venue looked. I suppose when I was younger it loomed larger in my mind because of its status as a mecca of cool. Now it looked vulnerable, banal, crestfallen. We are always told that life must go on as before, that the terrorists can't be allowed to make the party stop. But how do you do that? How do you put the site of a mass murder on mute so you can have a nice night out?

I remembered how nearly one year earlier I had walked in the procession, the so-called "Republican Marches" after the *Charlie Hebdo* attacks. The Place de la République was a sea of people seething with tension and mixed emotions. I was surprised by how many parents brought their children, carrying them on their shoulders. The scale is hard to convey. A million and a half turned out in Paris alone, and closer to four million across France. I had a *Charlie* sticker on my winter jacket, and I carried a rose for socialism and *fraternité* and a blue Bic pen as a symbol of freedom of expression and solidarity with writers. A French news reporter interviewed me in English as an American observing the scene. "Why are you here today?" he asked. I told him that I believed the importance of the crowd was in the young people. I

said we were determined to make a different future. I said it was important for people to come together unafraid, and to know that we are free.

That was last January. Since the November attacks, the state of emergency has prevented people from coming out to mourn together. Heavily armed paratroopers are ubiquitous, not only in public transportation but also guarding high schools, synagogues, mosques, and cathedrals. Armored jeeps patrol areas of central Paris after hours. Prime Minister (and presidential aspirant) Manuel Valls has declared that we are now facing "hyper-terrorism," whatever that may mean, and that a major new attack is not a matter of probability, but "a certainty." Highly placed French intelligence officials have made statements to the press suggesting that November 13 was merely "a dress rehearsal" for a more ambitious attack, a "European 9/11" coordinated across European capitals.

In place of a great rallying of the people there has been official state-sponsored grieving, including a performance by France's geriatric rocker Johnny Hallyday that was empty, uninspiring, and went largely unnoticed. Yet perhaps the inability to mourn isn't necessarily something we should deplore. There is something powerful about wresting the clock back from those who operate on apocalyptic time. Impatience is the zealot's most critical flaw. The assassins believe their time is always now, their triumph always imminent. They are convinced by the theater of their own cruelty and multiply their acts. In the short term we are on edge, of course, but eventually even these events are absorbed into our "new normal."

I had forgotten that the Boulevard Richard Lenoir turns into the Boulevard Jules Ferry. I was pondering the significance of Ferry, that contradictory French statesman, architect of French secular law, champion of free education, and faithful believer in France's colonial mission to civilize "inferior races," when I came suddenly upon the plaque commemorating Ahmed Merabet, the police officer who tried to stop the Kouachi brothers as they left the *Charlie Hebdo* offices. President Hollande had just officially consecrated it the week before. I felt the strange compression of history. Like the hundreds of commemorative plaques all over Paris on schools testifying to the Jewish children deported under the Occupation, or resistance fighters fallen in battle or executed by the Nazis, Merabet's plaque is diminutive, unnoticeable really

until you look. I realized with horror then that I was standing on the pavement right where he had been killed. I had watched his death on YouTube. Ahmed in his blue uniform already down, shot in the upper leg. "C'est bon, chef," he moans. The words so human. Neither plea nor a protest, but a statement of understanding, submission. It's over, you don't have to. Then the crack of the Kalashnikov.

The boulevard runs up to the southern end of the Canal Saint-Martin. I passed the terrace of the Café Bonne Bière, which had already reopened in December. A defiant "JE SUIS EN TERRASSE" banner floated over the awning where people sat outside despite the awful weather and the passersby lifting their phones to take pictures. But when I reached the canal proper I was stunned to find it completely drained. Municipal barricades had been erected all along the quays. Looking down from one of the green elevated footbridges you could see the trench, surprisingly shallow, as it cut a brown swatch, like a great scar, running along the gray curve of buildings under the gray sky. At the intersection ahead, a building face usually covered in graffiti or street art had been entirely painted black with the motto of the ancient mariners of Lutetia, "FLUCTUAT NEC MERGITUR," stenciled across it. *She wavers but does not sink.* Someone explained to me that they were draining the canal to improve navigation. Yes, I thought. You can't sink any further if you can see the bottom.

—2016

Harlem Is Everywhere

O N LENOX AVENUE, just south of 125th Street and a few steps from James VanDerZee's old darkroom in which he caught the dazzling glamour of a black Manhattan at twilight, stood, and perhaps still stands in ruined form, the Lenox Lounge, a storied uptown nightspot famous for its zebra uphol-stery and players only–priced drinks, its checkered mosaics and its check-ered history.

The club was already something of a living museum when I first came to know it. Vaulted and low-lit, the Lenox was a vivid palimpsest of Afro-America. One half expected Duke Ellington's insomniac eyes to fix on you from across the bar as you listened to Ja Rule and Ashanti duet. Brothers rocked their logo-splashed Avirex and Fubu carapaces with impeccable cus-tom suede Wallabees or unlaced Timbs. Gorgeous, ageless women decked in furs, hooped earrings, and plunging tops laughed with sly glee at the players always running their game. Ossie Davis bar-side baritones, distinguished and downhome, traded Melvin Van Peebles–like tales you could scarcely believe, yet were all true. Matter of fact, I'm damn near certain I saw Melvin storying there one night myself. But to tell you the truth, it's been years, and a night at the Lenox Lounge never lent itself to clear recollection.

The opening last summer of a 40,000-square-foot Whole Foods directly across from the old Lenox Lounge felt like a chess move: White Queen to Black King. The new emporium, which comes with an Olive Garden, is the crown jewel of the redevelopment of the 125th Street corridor—a 2008 City

Council rezoning plan that paved the way for what has been described as the "mallization" of Harlem's main street, Martin Luther King Jr. Boulevard. The street now boasts a Red Lobster, an Old Navy, and a Raymour & Flanigan outlet. But the M&G Diner that had survived since 1968 is gone. Only its "vintage" sign still hangs over what is now a fashion boutique.

But laments about the loss of black Harlem are old hat. Already in 1925 James Weldon Johnson was prophesizing that "when colored people do leave Harlem . . . it will be because the land has become so valuable they can no longer afford to live on it." By midcentury the neighborhood was already a symbol of loss and decay. As Lawrence Jackson observes in *The Indignant Generation*, essays and novels about the ruin of Harlem became a genre unto itself. For Lutie Johnson, the heroine of Ann Petry's 1946 novel *The Street*, Harlem's tenements are a quagmire she is forced to flee in tragic and desperate circumstances. Ralph Ellison's pessimistic essay, "Harlem Is Nowhere," originally written in 1948 (but not published until 1964 in *Harper's*), is about the activities of the Lafargue Clinic on 134th Street, at the time a pioneering mental-health facility. Musing on the wider condition of black Americans, Ellison is struck by how a sense of homelessness connects Lafargue's patients to the ordinary man in the street. On the block he hears repeatedly, "Man, I'm nowhere," which he writes "expresses the feeling borne in upon many Negroes that they have no stable, recognized place in society. . . . One 'is' literally, but one is nowhere; one wanders in a ghetto maze, a 'displaced person' of American democracy."

Revisiting this legacy in the new millennium, Sharifa Rhodes-Pitts's stunning 2011 book *Harlem Is Nowhere* captured the decline of a legendary neighborhood that continues to radiate cultural energy through its archives, its scrapbooks, its folk heroes, and its block association battles. There's a deep melancholy to her story of coming to know a place only to watch its residents pushed evermore to the edge; of attempting to find belonging in a neighborhood where a proud past looms over a community that is losing the battle to determine its own future.

For a long time, it was a melancholy I shared. Harlem seemed like an anchor of the imagination—impossible to let go. True, it was never entirely (or originally) black. But its special character for over a century was the

unique result of middle- and upper-class blacks, proud and fed up with racist redlining, banding together to buy real estate uptown. That action paved the way for countless others, generations who have called it home, and in the best and worst of times kept alive its spirit. For black artists and writers it has been nothing less than a literary mecca, a Paris with better music, warmer voices, and hot sauce.

But what if, in this generation, the hope we continued to place in that one neighborhood, like the hope that in 2008 we had placed in one man, was misallocated? What if, at this very moment, the seeds are being planted for another kind of revolution, for a global mecca whose birth pangs you might miss if your vision was focused too narrowly on the blocks north of Central Park?

RIGHT AFTER THE neo-Nazi marches in Charlottesville last summer, I found myself on an A train heading uptown. Next to me, an old man pored over the images of chaos and hatred in the *Daily News*. Nearby, in a typical scene of contemporary courtship, a teenage couple shared earbuds, watching a music video on her iPhone. Both of them sang along with the chorus, stopping only to flirt with each other in Dominican Spanish and English. They were listening to one of the summer's breakout hits, a song called "Unforgettable" by the Moroccan-born, Bronx-raised singer French Montana, featuring American rapper Swae Lee. In the video, the duo dance with kids from a local troupe in the shantytowns of Kampala, Uganda. For Montana, the location reflects a subtle choice (in an otherwise decidedly apolitical career) to showcase the African diaspora in his music, reminding his audience of his own identity. The video for his 2016 single "Lockjaw" does something similar. Featured rapper Kodak Black's Haitian origins are evoked in scenes of street life in Port-au-Prince juxtaposed against images of the Haitian community in Broward County, Florida.

These videos chart a dizzying path from postcolony to American empire— from North Africa to the Caribbean to Florida and back to New York City. They capture how, sometime in the last decade, the felt presence of what cultural theorist Paul Gilroy called the "Black Atlantic" has shifted into high gear. This imaginative umbrella term for the communities and transoceanic

linkages produced by the Atlantic slave trade can no longer be relegated to an academic concept; it has become a reality. You can hear it all around you. The Yale art historian Robert Farris Thompson, famous for his pathbreaking studies of artforms across the Afro-Atlantic, declared in 2011: "The big triumph [today] is that the airwaves of our planet belong to black people."

In a sense, this is obvious. Stars like Beyoncé, Jay-Z, and Kanye West are global icons, tastemakers, and ambassadors for American blackness. But the American R&B that they represent has been creolized. The influence of the Barbadian singer Rihanna, for instance, has been decisive in mainstreaming the rhythms of the Caribbean in pop music. Justin Bieber is just one of a slew of white pop stars who have turned to dancehall in order to make hit records. The sonic contours of the Black Atlantic have become louder, more insistent than ever before.

One of the most striking examples of this has been the return of Afro-beats, mixing the Atlanta-based style of contemporary US rap and R&B with primarily Ghanaian and Nigerian pop music, producing a hybrid sound that is poised to dramatically reshape the landscape of popular music in the coming years. It builds upon an already dense transatlantic feedback loop: the collage of Mississippi and Niger Delta blues made famous by the Malian musician Ali Farka Touré, the interpretation of funk and soul for the Lagos dancefloor by Fela Kuti, and the pioneering jazz of voyagers like Randy Weston and the South African singer Sathima Bea Benjamin who, as Robin D. G. Kelley traces in *Africa Speaks, America Answers* (2012), captured the spirit of African nationhood and resistance to apartheid. Now a new wave of artists is poised to reiterate that call, carrying forward a vision of diaspora that is, on one hand, enabled by social media, smartphones, and streaming downloads, and on the other, threatened by a resurgent ethno-nationalism that is hostile to everything it stands for.

Did Paul Gilroy see all of this coming? His 1993 book *The Black Atlantic* argued for a major rethinking of black cultural geography and its relation to the modern world. Pushing back against the tendency of scholars of his generation to assert essentialist and often reductive nationalist claims about black identity, Gilroy theorized a new world mediated by the Atlantic littorals—

one brought into being by the triangular slave trade that tied Africa, South America, the Caribbean, North America, and the British Isles together. Black culture, he argued, is inherently heterogeneous and transnational and best understood through the concept of diaspora—a historical analogy borrowed from Jewish history—whose use he helped popularize in relation to people of African descent.

Gilroy was concerned primarily with the circulation of ideas, in particular the movement of utopian, dissident, and activist thought. *The Black Atlantic* correspondingly focuses on black intellectuals whose work traversed the continents, like Martin Delany, W. E. B. Du Bois, and Richard Wright. It also explores the occasions and paradoxes of cultural belonging in black music: the introduction of African-American spirituals to Europe by the Fisk University Jubilee Singers in the 1870s; Jimi Hendrix's "gypsy" aesthetic against the backdrop of the Swinging London of the 1960s; and the importance of Marvin Gaye and Detroit's Motown sound to Nelson Mandela and the ANC political prisoners on Robben Island.

The music of the black diaspora is a polyrhythmic matrix that includes R&B, merengue, jazz, reggae, funk, disco, rhumba, soul, hip-hop, samba, reggaeton, baile funk, and dancehall. But from the vantage point of the early nineties, just before the explosion of global interconnection fostered by the internet, the consumption and exchange of this music—the ability of musicians to circulate their work instantaneously or to collaborate with major artists in other countries—was still limited.

Today it's never been easier, and the Black Atlantic is thriving. Consider the literature of Chimamanda Ngozi Adichie, Teju Cole, Zadie Smith, Edwidge Danticat, Jamaica Kincaid, and Junot Díaz; or the lesser-known explosion of francophone writing from the Haitian-Canadian novelist Dany Laferrière, the Guadeloupian writer and scholar Maryse Condé, or the Djiboutian satirist Abdourahman Waberi. The surge of interest in transnational narratives ranges across the arts. Ryan Coogler's recently released superhero film *Black Panther* has occasioned a popular outburst of Afrocentric pride unseen in Harlem since Marcus Garvey's UNIA parades came down the block a century ago. Unsurprisingly, the diasporic communion in music is an even

broader and more striking phenomenon; it is the live signal of this grand cultural transformation, the shockwave of Black Atlantic cultures reconnecting in our time.

WHAT WILL THE MUSIC of this new phase of the Black Atlantic sound like? One answer comes in the form of Nigerian superstar Wizkid. Citing Fela Kuti and Bob Marley as key inspirations, as well as the hip-hop of Snoop Dogg and Master P, Wizkid (Ayodeji Ibrahim Balogun) hails from Lagos, grew up in an interfaith household reflective of the national religious split (his mother is Christian and his father is Muslim), and quickly stood out for his ability to fuse the older Fela Afrobeat sound with contemporary rap, R&B, and reggae. His crossover into the American market began after Drake was introduced to his music by the UK grime artist Skepta. (This is itself an example of how London—with its overlapping generations of migrants from Africa and the Caribbean, as well as the abiding influence of black America—is a creative hub for the diaspora.) Wizkid's mainstream appeal seems nothing less than assured—he's rumored to appear on Beyoncé's next album; he has recorded with Chris Brown and Drake; he'll perform at Coachella in April; he started his own label, Starboy Entertainment; and he's been an important patron of Nigeria's booming fashion industry.

The new generation of Afrobeats is colored by the distinctive warble of Auto-Tune crooning, itself a legacy of the talk-box Zapp & Roger introduced into R&B in the 1980s before Daft Punk (in a classic Elvis move) repopularized it and made it a key signature of the hip-hop and R&B of the early noughts. In Wizkid's music, this vocal style is married to distinctive rhythmic patterns inspired by percussion from across West Africa and the Sahel. The digitized vocals as well as a combination of Moog synth lines fill in the slick arrangements favored by contemporary producers. Atmospheric chords and relaxed tempos, closer to lovers' rock than to disco, replace the jazzy horn and guitar licks of the Ghana "highlife" sound and the train-chugging funk riffs that characterized the classic Nigerian Afrobeat of the seventies.

You can hear all of this come together on Wizkid's 2014 breakout hit "Ojuelegba," a track that celebrates the eponymous neighborhood in Lagos where he got his start in music, where the people, as he sings, "know my

story." Alternating between English and Yoruba, his lyrics like "My people suffer, they pray for blessings / for better living" evince the themes of every classic rap record: a celebration of hustling and striving to achieve success that would get one out of the hood, while simultaneously showing profound attachment to one's rough-and-tumble origins. Ojuelegba is literally a cross-roads in the city of Lagos, but it is also a metaphorically rich and suggestive site from which to think about the roots and potential reach of this music. The landing spot for most migrants coming to the city from across the African continent, its name joins together Eshu and Elegba, two of the most import-ant spiritual figures in the Yoruban religion of Orisha. These complementary figures often appear as one, the god of trickery, with one foot in the spiritual world and one in the material (causing him to limp or move in a syncopated manner, to dance). Somewhat like Hermes, he is tasked with relaying mes-sages, especially to people who find themselves at a crossroads.

"Ojuelegba" traces Wizkid's trajectory from the studio where he got his start to his career as global pop star, and it speaks to a new generation of Africans who see in his journey their own aspirations. Africa is at a cross-roads, and young people want to connect across borders, to enjoy a freedom that has for them long been undercut by conflict, neocolonial exploitation, and rampant corruption. The sense of pride is palpable, the message clear: It's a new day.

The appeal of this music tracks real change on the ground. Where at one time there might have been room for only one pop star to represent the African and American continents (a role an artist like Akon played in the mid-2000s), there is now a thriving music scene with viable internal mar-kets for streaming and touring. One important result is the emergence of black women as pop stars in their own right, like Tiwa Savage, sometimes touted as Nigeria's Rihanna, or the phenomenally talented Yemi Alade, a cross between Missy Elliott and Janelle Monáe with her own unique Afro-pop sensibility. There is also hope for bridging the sometimes hostile divides between neighboring countries. One of the leading superstars of Afrobeats, Mr Eazi, born in Nigeria but schooled in Kumasi, Ghana, embodies this out-reach (his breakout 2017 mixtape is entitled *Life is Eazi Vol. 1: Accra to Lagos*). African American artists like the Wisconsin-born Jidenna are seizing on the

moment as well, reaching across the Atlantic to catch the Afrobeats wave and boomerang it back.

The new accessibility of platforms for production and distribution (including drones for making high-quality music videos) means that musicians have more power both to share their music and to control their artistic vision. The image of modern Africa that Yemi Alade portrays in her videos is not entirely dissimilar from the Wakanda imagined in the alternative future of Marvel's fantasy; the afro-modernity of Wizkid's sets update the vibrant, modish aesthetic of Malick Sidibé's 1960s studio portraits, giving them a similar retro-futurism. His sold-out stadium concerts in Sierra Leone, Rwanda, Cameroon, and South Africa, each carefully documented and shared on social media, demolish the perception of these countries as hopelessly backward "shitholes" from which people can only want to escape—instead refashioning them as places we might be lucky to reach.

Du Bois said that the twentieth century would be defined by "the problem of the color-line." He foresaw the decline of empires in the West as an opportunity to rebalance power across the globe. Today Lothrop Stoddard's old fear of "a rising tide of color" continues to hold sway, and the color line has resurfaced as the imperial fever dream of impregnable border security, drone sentinels, a Great Wall to keep out the dark hordes. The president of the United States' derogatory remarks on Haiti and the lump-category of Africa (which also appears to include all of the Americas south of the Rio Grande) are typical in this respect. They illustrate the imaginary cordon sanitaire peddled by reactionaries who want to contain an emergent Black Atlantic identity bloc that their antagonism will likely only help to consolidate.

One of the ironies of the present is that, even as we continue to reel from this renewed ethno-nationalist sentiment in the United States and Europe, and neoliberal capitalism continues to hollow out our metropoles, the reach of black cultural capital is growing, reaching heights that would have dazzled even the most accomplished fellow travelers of the Harlem Renaissance.

Yet when Paul Gilroy revisited the question of the Black Atlantic in 2006, he sounded a distinctly pessimistic note. While observing that "much of what now passes for U.S. culture worldwide, is in fact African American in either

character or derivation," Gilroy feared black expressive culture was losing its ability to resist cooptation. The pressures of neoliberalism upon the production of black music, he argued, were chaining it ever more tightly to the logic of material consumption, deskilling its artistry and craft, and encouraging the glamorization of sexism, among other worrying trends. Looking around, he felt "an acute sense of being bereft of responsible troubadours," figures like Jimi Hendrix and Bob Marley who wove a note of rebellion and an ethical or spiritual message into their music.

Such debates about the political role of black music are vital and can continue without replacing protest, organizing, and voting. It would be delusional to imagine that resistance or even opposition can be martialed simply by enjoying a style of music, even if that music were produced by "responsible troubadours." But we also know that culture can feed political mobilization. The Popular Front of the 1930s, as cultural historian Michael Denning has shown, was also the time of the Cultural Front. The Freedom Songs accompanied the Freedom Riders. Public Enemy has done more to popularize the spirit of Black Power among the hip-hop generation than what remains of the Black Panther Party.

As Plato once warned, "When modes of music change, those of the State always change with them." Fela Kuti saw this insight as an opportunity. He saw a role for black music in nudging world historical change in the direction of decolonization, not just of the African continent, but of the minds of everyday people everywhere. In declaring that "music is the weapon of the future," he meant not only that the creative seduction of music is preferable to the coercive destruction of guns, but that a new era was coming, one that would be characterized by fluid cultural exchange, where music would dissolve the old borders of blood, soil, and nation.

WE ARE NOT going to win the battle over the gentrification of Harlem. The black mecca of the new millennium, if there is to be one, might well prove to be that city Du Bois rhapsodized in *The Souls of Black Folk*, "the City of a Hundred Hills, peering out from the shadow of the past into the promise of the future." That city was Atlanta, where he hoped the flourishing of black universities and centers of learning would break the spell of crass American

materialism and bring a renaissance to the South, a mighty cause that urgently needs and deserves our vigorous support today.

We will remember, and must remember, Harlem; but we will also have to begin to look forward and redraw our horizons. The days when James Baldwin might head uptown to Wilt Chamberlain's nightspot, Smalls Paradise, to celebrate the appearance of a new novel, when the party went to the break of dawn at Baby Grand's over by the bridge, when Charlie Parker jammed at Minton's, and Billie Holiday, her gardenia perfuming the air, as Frank O'Hara remembered it, "whispered a song along the keyboard / to Mal Waldron and everyone and I stopped breathing," the glamorous age of Harlem when black folk decided to make it a showcase for the world—those days are not coming back.

The Renaissance Ballroom and Casino, which opened in 1923 on Seventh Avenue at 138th Street—the place that gave birth to the Lindy Hop, was home court for the all-black New York "Rens" basketball team in the 1920s, hosted political rallies and college dances memorialized by Langston Hughes, and gave its name to one of the most celebrated and iconic periods of American cultural history—was finally torn down in 2015 after several decades of vacancy and neglect. Despite desperate attempts by local activists (including the arrest of the Harlem historian Michael Henry Adams) to preserve the historic facade, it was sold to a real estate developer that has turned it into an eight-story mixed-use condominium site they call "The Renny."

It's also true that kids play in Saint Nicholas Park now, even after dusk, without fear. There's no shortage of drug dealing, but the worst of the heroin and crack-cocaine years has receded. As Darryl Pinckney put it, the sense that "Harlem was the place where you could do or get anything and get away with it" is no longer the first assumption people make about the place. Hip-hop tours will take you up to 140th Street where you can see the mural dedicated to the rapper Big L, once one of the neighborhood's most prized and influential artists (and an early mentor to Jay-Z), who was gunned down in a drive-by shooting in 1999. The comedian, SNL writer, and New York-native Michael Che recently joked that he grew up poor, but he now lives in "a wealthy white neighborhood: Harlem."

But there's also a lot more French being spoken on 116th Street, and it's

not by tourists from Paris but families from Dakar and Bamako and Yaoundé. The story of Harlem and its dream of a black internationalism is only turning a new chapter. The Lenox Lounge may be gone, but "the Gift of Black Folk," as Du Bois put it, has never been more potent. From Lagos to London, from Havana to East Atlanta, from the Gulf of Aden to the Gulf of Mexico: Harlem is everywhere.

—2018

Acknowledgments

Acknowledgments are due to *Dissent*, *The Nation*, *The Point*, *n+1*, *Harvard Magazine*, and the *Los Angeles Review of Books*, where some of this work first appeared. I am especially grateful to Dan Gerstle of Norton who was the first to believe in this project and did so much to shape these fugitive pieces into a book. I also wish to acknowledge the many editors I've worked with over the years who marked the writing and thinking in these essays in important ways: Jon Baskin, Jonny Thakkar, Rachel Wiseman, John Palatella, Jennifer Szalai, David Marcus, Laura Marsh, Natasha Lewis, Nikil Saval, Anna Shechtman, and Sophia Nguyen. Although I cannot list them all here, I wish to acknowledge some of those who have taught, mentored, and inspired me along the way: Daphne Brooks, Kinohi Nishikawa, Joshua Guild, Imani Perry, Joshua Bennett, Joshua Kotin, Brent Hayes Edwards, Fred Moten, Robin D.G. Kelley, Hortense Spillers, Eddie Glaude, Jr., Margo Jefferson, Vinson Cunningham, Marisa Parham, John Drabinski, Andrea Rushing, and in memoriam, Jeffrey B. Ferguson and Cheryl Wall; the entire faculty of Harvard's Department of African and African American Studies, with special thanks to Glenda Carpio, Henry Louis Gates Jr., Cornel West, Tommie Shelby, Brandon Terry, and Robert Reid-Pharr; the entire Harvard Department of English with special thanks to Teju Cole, David Alworth, and Louis Menand. These essays are also indebted to the friendship and intellectual community of Adrián Emmanuel Hernández-Acosta, Olivia Carpenter, Panashe Chigumadzi, Roshad Meeks, Jarvis Givens, Jovanna Jones, Janet Kong-Chow, Tim Pantoja, Nyle Fort,

Angela Dixon, Ashon Crawley, Brittney Edmonds, Camara Brown, Lovia Gyarkye, Liv Adechi, Tobi Haslett, Edyson Julio, Peyton Morgan, Wangui Muigai, Stanley Onuoha, Will Pruitt, Rafael Walker, Simone White, Justin Mitchell, Ben Ewing, Timothy Stoll, Gabriel Arce Riocabo, Carina del Valle Schorske, Nijah Cunningham, Julian Lucas, Matthew McKnight, Robert Watson Jr., Zachary Sachs, and many others. Several of these essays were significantly shaped by two of the finest writers, scholars, and readers I know, and to whom I am profoundly indebted: Ernest Julius Mitchell and Namwali Serpell. Nothing would be possible without the love of my entire family: Elaine, Robert, Raymond; my brothers Jake and Ray Jr. especially, who inspire me always; all my aunts, uncles, and cousins. Thank you all for being who you are. Finally, there are many people from all walks of life, friends, intimates, comrades, and companions, who have been important to me in ways small and large over the years since I started these writings who I won't have mentioned by name. I am no less grateful to all of them for everything, for all of those moments. I wish this book could honor, in its own complicated way, all of these accumulated debts; but the truth is the blessings I have received are too numerous and too generous to ever be repaid in full.

Sources and Suggested Reading

THE MASTER'S TOOLS

Baker Jr., Houston. *Modernism and the Harlem Renaissance*. Chicago: University of Chicago Press, 1987.

Brown, Jonathan. *Velázquez: Painter and Courtier*. New Haven, CT: Yale University Press, 1986.

English, Darby. *How to See a Work of Art in Total Darkness*. Cambridge: The MIT Press, 2010.

Erickson, Peter. "Posing the Black Painter: Kerry James Marshall's Portraits of Artists' Self-Portraits" *Nka: Journal of Contemporary African Art*, Number 38-39 (November 2016): 40–51.

Ford, Tanisha C. *Liberated Threads: Black Women, Style, and the Global Politics of Soul*. Chapel Hill: University of North Carolina Press, 2017.

Foucault, Michel. *The Order of Things*. New York: Vintage, 1994.

Fracchia, Carmen. *'Black but human': Slavery and Visual Art in Hapsburg Spain, 1480–1700*. New York: Oxford University Press, 2019.

Golden, Thelma; Halley, Peter; Hobbs, Robert; Jackson, Brian K.; and Lewis, Sarah. *Kehinde Wiley*. New York: Rizzoli, 2012.

Hegel, G. W. F. *Aesthetics: Lectures on Fine Art Vol. I*. Translated by T. M. Knox. New York: Oxford University Press, 1975.

Hemphill, Essex. *Ceremonies: Prose and Poetry*. New York: Plume, 1992.

Lewis, Sarah. "From the Archives: De(i)fying the Masters." *Art in America*, April 1, 2005.

Lorde, Audre. *Sister Outsider*. New York: Random House, 1984.

Montagu, Jennifer. "Velázquez Marginalia: His Slave Juan de Pareja and His Illegitimate Son Antonio." *The Burlington Magazine* 125, no. 968 (November 1983): 683–685.

Reiss, Tom. *The Black Count: Glory, Revolution, Betrayal, and the Real Count of Monte Cristo*. New York: Random House, 2012.

St. Félix, Doreen. "The Power and Paradox of Beyoncé and Jay-Z Taking Over the Louvre" *The New Yorker*, June 19, 2018.

Taylor, Keeanga-Yamahtta. *How We Get Free: Black Feminism and the Combahee River Collective*. Chicago: Haymarket Books, 2017.

Todorov, Tzvetan. *The Conquest of America: The Question of the Other*. Translated by Richard Howard. New York: Harper & Row, 1984.

Whitehead, Colson. "The End of the Affair." *New York Times*, March 3, 2002.

THE ORIGIN OF OTHERS

Als, Hilton. "Ghosts In the House: How Toni Morrison Fostered a Generation of Black Writers." *New Yorker*, October 27, 2003.

Ghansah, Rachel Kaadzi. "The Radical Vision of Toni Morrison." *New York Times Magazine*. April 8, 2015.

McCluskey, Audrey Thomas, and Smith, Elaine M., eds. *Mary McLeod Bethune: Building a Better World, Essays and Selected Documents*. Bloomington, IN: Indiana University Press, 1999.

Morrison, Toni. *Playing in the Dark: Whiteness and the Literary Imagination*. New York: Vintage, 1993.

_____. *What Moves at the Margin: Selected Nonfiction*. Jackson: University Press of Mississippi, 2008.

_____. *The Origin of Others*. Cambridge, MA: Harvard University Press, 2017.

_____. *The Source of Self-Regard: Selected Essays, Speeches, and Meditations*. New York: Alfred Knopf, 2019.

Smith, Zadie. "Fascinated to Presume: In Defense of Fiction." *New York Review of Books* 66, no. 16. October 24, 2019.

Truth, Sojourner. *Narrative of Sojourner Truth; A Bondswoman of Olden Time, With a History of Her Labors and Correspondence Drawn from Her "Book of Life."* New York: Oxford University Press, 1991.

Woolf, Virginia. *Between the Acts*. Harvest/Harcourt Brace Jovanovich, 1941.

VENUS AND THE ANGEL OF HISTORY

Benjamin, Walter. *Illuminations*. New York: Harcourt Brace Jovanovich, 1968.

_____. *One-Way Street*. Cambridge, MA: Harvard University Press, 2016.

Best, Stephen. *None Like Us: Blackness, Belonging, and Aesthetic Life*. Durham, NC: Duke University Press, 2018.

Carpio, Glenda. *Laughing Fit to Kill: Black Humor in the Fictions of Slavery*. New York: Oxford University Press, 2008.

Crais, Clifton, and Scully, Pamela. *Sara Baartman and the Hottentot Venus: A Ghost Story and a Biography*. Princeton, NJ: Princeton University Press, 2010.

Hartman, Saidiya. *Scenes of Subjection: Terror, Slavery, and Self-Making in Nineteenth-Century America*. New York: Oxford University Press, 1997.

_____ . *Lose Your Mother: A Journey Along the Atlantic Slave Route*. New York: Farrar, Straus and Giroux, 2008.

_____ . "The Belly of the World: A Note on Black Women's Labors." *Souls* 18, no. 1 (January–March 2016): 166–173.

_____ . *Wayward Lives, Beautiful Experiments*. New York: W. W. Norton, 2019.

Hurston, Zora Neale. *Their Eyes Were Watching God*. New York: Harper Perennial, 2006.

James, Darius. *Negrophobia. An Urban Parable*. New York: New York Review Books Classics, 2019.

Lepore, Jill. *Joe Gould's Teeth*. New York: Alfred A. Knopf, 2016.

Lewis, Robin Coste. *Voyage of the Sable Venus and Other Poems*. New York: Alfred Knopf, 2017.

Löwy, Michael. *Redemption and Utopia: Jewish Libertarian Thought in Central Europe*. New York: Verso, 2017.

Nyong'o, Tavia. *Afro-Fabulations: The Queer Drama of Black Life*. New York: New York University Press, 2018.

Perl, Jed. "The Cult of Jeff Koons." *New York Review of Books*, September 25, 2014.

Shaw, Gwendolyn DuBois. *Seeing the Unspeakable: The Art of Kara Walker*. Durham, NC: Duke University Press, 2004.

Smith, Zadie. "What Do We Want History to Do to Us?" *New York Review of Books* 67, no. 3 (February 27, 2020).

Steedman, Carolyn. *Dust: The Archive and Cultural History*. New Brunswick, NJ: Rutgers University Press, 2002.

Threadcraft, Shatema. *Intimate Justice: The Black Female Body and the Body Politic*. New York: Oxford University Press, 2016.

Ward, Jesmyn. *Men We Reaped*. New York: Bloomsbury, 2013.

THE LOW END THEORY

A Tribe Called Quest. *The Low End Theory*. Jive Records, 1991 [sound recording].

Ashbery, John. *Flowchart: A Poem*. New York: Noonday Press, 1998.

Edwards, Brent Hayes. *Epistrophies: Jazz and the Literary Imagination*. Cambridge, MA: Harvard University Press, 2017.

Johnson, Barbara. *The Barbara Johnson Reader: Surprised by Otherness*. Durham, NC: Duke University Press, 2014.

Marx, Karl, and Engels, Fredrick. *Economic and Philosophic Manuscripts of 1844*. Translated by Martin Milligan. New York: Prometheus Books, 1988.

Moten, Fred, and Harney, Stefano. *The Undercommons: Fugitive Planning & Black Study*. Brooklyn: Autonomedia, 2013.

_____ . *In the Break: The Aesthetics of the Black Radical Tradition*. Minneapolis: Minnesota University Press, 2003.

_____ . *Consent not to be a single being, Vol.1: Black and Blur*. Durham, NC: Duke University Press, 2017.

BLACK DADA NIHILISMUS

Baraka, Amiri. *S O S: Poems, 1961–2013*. New York: Grove Press, 2014.

_____ . *Digging: The Afro-American Soul of American Classical Music*. Berkeley: University of California Press, 2009.

Buchhart, Dieter. *Jean-Michel Basquiat*. Paris: Editions Gallimard (Fondation Louis Vuitton), 2018.

Childish Gambino. "This Is America." RCA, 2018 [digital sound recording and music video].

Du Bois, W. E. B. *Dusk of Dawn*. New York: Oxford University Press, 2007.

Ducrozet, Pierre. *Eroica*. Paris: Grasset, 2015.

Eisen-Martin, Tongo. *Heaven Is All Goodbyes*. San Francisco: City Lights Pocket Poets Series 61, 2017.

Fussell, Paul. *The Great War and Modern Memory*. New York: Oxford University Press, 1977.

hooks, bell. "Altars of Sacrifice: Re-membering Basquiat." *Art on My Mind: Visual Politics*. New York: The New Press, 1995.

Lil Wayne. "God Bless Amerika." *I Am Not a Human Being II*. Cash Money Records, 2013 [sound recording].

Public Enemy. "He Got Game." *He Got Game*. Def Jam, 1998 [sound recording].

Rasula, Jed. *Destruction Was My Beatrice: Dada and the Unmaking of the Twentieth Century*. New York: Basic Books, 2015.

Reed, Ishmael. *Mumbo Jumbo*. New York: Scribner, 1977.

Tisserand, Michael. *Krazy: George Herriman, a Life in Black and White*. New York: Harper Collins, 2016.

Woodard, Komozi. *A Nation Within a Nation: Amiri Baraka (Leroi Jones) and Black Power Politics*. Chapel Hill: University of North Carolina Press, 1999.

TO MAKE A POET BLACK

Adorno, Theodor. *Notes to Literature Vol. I*. New York: Columbia University Press, 1991.

Baker, Anita. "Caught Up in the Rapture of Love." *Rapture*. Elektra, 1986 [sound recording].

Bayle Pierre. *Dictionnaire Historique et Critique, Tome second, Seconde partie. P–Z*. Rotterdam: Reinier Leers, 1697.

Bottéro, Jean. *Mesopotamia: Writing, Reasoning, and the Gods*. Chicago: University of Chicago Press, 1992.

Burn, Andrew Robert. *The Lyric Age of Greece*. New York: Minerva Press, 1968.

Cairns, Huntington, and Hamilton, Edith, eds. *The Collected Dialogues of Plato*. Princeton, NJ: Princeton University Press, 1961.

Carretta, Vincent. *Phillis Wheatley: Biography of a Genius in Bondage*. Athens: University of Georgia Press, 2011.

Carson, Anne. "Putting Her in Her Place: Women, Dirt, Desire." In *Before Sexuality: The Construction of Erotic Experience in the Ancient Greek World*, edited by D. M. Halperin, J. J. Winkler, F. I. Zeitlin. Princeton, NJ: Princeton University Press, 1990, 135–169.

_____ . *Eros the Bittersweet*. Champaign, IL: Dalkey Archive Press, 1998.

_____ . *If Not, Winter: Fragments of Sappho*. New York: Vintage, 2003.

Crawley, Ashon T. *Black Pentecostal Breath*. New York: Fordham University Press, 2017.

Cullen, Countee. *Collected Poems*. New York: Library of America, 2013.

Davis, Angela Y. *Blues Legacies and Black Feminism: Gertrude "Ma" Rainey, Bessie Smith, and Billie Holiday*. New York: Vintage, 1999.

DeJean, Joan. *Fictions of Sappho, 1546–1937*. Chicago: University of Chicago Press, 1989.

Dionne, Searcey. "Across Senegal, the Beloved Baobab Tree Is the Pride of the Neighborhood." *New York Times*, September 30, 2018.

DuBois, Page. *Sappho Is Burning*. Chicago: University of Chicago Press, 1995.

Du Bois, W. E. B. *The World and Africa and Color and Democracy*. New York: Oxford University Press, 2007.

Gates Jr., Henry Louis. *The Trials of Phillis Wheatley: America's First Black Poet and Her Encounters with the Founding Fathers*. New York: Basic Civitas Books, 2003.

Gikandi, Simon. *Slavery and the Culture of Taste*. Princeton, NJ: Princeton University Press, 2014.

Holiday, Billie, and Dufty, William. *Lady Sings the Blues*. New York: Penguin, 1992.

Jeffers, Honorée Fanonne. *The Age of Phillis*. Middletown, CT: Wesleyan University Press, 2020.

Jefferson, Thomas. *Notes on the State of Virginia*. New York: Penguin, 1998.

Kramer, Samuel Noah, and Wolkstein, Diane. *Inanna, Queen of Heaven and Earth: Her Stories and Hymns from Sumer*. New York: Harper Perennial, 1983.

Lorde, Audre. *Sister Outsider*. New York: Random House, 1984.

Matos, Luis Palés. *Selected Poems*. Houston: Arte Público Press, 2000.

Morrow, Susan Brind. *The Names of Things: Life, Language, and the Beginnings in the Egyptian Desert*. New York: Riverhead Books, 1997.

_____ . *The Dawning of the Moon Mind*. New York: Farrar, Straus and Giroux, 2015.

Moten, Fred. *In the Break: The Aesthetics of the Black Radical Tradition*. Minneapolis: Minnesota University Press, 2003.

_____ . "Manic Depression: A Poetics of Hesitant Sociology." Public lecture: University of Toronto, April 4, 2017.

Nepomnyashchy, Catherine T., Svobodny, Nicole, and Trigos, Ludmilla A. *Under the Sky of My Africa: Alexander Pushkin and Blackness*. Evanston, IL: Northwestern University Press, 2006.

Ong, Walter J. *Orality and Literacy: The Technologizing of the Word*. New York: Routledge, 1988.

Page, Denys. *Sappho and Alcaeus: Introduction to the Study of Ancient Lesbian Poetry*. London: Oxford University Press, 1955.

Schmidt, Michael. *Gilgamesh: The Life of a Poem*. Princeton, NJ: Princeton University Press, 2019.

Shange, Ntozake. *For Colored Girls Who Have Considered Suicide When the Rainbow Is Enuf*. New York: Scribner, 1997.

Thorsen, Thea S. "Sappho: Transparency and Obstruction." In *Roman Receptions of Sappho*, edited by Thea S. Thorsen and Stephen Harrison. Oxford: Oxford University Press, 2019 [online].

Voigt, Eva-Maria. *Sappho et Alcaeus, Fragmenta*. Amsterdam: Polak & van Gennep, 1971.

Ward, Adolphus William, ed. *The Globe Edition of the Poetical Works of Alexander Pope*. London: Macmillan & Co., 1869.

Wheatley, Phillis. *Complete Writings*. New York: Penguin, 2001.

Wilson, Emily. "Tongue Breaks." *London Review of Books* 26, no. 1 (January 8, 2004).

Wilson, Ivy. "The Writing on the Wall." In *American Literature's Aesthetic Dimensions*, edited by Cindy Weinstein and Christopher Looby, 58–61. New York: Columbia University Press, 2012.

Winkler, John J. "Double Consciousness in Sappho's Lyrics." In *Sexuality and Gender in the Classical World*, edited by Laura K. McClure, 39–76. Oxford: Blackwell, 2002.

BACK IN THE DAY

Doc Gynéco. *Première consultation*. Virgin/Parlophone, 1996 [sound recording].

IAM. *L'École du micro d'argent*. EMI Records, 1997 [sound recording].

Kassovitz, Mathieu. *La haine* [The Hate]. Canal+, 1995 [feature film].

MC Solaar. *Qui sème le vent récolte le tempo*. Musicrama Records, 1991 [sound recording].

NTM. *Paris sous les bombes*. Epic, 1995. [sound recording].

Pinoteau, Claude. *La boum* [The Party]. Gaumont Film Company, 1980 [feature film].

Piolet, Vincent. *Regarde ta jeunesse dans les yeux: Naissance du hip-hop français 1980–1990*. Marseille: Le Mot et le Reste, 2015.

NOTES ON TRAP

21 Savage. "Numb." *Issa Album*. Slaughter Gang/Epic Records, 2017 [sound recording].

Agamben, Giorgio. *The Use of Bodies*. Stanford, CA: Stanford University Press, 2015.

Baldwin, James. *Collected Essays*. New York: Library of America, 1998.

Barrett, Lindon. "Dead Men Printed: Tupac Shakur, Biggie Smalls, and Hip-Hop Eulogy." In *Conditions of the Present: Selected Essays*, edited by Janet Neary. Durham, NC: Duke University Press, 2018, 238–269.

Brooks, Gwendolyn. *Beckonings*. Detroit: Broadside Lotus Press, 1975.

Carmichael, Rodney. "Culture Wars: Trap Music Keeps Atlanta On Hip-Hop's Cutting Edge. Why Can't The City Embrace It?" NPR Music, March 15, 2017 [online].

Debord, Guy. *Comments on the Society of the Spectacle*. New York: Verso, 2011.

Du Bois, W. E. B. *The Souls of Black Folk*, edited by Henry Louis Gates Jr. and Terri Hume Oliver. New York: Norton Critical Editions, 1999.

Future. "Mask Off." *Future*. Freebandz/Epic Records, 2017 [sound recording].

hooks, bell. *Outlaw Culture: Resisting Representations*. New York: Routledge, 2006.

Iton, Richard. *In Search of the Black Fantastic: Politics and Popular Culture in the Post-Civil Rights Era.* New York: Oxford University Press, 2010.

Judy, R. A. T. "On the Question of Nigga Authenticity." *boundary 2* 21, no. 3 (Autumn 1994): 211–230.

Migos. *Culture.* Quality Control Music/300 Entertainment, 2017 [sound recording].

Morgan, Philip D. *Slave Counterpoint: Black Culture in the Eighteenth-Century Chesapeake and Lowcountry.* Chapel Hill: University of North Carolina Press, 1998.

Moten, Fred. "Taste Dissonance Flavor Escape: Preface for a solo by Miles Davis." *Women & Performance: A Journal of Feminist Theory* 17, no. 2 (July 2007): 217–246.

———. *Criticism* 50, no. 2 (Spring 2008): 177–218.

Radano, Ronald. *Lying Up a Nation: Race and Black Music.* Chicago: University of Chicago Press, 2003.

Saville, Julie. *The Work of Reconstruction: From Slave to Wage Laborer in South Carolina 1860–1870.* New York: Cambridge University Press, 1996.

Sontag, Susan. *Notes on "Camp."* New York: Penguin, 2018.

T. I. "Rubber Band Man." *Trap Muʑik.* Grand Hustle/Atlantic Records, 2003 [sound recording].

Warshow, Robert. "The Gangster as Tragic Hero," in *The Immediate Experience: Movies, Comics, Theatre & Other Aspects of Popular Culture.* Cambridge. MA: Harvard University Press, 2001, 97–103.

Weheliye, Alexander. *Phonographies: Grooves in Sonic Afro-Modernity.* Durham, NC: Duke University Press, 2005.

White, Simone. *Dear Angel of Death.* Brooklyn: Ugly Duckling Presse, 2018.

Young Thug. *Jeffery.* 300 Entertainment/Atlantic Records, 2016 [sound recording].

AN OPEN LETTER TO D'ANGELO

Abdurraqib, Hanif. *Go Ahead in the Rain: Notes to a Tribe Called Quest.* Austin: University of Texas Press, 2019.

D'Angelo. *Brown Sugar.* EMI Records, 1995 [sound recording].

D'Angelo and The Vanguard. *Black Messiah.* RCA Records, 2014 [sound recording].

Hughes, Langston. *The Collected Poems of Langston Hughes*, edited by Arnold Rampersad and David Roessel. New York: Vintage, 1995.

Neal, Mark Anthony. *What the Music Said: Black Popular Music and Black Public Culture.* New York: Routledge, 1998.

Tenaille, Frank. *Music Is the Weapon of the Future: Fifty Years of African Popular Music.* Chicago: Lawrence Hill Books, 2002.

Thompson, Ahmir. "Questlove." *Mo'Meta Blues: The World According to Questlove.* New York: Grand Central Publishing, 2015.

LANGUAGE AND THE BLACK INTELLECTUAL TRADITION

Coates, Ta-Nehisi. *We Were Eight Years in Power: An American Tragedy*. New York: One World, 2018.

Cruse, Harold. *The Crisis of the Negro Intellectual*. New York: New York Review Books Classics, 2005.

Glaude Jr., Eddie S. *Begin Again: James Baldwin's America and its Urgent Lessons for Our Own*. New York: Crown, 2020.

Nash, Jennifer C. *Black Feminism Reimagined: After Intersectionality*. Durham, NC: Duke University Press, 2019.

Shelby, Tommie. *We Who Are Dark: The Philosophical Foundations of Black Solidarity*. Cambridge, MA: Harvard University Press, 2007.

Spillers, Hortense J. *Black, White, and in Color: Essays on American Literature and Culture*. Chicago: University of Chicago Press, 2003.

Walker, David. *Appeal to the Coloured Citizens of the World*. Edited by Peter P. Hinks. University Park: Penn State University Press, 2000.

UNDERGROUND MAN

Johnson, Charles. "The End of the Black American Narrative." *American Scholar* 77, no. 3 (2008): 32–42.

Whitehead, Colson. *The Intuitionist*. New York: Doubleday, 1999.

———. *John Henry Days*. New York: Doubleday, 2001.

———. *The Colossus of New York*. New York: Doubleday, 2003.

———. *Apex Hides the Hurt*. New York: Doubleday, 2006.

———. *Sag Harbor*. New York: Doubleday, 2009.

———. *Zone One*. New York: Doubleday, 2011.

———. *The Underground Railroad*. New York: Doubleday, 2016.

———. *The Nickel Boys*. New York: Doubleday, 2019.

Young, Kevin. *The Grey Album*. Minneapolis: Graywolf Press, 2012.

FATHERS AND SONS

Ellison, Ralph. *Shadow and Act*. New York: Random House, 1964.

Wideman, John Edgar. *Hurry Home*. New York: Harcourt, 1970.

———. *The Lynchers*. New York: Harcourt, 1973.

———. *The Homewood Trilogy*. New York: Avon Books, 1985.

———. *Brothers and Keepers*. New York: Henry Holt, 1984.

———. *Philadelphia Fire*. New York: Henry Holt, 1990.

———. "In Praise of Silence." *Callaloo* 22, no. 3, special issue (Summer 1999): 546–549.

———. *Hoop Roots*. New York: Mariner Books, 2003.

_____ . *Fanon*. New York: Houghton Mifflin, 2008.

_____ . *Writing to Save a Life: The Louis Till File*. New York: Scribner, 2016.

THE PROTEST POETS

Baraka, Amiri. "A Post-Racial Anthology?" *Poetry* 202, no. 2 (May 2013): 166–173, 179.

Ellis, Thomas Sayers. "A loud noise followed by many louder ones: The Dark Room Collective (1987–1998)." *American Poetry Review* 27, no. 2 (March/April 1998): 39.

Hayes, Terrence. *Lighthead: Poems*. New York: Penguin, 2010.

_____ . *How to Be Drawn*. New York: Penguin, 2015.

_____ . *To Float in the Space Between: A Life and Work in Conversation with the Life and Work of Etheridge Knight*. Seattle: Wave Books, 2018.

Rankine, Claudia. *Citizen: An American Lyric*. Minneapolis: Graywolf Press, 2014.

Reeves, Roger. *King Me*. Port Townsend, WA: Copper Canyon Press, 2013.

Rowell, Charles Henry, ed. *Angles of Ascent: A Norton Anthology of Contemporary African American Poetry*. New York: W. W. Norton, 2013.

ON AFROPESSIMISM

Bell, Derrick. *Faces at the Bottom of the Well: The Permanence of Racism*. New York: Basic Books, 1992.

Brown, Vincent. *Tacky's Revolt: The Story of an Atlantic Slave War*. Cambridge: Harvard University Press, 2020.

Fanon, Frantz. *Les damnés de la terre*. Paris: François Maspero, 1961.

_____ . *Peau noire, masque blancs*. Paris: Editions du Seuil, 1952.

_____ . *The Wretched of the Earth*. Translated by Richard Philcox. New York: Grove Press, 2004.

_____ . *Black Skin, White Masks*. Translated by Richard Philcox. New York: Grove Press, 2008.

_____ . *Alienation and Freedom*. Edited by Jean Khalfa and Robert J. C. Young and translated by Steven Corcoran. New York: Bloomsbury, 2018.

Hayes Edwards, Brent. "Aimé Césaire and the Syntax of Influence." *Research in African Literatures* 36, no. 2 (2005): 1–18.

Lewis, Gordon R. *Fanon and the Crisis of European Man*. New York: Routledge, 1995.

_____ . *Bad Faith and Anti-black Racism*. New York: Prometheus Books, 1995.

Noland, Carrie. "Red Front/Black Front: Aimé Césaire and the Affaire Aragon." *Diacritics* 36, no. 1 (2006): 64–85.

Marriott, David. *Whither Fanon?* Stanford, CA: Stanford University Press, 2018.

Patterson, Orlando. *Slavery and Social Death: A Comparative Study*. Cambridge, MA: Harvard University Press, 1982.

Perry, Imani. *Vexy Thing: On Gender and Liberation*. Durham, NC: Duke University Press, 2018.

Robinson, Cedric J. *Black Marxism: The Making of the Black Radical Tradition*. London: Zed Press, 1983.

Sexton, Jared. "'The Curtain of the Sky': An Introduction." *Critical Sociology* 36, no. 1 (January 2010): 11–24. ·

––––––. "Unbearable Blackness." *Cultural Critique* 90 (Spring 2015): 159–178.

––––––. "Afropessimism: The Unclear Word." *Rhizomes* Issue 29 (2016).

Sharpley-Whiting, Tracy Denean. *Frantz Fanon: Conflicts and Feminisms*. Lanham, MD: Rowman & Littlefield, 1998.

Warren, Calvin L. *Ontological Terror: Blackness, Nihilism, and Emancipation*. Durham, NC: Duke University Press, 2018.

West, Cornel. *Race Matters*. New York: Vintage, 1993 [rep. 2017].

Wilderson III, Frank B. *Red, White & Black: Cinema and the Structure of U.S. Antagonisms*. Durham, NC: Duke University Press, 2010.

––––––. *Incognegro: A Memoir of Exile and Apartheid*. Durham, NC: Duke University Press, 2015.

––––––. *Afropessimism*. New York: W. W. Norton, 2020.

WHO WILL PAY REPARATIONS ON MY SOUL?

Agamben, Giorgio. *Homo Sacer: Sovereign Power and Bare Life*. Stanford, CA: Stanford University Press, 1998.

Coates, Ta-Nehisi. "The Case for Reparations." *The Atlantic*, June 2014.

Klein, Ezra. "Ta-Nehisi Coates: The Vox conversation." June 2, 2014 [online].

Pettit, Philip. *On the People's Terms: A Republican Theory and Model of Democracy*. New York: Cambridge University Press, 2013.

Scott-Heron, Gil. "Who'll Pay Reparations on My Soul?" *Small Talk at 125ᵗʰ St and Lenox*. Flying Dutchman/RCA Records, 1970 [sound recording].

Shabazz, Jamel. *A Time Before Crack*. Brooklyn: powerHouse Books, 2005.

Terry, Brandon, and Shelby, Tommie. *To Shape a New World: Essays on the Political Philosophy of Martin Luther King Jr.* Cambridge, MA: Harvard University Press, 2018.

THE WORK OF ART IN THE AGE OF SPECTACULAR REPRODUCTION

Berrebi, Marco, and JR. *Women Are Heroes*. New York: Harry N. Abrams, 2012.

Debord, Guy. *The Society of the Spectacle*. Translated by Donald Nicholson-Smith. New York: Zone Books, 1994.

Ladj Ly. *Les Misérables*. Le Pacte, 2019 [feature film].

Sontag, Susan. *On Photography*. New York: Farrar, Straus and Giroux, 1977.

Varda, Agnès, and JR. *Visages Villages* [Faces Places]. Le Pacte, 2017 [feature film].

Wacquant, Loïc. *Punishing the Poor. The Neoliberal Government of Social Insecurity*. Durham, NC: Duke University Press, 2009.

WHAT IS A CAFÉ?

Balzac, Honoré de. *Traité des excitants modernes*. Paris: Éditions de L'Herne, 2009.

Coubard d'Aulnay, G.E. *Monographie du café, ou manuel de l'amateur de café*. Paris: Delaunay, 1832.

Cortázar, Julio. *62: A Model Kit*. Translated by Gregory Rabassa. New York: New Directions, 2000.

Lefebvre, Henri. *Toward an Architecture of Enjoyment*. Minneapolis: University of Minnesota Press, 2014.

IN THE ZONE

Énard, Mathias. *Zone*. Translated by Charlotte Mandell. Rochester, NY: Open Letter Press, 2010

_____. *Street of Thieves*. Translated by Charlotte Mandell. Rochester, NY: Open Letter Press, 2014.

_____. *Compass*. Translated by Charlotte Mandell. New York: New Directions, 2018.

_____. *Tell Them of Battles Kings and Elephants*. Translated by Charlotte Mandell. New York: New Directions, 2018.

Houellebecq, Michel. *Submission*. Translated by Lorin Stein. New York: Farrar, Straus and Giroux, 2015.

THE TIME OF THE ASSASSINS

Amnesty International. "Syria's 'Circle of Hell': Barrel Bombs in Aleppo Bring Terror and Bloodshed Forcing Civilians Underground." May 5, 2015 [online].

Arendt, Hannah. *On Violence*. New York: Harcourt Brace Javanovich, 1970.

Benetti, Pierre. "Ahmed Merabet, 'français, policier, musulman,' tué par les frères Kouachi." *Libération*, January 13, 2015 [online].

Blanchot, Maurice. *The Writing of the Disaster*. Omaha: University of Nebraska Press, 1995.

Helm, Sarah. "ISIS in Gaza." *New York Review of Books*, January 14, 2016.

Einaudi, Jean-Luc. *La bataille de Paris, 17 octobre 1961*. Paris: Seuil, 1991

_____. *La Ferme Améziane: Enquête sur un centre de torture pendant la guerre d'Algérie*. Paris: L'Harmattan, 1991.

Lazreg, Marnia. *Torture and the Twilight of Empire: From Algiers to Baghdad*. Princeton, NJ: Princeton University Press, 2008

Rukmini Callimachi, Rubin, Alissa J., and Fourquet, Laure. "A View of ISIS's Evolution in New Details of Paris Attacks." *New York Times*, March 19, 2016.

Seelow, Soren, Piel, Simon, and Cazi, Emeline. "Attentats de Paris: l'assaut du Bataclan, raconté heure par heure." *Le Monde*. Paris: December 31, 2015.

Švec, Adrián, Harding, Luke, and Shields, Fiona. "The Scene at La Belle Equipe After the Paris Attacks." *The Guardian*, November 17, 2015 [online].

Zemmour, Éric. *Le Suicide français*. Paris: Albin Michel, 2014.

HARLEM IS EVERYWHERE

Du Bois, W. E. B. *The Gift of Black Folk: The Negroes in the Making of America*. New York: Washington Square Press, 1970.

Ellison, Ralph. "Harlem Is Nowhere." *Harper's Magazine, August 1964.*

Gates Jr., Henry Louis. *The Signifying Monkey: A Theory of African-American Literary Criticism*. New York: Oxford University Press, 1988.

Gilroy, Paul. *The Black Atlantic: Modernity and Double-Consciousness*. Cambridge, MA: Harvard University Press, 1993.

_____. *Darker than Blue: On the Moral Economies of Black Atlantic Culture*. Cambridge, MA: Harvard University Press, 2011.

Jackson, Lawrence. *The Indignant Generation*. Princeton, NJ: Princeton University Press, 2010.

Johnson, James Weldon. "Harlem: The Culture Capital." *Survey* 53 (1925): 635–39.

Kelley, Robin D. G. *Africa Speaks, America Answers: Modern Jazz in Revolutionary Times*. Cambridge, MA: Harvard University Press, 2012.

Mr Eazi. *Life is Eazi, Vol. 1 — Accra to Lagos*. Alex Bosh, 2017 [sound recording].

Rhodes-Pitts, Sharifa. *Harlem Is Nowhere: A Journey to the Mecca of Black America*. New York: Little Brown, 2011.

Wizkid. "Ojuelegba." *Ayo*. Starboy/E.M.E. Records, 2014 [sound recording].

Index